NATURE DRAWING
A Tool for Learning

The Art & Design Series

For beginners, students, and working professionals in both fine and commercial arts, these books offer practical how-to introductions to a variety of areas in contemporary art and design.

Each illustrated volume is written by a working artist, a specialist in his or her field, and each concentrates on an individual area—from advertising layout or printmaking to interior design, painting, and cartooning, among others. Each contains information that artists will find useful in the studio, the classroom, and in the marketplace.

Books in the Series:

Clare Walker Leslie is a professional artist, naturalist, and teacher. She has developed courses and workshops throughout the New England area, combining the study of drawing and nature for students of all ages, from elementary to graduate level. She lives with her husband and young son in Vermont and Cambridge, Massachusetts.

NATURE

CLARE WALKER LESLIE

DRAWING
A Tool for Learning

A SPECTRUM BOOK PRENTICE HALL, INC. Englewood Cliffs, New Jersey 07632

Library of Congress Cataloging in Publication Data

LESLIE, CLARE WALKER.
 Nature drawing.

 (Art & design series) (A Spectrum Book)
 Includes bibliographies and index.
 1. Animals in art. 2. Plants in art.
3. Landscape in art. 4. Drawing—Technique.
5. Artists' materials. I. Title. II. Series.
NC780.L42 743'.83 80–14242
ISBN 0–13–610360–X
ISBN 0–13–610352–9 (pbk.)

For permission to reprint the following chapter opening illustrations, grateful acknowledgment is extended to the following: Deborah Prince for Introduction and chapter 9, Laurel Smith for chapter 2, Linda Kaminski for chapter 4, and the Massachusetts Audubon Society for chapters 6 and 7.

For permission to reprint chapter opening quotations, grateful acknowledgment is extended to the following: for chapter 1 (p. 6), from Edward Hill, *The Language of Drawing,* © 1966, p. 39, reprinted by permission of Prentice-Hall, Inc.; for chapter 3 (p. 32), from Paul Duval, *The Art of Glen Loates* (Foreword by Les Line), by permission of Cerebrus Publishing Co., Inc.; for chapter 4 (p. 54), from Frederick Franck, *The Zen of Seeing: Seeing/Drawing as Meditation* (New York: Alfred A. Knopf/ Vintage, 1973), permission of the author; for chapter 5 (p. 80), from J. W. Grant MacEwan, *Tatanga Mani, Walking Buffalo of the Stonies,* by permission of Hurtig Publishers; for chapters 6 and 7 (pp. 100, 130), from *Animals in Art,* ed. Peter Buerschaper, Royal Ontario Museum, 1975, by permission of the Museum; for chapter 9 (p. 176), from Georgia O'Keefe, *Georgia O'Keefe* (New York: Viking Press, 1976), by permission of Robert Lescher.

THE ART & DESIGN SERIES

Cover Illustration:
J. FENWICK LANSDOWNE
Preliminary Sketches for a Painting of a Fox Sparrow
Reprinted from *Birds of the West Coast* by J. Fenwick Lansdowne, with permission of Houghton-Mifflin Company, Boston

Frontispiece (page ix):
GUNNAR BRUSEWITZ (Swedish, 20th century)
Illustration from the book Sjö *by the artist* (pencil and watercolor)
Courtesy of the artist and the publisher Wahlstrom and Widstrand, Stockholm, Sweden

10 9 8 7 6 5 4 3 2 1

Editorial/production supervision by Frank Moorman
Page layout by James Wall
Manufacturing buyer: Cathie Lenard

PRENTICE-HALL INTERNATIONAL, INC., *London*
PRENTICE-HALL OF AUSTRALIA PTY. LIMITED, *Sydney*
PRENTICE-HALL OF CANADA, LTD., *Toronto*
PRENTICE-HALL OF INDIA PRIVATE LIMITED, *New Delhi*
PRENTICE-HALL OF JAPAN, INC., *Tokyo*
PRENTICE-HALL OF SOUTHEAST ASIA PTE. LTD., *Singapore*
WHITEHALL BOOKS LIMITED, *Wellington, New Zealand*

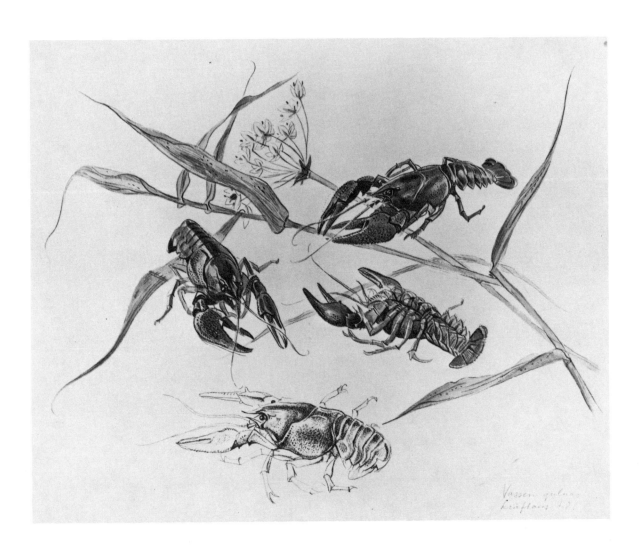

*We are not conscious enough in our human world of
this other shaping of life beside us, taking little account
of its presence and its ways, yet without such an
awareness our thoughts of life must remain a thing of
our own firesides where none see beyond the flame.*

WILLIAM HAMILTON GIBSON
Sharp Eyes: A Rambler's Calendar (1891)

Dedicated to the inhabitants of the natural
world who have been my best teachers
in learning to see and to draw.

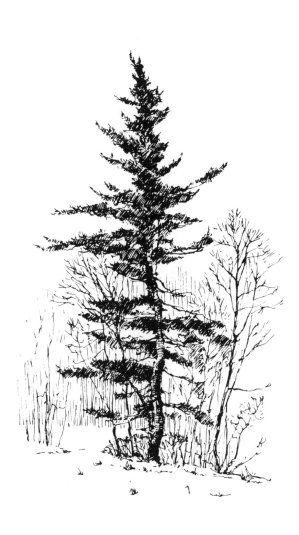

Contents

CORTINARIUS ARMILLATUS 1978

European Beech

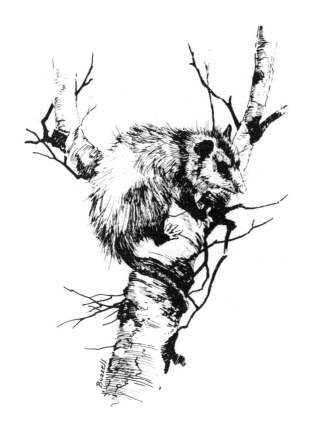

CHAPTER SIX

Animals *100*

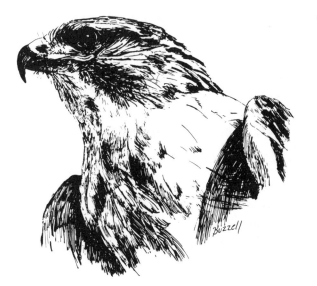

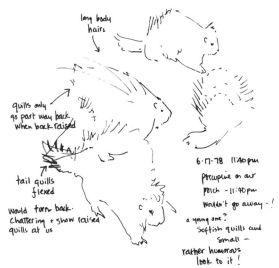

long body
hairs

quills only
go part way back
when back raised

tail quills
flexed

Would turn back.
chattering + show raised
quills at us

6·17·78 11:40 pm
Porcupine on our
porch - 11:40 pm
Wouldn't go away -!
a young one?
Softish quills and
small -
rather humorous
look to it!

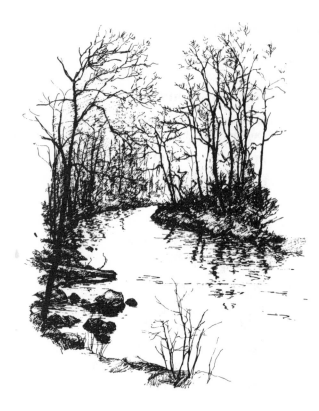

ACKNOWLEDGMENTS

I would like to give special thanks to a number of people who gave much support and encouragement throughout the year it took to write this book:

To Mary E. Kennan, editor for Spectrum Books, Prentice-Hall, who has given strong support to the book since its inception and never doubted its completion.

To all my students, who convinced me to write and who generously contributed their drawings.

To the many artists and naturalists who contributed their works and their enthusiasm for the book. To name just a few who shared their ideas through numerous, helpful letters and conversations: Gunnar Brusewitz, John Busby, Eric Ennion, Robert Gillmor, Wayne Trimm, Lee Salber, Chuck Roth, Don Stokes, Nathan Goldstein, and Frederick Franck.

To my husband, who supported, listened, and read over the manuscript, offering many valuable suggestions and changes.

And to Eric, who was born shortly after the manuscript's completion.

NATURE DRAWING
A Tool for Learning

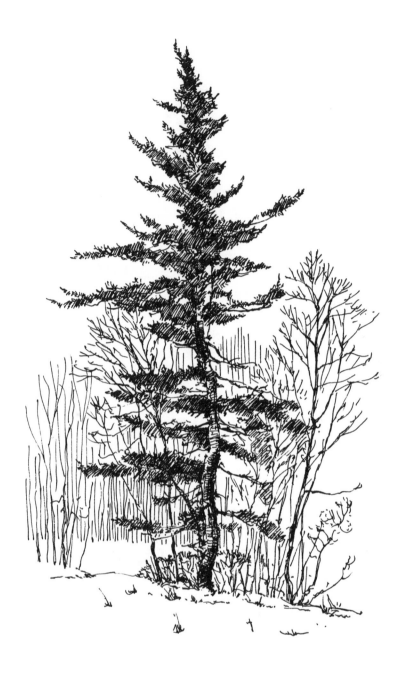

YOU DO NOT HAVE TO BE an experienced drafts-
man or scientist to enjoy drawing and ob-
serving nature. All that is needed are time, curios-
ity, some drawing skills, an ability to look, and
a true desire to learn from nature. This is a book
for anyone who wishes to come closer to appreci-
ating and understanding the events of the natural
world through drawing. It is for the beginner and
the experienced alike, for the eight and eighty
year old.

There is no one way to draw nature. There
is only the way that suits you. And that comes
from hours of trying this way and that until you
are comfortable with your style. Throughout this
book you will find exercises and techniques to
try, some basic natural history information, ideas
of subjects to draw, and many examples of artists'
works to study. Above all, the intent is to show
you an approach to nature drawing which puts
more emphasis on knowing the natural history
of plants and animals than do other drawing
books. Thus, this is a book about nature as well
as about drawing.

The tool of drawing can open doors to end-
less roaming in both city and country, where you
can carefully record what you see without having

Introduction

to collect or run home to a field guide book. Wonder, mystery, beauty, and a sense of closeness with the natural world are there when you sit with paper and pencil, drawing a spring crocus, a darting bird, a feeding butterfly, or a small landscape.

Learning simple techniques will keep you from continually struggling with skills and methods. Like anything, though, with practice, time, and continual study, improvements will come. The eye, as well as the hand, must be trained. Along with learning drawing skills, it is a good idea to find out more about what you

are drawing: what are deciduous trees, where are the primaries on a bird's wing, or where are the stamens and pistils in a flower head? Your drawings will be more accurate and individual.

I find drawing to be the simplest, the most direct, and the least expensive art medium for studying nature. We have so encumbered ourselves today through sports, recreation, and hunting with an abundance of tools for "being in nature" that we have lost the greatest tool of all: simply sitting and watching. Drawing allows for this. We have also lost the ability to learn on our own and to trust our own learning. Nature

drawing is a solitary pursuit. The experience is between ourselves and the object. Often it becomes more sketching than drawing, using the pencil more as a tool for taking notes of observations than for creating a lovely drawing. The art of drawing has taught me more about the realms of nature and about the techniques of drawing than has either a biology or an art class. Above all, it has taught me to *see* and to no longer go anywhere without turning over a leaf or a rock or pausing to watch a bird preening and asking myself, "How would I draw that?" As a teacher I find students continually wanting to know *how* to draw nature. The best teacher is nature itself. I can offer suggestions, exercises, and moral support. But the best suggestion I can give is to go out and begin *looking*.

Use the opportunity to learn about nature as well as drawing. Study both equally, but do not expect to become a great artist or naturalist overnight. Both skills take time to acquire. Again and again I find that the most valuable product of my study has been not the image on a piece of paper, but the experience of being so directly involved with nature. My area of study has been New England; therefore, my references and examples tend to pertain more to the inhabitants of this region. If you are not from this area, however, you can easily adapt the information to where you live.

Enjoy reading through the chapters and studying the drawings. Use it for your own course of study or as a companion to another art or nature course you may be taking. Use it as a *tool* to help bring yourself closer to a world that at one moment is eternal and, at another, extremely fragile.

Figure 0.1
Student drawing grasses. This student came for a week's course in nature drawing; he claimed that he had never drawn before, but wanted to learn the skill in order to use it in classes at the nature center where he taught. He worked hard and found, to his delight, that not only was he learning to draw better, but he was also finding himself looking at nature much more carefully.

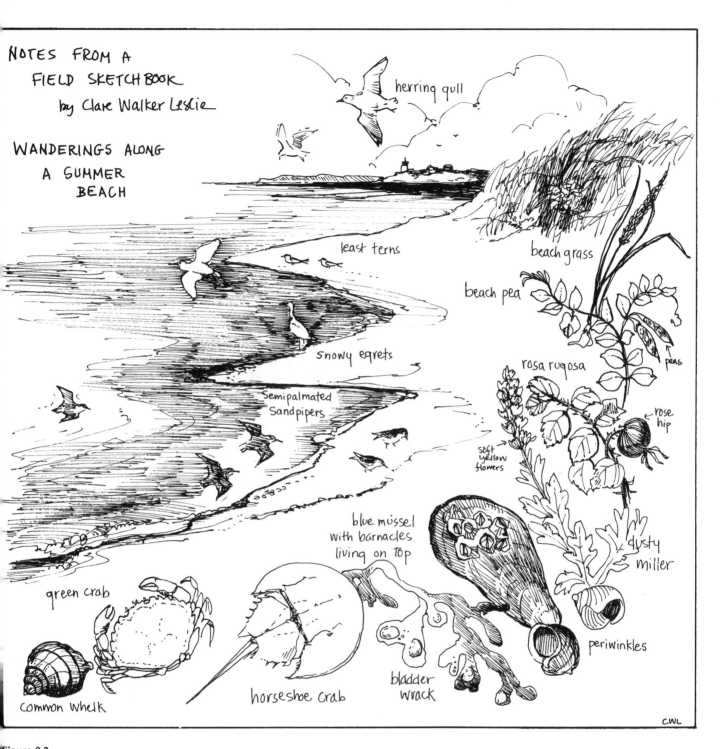

Figure 0.2

CLARE WALKER LESLIE

Page from a field sketchbook

Massachusetts Audubon Society Newsletter (June–July 1979), a publication of the Massachusetts Audubon Society

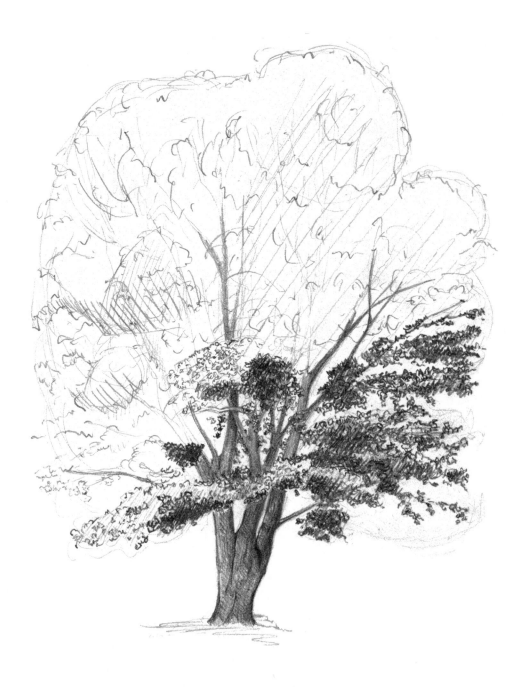

I N ORDER TO APPREHEND MEANING in our experience, it is essential for us to *see,* and drawing is the instrument of the inquiring eye that teaches us to see.

Edward Hill, *The Language of Drawing*

The most difficult step in drawing is getting started, whether you are experienced or just beginning. You may be skilled in drawing but know little about nature, or you may know a great deal about nature but little about drawing. Since the purpose of this book is to learn more about *both,* most exercises are designed to help you improve your knowledge of nature while improving your drawing skills. Although at times one may take precedence over the other, try to keep your study of both running parallel. But above all enjoy what you are doing.

Stop every now and then to evaluate whether you are really learning or enjoying as much as you would like. If not, have the courage to find out why and then change your path of study. If ever truly frustrated with your drawing, leave it for a while and simply go out and look at nature. Then return to your drawing when you

CHAPTER ONE

Beginning drawing exercises

are refreshed and have had some time to see once more what interested you in wanting to draw in the first place. Never lose touch with that vigor, that thrill that takes you to the natural world to observe, to learn, to cherish, and to draw.

The following exercises are modeled after ones I use when starting any of my nature drawing classes, for beginners as well as advanced students. They are intended to relieve anxieties we *all* have at beginning anything, to be fun, and to start you drawing right away. It takes as much time to learn how to see as to learn how to draw. Both are skills, like playing tennis or the violin,

that call for time and practice to be developed. I often tell adult students an alarming fact. If you have not drawn since you were ten, you will draw like a ten-year-old—understandably so, since you have had no opportunity to improve on what you were learning when you stopped. So accept the point at which you are beginning and be patient with yourself while you improve.

At first reading these exercises may seem trivial, but they are important as foundations for learning to draw anything, be it an animal, plant, human, or cardboard box. Since they are discussed again in relation to drawing particular sub-

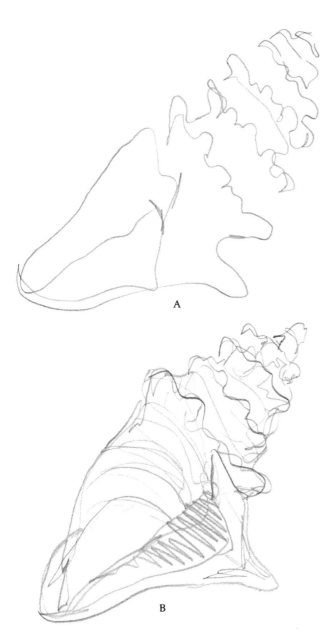

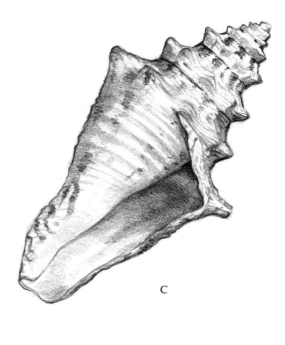

Figure 1.1
Student study drawings:
A. Contour
B. Gesture
C. Detail

jects throughout the book, it is recommended that you do these exercises first and in sequence to familiarize yourself with their purpose before going on.

EQUIPMENT TO USE FOR THE EXERCISES:

You should have several sheets of any 8-by-11-inch white paper having a smooth surface. Have a sharpened pencil but do *not* use its eraser. Nothing in these first drawings is to be considered a "mistake" which must be erased. Use a drawing board or a firm backing for support. Allow about one hour for all the exercises, which includes settling in, looking carefully at the object you are drawing, and taking breaks. Do not concern your-

self yet with technique or style. That will come later.

Exercise 1

OBSERVING

(No more than ten minutes)

Find something that is both interesting and natural to draw. Have it be something with a relatively simple outline that you can hold in your hand and look at closely, for example, a small flower, a shell, a vegetable, a dried seed pod, or the end of a leafy branch. You may have to go outdoors to find something. If so, give yourself a few extra minutes just to look—to notice tree forms, animal activity, cloud patterns—or just to listen for birds or wind sounds. An essential part of drawing is learning to observe and to improve sensory awareness. Having found something interesting to draw, find a comfortable, well-lit, and quiet place where you cannot be distracted for a while, either outdoors or in.

Figure 1.2
Demonstration of the four exercises for this chapter:
A. Memory
B. Contour
C. Gesture
D. Diagrammatic and detailed

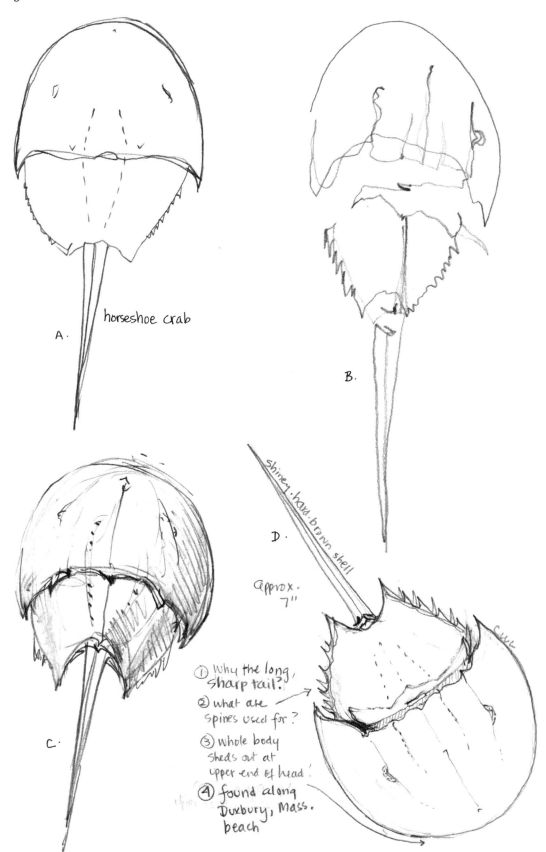

horseshoe crab

A.

B.

D.

shiney. hard. brown shell

approx. 7"

① Why the long, sharp tail?
② what are spines used for?
③ whole body sheds out at upper end of head!
④ found along Duxbury, Mass. beach

C.

9

Exercise 2
MEMORY DRAWING

(No more than ten minutes)

Clear your mind of other thoughts and distractions. Even close your eyes for a minute to relax. Then open them and pick up the object you have chosen. Look at it with total concentration. Feel its edges, curves, inner and outer shapes, and texture. Try exploring it without looking, but by touch only. Notice the difference in what your fingers tell you. Consider its shape and how it is designed to best function, grow, and survive as a plant, shell, feather, seed pod, or whatever. Consider where it was once growing or how it would look in other seasons.

Memorize its features, distinguishing key points. Then, in about five minutes, draw it from memory. Though seemingly a game, memory drawing is an important skill to acquire. There will be times when you are drawing a bird and it hops away, or you come across an interesting plant but do not have your sketchbook. Learn to absorb very accurately what you are seeing, whether actually drawing it, taking written notes, or just looking. Then if it moves or when you have your sketchbook, you can draw what you remembered. Whenever there is a choice between drawing or watching, I suggest that students watch. While your head is down looking at your paper, your subject may be doing some interesting things you are missing. Then when you look up, it has gone.

Things to notice for any memory drawing are the essential elements that initially describe any form: general shape (large, small, oval, serpentine), key parts (head, body, tail, or leaves, stem, and flowers), and key features (long hair, brightly colored, large eyes). Record it as if you were remembering it to describe to someone else. Ability to draw is not just knowing technique but also knowing what should be described. Keep to a simple line drawing here.

Exercise 3
CONTOUR DRAWING

(No more than five minutes)

Contour drawing is fun to do because you cannot look at your paper while you draw your object. Only your eyes can tell you how to draw. I find the results of this exercise always fascinating and quite beautiful. For the beginner, you cannot possibly make a "good" drawing. For the advanced student, here is a way to see a form in a fresh and unrestrained manner. Some students will use it before starting a study drawing, in order to "warm up" and to become accustomed to looking carefully at their subject (see Figure 4.3A).

Take another sheet of paper and draw the same object. This time look only at the object and not at your paper. Position your drawing page so that you will not be tempted to look. If you have not done Exercise 2, make sure you have looked thoroughly at your object for at least three minutes. Then place your pencil on the paper at the same point that your eye is looking on the object's surface. Imagine your eye is an ant crawling slowly over the whole shape. Either go from right to left or left to right.

Using a continuous and careful line, draw the wanderings of the ant over the contours of the object, in and out of each part your eye follows. Do not merely record the outline. Do not lift your pencil from the page or you will be lost; and do not cheat and look. If you are drawing the tip of a leaf vein, just go back into the center and out again. The value of this exercise is that your hand is totally dependent on your eye. For once, your mind cannot interpret or judge how things "should" look. You have no idea of the result until you are finished.

I guarantee you that this awkward, squiggly drawing conveys more of the sense, or basic characteristic, of the object than will the detailed drawing in which you will be looking at the paper and trying to make a "good" replica. Contour drawings have a way of capturing the gesture, feeling, and basic form in a manner that is uninhibited by the intellectual judgments imposed when we begin thinking how something should look. I will do a contour drawing if I feel that in doing a longer study I am simply not getting a sense, or feeling, for the object. Look at the contour drawings included in this chapter and judge for yourself what characteristics were conveyed and what you consider the value of this exercise to be.

Exercise 4
GESTURE DRAWING

(Twenty seconds and no longer)

The gesture drawing will be referred to again and again throughout this book. It is a very important technique to use when drawing active animals or sketching anything quickly. Its purpose is to get down the whole shape of an object and its major features quickly and accurately. Fast, continuous, flowing lines are used. The whole object is seen at once. Gesture drawings, or field sketches as they are called in nature drawing, are the preliminary studies made in preparation for longer works. Basic postures, features, behavior characteristics, and even composition can be worked out much as an outline indicates the whole thesis of a research paper.

For an idea of gesture drawing, try this exercise and refer to the examples of such drawings in this chapter. Pick up your object or place it on a table. Hold your pencil loosely, even further back than you usually would. If you tend to draw tightly, this is a good exercise for freeing your strokes and helping you loosen your style. Even try using your nondrawing hand. Concentrate on general posture and features. Is it drooping, sprawling, contained, geometric, or intricately uneven? Draw the outline and primary masses within the outline simultaneously. Place lines over lines, not taking time to erase. Put in major areas of shading only if you wish. Keep your lines and your eye moving quickly, learning to connect the hand's response to the eye accurately and rapidly. At the end of twenty seconds, stop. Gesture drawings have very restricted time limits. Do another from another position, and see how more flexible your hand becomes. These exercises are standard in art school and in figure drawing classes. A model poses for anywhere from ten seconds to five minutes and then moves in a series of changing positions throughout the hour. Students learn to record quick, characteristic poses much as you are doing here.

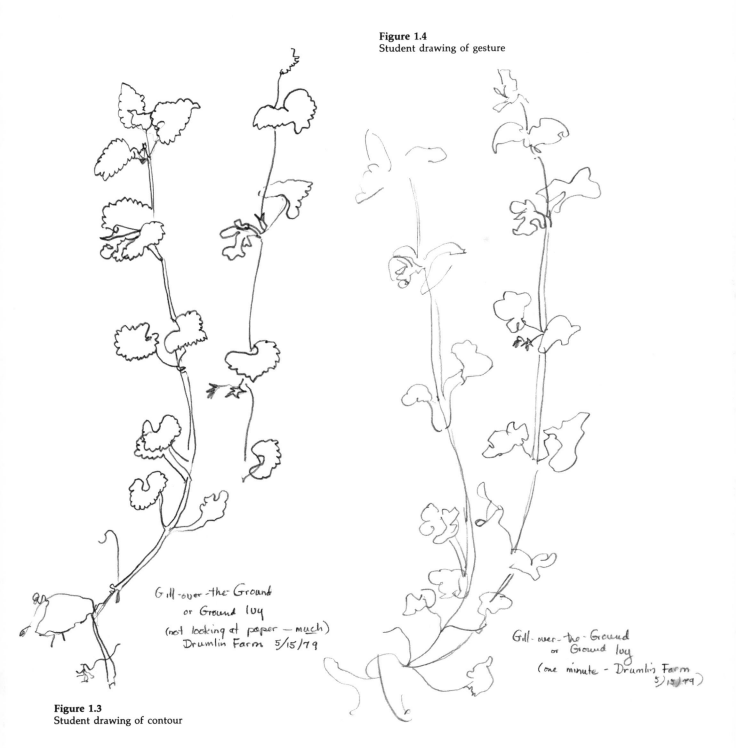

Figure 1.4
Student drawing of gesture

Gill-over-the-Ground
or Ground Ivy
(not looking at paper — much)
Drumlin Farm 5/15/79

Figure 1.3
Student drawing of contour

Gill-over-the-Ground
or Ground Ivy
(one minute - Drumlin Farm
5/15/79)

Figure 1.5
Student drawing: diagrammatic and detailed

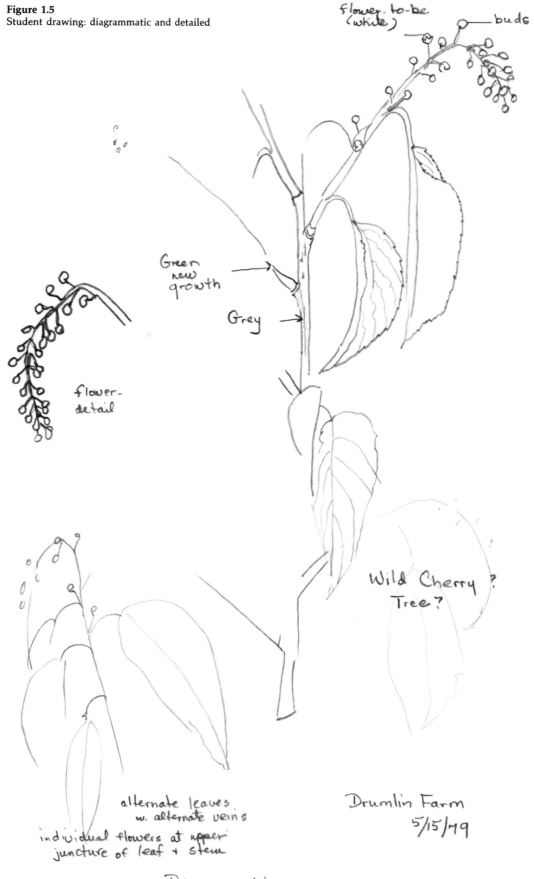

flower-to-be
(white)

buds

Green
new
growth

Grey

flower-
detail

Wild Cherry ?
Tree ?

alternate leaves
w. alternate veins

individual flowers at upper
juncture of leaf + stem

Diagrammatic

Drumlin Farm
5/15/79

Exercise 5
DIAGRAM OR DETAILED DRAWING

(Twenty minutes)

Obviously a detailed drawing can take any amount of time and can involve a wide variety of styles and techniques. But we will conclude this series of exercises with a detailed drawing more like a diagram, that records what you have so far learned both about drawing and about the object. As will be further explained in Chapter 3, "Methods and Techniques," the diagrammatic line drawing is used principally to describe the specific features of a plant or animal for purposes of identification. Drawing technique is less important than scientific accuracy. Therefore, artistic interpretation is kept to a minimum, and a solid line is used to make sure that all of a form is defined. (See Figure 1.5.)

For this exercise, do a simple line drawing of your object, approximately to size. If it is smaller than two inches, draw it larger; if it is larger than ten, draw it smaller; if it is a large plant, draw just part of it. Be sure to label size. Consider accuracy of shape, size, and proportion. Do not bother with shading unless you wish to, as the student did in Figure 1.1C. Make this a drawing that could go into a field identification book. For discussion on various ways to handle line, refer to Chapter 3 and the section entitled Line: Diagrammatic and Expressive.

Begin with a light pencil sketch of the basic form; then put in details. Judge your time so that in twenty minutes you have completed your drawing. Keep seeing the whole and do not get lost in detail. If you are drawing a plant with many repeated parts, such as leaves or needles, draw just a few in detail and leave the others just outlined. If you are drawing a shell with a lot of surface detail, try to stay somewhat general, including only enough to identify the species.

When the drawing is finished, write down three or four key features that help identify the plant, such as white flowers, prickly stem, fuzzy leaves, found growing under a maple tree. Then write one question about its form or function that you would like to know more about, such as, where else does it grow? Why is the stem prickly? How does it reproduce? Start getting into the habit of drawing subjects in nature not *just because they are nice to look at but because you want to learn something about them.*

Look over the four drawings you have just done. See how much you have observed in just one hour. Notice the progress of your seeing, from the uncertain memory drawing to the more assured detail drawing. You may be frustrated and see all the skills you are lacking, but drawing is not an easy subject to master. It takes time, practice, much trial and error, and a lot of patience. I have talked with one artist who is in his seventies and is a superb draftsman. He once sighed and said, "I am *still* learning how to draw."

So enjoy your study of nature through drawing. Learning about both is a life-long process. Use this book to help guide you. Keep these first exercises and do them again and again, whether as a warm-up before beginning a longer drawing or as studies in themselves.

L. Smith

I NEVER REALIZED I would see so much more by having to draw it. Drawing makes me learn about nature more carefully. It makes me see better. . . . And it makes me appreciate a lot more what I do see.

Student in "Keeping a Naturalist's Sketchbook" workshop

The materials used for studying nature should be kept simple, portable, and uncomplicated. Too many excellent artists prevent themselves from drawing by claiming that they don't have the right equipment. Although having good equip-

ment is important, it is far from essential. Materials that are essential are time, interest, and careful observation. Many drawings of nature have been done on paper napkins or across backs of envelopes, and many scientific discoveries have been made with the cheapest hand lens and pocketknife.

Materials for drawing may seem endless. So begin with a few and branch out to others when you feel like experimenting. Better equipment potentially means better drawing but does not guarantee it. Knowledge and experience are also necessary ingredients. The tools used for the

14

CHAPTER TWO

Materials

exercises in this book are intentionally kept simple and can be found in most art or stationery stores. Ask for help when selecting from the lists I give you. You may feel weights and surfaces of papers, but ask to see charts on pen and pencil varieties because trying them out is not recommended. I still go into an art store and browse. Trying a new pen or different paper can push me into new areas of expression or technique. Do not get into a rut, continually using the same pencil and the same paper. Also remember that the equipment you use really matters less than what you are studying with it.

PAPERS

The brand names for art supplies may vary but the types should not. Knowing something about types and qualities of paper will help in deciding what to use. Battling paper that is too rough, too thin, or meant for a different medium can be frustrating. Often I find that a beginning student's first problem is not with technique but with having the wrong kind of equipment for what he or she wants to do. The right equipment, though, does not necessarily mean the most ex-

pensive. I use all sorts of scrap paper, liking the varieties of weights and textures and the unexpected things that can be done on something I have not tried for a while.

Paper is used for a wide variety of artistic purposes, and it is cataloged by weight, surface texture, color, quality, and purpose. Tracing paper is no good for watercolor, nor is rice paper good for pencil. You can get paper from one ply (thin) to four ply (thick). The thicker the paper used, the more sturdy the drawing surface and the better it will take the medium without tearing. The cheaper papers, such as newsprint, are made of all wood pulp. The more expensive papers are more commonly made of cloth, which is termed *rag.* What art stores call *300-type paper* is made of all wood pulp and is of the lowest grade since acid in the wood causes the paper to discolor and disintegrate with age. A *400-type paper* is part wood and part rag and is considered the standard drawing paper. A *500-type paper* is top quality and 100 percent rag. The all-cloth paper will not discolor or disintegrate with age.

Paper surfaces may be termed *plate* (shiny), which are good for pen or harder pencils and for detail or scientific work where any texture would be a hindrance; or *vellum* (with a varying texture), which are good for softer pencils, pastel, and charcoal where texture can absorb the graininess and add an expressive surface effect.

Select a ring-bound pad over glue-bound so that pages can be turned back on themselves or be removed without tearing others. The better

quality papers, however, will come in glue-bound pads (particularly watercolor paper) or in single sheets. These should be cut out carefully with a knife or clipped onto a board backing if you are drawing in the field.

Inexpensive Papers

NEWSPRINT

This is the same paper that news is printed on and is most often used for basic drawing classes in art schools. It is inexpensive and takes well charcoal, soft pencil, ink and brush, or pastel. Since the paper quality is poor, will yellow with age, and rips easily with much erasing, it is not used for any fine detail work. However, because newsprint sheets are available in large sizes and are inexpensive, it is good for practice and loosening up before starting a longer study.

MANILLA

A form of newsprint paper that is textured and of heavier weight, manilla can be used for similar purposes as newsprint but will hold up a bit better. It has a slightly yellow color.

DUPLICATOR BOND PAPER

Bond is the name for the 300-type white paper used in Xeroxing, duplicating, and writing letters. It comes in 8½-by-11-inch packages of five hundred sheets, ranging in weight from light to heavy. I use this paper in workshops and with

Figure 2.1
Student drawing plant forms

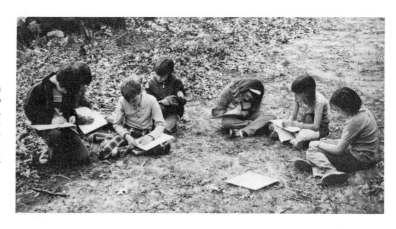

Figure 2.2
Children drawing in a class on keeping a field sketchbook. They had been told to draw signs of spring: green leaves, ants, birds, dandelions, and so on. They are using sheets of 8-by-11-inch bond paper clipped onto a backing of heavy cardboard. The pencils are easily handled, thick Primer pencils.

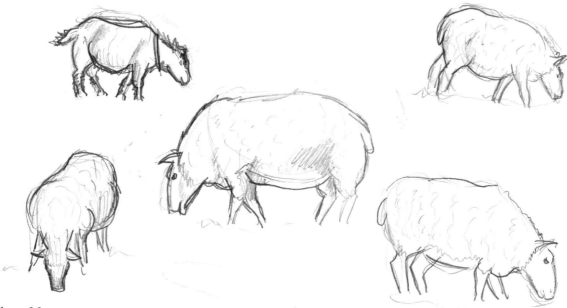

Figure 2.3
Field sketches of sheep and a goat by an eleven-year-old using a Primer pencil on duplicator bond paper.

beginning students because it does not have the aura of being "drawing paper" yet it allows for a clean, clear drawing right away. The surface is smooth and so will take pen and pencil better than pastel or watercolor. I recommend buying a pack to have around for experimenting and for doing a number of fast, free sketch-type drawings, without having the feeling of "wasting" good paper.

You can make an inexpensive drawing board out of a masonite sheet (minimum size being 10 by 13 inches) or out of heavy cardboard. Clip a number of sheets onto a firm backing and you have a versatile sketch pad for both outdoors and indoors. I use bond paper, with boards for backing, in all beginning adult courses drawing outdoors as well as in all children's classes. With the children, when the classes entail drawing various types of animals at a nature center or keeping

a field sketchbook of seasonal events, these sheets of paper can be accumulated throughout the weeks to be made into individual booklets.

There is another good use for bond paper. When you are working on an extended study, place an extra sheet under your drawing hand so as not to smudge or discolor the image underneath.

Medium-Quality Papers

Although it is nice to do casual drawings and sketches on inexpensive paper, you should have a good drawing pad for more careful drawings that can be kept in order and in one unit. Having one or two drawing books specifically for drawing nature can help you focus your study as well as take it more seriously.

STANDARD DRAWING PAPER

The 400-type drawing paper comes in a variety of sizes, thicknesses, and surfaces and can be used with pencil, pen and ink, crayon, or charcoal. The surface is a bit too smooth to hold the charcoal but will not smudge as much if sprayed with a fixative. Watercolor can be used on it, if laid on fairly dry; otherwise, it will wrinkle the paper. Pads of ring- or glue-bound paper are 5 by 8 inches (good for travel and carrying in a pocket), 9 by 12 inches (can be taken in a pack and is the most common size used), or 11 by 14 inches (a size I prefer because it is large enough to lay out full-size studies and yet is not too cumbersome to carry or hold when drawing outdoors). Strathmore and Aquabee are brand names of standard drawing pads. Some papers will have rougher surfaces and heavier weights than others. Choose a smooth surface and a medium-weight paper. The grainier the paper, the more textured will be your drawing; and the thinner the weight, the less it will hold up to a heavy drawing line or to erasing. (To avoid both problems, keep a light hold on your pencil and be sure to keep it sharp.)

FIELD SKETCHBOOK

Refer to Chapter 8, "Keeping a Field Sketchbook," for ways to use these hardbound drawing books. If you want to keep a running journal documenting specific observations in nature, it is important to have one place, apart from the drawing pad, to keep these ongoing notes and sketches. Pages are less likely to get torn or ripped out, and the tendency to do sketches in a sequence, rather like a diary, is increased. Since the paper is a low-grade bond type, it is better used for more informal field sketches and records where detailed work is not necessary. I use a hardbound drawing book when observing in the field because it can take the wear of transport in a backpack and the general battering of a year's use. Use the drawing pad for your more technical studies of nature or when you want a finished piece that can be taken out and saved in another place.

Specialty Papers

Treat yourself now and then to really nice paper. Buy it by the single sheet first, or try a small pad before investing in a larger one. Expensive paper may not necessarily produce better work, but it will make you take your drawing more seriously. It will erase better and will hold pen and pencil, as well as watercolor, more easily. As paper is a personal thing, you will find certain types suit certain styles and tools better than others.

BRISTOL PAPER

This is a good all-purpose drawing paper, ranging in weight from one to four ply. Its surface is either plate or vellum, and its quality ranges from 300 to 500. It generally comes in 22-by-30-inch single sheets but can be cut down to the size you want. For professional or scientific illustrations, bristol paper is most commonly used.

BRISTOL OR ILLUSTRATION BOARD

Illustration board is really just good bristol or bristol-type paper backed with cardboard to give it more durability. Boards are either smooth (called hot pressed) or textured (called cold pressed.) The quality ranges from 400 to 500. Boards come in varying single sheet sizes and can be cut to the size desired. Bristol board is a good, receptive surface for watercolor and illustration work where a certain amount of detail or fine brushwork is required. Since it has the stiff backing, it will not buckle with a watercolor wash and can be handled without fear of ripping or bending it. It is also less expensive than some of the fancier watercolor papers. Illustration board is what most artists use when drawing for professional purposes, where their work must be handled by clients or printers.

A comparable board is mat board, used in matting drawings and prints. If you have access to it or to scraps of it, use the underneath, uncolored side. You can also use shirt cardboard or poster board, but because the surface is shiny, it will take pen better than pencil and dry watercolor better than wet.

TRACING PAPER

This is a thin, translucent paper which artists use to overlay a study sketch on top of a working drawing. Changes can be checked with the drawing underneath without disturbing it. This paper takes pen and ink or a medium soft pencil but will not take erasing or a hard pencil.

Some artists use it to lay out an initial drawing; then on the reverse side, they scribble in a tone of graphite. Laying this sketch over a better quality paper, they trace over the lines of their initial study. Like carbon paper, where pencil presses onto the graphite underneath, a line is left to indicate the identical form on the better paper. In this way, initial sketching and erasing need not be done on the final paper in order to keep its surface clean.

CHARCOAL AND PASTEL PAPER

These are textured, medium-weight papers in varied shades of grey, beige, and soft rainbow colors. They are useful for rough, tonal drawings in charcoal, washes, or pastels. Because of the rough surface, they are not used as much for fine detail. Try them when you want to be more abstract or to try working on colored surfaces.

COQUILLE BOARD

If an even tone or texture is desired over a larger area of pen and ink work, a coquille board may be used. This is a heavy paper having a surface texture which comes in several varieties of small, wave-like patterns. A black lithographer's crayon or china marker is used for the tones, pen and ink for the lines, and a black ink wash for the solid areas. Rub the crayon or marker lightly over the paper's surface as if you were doing a rubbing, and the texture will appear. Artists may use this technique for a piece that must be photo-reproduced because the stippled coquille tone reproduces more clearly and easily than does a solid tone.

WATERCOLOR PAPERS

Most watercolor paper is heavy and rough and can absorb water without buckling. The rough-textured papers are better for the loose, watery effects of abstract paintings, particularly those of landscapes. The smoother surfaced papers are used more commonly in nature drawing since detail and illustration are more the intent.

Watercolor paper comes in single sheets, in bound pads with separate sheets glued together along the edges, or in tear-out pads. Papers can be rough textured (cold pressed) or smooth textured (hot pressed). Be sure to choose a paper that will not buckle and is not too coarsely textured or so slick that pigment will not be absorbed.

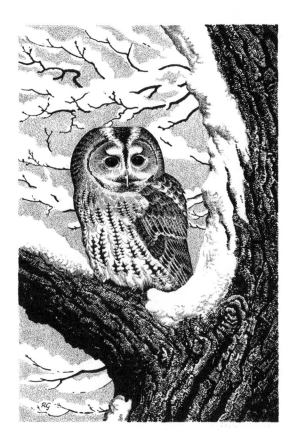

Figure 2.4
ROBERT GILLMOR (British, 20th century)
Tawny Owl in Winter (pen, brush and ink, and Chinagraph pencil on coquille board)
Courtesy of the artist

It takes a while to know what watercolor papers best suit your purposes. Since they can be very expensive, buy one sheet at a time to see what you work with best. One artist I know often prefers brown wrapping paper for small watercolor sketches of birds. He likes working off its dark and textured surface. If you know of a paper company or printer, keep in touch with them because often they have good-quality stock at remnant prices.

DRAWING TOOLS

Many things can serve as drawing tools. Charcoal, pastels, black litho crayons (a type of wax crayon), and the soft graphite pencils are better for less detailed and more tonal or abstract drawings. The harder pencils and pens are generally

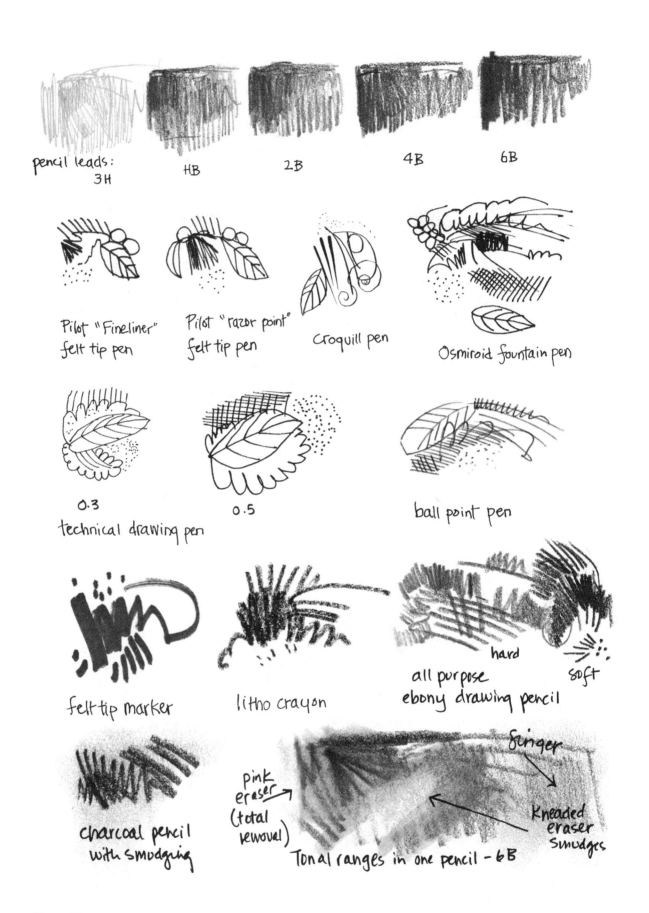

pencil leads:
3H HB 2B 4B 6B

Pilot "Fineliner" felt tip pen

Pilot "razor point" felt tip pen

Croquill pen

Osmiroid fountain pen

0.3
0.5
technical drawing pen

ball point pen

felt tip marker

litho crayon

hard soft
all purpose ebony drawing pencil

charcoal pencil with smudging

pink eraser (total removal)

finger

Kneaded eraser smudges

Tonal ranges in one pencil – 6B

Figure 2.5
Diagram of drawing tools

used for detailed or illustration work. Inexpensive, felt-tip pens and markers are good for field sketching. Color, of course, is an important element in drawing nature; it will only be briefly mentioned here since its subject is more vast than the scope of this book allows, but a basic understanding of its properties and application can be very helpful. Most often, in drawing nature, the simplest tools can be used since method is less important than subject. In all my classes, I suggest using primarily the HB, 2B, and 3B pencils before branching out into other tools. A tremendous variety of drawings can be done with just these pencils. However, keep the door open for experimentation and see what you can learn.

Pencils

For some inexplicable reason, pencils are characterized by the letters H (hard) and B (soft). A 6H pencil would be very hard, and HB would be between hard and soft, and a 6B would be very soft.

Soft pencils (B to 6B) can smudge, because the graphite sluffs off easily, but drawings can be sprayed with a clear plastic fixative which helps seal the image. Soft pencils must also be kept continually sharp if a light, thin line is wanted. However, their advantage is that they allow for varieties of tone and line, from very pale to very dark, which may be desired where gradations in tone and shading are needed (as in Figures 2.6 or 2.7). A hard pencil (H to 6H) is used in detailed line work or in scientific illustration where a sharp, clean image is desired. The range in tone is more limited and will tend to be paler than with the softer pencils.

Graphite pencils (erroneously called lead) come in a variety of forms: as a regular *wood pencil,* contained in a holder which extends the pencil down to a small stub, or as "leads" for a metal *mechanical* or *technical drawing pencil.* The latter is used in fine drawing and drafting where a very sharp and firm point is needed. It is also retractable and thus good for drawing outdoors. An inexpensive version is the common Scripto mechanical pencil which does not have a quality drawing lead but is handy for simultaneous drawing and taking notes.

Figure 2.6
RUSS BUZZELL
Owl (several soft pencils)
Reprinted with permission of the Massachusetts Audubon Society

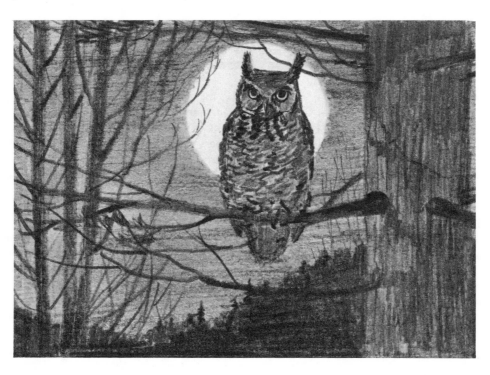

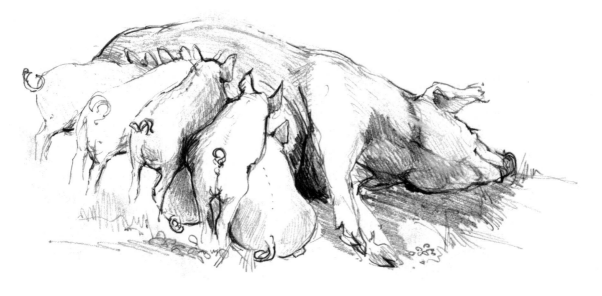

Figure 2.7
CLARE WALKER LESLIE
Pig studies (2B, 3B, and 4B pencils)

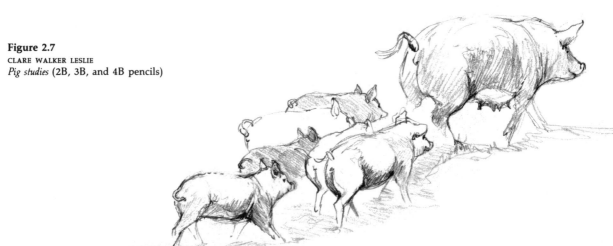

Pencils contain carbon and clay (not lead). The more clay present, the lighter and harder the line. The more carbon present, the darker and softer the line. The standard number 2 yellow writing pencil is a perfectly adequate HB pencil, although it does not have the quality lead of the graphite pencil. An Ebony pencil has a thicker soft lead which is good for expressive lines requiring great tonal ranges. Its scope is from 4B to 7B, being made of carbon rather than graphite. My favorite pencil, actually, is a child's primer pencil. It is thick like the Ebony pencil but is not as soft or grainy. I find it very flexible, with a range from about HB to 5B. Because it does not have the "stigma" of being a drawing pencil, I use it in all beginning classes. One can quickly get a nice, strong line with it; and it has *no* eraser, which is often liberating. You can buy boxes of twelve at a time at any school supply store.

Pen and Ink

It is a good idea to draw the same object with pencil and then with pen or with a range of pencil leads or types of pens to see stylistic variations. When using a pencil, I can get so involved with style of drawing and type of line in my effort to make a "good" drawing that I will no longer look at the object before me. I approach pen work quite differently. The line is clean and sharp and allows for no hedging. A mistake stays. Where a pencil enables buildup by areas of volume, tone, and shading, a pen is limited to line work only (as in Figure 2.11). Of course, a pen drawing can first be laid out in pencil and inked over in pen. Mistakes can be corrected with various white-out materials, such as typewriter correction fluid or watercolor white gouache, and tones can be added with washes of ink and a watercolor brush

(Figure 2.12). But like the oriental *sumi* calligraphies, there is something very beautiful about a clean, black image on a pure white page.

I tend to use pen outdoors because it allows for a more immediate and less complicated image, and pencil indoors because it allows for a more technically developed drawing. For me, the results from pen are more scientific, and from pencil, more artistic. But this can be very arbitrary. Decide for yourself the uses you prefer.

Since a good pen can be an expensive investment, first try using a felt-tip or ball-point pen. If it is lost, the cost is minimal. The quality of a drawing will not be as fine, but these pens can be more versatile to work with. I use felt-tip pens for field sketching (although they do blur in the rain) and good pens for drawings that require more care and professional results. They have a grace and fine quality of line that come only with a better pen. Also, the ink is rich and opaque, whereas the ink in the cheaper pens tends to be dull and more transparent.

To expand your equipment, you might first buy a *pen holder* and a variety of *pen points*. Ask to see a chart of line thicknesses and select just a few nibs. There are a range of good Pelican drawing inks in numerous colors (India ink is one name for a good, permanent black drawing ink.)

A *croquill pen* is a small, inexpensive pen point fixed in a plastic holder. It gives a thin, spidery line which can be most expressive. It requires a light, slow line or the nib may break and prick the paper. Any Pelican drawing ink or India ink can be used. The ink bottle has a stopper top so that you can gently squeeze a drop onto the curved underside of the point or dip it directly into the bottle. If excess ink is not wiped off on the bottle lip, the ink can blob and flow unevenly; and if the pen is pressed too hard the ink may not flow or will flow too fast.

Figure 2.9
CLARE WALKER LESLIE
Seed Head (croquill pen and black ink)

The *Osmiroid or Pelican drawing pens* look like standard fountain pens but have more varied points, specifically made for drawing. They have advantages over dip pens in that the inner tube can be filled with ink, as can regular fountain pens. Since you do not have to keep dipping, you can work without interruption. Be sure you use the right ink or the pen can clog. Clean all pen points off after each use to prolong life and quality. Unlike the cheaper felt-tip or plastic pens, these can last you a lifetime and are worth the investment.

A *technical drawing pen* is like a fountain pen except that its point is a thin metal needle with a flat point. It is used by architects and graphic and scientific illustrators who need a consistent

Figure 2.8
CLARE WALKER LESLIE
Lobster at the Aquarium (black felt-tip pen)

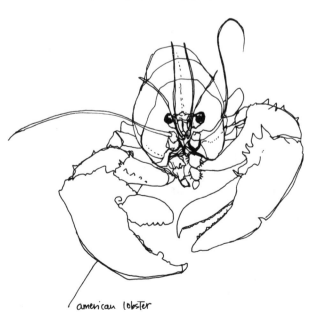

american lobster

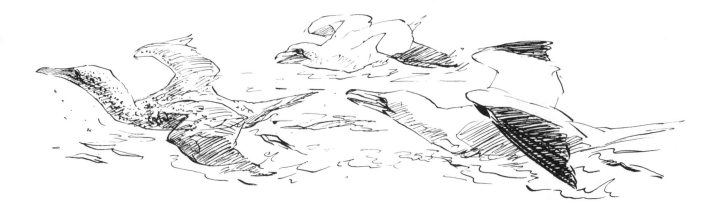

Figure 2.10
JOHN P. BUSBY (Scottish, 20th century)
Field sketches of a newly fledged, juvenile gannet harassed at sea by adults (fountain pen)
Courtesy of the artist

Figure 2.11
GEORGE ULRICH
Garden Pests (technical drawing pen)
Reprinted with permission from *Horticulture* Magazine, June 1978. Courtesy of the artist and Massachusetts Horticulture Society.

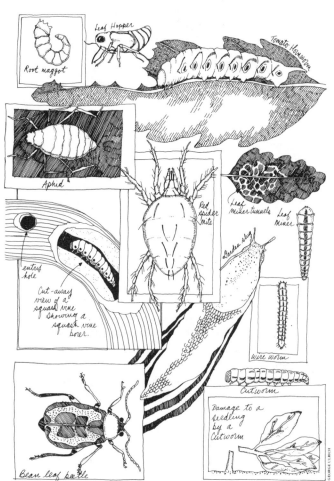

and evenly flowing line. The only way to vary line thickness is to use a different sized point, of which there are many. You need very little pressure to get a smooth line, but the pen must be held fully vertically or the ink will not flow. The correct ink to use should come with the pen. Do *not* use any other as it can clog the pen. Care of these pens is important. If ink clogs because of improper cleaning or the wrong ink, all old ink must be cleaned off the point very carefully under warm running water.

Since these pens do not flow if used too quickly, they make you draw slowly and carefully. Students first trying them fall in love with their drawings because they seem so much more beautiful with those clear, precise lines. They are particularly good for drawing small, delicate subjects where much detail is needed, such as a snake's skin or a butterfly's wing.

The more common brands today are Rapidograph, Castell, Staedler, and Mars. When buying one be sure to ask which brand will not clog and which will draw with the most even flow.

Other Drawing Tools

Experiment with charcoal pencils, charcoal sticks, litho crayons, colored pencils, crayons, and felt-tip pens and markers to see how these can vary your style and type of study. I will use colored pencils if I want to add color to a study of an animal without using watercolor. Crayons can be liberating when doing abstract landscape studies. Charcoal pencils and litho crayons are best used when tonal effects are wanted, such as for clouds, rock piles (Figure 9.16), landscapes (Figure 2.15), or for animals where fine detail is not needed

(Figure 6.6). Try mixing media, such as pencil with ink wash, pen with watercolor, crayon with pastel, or felt-tip pen with pencil.

Washes and Colors

Several methods for using color when drawing natural subjects will be discussed in Chapter 3, but for more detailed information on the techniques of watercolor in general, refer to another book specifically on that subject. In drawing nature, many color tools can be used: felt-tip markers, colored pencils, colored inks, pastels, crayons, watercolors, oils, and acrylics. When I want to add color to sketches while out in the field, I will carry along a small and inexpensive watercolor box or a few select colored pencils.

If you decide to use watercolors, buy a fairly good set, such as Grumbacher or Winsor-Newton. These come in a box of small, dry color cakes or in tubes of liquid pigment. If you buy the least expensive set, the colors may be of limited range, be chalky when applied, not build up tones well, and fade with age and exposure to light.

Ask in an art store what brand is recommended for your purposes.

Some artists may use an opaque watercolor called *gouache.* It also comes in small tubes as a liquid, but because of its thicker, opaque base, it gives a more brilliant solid color faster than the transparent layers of watercolor. An inexpensive form is poster paint, which comes in small jars of brightly colored liquid pigment. Acrylics

Figure 2.13
MARTHA CAIN
Gourds (colored pencil)
Courtesy of the artist

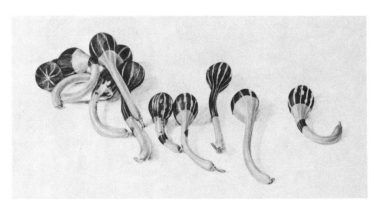

Figure 2.12
American Beech (Osmiroid drawing pen and black, watercolor wash)

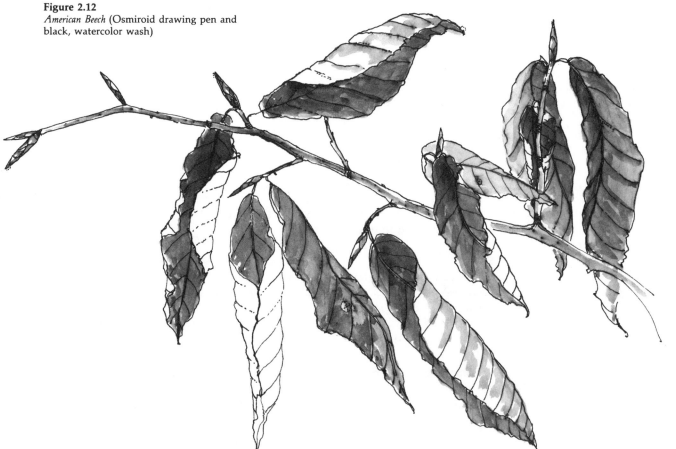

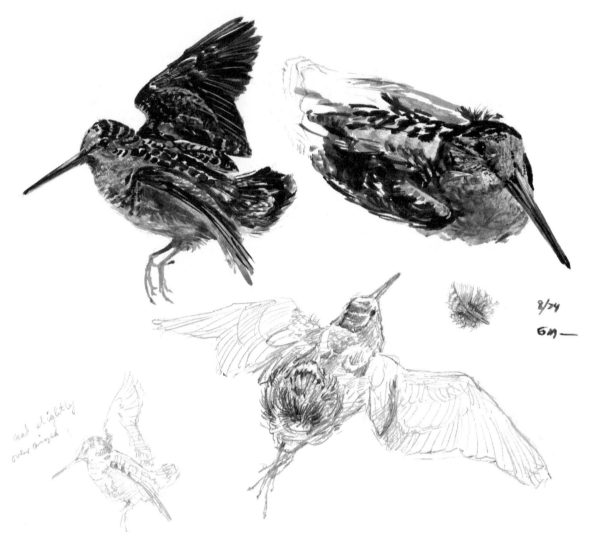

Figure 2.14
GORDON MORRISON
Studies of an American Woodcock (HB pencil and acrylic paint)
Courtesy of the artist

are also used, but they dry faster than watercolors and if not carefully mixed and thinned can result in intensely bright, plastic-looking colors. The color studies in Figure 2.14 are examples in which acrylics were used more like watercolors, applied thinly with carefully blended colors.

With your watercolor set, buy several brushes: one small for detail (size 5), one medium large (size 12), and one large (size 26). If you are painting outdoors, take along a small water bottle for mixing colors, a small sponge or paper towel for mopping colors that are too wet, and a pencil and eraser for preliminary drawing.

ADDITIONAL ITEMS

Erasers. Erasers can be used for more than erasing mistakes. They can soften lines and tones, pick up highlights, make textures, blend forms, and help create volume (as in Figure 2.15). If you have a dark tone on water and want to pick up highlights, use the tip of your eraser to pull out the image and create small, white areas. If you have a solid line along an animal's back and wish to indicate light hitting the fur (as in Figure 2.7 along the sow's back), break up that line by draw-

26

ing it in and then softening or erasing parts of it. Look at the plates throughout the book to see how erasers have been positively used.

You can use the usual dime-store pink eraser, an eraser stick, or a kneaded rubber eraser. The kneaded eraser, of better quality than the others, comes in a soft, small, grey block. Knead the block into a softened, warm ball and use the end tip to pick up graphite or charcoal. Twist it into the paper rather than rubbing it across or it will smear. As one part fills with graphite, just knead it until a clean surface appears. If you wish to erase a large area, use a pink or Magic-Rub eraser. The latter is simply of better quality than the pink variety. Some people like the Art Gum erasers. I find them crumbly, but you might like them.

Tortillon. This is a rolled paper smudger which is used on the plate-surfaced bristol paper to blend subtle tones made by the harder pencils. It is a delicate process, mostly used by scientific illustrators for intricately grading tones on surfaces such as bones, a frog's skin, or a fish's scales. You can use your finger to smudge tones, but it is less precise and can be messy. Or you can construct a tortillon by rolling a piece of paper tightly, twisting it into a point at one end.

Spray Fixatives. These fixatives in a spray can are used to spread a thin film of protective plastic over any soft drawing medium, such as charcoal, pastel, or soft pencil. I hesitate to use them because they contain a range of toxic chemicals and spread a potent odor over everything. If you do want to protect your drawings from fingerprint damage or smearing, this is the substance to use unless you immediately cover your work with acetate or tissue paper. Be sure to use it in an open, well-ventilated area.

Figure 2.15
MARC WINER
Landscape (vine charcoal)
Courtesy of the artist

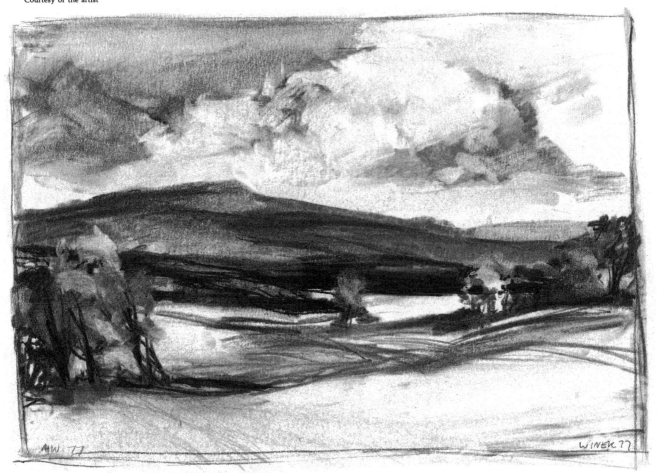

Pencil Sharpeners. The purists use only a pocketknife or sandpaper or a small Stanley retractable blade knife. Others of us use any inexpensive plastic pocket pencil sharpener. These give a nice, sharp point and do not drop shavings all over the place. Mechanical pencils need a special mechanical pencil sharpener.

Drawing Board. Drawing boards can be expensive but are easily homemade. Their function is to prop your drawing paper up so that you see both it and your object at a fairly similar angle. Any art or architecture store will have varieties of drawing boards to examine as models for building your own. I usually simply pile books under my pad or under a masonite board. When in the field, I prop my legs so that my pad rests on them at a workable angle. Different perspectives of paper and subject may give you trouble matching proportions because you have to move your head up and down repeatedly.

Clips. Clips, tacks, tape, clasps, even rubber bands are good for holding down pages in the event a breeze blows your paper. It is so annoying to be drawing a delicately perched butterfly and have the wind flap up the page—Off goes the butterfly!

Small Pencil Case. When you are drawing outdoors or at a zoo or museum, it is helpful to have your tools in one container and easily accessible. Not only can it then be put in a pocket or pack, but it will be small enough to force you to carry only the essentials. Mine is an ordinary, plastic zippered pencil case, available at any stationery or general purpose store. You can also buy a small belt pouch at a sporting goods or camping supply store. One student made her own.

Small Knife. An inexpensive knife is useful for sharpening pencils or for cutting small samples to be identified and drawn later, such as twigs, flowers, plant galls, small mushrooms, or seed pods. If you do cut a specimen, be *sure* you are in an area that permits it and that what you cut is not on the endangered species list.

Camp or Folding Stool. It is nice to sit on the ground to draw, but it can be wet and cold. By sitting on a stool, you may be at a better level for seeing your subject as well as being more comfortable. A stool is particularly useful when drawing outdoors at a zoo, wildlife sanctuary, or farm; or indoors at a science museum, aquarium, or pet store. It can be bothersome to carry around in the field unless you know you will be in one spot for a while.

Small 6-inch Ruler. This can be carried in the pencil case and is good for measuring proportions when size is important, such as with animal tracks, plants, and insects.

Day Pack or Carrying Bag. It is nice to have all your drawing and nature study equipment in

Figure 2.16
Children drawing ducks at a wildlife sanctuary. They are using 8-by-11-inch bond paper and clip boards. The third boy from the left is lining the size and proportions of one duck up against the line of his pencil, a good technique to use (discussed in more detail in Chapter 9, "Landscapes").

one accessible carrier. I prefer a day pack so that my arms are free and everything does not fall out if I lean over. A day pack is also large enough to carry additional things, such as binoculars, a camera, lunch, or extra clothing.

Camera. Take photographs of your own to draw from later. A camera can also be a helpful tool for compositional study, for focusing in on things closely, and for learning how to frame drawings.

35mm Empty Slide Frame. An empty slide frame is useful to carry along if you want to design a particular composition—be it a landscape or portion of a plant—and are not sure what would make a good layout. The frame helps to focus on a particular composition within a particular space, as does the camera lens. (See Chapter 9 "Landscapes," for further discussion on framing compositions.)

Binoculars and Hand Lens. Binoculars are helpful for looking at distant birds, animals, or landscapes. A small magnifying glass or hand lens

is essential for looking at small parts of insects, the insides of flowers, or anything else with fine detail.

Suitable Clothing. Be sensible. When outdoors, go prepared. Standing drawing in the rain or whipping cold can be fine with proper clothing. If you get cold, move around and blow on your drawing hand or wear fingerless gloves. Always take a wool hat in winter. In summer, a hat or dark glasses can help cut the bright glare of sun on white drawing paper.

Plastic Bags and Bottles. Plastic bags are useful to have along to protect your drawing pad and tools in damp or snowy weather. Both bags and bottles can be used to carry back specimens, such as feathers, leaves, bones, or anything collectible that is fragile. Make a rule not to collect any live animal, anything that is one of a kind, or anything in a specified noncollecting area.

Field Guidebooks. Since there are so many, limit your beginning library to only a few. Start by borrowing several from a friend or from the

Figure 2.17
Woman drawing on a rocky sea coast. Notice her equipment: hat, day pack, spiral bound 8-by-11-inch drawing pad, assortment of pencils, a faithful companion.

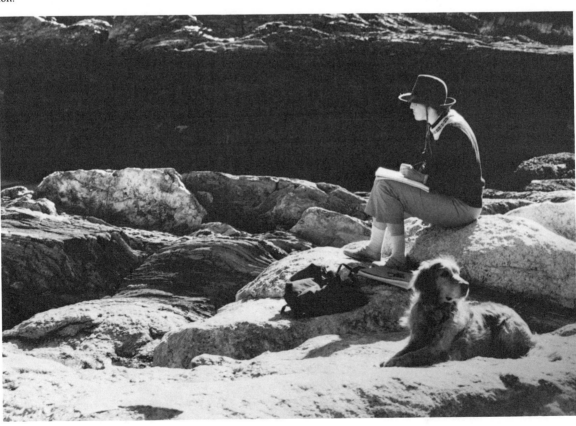

library. Go to a reputable bookstore and ask what basic guides are appropriate for your region. An accurate and simple field sketch, with descriptive notations added, can be enough for guidebook identification later; you don't want to waste time sorting through pages of text while you are hiking or traveling with impatient friends. Refer to the bibliographies at this chapter's end and at the end of other chapters for recommended basic guides.

Purpose. Have a purpose for drawing and you will be more inclined to make time for it. If you see a pigeon strutting across the road, don't just look at it but draw its walk, its postures, its actions. Learn what local pigeons do. It wasn't until I drew a pigeon that I noticed it had red eyes and red legs and bobbed its head in rhythm with its pace. I then read a book on pigeons to find out why all this was so. By gathering information about what you are drawing, you can improve not only your own learning but also the learning that can be described in your drawings.

As Oliver Wendell Holmes said: "Those who are really awake to the sights and sounds which the procession of the months offers them find endless entertainment and instruction. Yet there are great multitudes who are present at as many as threescore and ten performances, without ever really looking at the scenery, or listening to the music, or observing the chief actors."*

BASIC EQUIPMENT TO BE USED WITH THIS BOOK

White bond practice drawing paper no smaller than 8 by 11 inches

400-type, smooth-surfaced drawing pad (ring bound) no smaller than 8 by 11 inches

Hardbound field sketchbook (if setting up a field journal)

HB, 2B, 3B pencils (two of each)

Kneaded and pink (or Magic-Rub) eraser

Pencil sharpener

Black felt-tip pen

Small carrying case to hold tools

* William Hamilton Gibson, *Sharp Eyes: A Rambler's Calendar* (New York: Harper and Row Publishers, 1891), p. xxii.

OPTIONAL:

Any of the other pencils or pens described in this chapter

Watercolor set

Small hand lens

Small knife

6-inch ruler

Collecting bags or plastic bottles

Camera

Binoculars

Day pack

Basic field guidebooks

BIBLIOGRAPHY

General Drawing Study

COLLIER, NATHAN. *Form, Space and Vision.* Englewood Cliffs, N.J.: Prentice-Hall, Inc., 1963. (Hardback)

FRANCK, FREDERICK. *The Zen of Seeing: Seeing/Drawing as Meditation.* New York: Vintage Books (a division of Random House), 1973. (Paperback)

GOLDSTEIN, NATHAN. *The Art of Responsive Drawing.* Englewood Cliffs, N.J.: Prentice-Hall, Inc., 1973. (HB)

————. *Painting: Visual and Technical Fundamentals.* Englewood Cliffs, N.J.: Prentice-Hall, Inc., 1979. (HB)

HILL, EDWARD. *The Language of Drawing.* Englewood Cliffs, N.J.: Prentice-Hall, Inc., 1966. (PB)

MAYER, RALPH W. *The Artist's Handbook of Materials and Techniques* (rev.). New York: The Viking Press, Inc., 1970. (HB)

NICOLAIDES, KIMON. *The Natural Way to Draw.* Boston: Houghton-Mifflin Company, 1941. (PB)

SIMMONS, SEYMOUR, and WINER, MARC S. A. *Drawing: The Creative Process.* Englewood Cliffs, N.J.: Prentice-Hall, Inc., 1977. (PB)

Scientific Illustration

PAPP, CHARLES S. *Manual of Scientific Illustration.* Sacramento, Cal: American Visual Aid Books, 1976. (HB)

SAYNER, DONALD BENNETT. *Drawing for Scientific Illustration.* Tucson, Ariz.: Associate Student Union Bookstore, University of Arizona, 1969. (PB)

ZWEIFEL, FRANCES W. *A Handbook of Biological Illustration* (9th ed.). Chicago: The University of Chicago Press, 1972. (PB. Inexpensive and most useful.)

Artists on Art and Nature

GUSSON, ALAN. *A Sense of Place: The Artist and the American Land.* San Francisco: Friends of Earth; New York: A Continuum Book/The Seabury Press, 1971. (HB)

HALE, NATHAN CABOT. *Abstraction in Art and Nature.* New York: Watson-Guptill Pub., 1972. (HB)

HOVING, THOMAS. *Two Worlds of Andrew Wyeth: Kuerners and Olsons.* Boston: Houghton-Mifflin Co., 1977. (PB)

O'KEEFFE, GEORGIA. *Georgia O'Keeffe.* New York: The Viking Press, 1976. (HB)

Basic Field Guidebooks

BORROR, DONALD, and WHITE, RICHARD. *A Field Guide to the Insects of America North of Mexico.* Boston: Houghton-Mifflin Co., 1970. (PB)

BROCKMAN, FRANK C. *Trees of North America.* New York: Golden Press, 1968. (PB)

BURT, WILLIAM H., and GROSSENHEIDER, RICHARD P. *A Field Guide to the Mammals.* Boston: Houghton-Mifflin Co., 1964. (PB)

PALMER, E. LAWRENCE. *Fieldbook of Natural History.* New York: McGraw-Hill Book Company, Inc., 1974. (HB)

PETERSON, ROGER TORY, and McKENNY, MARGARET. *A Field Guide to Wild Flowers (of Northeastern & North Central America).* Boston: Houghton-Mifflin Co., 1968. (PB)

ROBBINS, CHANDLER S., BROWN, BERTEL, and ZIM, HERBERT S. *Birds of North America.* New York: Golden Press, 1966. (PB)

ZIM, HERBERT, and MITCHELL, ROBERT. *Butterflies and Moths.* New York: Golden Press, 1962. (PB)

General Recommended Readings in Environmental Awareness and Natural History

BASHLINE, L. JAMES, and SAULTS, DAN, eds. *America's Great Outdoors.* Chicago: J. G. Ferguson Publishing Co., 1976. (HB)

BESTON, HENRY. *The Outermost House: A Year of Life on the Great Beach of Cape Cod.* New York: The Viking Press, 1928. (PB)

CARSON, RACHEL. *The Sense of Wonder.* New York: Harper and Row, Pub., 1956. (PB)

CHINERY, MICHAEL. *Enjoying Nature with Your Family.* New York: Crown Publishers, 1977. (HB) (Informative, well illustrated, and with a good layout.)

Joy of Nature. Pleasantville, N.Y.: The Reader's Digest Association, Inc., 1977. (HB)

LEOPOLD, ALDO. *A Sand Country Almanac.* New York: Oxford University Press, 1949. (PB)

STOKES, DONALD W. *A Guide to Nature in Winter.* Boston: Little, Brown & Co., 1976. (HB and PB) (A well-written text with excellent pen and ink illustrations by artist Deborah Prince.)

WORTHLEY, JEAN REESE. *The Complete Family Nature Guide.* Garden City, N.Y.: Doubleday & Co., 1976. (PB)

Resources for Art and Natural Science Study

With some imagination and experience, you will find resources that can help you set up the kind of drawing and nature study you wish to pursue. Use this book and the bibliographies in it as a leaping-off point. Investigate local libraries, bookstores, and art and science museums. Inquire about courses at adult education centers or adult extension programs at local school or college biology departments. Investigate local nature centers, zoos, outdoor civic education programs, and town conservation commissions.

Guild of Natural Science Illustrators, Inc., P.O. Box 652, Ben Franklin Station, Washington, D.C. 20044 (A good contact if you are interested in this field. An informative newsletter is sent to members discussing techniques, workshops, and exhibitions.)

National Audubon Society, 950 Third Avenue, New York, N.Y. 10022. (Write to your state chapters.)

Nature Canada Federation, 46 Elgin Street, Ottawa, Canada. K1P5K6

National Wildlife Federation, 8925 Leesburg Pike, Vienna, Virginia, 22180.

United States Department of the Interior: Fish and Wildlife Service, Washington, D.C. 20240. (Write to your state chapters.)

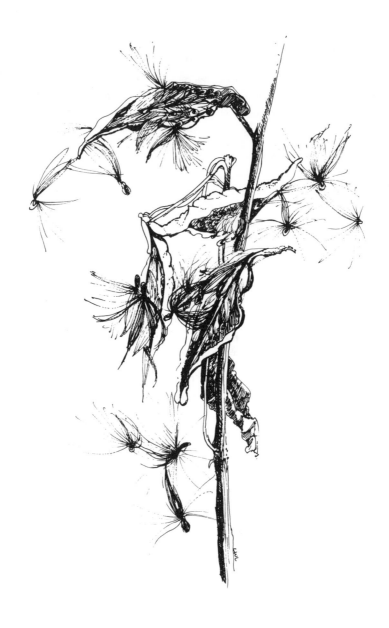

I HAVE BEEN ASKED MANY TIMES what I look for
in a nature painting. My answer is: Life! The
technique, the medium, is not what is important.
It may be an oil canvas with a minimum of detail,
an interpretive sketch, or a very literal rendering.
But the painting should convey the essence, the
vitality, the place of the creature it portrays.

Les Line, Foreword to *The Art of Glen Loates* by
Paul Duval

Every book on drawing and every artist will have
a different method and approach to drawing na-
ture. Some emphasize natural realism, some artis-

tic expressionism. I hope that by presenting a
wide variety of methods and techniques and by
showing works by many of the best wildlife art-
ists, this book will give you plenty of opportunity
to choose the ways for drawing that suit most
closely your reasons for studying nature.

It is my firm intention not to impress upon
you *my* way of drawing but to help guide you
into your own. But I will impress upon you the
importance of developing a solid background in
drawing technique if you want to take this at
all seriously, and I will urge you to spend a good
amount of time observing, questioning, reading,

CHAPTER THREE

Methods and techniques

and learning about nature. Above all, enjoy your study. Use it as a time to be in full contact with nature without the distractions and worries that so flood our everyday human lives. If a day's drawing results in nothing but torn-up pages but was fully enjoyed otherwise by being outdoors watching birds courting, studying various plant forms, or observing the wind blowing ripple patterns across a pond, then consider your day a success. Drawing should bring you to nature, not back you away from it. So be patient. Your way of drawing will change, evolve, and mature, as will your study of nature.

In this chapter, I will review some major techniques and methods most commonly used by artists when drawing nature. You should realize that the field of drawing in general is much broader and includes many more approaches. The type of nature drawing discussed in this book tends more toward aquiring skills for scientific realism than you might find discussed in other places. The idea is to help you develop experience both as an artist and as a naturalist. That combination encourages a more realistic style than would perhaps be taught in the art schools.

There are many good sources for learning

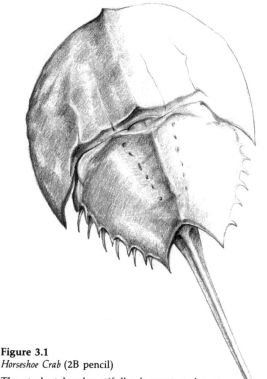

Figure 3.1
Horseshoe Crab (2B pencil)

The student has beautifully demonstrated a way of modeling tones on the shell of a horseshoe crab, using carefully layered shades of pencil. Lighter spots have been created by erasing or by leaving out tone.

them. They are nature's laws and you have to follow them just as nature follows them. . . . You don't create the formulae. . . . You see them."*

GENERAL METHODS FOR DRAWING NATURE

Four methods to be used when drawing nature have already been outlined in Chapter 1 "Beginning Drawing Exercises." Although these are described here as "beginning" exercises, they are used continually throughout an artist's study of nature, whether he or she is sketching quickly in the field (where memory, contour, and gesture are used) or doing lengthier drawing indoors (where gesture and diagrammatic drawing are used). For review of these techniques, refer to the first chapter. These techniques, as applicable to specific subjects, will be mentioned again more specifically within each chapter.

Quick Sketching in the Field

The best wildlife artists will tell you that a great part of your study of nature should be done outdoors observing things directly in their own environment. An animal does not behave the same way in the zoo; a plant picked and brought indoors soon wilts; an insect in a bottle or pinned as a specimen will teach you little about its behavior when out in open spaces; and a landscape cannot be drawn as well from a photograph. There is something deeply thrilling and involving about watching animals going about their ways without being aware of an onlooker. You are sharing their environment, not they yours. This experience cannot be matched by just drawing animals or plants from photographs or even in museums or zoos.

No artist depends solely on these sketches when making final studies but uses them for working out the fundamentals of behavior, posture, habitat, and interactions within and be-

more about drawing nature, but many of these have to be hunted down, as they are not readily available. Much of the best wildlife art appears as illustration in natural history books, nature magazines, field guides, children's books, posters and murals, and even greeting and gift cards. Little of it, as yet, appears in the art museums. There are a number of books out now featuring the works of the more renowned wildlife artists, such as John James Audubon, Ernest Thompson Seton, and Francis Lee Jacques. Look for books such as these, since studying directly from the better known wildlife artists can be an excellent way to develop your own drawing skills. And, of course, much can be learned about drawing technique in general by looking at any drawings by such master draftsmen as Leonardo da Vinci, Michelangelo, Rembrandt, Edgar Degas, Winslow Homer, and Andrew Wyeth.

Consider nature to be your primary teacher. The more carefully you observe, the more carefully you will draw. As the early twentieth-century American landscape painter John Marin remarked, "I would say to a person who thinks he wants to paint, go and look at the way a bird flies, a man walks, the sea moves. There are certain laws, certain formulae. You have to know

* Kynaston McShine, ed., "The Natural Paradise: Painting in America 1800–1950" (Catalog prepared for the exhibition *The Natural Paradise* by the Museum of Modern Art, New York, 1976), p. 110.

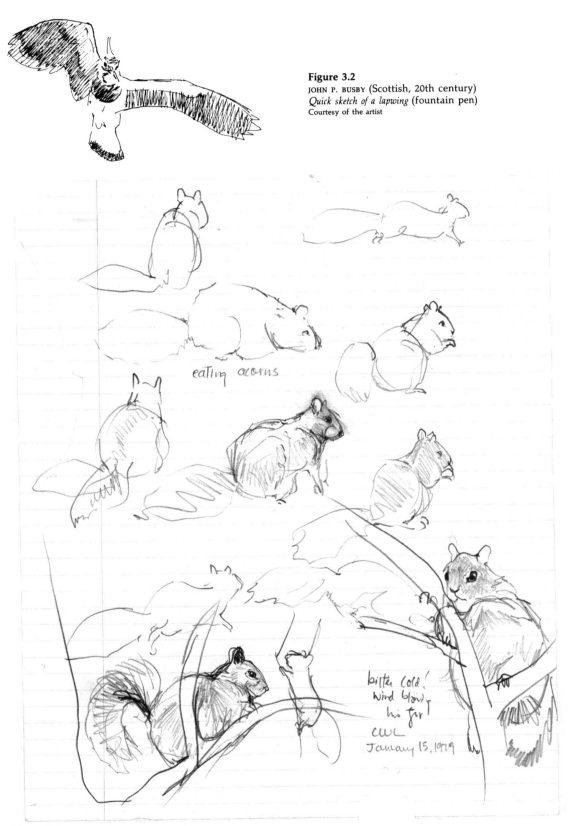

Figure 3.2
JOHN P. BUSBY (Scottish, 20th century)
Quick sketch of a lapwing (fountain pen)
Courtesy of the artist

eating acorns

bitter cold!
wind blows
his fur!
CWL
January 15, 1979

Figure 3.3
CLARE WALKER LESLIE

Field sketches done in preparation for the drawings of the eastern grey squirrel
(Figure 8.17). As it was bitter cold, these drawings were done very quickly, all
within a few yards of each other, on the grounds of a city university. The pencil
used was a 2B and the paper happened to be lined, tablet paper.

tween species, as well as for increasing his or her own personal feeling for an animal when wild and free. To render details, the artist then goes to the zoo or museum, to photographs, and to skins or mounted specimens.

The technique for quick sketching is that of the gesture study, as discussed in Chapter 1. Fast, loose lines are used to get down as quickly as possible the general shape of the whole object, its posture, behavior, and basic form. A detailed or polished drawing is not the purpose. Seeing well is more important than drawing well. Many artists will not even show their field sketches, they consider them so unpolished and seemingly crude. But they are the foundation for good detailed studies, and the best wildlife artists have drawers full of them. Styles of sketching vary. Some artists use just a few key lines and tones for quick studies (Figures 3.2 and 8.2). Some use a lot of scribbly lines, done very quickly while barely looking at the paper (Figure 3.3).

Practice quick sketching by drawing moving subjects, such as your cat stretching, a bird hovering at the feeder, a squirrel hopping over a roof,

or even a tree blowing in the wind. Record the gesture (or gestures) of its basic shape, how it is moving, what it is doing, and where it is. Add written notes on the last two points. Gesture sketches should take anywhere from three seconds to one minute, and no longer. Sketching is used as a *tool* to learn how to see nature better and not how to draw pictures better. That comes when you have something that is not moving or you have a longer time to work on drawing technique.

There are many examples of field sketches throughout this book. Look at each chapter for further ways to use this technique when drawing particular subjects, and particularly, Chapter 8, "Keeping a Field Sketchbook."

Quick Sketching to Lay Out the Longer Drawing

In preparation for a longer drawing, it can be useful to first study the basic form and structure of an animal, plant, or landscape before going

Figure 3.4A-B
Preparatory sketch (A) and finished drawing (B) by a student of an eastern grey squirrel. It can be useful to do a light, layout sketch first to establish shape and proportion before launching into the detailed study. Errors can be corrected before much time is lost, and another drawing can easily be started.

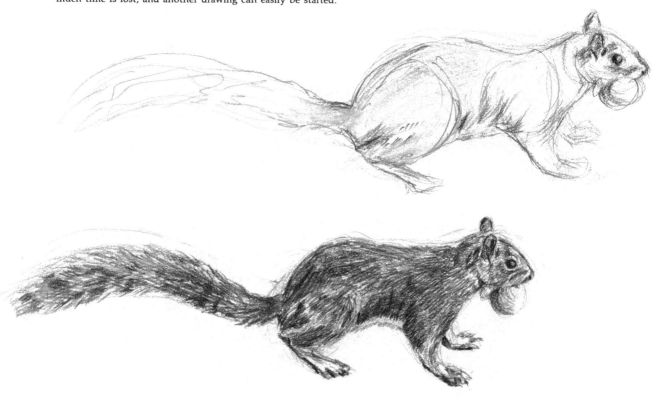

into all the details. This can be accomplished by several brief gesture sketches along the side of your page or on another page. These quick, small sketches can save you time because you will start your longer drawing already knowing something about it, the position and size you want to use, and how you want to describe it. Many students launch into a lengthy drawing only to find that the proportions are off or the subject is too large for the page, or they have bitten off more than they can chew. Always sketch out a plan of what you want to draw and you will have an easier time seeing what you are getting yourself into. This can be just a light sketch underneath a more developed drawing, with these preliminary lines erased once the final drawing is set in. (For examples of preparatory sketches, refer to the drawings in Chapter 1 and to Figures 3.4, 6.40, 7.8, and 7.32.)

The Longer Study

Of course sketching is not done just outdoors and longer, detailed drawing just indoors. Situation is less the issue than is intent. I might prefer a sketch to a longer drawing because I am more interested in the overall form and design of a vase of flowers than in each petal and twist of leaf detail; or I may prefer to sketch several animals quickly at a zoo than spend the time just drawing one animal. But generally sketching is used to capture general features, and the longer study to describe specific features. One may be done more frequently outdoors and the other more frequently indoors, but that should not be a rigid rule. Figure 3.5 is a beautiful example of a longer study in which the artist has chosen to render in fine detail the specifics of a subject as simple as an oak branch.

SPECIFIC TECHNIQUES

Whether doing fast sketches or longer studies, you can use various techniques according to the particular style or expression you want, or even to the time you have or the mood you are in. This section discusses some of the more common techniques used by artists when drawing nature.

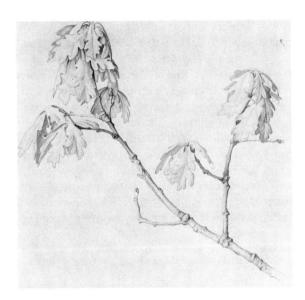

Figure 3.5
CHARLES H. MOORE (American, 19th century)
Oak Branch (drawing)
Courtesy of the Fogg Art Museum, Harvard University

See how Moore uses shading to bring out some forms and to set others back. Tone is created by a soft shading with the side of the pencil. Lines to be made distinct are placed in with the tip of the pencil.

Line Drawing: Diagrammatic or Expressive

Line is an essential ingredient: It defines shape, size, design, and detail. The addition of tonal areas for shading or volume can offer artistic expression but may blur the clarity that line has given. Dexterity with line is more important in natural history drawing because it helps define the information being gathered about a particular subject. Tone enhances but may not define. For the beginner, it is best to start with just line, learning accuracy of shape and proportion and then going on to tone and volume.

DIAGRAMMATIC LINE DRAWING

A solid, diagrammatic line is used most often for illustrations in field guides or for charts describing the various parts of something. Displaying information is more important than displaying the skills of the artist. For that reason, artists sometimes find that in doing guidebook or scientific illustrations, they must put aside some of their creative flourishes in order to describe a clear and informative image. A nice blur of tone might look aesthetically pleasing but

could hide an important feature. Leaving out a part because it "looks better that way" may result in omitting the key scientific part that identified the object. A solid line is used so as not to distract the viewer with more descriptive uneven or broken lines. A technical drawing pen is the preferred tool because it gives an even-flowing, clear line. Any artist who uses the solid line technique will tell you that it limits one to producing only an unimaginative, purely scientific image, although there is much opportunity for being creative with form, design, and composition. A well-rendered solid line drawing can be very beautiful (see Figures 3.6 and 4.11).

EXPRESSIVE LINE DRAWING

When scientific identification is of less concern than artistic expression, use a varied pen or pencil line and weight. Like modulating the tone of your voice, you can vary elements within a drawing, bringing out some and subduing others. Lines can be used instead of shading to accent the turn of an edge, the depth of an angle, the detail of a feature, the play of light on a surface. Use a dark line for emphasis and a light line for de-emphasis. A broken line can suggest motion or light penetrating a form. A line defining the outline of a form should be treated differently from one defining the interior parts. Outlines define a form separated from its background (and so in a different plane), whereas interior lines define forms separated from each other (and so in similar planes). Experiment with your pencil, seeing what weights and tones of line can do (see Figure 3.7). Look at other plates in the text to see how line is used by various artists and what different effects were achieved.

Figure 3.7
Diagram of line varieties

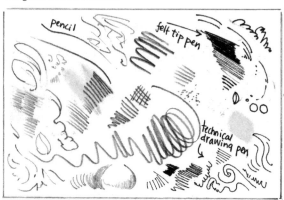

Figure 3.6

MARY S. SHAKESPEARE
Elderberry (technical drawing pen)
Courtesy of the Massachusetts Audubon Society.

Example of a diagrammatic line drawing where an even line is used to emphasize form and design within a subject.

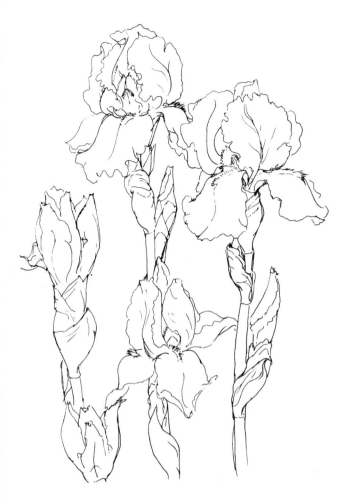

Figure 3.8
Student drawing of her garden iris (felt-tip pen). Example of line being used in a more expressive, freer style than in Figure 3.6.

Figure 3.9
CLARE WALKER LESLIE
Crab Apple

Here the pencil is used loosely, varying the weight and thickness to describe form and dimension without the use of shading.

Crab Apple

(no seeds in last year's
fruits : Eaten ? Dropped out ?)

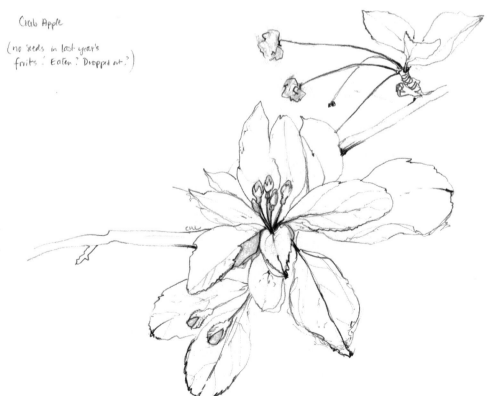

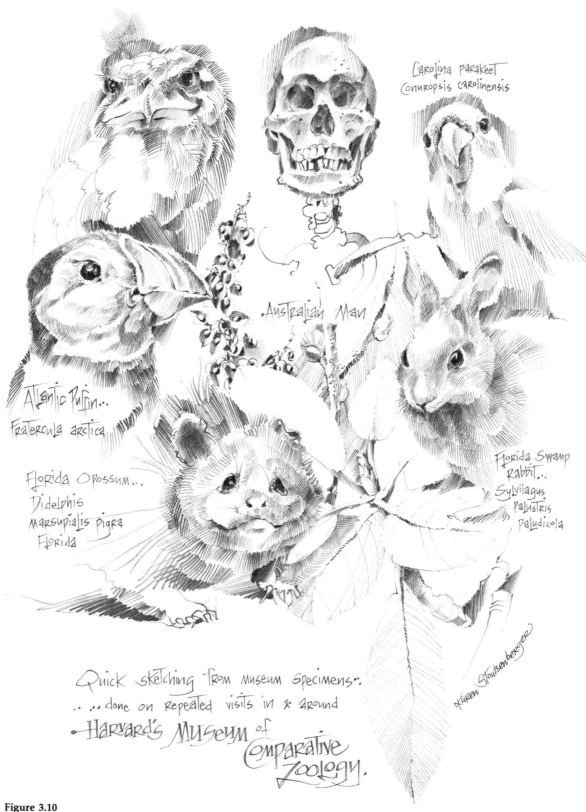

Carolina parakeet
Conuropsis carolinensis

Australian Man

Atlantic Puffin...
Fratercula arctica

Florida Opossum...
Didelphis
marsupialis pigra
Florida

Florida Swamp
Rabbit...
Sylvilagus
palustris
paludicola

Quick sketching from museum specimens...
...done on repeated visits in & around
Harvard's Museum of Comparative Zoology.

Karen Stoutsenberger

Figure 3.10
KAREN STOUTSENBERGER
Quick Sketching from Museum Specimens (technical drawing pencil)
Courtesy of the artist

One way to use hatch line to define dimension, tone, and shading on various
forms, these drawings were done over a period of several days, building up a
design as forms seemed to fit best together.

40

Shading

Shading of all types, both with color and with black and white media, is used in all aspects of drawing nature. Usually shading is used for realistic rather than expressive purposes, however, to further define elements of specific lighting, color, or texture within a form. Whether one is making a quick sketch or an extended drawing, a legible and informative method of shading is necessary. The three methods most often used are hatch line, stipple, and tone, with modification of all three according to how tight or free a style is wanted.

HATCH LINE

The hatched or repeated line is a shading technique used by many wildlife artists when drawing in pen or pencil. It originated in the wood engravings of fifteenth- and sixteenth-century Europe when printing was the only form of reproduction. Halftones, of course, could not be reproduced. Thus, shading was produced in varying tones by repeated lines placed nearer or further away from each other. (The wood engravings of Albrecht Durer are good examples of hatched shading.) Line thus repeated can often make a clearer definition of a shaded area than can a tone wash when the artist is working quickly in the field. It also photo-reproduces more clearly (and less expensively) than does a tone. Of course, if the artist is using pen and ink, only a line can be used. But really, which is preferred and when is a matter of taste.

Line, when used for shading, does not define outline but rather serves to cover an area of tone. Therefore, lines must be consistent, uniform, and when seen at a distance, appear blended into a solid tone. Lines should go along the plane of a form to help define volume as well as shading (see Figure 3.10). If a darker tone is needed, lines are placed closer together or more lines are put evenly between wider ones or even on top of other lines. Some artists will lightly outline the shape of the area to be shaded and then draw in lines to fill the space (see Figure 6.14). Just watch that your drawing does not become too patchy. Line can be applied quite evenly (Figures 7.5 and 8.2) or more loosely (Figure 3.11).

To practice the hatching technique, place your hand firmly on the paper. Then flick the thumb and two fingers holding the pencil evenly

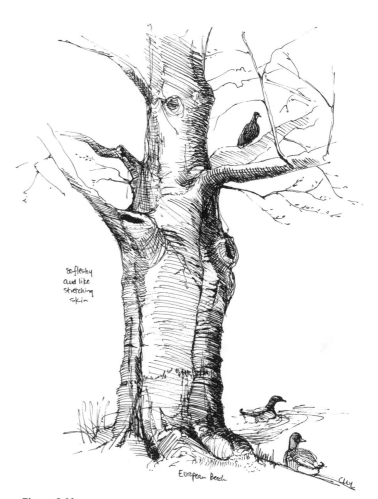

Figure 3.11
CLARE WALKER LESLIE
Study of a European Beech

Hatch line is used here in a free, sketch-like manner, to set back forms into a depth and to indicate volume, texture, and shading.

up and down, *without* moving the rest of your hand. Each stroke should always begin either at the top or at the bottom of a stroke, so that lines are consistent. Your lines should not extend beyond the area of shading being defined, or naturally the area becomes expanded and lacks clarity. Look at and even carefully copy Figures 4.9, 7.5, or 8.2 to learn hatched shading.

STIPPLE

The stipple, or dot method, of shading is used principally with a technical drawing pen and occurs widely in scientific illustration. Series of dots are built up to create ranges of tone (as in Figures 3.12 and 3.23D and F). The effect can be more subtle than with the hatched line. Since the end of the technical pen is flat, it can make even dots more easily than can other pens. The lightest areas of tone are put in first with the widest spaced dots. Darker tones are then put

in by placing dots between dots, getting progressively closer until the desired effect is attained. Artists sometimes have to work with a magnifying glass to get the closer dots evenly spaced. Freer forms of stipple are incorporated into many drawing styles, including graphic designs, children's book illustrations, and natural science illustrations.

Figure 3.12
ELIZABETH MCCLELLAND
Gourd (technical pen)
Courtesy of the artist

A good example of stipple dots used to indicate texture, shading, and mass.

TONAL SHADING

The hatch and stipple are used when a drawing must be reproduced, because tonal shading requires a special shooting of halftones and therefore is more costly to photo-reproduce well. Whereas hatch line and stipple are used primarily with pen, tonal shading is used primarily with pencil and other media, such as charcoal, pastel, crayon, colored pencil, watercolors, and oils. The horseshoe crab in Figure 3.1 is a superb example of shading where layers of pencil tone are built up with great care and detail. Here the side of the pencil rather than individual line strokes is used to suggest areas of tone. Practice this technique by "scribbling" your pencil over a piece of scrap paper, seeing what dark tones and light tones can look like. An eraser or your finger can be used to smooth areas together or to lighten highlights within tones. For other ways of using tonal shading, see Figures 3.13 and 6.23.

Figure 3.13
EDGAR DEGAS (French, 19th-20th centuries)
Horse with Saddle and Bridle (pencil)
Courtesy of the Fogg Art Museum, Harvard University. Grenville L. Winthrop.

Degas was a master at tonal shading. Study this drawing carefully. Light areas are created by erasing and softening the darker tones. Observe how he applies pencil and how he builds up tones to create such a full looking body with such a rich coat.

Watercolor

Since watercolor as a separate medium is not the subject of this book, it will be discussed more in terms of its application for "coloring" a drawing than as a medium unto itself. Generally in nature drawing, color is used more for illustrative than for expressive purposes. (With landscapes this is less the case, as it is so tempting to abstract into washes of color and tones of light and shadow.)

It is hard to see nature only in terms of black and white since color is such a wonderful part of it. Sunsets do not look the same in tones of grey, nor do birds' feathers, butterfly wings, or vases of flowers. But color can be overwhelming to use if you have never looked at a color chart or a paint box.

If you have not used color before, try a number of practice exercises using only black ink or black pigment to learn how to create tonal washes and nonlinear shapes. Choose a simple object, such as a fruit or vegetable, that has a uniform shape yet shows obvious tonal gradations when a strong light is placed next to it. Use large sheets of newsprint, manilla, or bond paper so that you will not worry about "wasting"

paper. Do *not* first draw with pencil. Use your brush as the drawing tool and become accustomed to how that feels. Squint at your form to remove details and to bring out primary shapes and areas of shading. See the areas to be shaded as distinct shapes and place them into your study just as you see them arranged. Use a brush of any size, drawing in your initial form outline with a brush full of black color (see Figure 3.14A). Then put in a very pale wash, using mostly water and little pigment, where you see the lightest tonal shape. Watch colors blur and blend. See for yourself what helps make a form look round or highlighted. Let this tone dry and then put in one or two middle shades of grey, mixing proportionally more pigment with less water as you see two more values existing on your form. Do not try for more than three or four basic values.

If you want to add watercolor to describe the specific colors on a turtle shell or a mushroom, in an arrangement of flowers, or even in a small landscape, use the technique often used for color plates of field guides or paintings of wildlife (see Figure 3.25). Called the *dry brush* method, this simply means using color with little water added. Pigments are carefully mixed to approximate as closely as possible the color on the subject. Use

Figure 3.14A-C
Steps in experimenting with drawing a pepper by using only black ink wash: (A) shows the first strokes, (B) the placement of the next and lightest wash, and (C), the placement of more washes to build up tone in a rather abstract fashion. Before using watercolor, practice applying tone and wash with just one color, such as black, to reduce the confusion of color.

1.

2 .

3 .

Figure 3.15
BEATRIX POTTER (English, 19th-20th centuries)
Boletus Badius (watercolor)
Reproduced by kind permission of F. Warne & Co., Ltd., from *The Art of Beatrix Potter*, © copyright by F. Warne & Co., Ltd., London and New York.

Beatrix Potter, though known as an illustrator of children's books (*Peter Rabbit*, e.g.), was also an accomplished naturalist. This is one of her many watercolor studies of mushrooms.

small brushes and lay your pigments in as if you were drawing. Start with a light pencil sketch. Add the lightest tonal areas first; then build progressively toward the darker tones or balance back and forth between the two ranges. Blend colors both wet and dry. Use a thick, hot-pressed watercolor paper, illustration board, bristol paper, or even white poster board. In addition to having a relatively smooth surface for details, these will take the paint and not buckle. Many watercolorists of a freer style of painting prefer the more textured, coarser papers, which give interesting, abstract effects when washes are applied; yet these papers can interfere with the definition of specific, small features.

Learn how to use watercolors to illustrate natural subjects by studying the styles of other artists you like. I began by copying the works of Beatrix Potter, the British artist, naturalist, and writer of the Peter Rabbit books; Gunnar Brusewitz, the Swedish artist and naturalist represented by several plates in this book; and Arthur Singer, whose illustrations in *The Birds of North America* are most helpful for practicing watercolor technique. Choose your teachers, copy their styles, and *then* develop your own.

Watercolor can also be used in a looser style.

Figure 3.16
CLARE WALKER LESLIE

Study of a mother cat and kittens (Osmiroid pen and watercolor washes).

44

Experiment with differing amounts of pigment, either wet or dry. A common beginner's problem is in not knowing how to mix colors and so using them directly from the tube or palette. Learn how to mix graded tones of brown, green, blue, or yellow. Another problem is having a brush that is too thick with either pigment or water. Learn to adjust these amounts to get the effects you want. Try using washes over pencil sketches (Figure 6.27 and 6.28) or in combination with pen and ink (Figure 3.16). Locate a book specifically dealing with the techniques of watercolor for further help with the method you want to use, whether it be for realistic or abstract purposes.

Scratch Board

A technique called the "poor man's woodcut" was developed partly because it reproduced well. The effect is a bold, black, and striking image with strong contrasts created without the smudging of pencil or charcoal. The method can be more precisely controlled than can pen and wash. In reverse of the usual method, white lines are cut out of black background. It is used more for reproduction purposes than for creating a work of art since corrections, knife gouges, and layers where ink has been added show easily and can cause an uneven, messy surface.

Coat either a prepared scratch board, which

John R. Quinn

size range: 8-10 feet

White-beaked

Figure 3.17
JOHN R. QUINN
White-Beaked Dolphin (scratch board)
From *A Field Guide to the Whales and Seals of the Gulf of Maine,* 2nd. ed., by Steven Katona, David Richardson, and Robin Hazard. College of the Atlantic, Bar Harbor, Maine. Courtesy of the authors.

can be purchased at any art store, or just a heavy poster board with an even coat of India ink, fine black tempera paint, poster paint, or black wash crayon for cheaper versions. With a sharp blade, such as a scratch board tool, small X-acto knife, or a paper clip, scratch carefully through the black just down to the white but not into it. Other lines can be added with pen and brush in areas otherwise left white. It is easy to correct mistakes by merely painting over marks with black ink. Care in handling the board is essential to prevent the ink from smudging.

Figure 3.18
RUSS BUZZELL
Grouse in a Winter Landscape (scratch board)
Courtesy of the Massachusetts Audubon Society.

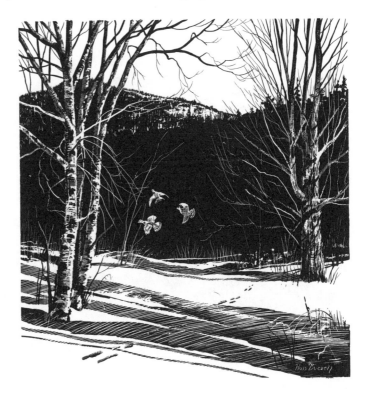

Educational Diagrams and Displays

This kind of drawing is illustration for a purpose and must be visually pleasing as well as informative. The artist must be a graphic designer as well as a naturalist. Unlike scientific illustration, which is intended for a specialized and knowledgeable audience, diagrams and displays are meant to explain concepts or specific subjects to the general public in an eye-catching, yet easily readable, fashion. Diagrams should take the place of the written word. They may be found as display panels in natural science museums, for example, illustrating trail guides, or in various magazines or books on nature.

Look at the diagram in Figure 3.19. The drawing is visually pleasing, easy to read, and maintains a balance between scientific realism and artistic abstraction. Another example of a way to create an appealing composition from natural subjects is the logo in Figure 3.20. To sell the product, realism is important but aesthetic appeal will probably do more to capture the eye of the public.

Figure 3.19
GEORGE ULRICH
Growing Strawberries (technical drawing pen)
Reprinted with permission from *Horticulture* Magazine, June 1978. Courtesy of the artist and Massachusetts Horticulture Society.

Seeing and Using Design Forms in Nature

Looking for design forms in nature can be a way of studying nature that lends a nice balance to the more analytic study of drawing techniques. Look for textures, geometric forms, aesthetically pleasing patterns and colors, and shape varieties. Look at a spider's web jeweled in morning dew, the opening petals of a tulip, frost patterns on the window, or textures of fallen leaves on a path. Beauty of design exists in the order and arrange-

Figure 3.20
LYNDA MCINTYRE
Shelburne Farms logo (photo offset print)
Courtesy of the artist and Shelburne Farms, Shelburne, Vt.

The logo was designed for a milk carton to sell farm-fresh milk.

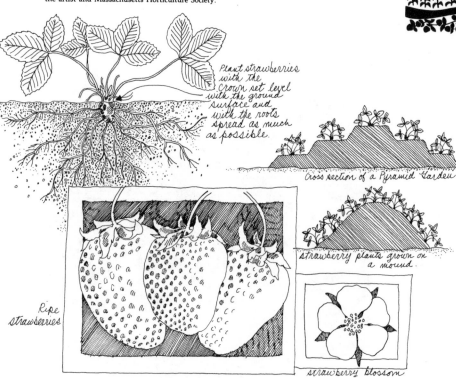

Plant strawberries with the crown set level with the ground surface and with the roots spread as much as possible.

Cross section of a Pyramid Garden

strawberry plants grown on a mound.

Ripe strawberries

strawberry blossom

Figure 3.21
Photograph of bleeding heart, showing the uniform geometry within each floret.

Figure 3.22
LYNDA MCINTYRE
Courtesy of the artist

Designs for silk-screened fabric, inspired by natural forms.

ment of natural forms. Throughout the world and for centuries, weavers, printmakers, jewelers, potters, and sculptors, as well as draftsmen and painters, have been inspired by forms and designs seen in nature.

Photography has opened up a whole new field of observation. If you have a camera, it can be a useful tool for recording specific information about plants, animals, or landscapes, as well as for finding design forms in nature. It helps focus the eye on compositional studies within the frame of its lens. Take photographs of interesting designs, such as rock shapes, bark textures, shadows on snow, vegetables and fruits, or floral shapes. Then draw from your photographs. Or draw these subjects directly, forming them into designs that blend the real image with the abstract. The images used for printing fabric in Figure 3.22 are good examples of natural forms inspiring the creation of semiabstract designs.

Scientific Illustration

This is a subject too large to go into in much detail here. If you are interested in learning technique in greater depth, I suggest locating a class specifically on scientific or medical illustration or a good book on the subject. I have listed several in the bibliography for Chapter 2. Scientific illustration is a highly specialized field, demanding a great deal of skill, and is growing fast in many areas of application: medicine, botany, zoology, chemistry and physics, paleontology, archeology, natural history, and ecology. It is to the artist's advantage to know something about the field for which he or she is drawing because both accuracy and technical skill are essential for figurative drawings as well as for charts, diagrams, and keys.

Illustrations are judged for accuracy of information, uniformity and neatness, and artistic beauty. Certain rules of technique are followed that can be understood in the international field of science. For example, Latin nomenclature identifies specimens; the metric system is the standard of measurement; and shading assumes light com-

ing consistently from the upper left. Variations on diagrammatic line, hatch, and stipple are the techniques most commonly used. The major media are pen and ink, pencil, pencil and pen, carbon pencil, litho crayon on stipple or coquille board, and watercolor. Whatever method is used, it must agree with the purpose of the illustration and the intentions of the employer. No matter how artistically defined a form may be, it can give false information if it is not scientifically accurate.

This description makes scientific illustration sound very dry and boring. Actually, it can produce extremely beautiful pieces of art as well as scientific work. The artist really has some leeway to include his or her own stylistic flair, as long as the drawing remains accurate. Some exquisite illustrations appeared in the eighteenth and nineteenth century when plates were often engraved and then hand-painted in beautifully descriptive colors.*

Depending on how large the artist likes to work, a drawing is generally reduced one-third to one-half because reduction cleans the lines but does not lose detail. Correct measurement is essential. Various devices are part of the illustrator's equipment when working in a scientific laboratory. Calipers and grids insure that proportion is correct, and various scientific equipment, such as special magnifying lenses and dissecting tools, must often be used. A microscope called a *camera lucida* is an essential piece of equipment for doing any work with small objects. This is a prismatic microscope that superimposes the subject over the drawing paper so that pencil hand and subject appear simultaneously through the scope. The hand traces around the form's outline, thus drawing in its exact measurements.

Drawings are laid out with a soft pencil (HB or 2H) on inexpensive paper or tracing paper. The sketch is then transferred onto the final drawing paper by toning the reverse side of the sketch with soft graphite and tracing over the image, which is placed on top of the final paper, much as carbon paper is used. A precise enough outline will appear so that at least the proportions are the same. The final drawing is made with a hard 2H to 6H mechanical pencil on a plate finish (two-ply to four-ply) bristol paper or illustration board. Various technical drawing pens are then

* See S. Peter Dance, *The Art of Natural History: Animal Illustrators and Their Work* (New York: Overlook Press, 1978) for further reading about historical scientific illustrators.

Figure 3.23
LASZLO MESZOLY
Anolis lizard—richardi griseus
Courtesy of the artist

The six drawings demonstrate various techniques used in scientific illustration:
A. Study of the skull using a solid, even line.
B. Study of the skull using a varied line.
C. Study of the skull using stipple or coquille board, ink, and litho crayon.
D. Study of the skull using ink stipple.
E. Behavior of two anolis lizards, using hatched lines in various ways.
F. Partially finished drawing of an anolis lizard, showing the penciled underdrawing and the beginning, final work with ink line and stipple. The process of diagramming such detail must be careful and methodical.

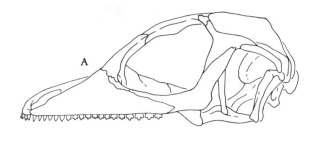

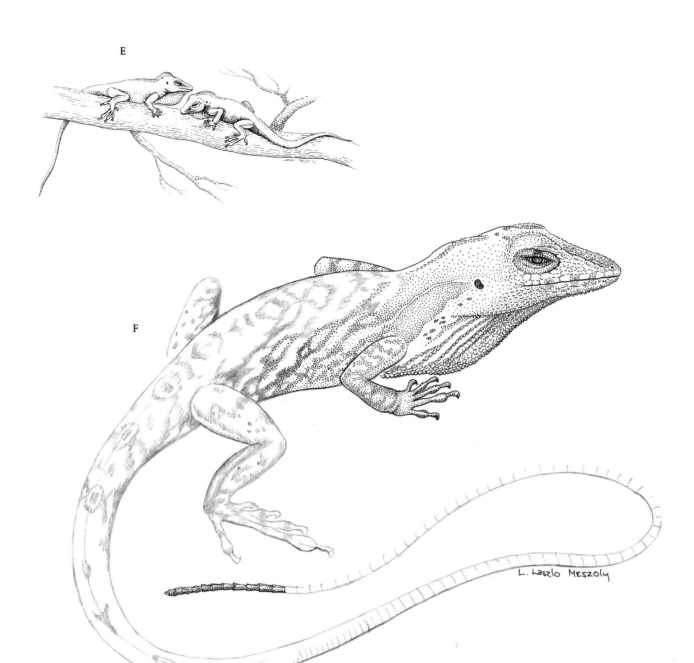

E

F

L. Laszlo Meszoly

used if the image is to be finished in ink. Scratch board (Figure 4.33), dry brush watercolor or black and white wash (Figure 7.19), or gouache are also used. There are numerous other more elaborate techniques now being used as photo reproduction and drawing equipment improves.

Included in this section are examples of two styles of scientific illustration. The six diagrams of the Anolis lizard were drawn specifically for this book to demonstrate various drawing methods. A mechanical pencil with 3H and 4H leads was used, in addition to a technical drawing pen

having several point sizes. All were drawn on two-ply bristol paper. Figure 3.23F is an excellent study of how a drawing is laid out and then filled in with stipple and line. Figure 3.24 was made with a crow quill pen on Cronoflex (drafting film) and demonstrates several different drawing methods used together. It also exhibits the standard parts to be identified: the whole plant showing fruits, flowers, and leaves; the flower; a cross-section of the flower; and a magnified underside of a leaf. The Latin name and meter markings are appropriately included. Look at the other sci-

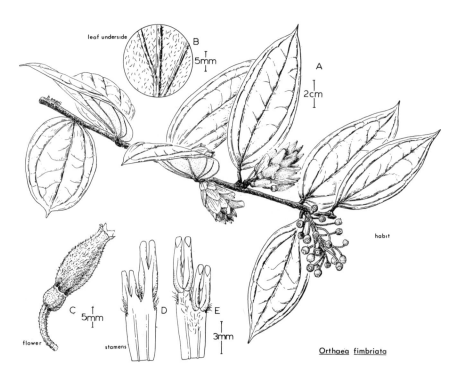

Figure 3.24
BOBBI ANGELL
Orthaea Fimbriata (crow quill pen on Cronoflex, drafting film)
Previously published in *Brittonia* (31/1) and reproduced here courtesy of the artist

The study was made from a pressed specimen and a photograph. A sketch was first done on tracing paper and then inked directly onto the film. This diagram demonstrates one way to illustrate plants and their parts for scientific journals and monographs. A variety of hatch lines and stipples is used.

entific illustrations throughout the book and compare style and technique (for example, Figures 4.30, 4.33, and 5.7).*

points are discussed more specifically when applied to particular subjects in other chapters; but having a general list can be helpful as an overall reminder.

GENERAL HINTS FOR ANY DRAWING

How you draw and how you decide to study nature is up to you. This book intends to offer support, guidance, and encouragement. It can do no more. Below is a list of general suggestions that apply to drawing anything in nature. Most

Considerations before Beginning to Draw

1. *Take time to think: What* do I want to draw? A landscape, tree, bird, animal, assemblage of all? *Why* do I want to draw? To learn more about nature, to relax, to improve drawing technique, or as an excuse to be outdoors?

2. *Know how much time you have* so that you will not feel rushed.

3. *How will you go about drawing?* What do you want to say? Will this be a quick sketch because the rabbit is disappearing into the bushes? Will this be a long study because you have an evening at home and several dried seed pods you want

* For further information on scientific illustration, see the bibliography for Chapter 2. A national association of scientific illustrators, a membership organization with a newsletter that can offer information and further resources for study, is The Guild of Natural Science Illustrators, P.O. Box 652, Ben Franklin Station, Washington, D.C., 20044.

to carefully draw? Will you use pencil, pen, or color?

4. *What style will you choose?* Do you want to convey a mood or memory of a particular place and so create a somewhat abstract landscape? Do you want to describe a woodland mushroom in full detail for scientific accuracy? Do you want to work on drawing technique to improve artistic skills?

5. *Take time to look* at your subject until you become involved with it and can sort out the dominant shapes, activities, and features you want to describe. Select essential from inessential elements. As an artist, you must represent; as a naturalist, you must interpret. You cannot include everything you see happening. Consider the major theme of your drawing and work details around that, such as interesting shape (Figure 3.11), grace and detail of branch (Figure 3.5), grouse appearing on a winter's day (Figure 3.18), or specific scales on a lizard's back (Figure 3.23F).

6. *What will your composition be?* Will it be just the tree or some birds as well? Will it be three inches of the branch or twelve, and at what angle will you draw it? Will it have birds flying or resting, in the foreground or middle ground? Will you draw all of the lizard or just part?

7. *Decide placement on the page:* larger than life, smaller, in a corner, grouped with other subjects, and so on. Space around your drawing is an important design component as it helps set the drawing into the frame of the paper. Artists often refer to this white paper space as *negative space,* and the subject as *positive space.* See both negative and positive spaces as compositional elements having shapes of their own. If you are having difficulty visualizing this concept, construct these shapes like flat cutouts, as if you were making a collage, and move them around to see what compositional arrangement you prefer (see Figure 3.25).

A. good compositional placement

forms too large for shape of page
B.

Figure 3.25
Diagrams of negative and positive space. Seeing these as compositional elements will help you establish correct proportions as well as create an interesting design.

C. poor placement

Considerations while Beginning a Drawing

8. *Pencil in lightly the total layout* of your drawing, either with light dots around the form's perimeter or with delicate sketch lines.

9. *Work the whole drawing* and not isolated parts so that proportions and balance of shading will be correct.

10. *See major shapes before minor details.* Refer to specific chapters for ways to build up a drawing of a landscape, bird, animal, or plant. (For example, see Figures 4.5, 4.6, 6.4, 7.21, or 9.7.)

11. Periodically, *hold drawing at arm's length.* Check total design, accuracy of individual elements, and their proportional relationships to each other, for example, leaf position and size to adjacent twig or animal's head position and size in relation to its neck.

12. *Never get so set on a drawing* that you cannot flip the page over and do another. So often doing it again shows vast improvement and a freer, bolder style. Sometimes if I find myself getting tight with a long and detailed drawing, I will stop and do a quicker sketch of the same thing. Often I find the quick sketch will bring me back to looking more clearly at the object, whereas the detail of technique in the longer drawing had pulled me away.

13. *Continually keep in touch with your subject.* Be objective. Are you doing your subject justice? If not, why not? Get up and walk around. Leave it for awhile and come back when you are refreshed. Read some literature about it, to increase the knowledge you put into your drawing.

14. *Make lines varied and interesting.* Break them up. Leave some out where light breaks up form (as in Figures 2.7 or 5.32).

15. *Do not overdo* your drawing. Stop before you are totally finished. You can always go back, but it is very hard to undo what has already been done. Put the drawing on the wall and live with it for a few days. If you still like it after a day or a week, then keep it. Otherwise throw it away and do another. Above all, have patience with yourself. You are learning. The more you draw and the more you observe, the better you will get.

Keep Your Study Growing

16. *Try different tools* and do not get caught by one style and one medium. Use a crude stick with black paint. Use long white shelf paper or shirt cardboard. Use varying sizes of brushes, hard and soft pencils, and different types of pens. Make things larger or smaller than size. Repeat the same subject from a different angle and using different tools and media.

17. *Study other artists' styles.* Learn what is being done and has been done in the field of nature drawing. Even copy an artist's style (just as long as you do not make it your own); know what technique was used and how.

18. *Get to know nature better.* Do not glance but really look. Find yourself through drawing better understanding how, what, why, and where in the world of the sparrow, fox, butterfly, mountain wild flower, or coastal tidal pool.

Figure 3.26
NICK WILSON (American wildlife artist, 20th century)
Ocelot
Courtesy of the artist and Mill Pond Press, Inc., Venice, Fla.

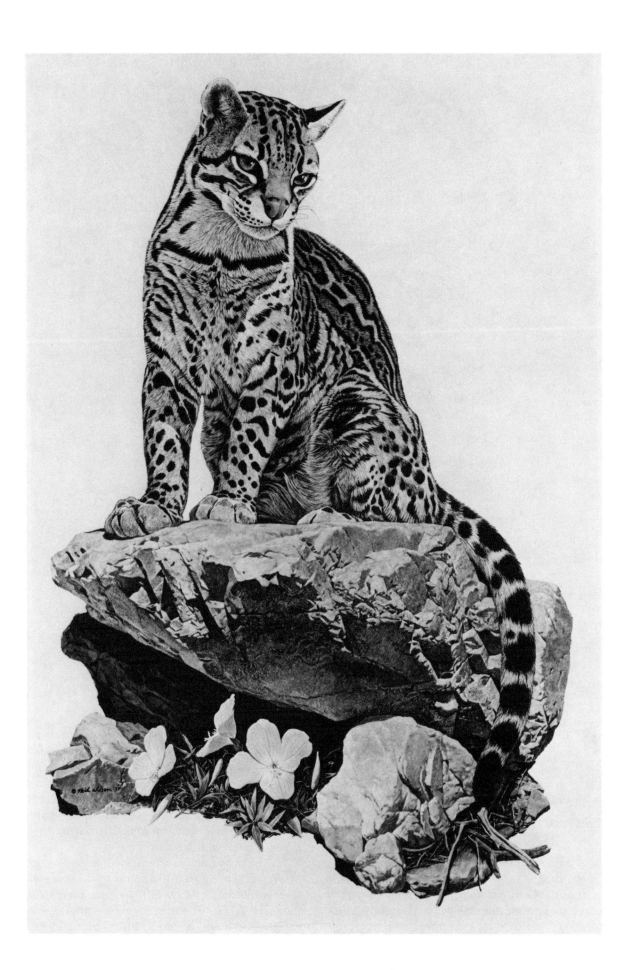

In THIS TWENTIETH CENTURY, to stop rushing around, to sit quietly on the grass, to switch off the world and come back to the earth, to allow the eye to see a willow, a bush, a cloud, a leaf, is an unforgettable experience.

Frederick Franck, *The Zen of Seeing: Seeing/Drawing as Meditation.*

There is still snow on the ground, yet from a spot of mud and wet snow rises a burst of yellow crocuses. I get my drawing pad to pause a moment to enjoy a closer look at their spritely forms spreading across my lawn. Plants are wonderful to draw not only for their beauty and form, but also for the energy of life they symbolize, being capable of growing in the most diverse lands and in the most extreme climates. By studying plants, you can learn much about types of soils and habitats, as well as about the joys of drawing their artistic forms and designs.

The next time you notice an assemblage of flowers blooming in a field stop to ask yourself several questions. How did they get there? Are they similar to those growing in the woods nearby, and if not, what conditions cause the dif-

CHAPTER FOUR

Plants: flowers, fruits, and vegetables

ferences? Why are they so brightly colored? What insects seem attracted to them and how? When is their peak of bloom and when do they start dying back? You may not have answers to these questions, but at least they might help you to think about flowers as vital participants in a natural system.

There are many ways to draw flowers, fruits, and vegetables, from an artistically abstract to scientifically realistic style. Throughout history, people have delighted in drawing, painting, sculpting, and weaving plant forms, and scientists have spent much research on their habits and habitats. However you choose to draw plants, give yourself the time to notice aspects about them that you might not have seen otherwise. I started to draw a shasta daisy one day only to spot a crab spider, colored the same soft white of the petals, disguising itself while waiting for an unsuspecting fly. I had never seen one before, and I was amazed that it was able to match the white flower so completely. When I looked in a guidebook, I read that crab spiders characteristically hide in this way because they make no entrapping webs like others of their kind. Thus camouflaged, they can jump out and poison a

Figure 4.1
FIDELIA BRIDGES (American, 19th century)
Milkweeds (watercolor)
Courtesy of the Munson-Williams-Proctor Institute, Utica, N.Y.

victim before it can get away. In studying flowers, therefore, you can learn not just about them but also about their interrelationships with other plants and animals and with the land around them.

This chapter will give you some technical assistance in the study of plants, a variety of ways to draw, and a briefing in plant botany, all of which will, I hope, lead you into studying more on your own. Many people draw plants very well without knowing anything about botanical parts. Yet your drawings can be more accurate and meaningful if you know something about what you are drawing, where it grows, and its life history. The same holds true for drawing other aspects of nature as well. Whether seeking proficiency of drawing technique, scientific accuracy, or expressive representation, always try to learn something new about your subject.

A drawing that struck me for the strength of its interpretation of a plant form, both artistically and naturalistically, is the *Chrysanthemum* by Piet Mondrian (Figure 4.2). He has beautifully constructed his work, showing a rich use of line

and modeling while integrating a variety of media. One has the sense that he had really examined this plant to the point of feeling a rapport with it. When drawing any plant, it helps to take enough time to get to know it and to draw it several times, even using different media, different poses, or different styles.

Throughout this chapter, you will be confronted with a question you must answer for yourself: How do I combine to my own satisfaction realism, technical proficiency, and personal expression? Are you an artist wanting to increase your knowledge of nature? Are you a naturalist wanting to increase your knowledge of drawing? Do you have only brief moments to draw? Are you considering art as a profession? Or are you a student who must draw in your botany classes? Whatever your purpose, read through these pages, see how the exercises are laid out, study carefully the illustrations, and then adapt what is offered to suit your own interests.

For the purposes of this chapter, we are separating plants (flowers, fruits, and vegetables) from trees. The plants included here are *herbaceous*,

Figure 4.2
PIET MONDRIAN (Dutch, 19th-20th centuries)
Chrysanthemum (black crayon with pencil, charcoal, brown crayon, and white chalk accents)
Courtesy of Smith College Museum of Art, Northampton, Mass., purchased 1963.

There are many ways to draw a chrysanthemum. Mondrian has chosen to use a variety of media emphasizing shape, texture, and tone in a realistic as well as expressive manner.

that is, those having soft stems, and if grown outside, dying back each winter. There are annual (live and bloom one year), biennial (grow one year and bloom the next), and perennial (bloom every year) plants in this group. Trees, shrubs, and vines are called *woody* plants because they do not die back but continue to grow their firm stems and branches from year to year.

I have chosen to discuss the drawing of plants by going through a year's cycle, pointing out aspects of plants that can be drawn in each of the seasons. Fruits, flowers, and vegetables are good subjects to begin with: their shapes can be contained and quite simplified; they can be held in the hand and studied closely; they will not hop away like a frog or require detailed analysis like a landscape. However, plants are seasonal. It is difficult to draw bunches of blooming wildflowers in winter, and to watch tulips open you must wait until spring. When it is the wrong season for drawing outdoors, photographs can be used, although they offer nowhere near the same experience as drawing the subject fresh and there before you. During the winter months, a visit to the florist can please your household as well as your desire to draw flowers in bloom.

A word on picking plants: Since the cutting or taking of plants can be a controversial issue, always use caution and discretion when you do find it necessary to collect. Draw on location wherever possible. If you must collect, choose only a small part of a plant and make sure it is one of many in the area. Ask permission before you do, and never cut any part of a plant from the endangered species list (which you should know for your area). Be sure to carry a knife or small scissors so that you will not tear or rip out a specimen.

BEGINNING EXERCISES

Refer to the first chapter, "Beginning Drawing Exercises," for an explanation of various exercises. I will use them repeatedly throughout this book because they are a good way to get started and to feel relaxed with drawing. Invent your own beginning exercises if you wish, but always try to provide a brief time to warm up and become adjusted to seeing your object clearly before attempting your major work. One way to get started is to draw larger and faster than you usually do if your tendency is to become tight, small, or immediately detailed.

Exercise 1
THE BEGINNING EXERCISES

(Time: 30–45 minutes. Materials: soft pencil, 8-by-11-inch or larger drawing paper.)

Keep the subjects you choose uncomplicated and contained. Find one object that is a simple, small plant form, such as a green

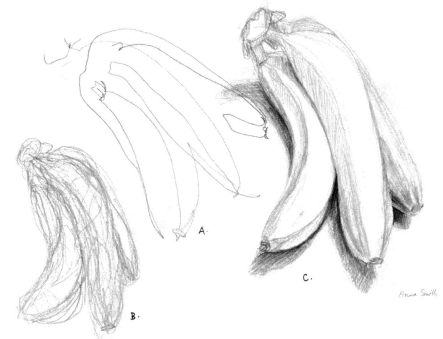

Figure 4.3
Student drawing:
A. Contour.
B. Gesture.
C. Extended drawing.

pepper, seed pod, banana, daffodil, mushroom, or artichoke. Draw one single object or make an arrangement with two or three if you like.

1. Take time to look thoroughly at your subject, as if you had never noticed it before. Again, refer to Chapter 1 for specific directions for each drawing exercise and to Figure 4.3 as an example of how one student did these exercises.

2. Do one *memory drawing,* having concentrated a full five minutes on your subject. This exercise is important for improving your ability to absorb visual information.

3. Do one *contour drawing* (3–5 minutes). The purpose of this exercise, in which you will be looking *only* at the object and not at your paper, is to begin to establish a connection between what the eye sees and what the hand records.

4. Do one *gesture drawing* (15–45 seconds and no more). Learning to do fast gesture drawings is essential when you are drawing in the field: time is limited, and it is important to put down the whole image before adding detail.

Figure 4.4
Student drawing of a narcissus.

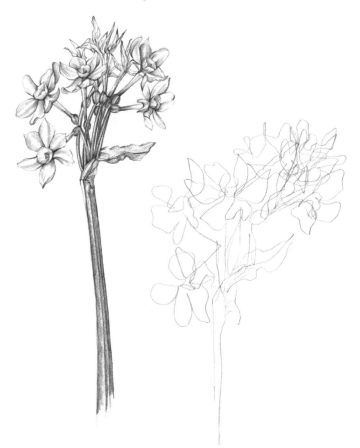

5. Do one *longer drawing* (15–20 minutes), using a whole piece of good drawing paper. Plan your layout and proceed carefully, building up from the first light pencil sketch to one with darker and more refined lines. Add tone and volume only if you want to. Do not spend a lot of time on details. See this drawing as a process of learning to coordinate your hand and eye and in learning what is worth recording and what is not. Some students wish to throw away these early drawings. Do save them, however, as they are interesting to refer to when you have had more experience and can see how much you have improved.

6. If you have time, do one more *longer drawing,* using a different arrangement or view and a different tool, such as pen, crayon, or wash.

Exercise 2
PLANT STUDY DRAWING

(Time: 45 minutes to one hour. Materials: HB, 2B, or 3B pencil and 8-by-11-inch or larger drawing paper.)

Before learning how to do this and that and exactly what stamens and pistils are, it is important to do your own exploratory drawing. Then you will discover your own list of questions and difficulties. As you draw, also keep a running list of such problems as how to set leaves into space or how to give the effect of depth. See if you can figure out a way. Go through this exercise, developing questions about both technique and botany, and then proceed to the next two sections, Techniques for Drawing Plants and Plant Botany. Be experimental with pencil line. Vary its weight and thickness. See if you can indicate shading and depth by line variation rather than by tone.

Subjects to Draw. Choose a relatively simple subject or group of subjects—one of your house plants, buttercups in the yard, some iris from the florist, a tomato plant in your garden, a bowl of fruit—that would make an interesting composition but is not too difficult to draw satisfactorily in one hour. Do not get overwhelmed by answerless questions.

TECHNIQUES FOR DRAWING PLANTS

Composition

A lengthy amount of time spent looking at your object is as important as the time spent drawing. How big is it? How do the petals or leaves curl? How much do you want to draw? Move it around

until it is in a position you like. Think about placement on the page. Study its form and ask yourself what you want to *say* about it. How does it grow, reproduce, and flower, and where would it grow naturally if it is an indoor plant, fruit, vegetable, or cut flower?

Before you spend time with detail, first be sure you are pleased with the way you have set your subject on the page. Is it squeezed in the upper corner, or is it too big for the page? How you position your drawing can greatly enhance or detract from the pleasure of the whole. Too often students rush into the detail of a drawing only to find that their basic layout is unsatisfactory and they have wasted a lot of effort—which must be erased.

Proportion and Shape

Your first layout sketch should be similar to a gesture sketch. See the elements as part of the whole and all at once. Thus, you will not have imbalanced proportions. These light pencil lines can always be erased later as you work into your drawing, refining lines and shapes.

As you begin to develop your drawing, see shapes first as simple geometrics (as in Figure 4.5). Imagine you are cutting them out of the space around them. What is the *flat* shape of this space around the form (called the negative space) as well as the *flat* shape of the form itself (called the positive space)? Compare repeated elements, like leaves, seed heads, or flowers, and see how

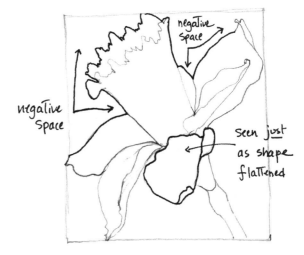

Figure 4.5
See forms as flat shapes to help visualize correct size and proportion. See negative spaces as forms also to help with angles and measurements of the positive subject.

their shapes vary. Getting the shape of both your negative and positive elements *proportionally* correct will help lay the foundation for an accurately seen drawing. This is particularly important if you are drawing for plant identification, such as in an illustration or diagram.

Exercise 3
PROPORTION AND SHAPE

(Time: 5–10 minutes. Materials: 2B pencil and any drawing paper.)

Do one short gesture or simple line drawing really concentrating on making the proportion and shapes of the forms correct. Follow the suggestions in the above paragraphs. Use line and do not bother with tonal shading unless you wish to do so.

Figure 4.6
Drawing parts of a flower:
A. Leaf serrations.
B. Floral heads.
C. A floral head with even parts.

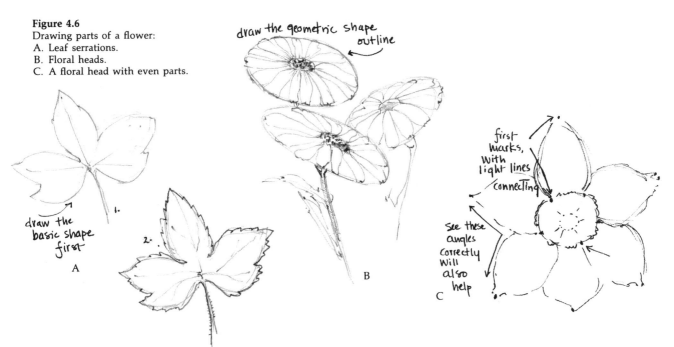

INDIVIDUAL LEAF AND FLORAL SHAPES

If you are drawing a cluster of leaves with serrations and uneven outlines, begin with the simple geometric form and then position the specific outline configuration evenly on top, erasing the first lines if you wish. (See Figure 4.6A 1 and 2 as an example.) This method can also be used to draw floral heads at an angle or head on so as to get the uniformity of petals fitting into the overall shape (see Figure 4.6B). Many people, because they keep shifting their position ever so slightly, have trouble drawing flowers at an angle. Do not move your eye level or the position of the object once you have begun. If it is a flower with evenly spaced petals, such as a daffodil or tulip, place light marks where you want the petal tips and their bases to be. Then draw lines to connect these markings (as in Figure 4.6C).

Foreshortening

If we know a leaf is shaped like the following diagram A, it is hard to know what to do when it is pointing directly toward us. See the leaf, once again, as a *flat* shape (B or C). Again, look at the shape and angles of the negative space to help determine the correct shape and angles of the positive form. Take any object, such as a leaf, banana, or your hand. Hold it vertically. Slowly tilt it toward you. How does the angle change the shape?

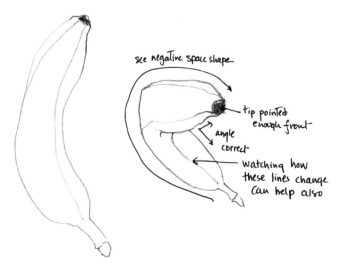

Figure 4.7
Seeing shapes foreshortened.

To foreshorten the stem or flower or seed head as it tips toward you, make sure the stem tucks up under the head at the correct angle, is drawn lighter, and the flower or seed head has a distinctly drawn base as it curves out from the stem. To help clarify this, study Figure 4.8.

Figure 4.8
Seed heads in foreshortened positions.

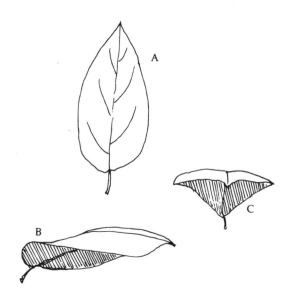

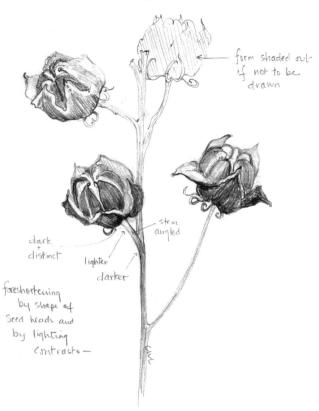

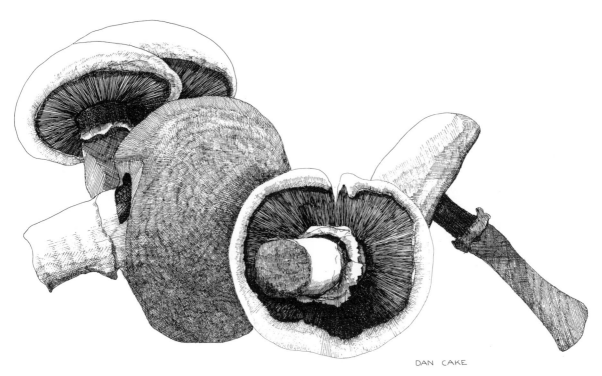

DAN CAKE

Figure 4.9
DAN CAKE
Mushrooms (technical drawing pen)
Courtesy of the artist

Using a network of cross-hatched lines, the artist has created a subtle study of shape and tone. Squint at the drawing to see how contrasting the values are.

Exercise 5
LEAVES FORESHORTENED

(Time: no limit. Materials: no requirement.)

Draw a plant with large, simple leaves in various foreshortened positions. A rubber, jade, or philodendron plant is good to use because the leaf outlines are uncomplicated. Drawing correctly the lines of the center and primary veins, if there are some, will help to give directional indication of the leaf's plane and angle. Again, be very careful that you do not change your angle of viewing, or your drawing will be off as well.

Exercise 6
FLOWERS FORESHORTENED

(Time: no limit. Materials: no requirements.)

Draw one flower head in three different positions: profile, angle, and top view. Notice how shapes subtly change and different elements come into view.

Leaf Veins

If we see all the veins in a leaf, it is hard not to draw each one (a beginner's common dilemma). But if we do, the leaf can look like an ant highway. Remember that the lines with which you drew the leaf's outline represent *outline*. If you use the same lines to indicate veins, the eye will think those are outlines too, and your leaf will have a confused look. Thus you must use a different *weight* and/or *style* of line. Also, do not feel you must draw every minute tear and insect chew on the leaf. The midrib should be almost as strong a line as the outline, or it should be drawn with two lighter parallel lines indicating the rib's thickness. Often, when beginning a leaf, my first line will be the midrib as it helps determine the angle and length of the whole leaf. The side veins can be indicated by light, broken lines, as in Figure 4.10.

Figure 4.10
Leaf veination.

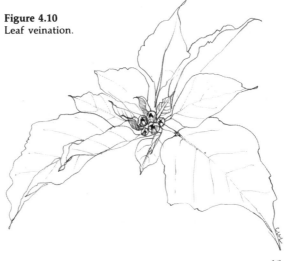

61

Shading versus Line Drawing

The beginning student often thinks a drawing is "good" if it has shading. Nonsense! Shading is like adding color; it is a nice extra touch that is not necessary to the definition of form. In many pen and ink drawings, shading is not used at all since line can so clearly render the image. But it all depends on your preference and style of expression. Figure 4.11 is a good example of depth and foreshortening achieved only with line.

Figure 4.11
ELIZABETH MCCLELLAND
Nootka Rose (technical drawing pen)
Courtesy of the artist

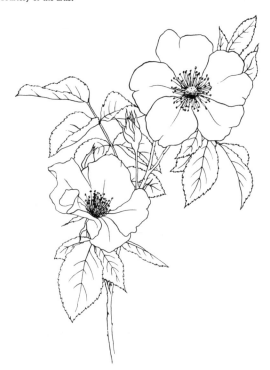

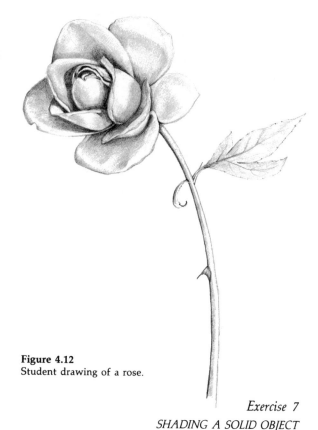

Figure 4.12
Student drawing of a rose.

Exercise 7
SHADING A SOLID OBJECT

(Time: 45 minutes. Materials: any soft pencil, grease crayon, charcoal pencil, or pen and ink wash; good drawing paper.)

To make an object look round, position a good light source beside it so that variations in the curve of its surface can be more easily distinguished. Choose a simple shape to draw, whether it be a green pepper, onion, banana, mushroom, or whatever. Draw in the form first; then go from the darkest shadow to the two middle ones and then to the lightest, leaving the white of the paper for the last tone. Try erasing parts of the outline facing the light source to give the suggestion of light penetrating and thus breaking the form's outline. Too strong an outline can flatten a form, rather than help describe its volume. As a matter of fact, the line of an outline should not usually be darker than the tonal value beside it.

If you do use shading, it can be done in numerous ways. The most common techniques are *hatched line* (Figures 4.9 or 4.21); *tonal shading*, which uses the side of the pencil to attain differing shades of grey (Figure 4.12); or *ink wash*, which uses pen and ink with a brush wash, and *watercolor* (or other color media). Often scientific illustrators will employ other techniques, particularly *stipple*, which is a series of ink dots placed carefully in sequential patterns to indicate gradations of tone. If you are interested in this technique and a further explanation of the other shading methods, refer to Chapter 3, "Techniques and Methods."

Figure 4.13
Exercise in shading a form.

Depth and Variation between Planes

Many students ask how to achieve the sense of depth and the distinction between foreground and background when drawing plants. It is difficult to isolate one feature that will make the difference. Basically, it is the combination of *foreshortening, shading,* and the varied use of *line.*

Look at Figure 4.14A and B for a breakdown of the basic concepts. What is in the foreground should be drawn *more* distinctly and with more detail. What is further away should be drawn decreasingly *less* distinctly and with less detail (Figure 4.14A). Generally, what is further away is in more shadow, although because of coloration or lighting it may not be. Whatever you do, make a *contrast* between planes, otherwise the forms will appear as if they are all in the same plane. Correct

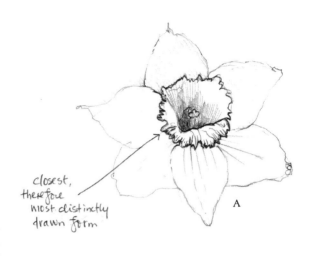

closest, therefore most distinctly drawn form

A

less distinctly drawn, further away

shading to indicate angle of petal and to create contrast with closer trumpet

B

more distinctly drawn to emphasize closeness

Figure 4.14
CLARE WALKER LESLIE
Summer grasses (2B and 4B pencils)

To work on elements of depth, shading, and composition, it can be useful to abstract a subject. Here I was using a natural subject for purposes of artistic study. If your tendency is toward realism and detail, abstracting forms can help you see new technical possibilities. Try using bold, expressive lines, erasing, smudging, and rearranging forms to create an interesting composition.

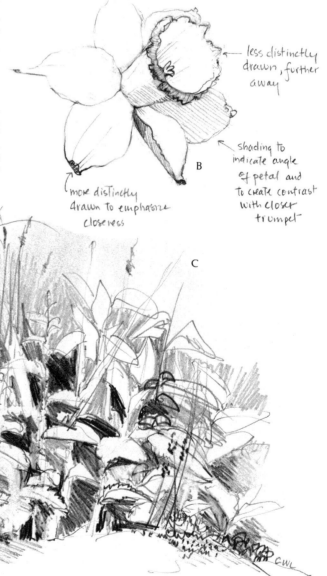

C

foreshortening of shapes can also help to suggest depth. Another hint is to angle the lines of your shading along the angle of the form's plane to further help the eye go beyond the flat of the paper (See Figure 4.14B).

Exercise 8
DEPTH AND VARIATION
BETWEEN PLANES

(Time: no limit. Materials: any soft pencil and good drawing paper.)

Choose an arrangement of simple floral forms—a potted plant, an arrangement of fruits and vegetables, or some similar composition—to practice drawing depth by the use of line and shading. Be free with your eraser. Darken an area, and if it brings a form out rather than setting it back, erase it and see what will work. Much of the understanding of how to achieve a sense of depth in plant forms comes from experience and trial and error.

Which Comes First: Color, Shading, or Texture?

There is no one answer to this question. I prefer to draw my major tonal areas first so that I can see how well my subject is sitting in space. Color, as in a black and white photograph, can only be indicated in ranges of grey; thus color often appears as a type of tone. Texture and surface patterning, such as the prickly stem of a thistle or the mottled leaves of the trout lily, can be indicated over tone and color. Recognize that tone, color, and texture all really overlap and can be worked on simultaneously. What is important is that you have quite accurately represented each.

Above All, Draw to Learn and to Enjoy

Try not to be defeated by failure but realize that you learn by your mistakes. Draw out of a curiosity and desire to know plants better. If you are not always satisfied with the way your drawings look, try to consider what new aspects of the plant you learned while drawing it. I will often study a plant, *not* for the drawing that will result, but for the observations I will be able to make while drawing.

PLANT BOTANY

Plants are a fascinating study in form and function. Wherever one may be found, each plant

Figure 4.15
BEATRIX POTTER (English, 19th-20th centuries)
Flower Drawing (pencil)
Reproduced by kind permission of F. Warne & Co., Ltd., from *The Art of Beatrix Potter,* © Copyright by F. Warne & Co., Ltd., London and New York.

Beatrix Potter combined the study of an artist and a naturalist in her many drawings and watercolors of natural subjects throughout her life. Here, at age nine-and-a-half, she already showed a keen desire to draw and to study from nature.

has evolved its form to function in that particular environment. Plants that cannot vary their structures and adjust to environmental changes gradually become extinct.

Unlike animals, most plants must gather food in a stationary position. Food is made by a plant from combinations of sunlight, water, oxygen, and nutrients from the soil. A process called photosynthesis, working in plant leaves, converts these external substances into starches and sugars which the plant can then absorb. Leaves are green because the compound that enables this process is a green chemical called chlorophyll. Leaves can have other colors too, depending on various chemicals also present within the leaf. These are usually masked by the dominant pigment of chlorophyll until fall, when the food-making process in a leaf shuts down and the chlorophyll pigment fades. This process accounts for the brilliant and varied colors particularly present in autumn trees.

Exercise 9
LOOKING AT A PLANT

Get a seed pod, fruit, vegetable, house plant, or cut flower. Look at it and think about its form and function. If it is part of a plant, what part? If it is the whole plant, can you locate all the various parts: leaves, stem, roots, flowers? Many of our house plants have large leaves, fairly rapid growth, and the ability to live in our warm houses year round. This is because their ancestral home is the tropics. Knowing something about the natural history of a plant will help you draw it more accurately.

If you have a seed pod or fruit, realize that it is the expanded ovary from the base of the flower head. On apples, opposite the stem you can sometimes see the old sepals and even the stamens. Go to your garden and look for flowers transforming into fruit. The edible parts of many vegetables are fruits by scientific definition because they develop from fertilized flowers: tomatoes, peas, corn, cucumbers, squash, and green peppers. Fall's dried seed pods, such as those from milkweed, thistle, and evening primrose, also began from the female flower part. When fertilized, the ovary expanded, hardened, and developed mature seeds. These seeds are generally then shaken from their cases to spread across fields in the chance of developing a whole new plant in the spring.

Flowers, astonishing though it may seem, are not showy and fragrant for our pleasure alone. Rather, their form, color, and fragrance serve to attract insects that crawl over and into them gathering nectar (from the female pistil) and pollen (from the male stamen). In picking up this food, they in turn scrape from their bodies male pollen granules gathered from other flowers. If these land on a similar flower's pistil, they will seep down to fertilize the awaiting ovules. Plants are remarkably designed to receive pollen from only certain insects and from only other plants of the same species. Most individual flowers are not receptive to their own pollen which, as with human in-breeding, would weaken the species. Therefore, the design of a flower head has evolved in form to best attract a certain insect species to pollinate in a certain way. The shape of the orchid or the pansy or the daisy, therefore, is not random but highly selective. What in the color and design of each would attract an insect? Noticing such things will help you to draw plants with more care.

There are numerous books on the botany of plants, from college texts to less advanced sources for the general reader. Golden Press's basic, but very fine, small paperback *Botany* has good information to begin a study of plants. (See Bibliography.) In fact, Golden Press has published a number of small paperbacks on numerous subjects in natural history which are worth having before launching into more sophisticated texts. I will refer to various ones in the series throughout this book. Most bookstores carry these guides, and you may even find them in a local drugstore or airport. Although sometimes placed in the children's section, they are just as useful for adults.

Figure 4.16

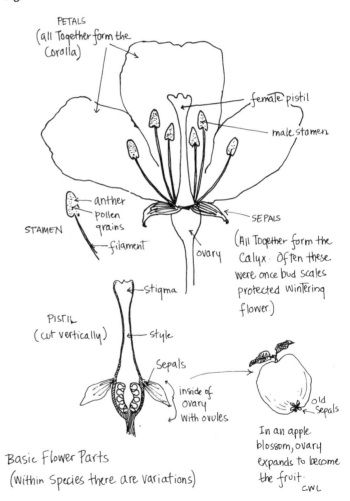

Basic Flower Parts
(Within Species there are variations)

Figure 4.17
Study of fruits and vegetables as interesting, compositional forms (felt-tip marker).

Exercise 10

*LOOKING AT A FLOWER AND DRAWING
ITS PARTS: DIAGRAMMATIC DRAWING*

(Time: no limit. Materials: no requirements.)

If you have a flower, take it apart with a knife and look at the various pieces. Have several flowers of the same kind so that you can draw the various stages of your examination. Using a magnifying glass to see better, locate stamens, pistils, sepals, and petals. Cut open the ovary and find the little ovules. Each species has its own reproductive design, so that daffodils will look very different inside from tulips, daisies, or primroses. But all plants in the same family will have similar reproductive parts, such as all those in the rose, daisy, or mint family.

Do a simple diagrammatic line drawing in a more illustrative than artistic style. In this exercise, you are meant to experience drawing more as a tool for study than for artistic expression. Indeed, you may find in your study of nature that you often draw just to learn; balance that with your need to be artistic at times.

DRAWING PLANTS
THROUGHOUT THE SEASONS

The following topics for drawing progress according to season, from winter to fall. Since you may not live in the region that I am most familiar with, which is New England, adjust the subjects to suit your own area and interests. I have not listed specific exercises or styles for drawing. The possibilities are many, and it is much more valuable for you to set up your own drawing program. You may wish for a quick field sketch or for a more detailed drawing or for an abstract, more interpretive style. You may want to use pencil, pen and ink, charcoal pencil, colored pencil, or

Figure 4.18
STEVEN POLKINGHORNE
Eggplant (soft pencil)
Courtesy of the artist. Photograph by Anne Ficarra

66

watercolor. Look at the examples included in this chapter for ideas of styles and media and how they were utilized in drawing plants.

WINTER

FRUITS AND VEGETABLES

Go to your refrigerator or to a local market and look for three or four interesting shapes you would like to draw. Put them in an arrangement, taking time to set them up and move them around. Do not bother with a bowl, drapery, or nonnatural materials. Have a good light shining over the surfaces so that you can see clearly shadows and highlights if you want to do a tonal study; or just draw their outlines with one continuous contour line. This method is wonderful on a large piece of newsprint or inexpensive white paper with a large brush full of black ink or a thick felt marker. Concentrate on form. Then make a smaller and more detailed study in pencil of shadows, volume, and depth relationships. Use any medium.

Figure 4.19
KAREN STOUTSENBERGER
House Plants (ball-point pen)
Courtesy of the artist

Often the artist will use a ball-point pen because she likes the tonal effect it can give, more like a pencil than a pen at times. It is also easier to carry around and does not need the care that other pens demand. Notice how she uses carefully repeated lines, rather than areas of tone, to create compositional values.

HOUSE PLANTS

House plants are good subjects for winter study. Technical practice in creating shading, foreshortening, depth, and so on can be worked out before you go outside to draw the plants of field and woodland. However, because house plants can be complex and detailed, you might wish to draw only a portion of a plant or a group of several, emphasizing overall composition more than detail of individual form (as in Figure 4.19).

SEED PODS, SEEDS, AND WINTER WEEDS

Winter is the time of gestation. New plants are in seed form waiting to sprout in the spring. Brown stalks decorate the fields where meadow flowers used to be. There are a number of plants that in blooming late develop dry, firm stems and seed heads which survive the autumn frosts to scatter their progeny over the landscape. These wildflowers (or weeds) of late summer and fall are noted for their fascinating seed heads having intricate geometric containers to hold multitudes of tiny seeds. Throughout most of the winter, these dried stalks and seed heads can be gathered for interesting dried arrangements and for drawing. Look for such ones as evening primrose, motherwort, milkweed, teasel, thistle, or purple loosestrife. Study the mathematics of their evenly arranged parts in shapes of triangles, hexagons, pentagons, and so on. In fact, it was nature that invented geometry, not man. A useful book for identifying dried weeds of the East Coast is Lauren Brown's *Weeds in Winter*, which is illustrated by the author. (Because numerous weeds have spread across the country, many plants she mentions may also be in your area.) When drawing these dried plant forms, you might want to use line more than tone since their shapes can be quite intricate and delicate. Too much shading might only disguise the clarity of their designs.

A VISIT TO THE GREENHOUSE OR FLORIST

If you want a pleasurable experience at any time of year, go to a local greenhouse or florist and draw the rows of hot-house plants in all manner of growth stages, from seedling to full blooming plant. Before focusing on one specific plant, give yourself enough opportunity to walk around, selecting several subjects that look interesting to draw. Just be sure you have asked permission before beginning. The advantage of drawing in a greenhouse is that you have the opportunity to study a variety of plants and to compare shapes and species (and to have an enjoyable time of it). First, do quick five- or ten-minute sketches to limber yourself up, to start yourself looking, and to become accustomed to drawing in such a situation. Then do several thirty-minute drawings of two or three contrasting species. Because you may be standing, prop-

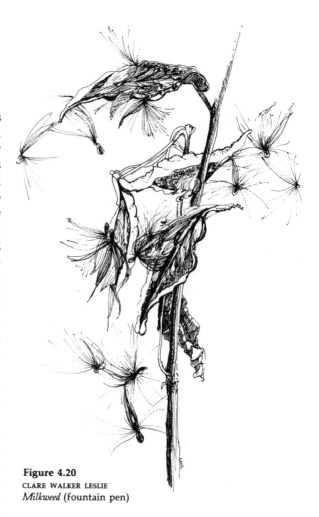

Figure 4.20
CLARE WALKER LESLIE
Milkweed (fountain pen)

ping your pad awkwardly against you, do not try for a masterpiece. Rather, work on improving your observation and documentation by making brief records. You can always rework the drawings when you return home and have more time.

DRAWING VASES OF FLOWERS

Treat yourself to a bouquet of flowers and draw them. Select something simple, such as a few iris, a rose, several daisies, some freesia, and laurel or ferns for background. These may last for over a week so that you can have plenty of time for a variety of drawings, from the quick sketch to the unhurried study. Draw one flower or the whole assemblage, using just lines and no shading. Draw very realistically and then very abstractly, using pencil, ink, watercolor, or colored pencils. Compare your drawings over a period of time to see where you have improved. One student drew a series of pencil studies of a large red amaryllis as it grew from bulb to full flower, then to withered bloom. The sequence showed not only growth of flower but growth of her skill in observation.

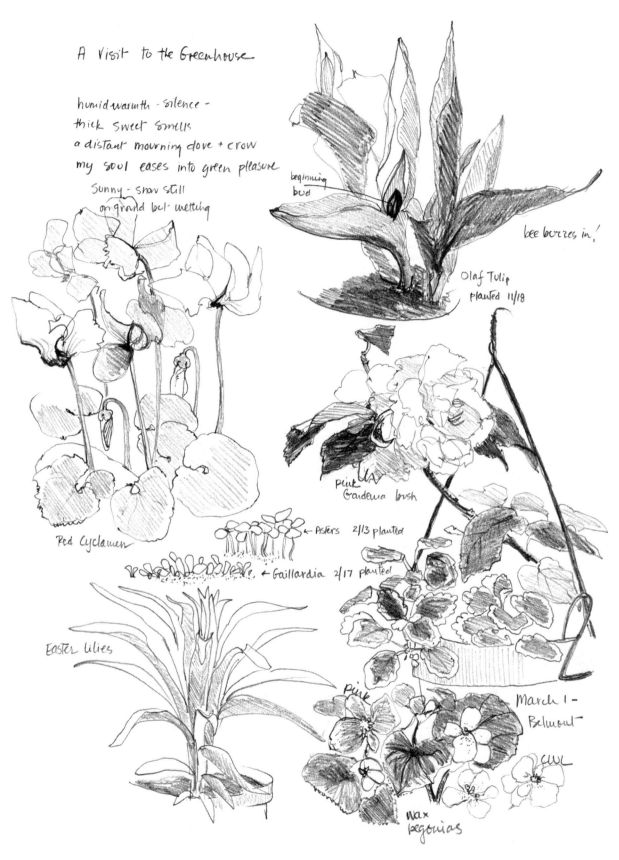

A visit to the Greenhouse

humid warmth - silence -
thick sweet smells
a distant mourning dove + crow
my soul eases into green pleasure
Sunny - snow still
on ground but melting

beginning
bud

bee buzzes in!

Olaf Tulip
planted 11/18

Pink
Gardenia bush

← Asters 2/13 planted

← Gaillardia 2/17 planted

Red Cyclamen

Easter Lilies

Pink

Wax
begonias

March 1 -
Belmont

CWL

Figure 4.21
CLARE WALKER LESLIE

Figure 4.22
KATSUSHIKA HOKUSAI (Japanese, 18th-19th centuries)
Flowers in a Bowl (brush and ink)
Courtesy of the Museum of Fine Arts, Boston. Bigelaw Collection.

The Japanese were masters in the art of simplicity and the sensitive use of the brush. Many hours were spent just in looking before a single stroke was put on the paper, and then a work was often drawn fully from memory.

Spring

SPRING BULBS

The earliest outdoor blooms, such as snowdrops, crocuses, hyacinths, and daffodils, make interesting subjects to draw and their shapes are simple. Draw them progressively, starting as the shoots first poke through the warming soil until masses of flowers are in bloom and other, flashier flowers distract your eye. Watch carefully how a prowling bumblebee seeks out pollen, stacking it along its legs and powdering its back.

WILDFLOWERS AND WEEDS OF THE REGION

Spring is fully on its way when skunk cabbage, bloodroot, and trillium are in bloom in our New England woods. Wildflowers appear in sequences that mark the season's progression from early spring's first hepatica to autumn's last aster. Some wildflowers need rich wet soil, some need dense shade, some need barren and dry soil, and some need full sun. Each region of the country will have its own community of wildflowers, varying from place to place.

What are wildflowers and why are they different from tulips, African violets, and poinsettias? Basically, wildflowers today are defined as any naturally evolved plant that does not grow just by human cultivation. In addition to the plants native to this country, many plants have been accidentally or intentionally brought in from all over the world and now grow wild in many regions: dandelions from Europe, thistle from Canada, marigolds from Mexico, gladiolas from South America. With the colonists came all their garden "pot herbs" for food, medicine, or decoration. Grasses came in from foreign shores. Corn and squash are two native "wildflowers" that the Indians introduced to the early settlers.

Some wildflowers, such as pink lady's slipper and trailing arbutus, have become scarce to the point of being endangered in New England because of man's encroachment on their specialized habitats. Other wildflowers, less selective in their needs, can be found thriving throughout most of the country: dandelions, clover, ragweed, milkweed, thistle, and poison ivy. This latter group has been termed *weeds*. Basically, the definition of a weed is any plant that grows where it is not wanted. There are, in fact, many gorgeous weeds. Weeds have become resistant to control, thriving in the most varied of conditions. Start looking for weeds around your area, such as chickweed between sidewalks, blue chickory along highways, pigweed in farm yards, or bluets in rocky meadows. To learn some of your local weeds, you might want to look at *Weeds* by Alexander Martin.

Make a project of drawing ten local weeds and ten local wildflowers. See if you can put your

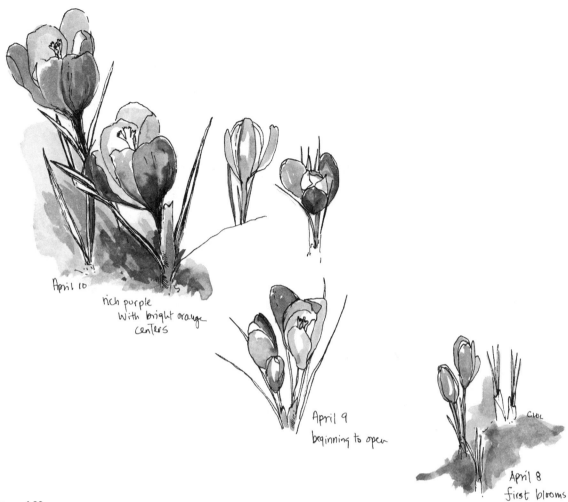

Handwritten labels on figure:
April 10
rich purple
with bright orange
centers

April 9
beginning to open

April 8
first blooms

Figure 4.23
CLARE WALKER LESLIE
Spring Crocuses (technical drawing pen with black watercolor wash)

Figure 4.24
LAUREL H. PYE
Star-Thistles (pen and ink and watercolor)
Courtesy of the artist

As a botanist and artist, Laurel Pye was interested in the beauty of design in these weeds which grow wild in Western pastures and waste places.

plants into these two categories, or see which ones overlap. All weeds are wildflowers but not all wildflowers are weeds. Learning the progression of blooming plants throughout the seasons helps one become more aware of the cycles of the year. Locate a useful guide to the wildflowers of your area and take it with you when you go outdoors. A common one is *A Field Guide to Wildflowers* by Roger Tory Peterson. Make brief but accurate sketches in the field. Then upon returning, redraw the plant carefully (in ink, pencil, or watercolor), using your sketches and the field guide. Label each drawing according to name, location found, date, and other key features of identification. You might want to draw one plant per page (perhaps enlarged to double size), or you might want to make a page study of plants found in one particular habitat (see Figure 4.28). Keep shading to a minimum and emphasize the linear quality of these plants. Identification is more the purpose than artistic interpretation.

emerald damselflies
with perfectly black wings

Swamp Azalea
R. viscosum
··· the sticky hairs
on the outer petal
surface might stop
nectar-stealing ants
··· butterfly is the
preferred pollinator.

Calopogon
pulchellus

··· magenta flowers
ingeniously up-
side-down.

Bee lands on furry
pollen arm which
hinges over to
touch the bee
against the
lower, stiffer
stigma, pollin-
ating the
flower!
Works everytime.

Pitcher plant
Sarracenia purpurea
Dark, waxy flowers
held high above the
furry lips of the fatal
pitchers.

hinge

pollen
on the
bee

stigma

½ X

Figure 4.25
JORIE HUNKEN
Bog Day, June 29, 1979 (felt-tip pen)
Courtesy of the artist

As both naturalist and artist, Jorie Hunken's interest in drawing these specific
plants was to have opportunity to study the structures of the pollinating mecha-
nisms particular to these bog-loving plants. Drawing groups of plants by habitat,
such as these, can help you learn what characteristics are similar to those plants
that live near each other.

Summer

LEARNING PLANTS BY HABITAT

Summer offers a tremendous opportunity to learn and to draw a wide variety of plants. Set up a plan to learn groups of plants by their habitats, such as those of the woodland, mountain, sea coast, desert, or city. Look at Figure 4.28, a chart of some of the major Northern American habitats and a selection of plants to be found in each. The choice is random, mostly designed to acquaint you with the diversity of plant habitats existing in North America. Fill in the last blocks with regions you might study.

Figure 4.26
MARTHA CAIN
Beets (colored pencil)
Courtesy of the artist

The artist comments on her work: "My art is presently a manifestation of my love of quiet abandonment in close observation of nature. . . . I enjoy singling out common and not so common objects and presenting them in a formal way, thus giving the viewer a heightened awareness of objects in my environment and hopefully stimulating them to observe the richness in their own surroundings."

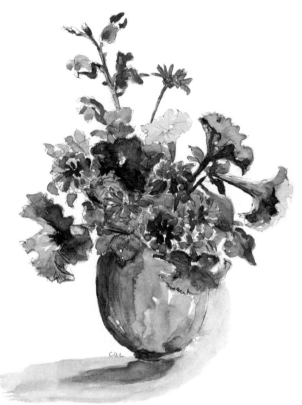

Figure 4.27
CLARE WALKER LESLIE
Garden Flowers (pencil and watercolor)

THE FLOWER AND VEGETABLE GARDEN

Plant your garden with drawing in mind. When you are tired of weeding, trimming, and fussing, find a quiet spot beside a zinnia, pea plant, day lily, or cabbage. Fill your drawing paper with large, bold line drawings of bean bushes or peas on their fences, communicating overall growth forms and shapes of leaves. Do longer studies of a specific vegetable plant or make an arrangement of the gathered produce from your garden. Experiment with media and types of papers. Be sure to date your drawings so that you can note the stages of your growth.

Draw also the flowers in your garden (perhaps bringing an arrangement indoors to draw). For ideas on styles refer to the other drawings in this chapter. You may want to add some color over your pen or pencil drawing. Decide if color is to help illustrate or to help abstract a form. If I am not sure exactly what style I want for drawing, I will either think a while, until the image of what I want comes to mind, or I will

Arctic + Alpine Regions on Mountain Tops: Western Rockies to White Mountains	Northern Swamps + Bogs	Northeastern Deciduous Forest
Mountain sandwort dwarf cinque foil lapland rosebay alpine azalea twisted stalk mountain avens	Sundew Pitcher plant orchids cranberry bearberry shinleaf purple loosestrife	trilliums violets bloodroot partridgeberry mayapple indian pipe skunk cabbage Solomon seal

		Sandy East Coast Beach
		dusty miller rock weed tall wormwood seaside goldenrod beach pea sea lavender seaside plantain spartina grass

Midland Prairie	Southwestern Desert	Forests of the Western Mountains
Sunflowers mullein teasel fireweed bindweed sow thistle clover burdock timothy grass	Prickly-pear desert marigold hedgehog cacti Prickly-poppies evening primrose desert mallow	Columbines larkspurs gentians indian paintbrush lupines buttercups ox-eye daisy

	add your own + label region:	The City
		Japanese knotweed lady's-thumb mustards yarrow common plantain shepherd's purse dandelion chickory

		Southeastern Evergreen Forest + Subtropics
		honeysuckles lantanas wild pineapple water hyacinth common St. Johnswort swamp buttercup

		California
		seacoast: succulents, thistles dry chapparal groves: flannel bush + yucca green valleys: california poppy larkspur saxifrages mariposa lily

Plants by North American Regions

74

Figure 4.28

begin to draw, seeing what style seems to emerge of its own. Rather than impose a style on a drawing, I let the composition help determine its own.

NONFLOWERING PLANTS

Not all plants have flowers. Those that reproduce by spores (microscopic, male fruiting bodies) or other nonflowering means are of an earlier evolutionary development than the flowering plants. Fungi, seaweed, mushrooms, lichens, mosses, and ferns are in this group. Though less conspicuous than the flowering species, these plants initiate the exploration of habitats you might not have noticed otherwise. Ferns and mosses are abundant in shady woods, in damp meadows, hanging onto rock outcrops, and along borders of fields. The fern has two parts: the elab-

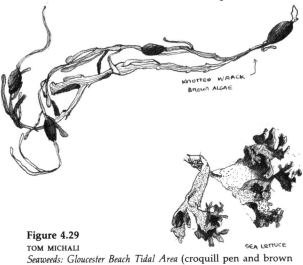

Figure 4.29
TOM MICHALI
Seaweeds: Gloucester Beach Tidal Area (croquill pen and brown ink)
Courtesy of the artist

orately serrated leaf frond and the fruiting body, which may be in clusters along the frond or on a separate stalk.

Mushrooms appear after rains or in early fall woods and are actually only the fruiting body of the fungal growth which lies beneath the soil or within the wood of rotting trees. Look under their caps to discover the myriads of dusty spore granules within gills or tiny holes. Various hard fungi cover rotting wood and make interesting studies for winter drawings, when their shapes become most apparent in the whitened woods. Lichens (a combination of algae and fungi) are like a crusty skin covering barren and rocky exposures where no other plants can survive. Other lichens form leafy rosettes on tree trunks or mini-

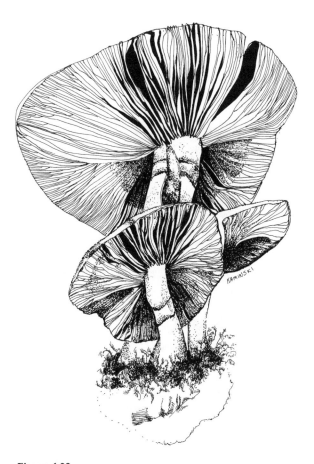

Figure 4.30
LINDA KAMINSKI
Cortinarius Armillatus (technical drawing pen)
Courtesy of the artist

The artist is a scientific illustrator who believes in recording botanical accuracy of species as well as pointing out artistic beauty of form. Thus this demonstrates a freer form of scientific illustration than is shown in other examples throughout this book.

ature sculptures on bare earth or mossy logs. Their subtle colors and designs are well worth drawing.

A trip to a pond or seacoast tidal pool can offer opportunities for drawing both fresh and saltwater algae and seaweed. In a pond, distinguish the structural differences between the flowering and nonflowering plants. Carry a hand scoop to gather these plants from under the water. Dry out small samples of aquatic plants on a flat surface so that you can draw their full dimensions. Record on your paper location, size, date, coloration, and any other key features.* If you are drawing directly outdoors, use a quick record-taking method which you can work over or redraw when you are indoors with a guidebook and a steadier hand.

* A useful guide to have nearby is another Golden Press paperback, *Nonflowering Plants* by Herbert Zim.

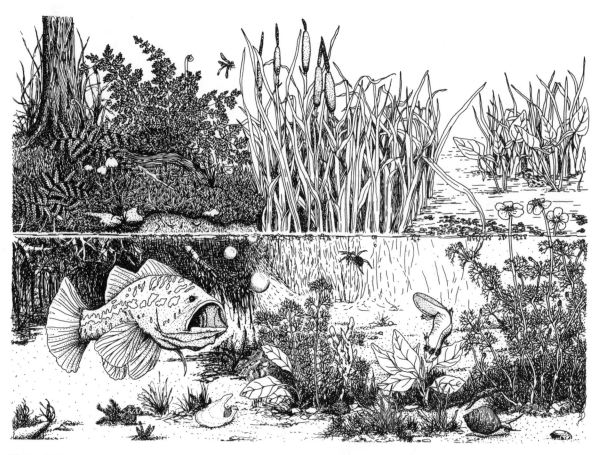

Figure 4.31
ROBIN BRICKMAN
Cross-Section of a Pond (technical drawing pen)
Courtesy of the artist

Depicted here is one way of describing plants and animals living together within a specific habitat. Notice how individual plant forms are stylistically repeated and simplified to help eliminate confusion and to achieve an overall character of plant type.

GRASSES

Do not forget grasses. Their beauty exists more in subtle variation of form and design than in showiness of color or shape. I have identified at least twenty-five different kinds of grasses (which include sedges and rushes) just in the field below our Vermont home. Use a hand lens, look closely, and you will notice seed heads looking like shooting stars, dew droplets, weavings, and tiny birds. Dried grasses can be gathered to make late summer arrangements and can then be drawn as abstract groupings of pattern and design. Do line identification drawings of various grasses you find locally or combine them with other flowers as part of a whole composition. Grasses are a much overlooked subject worth more study.

Figure 4.32
Quaking Grass
Illustration from *A Handbook of Plant and Floral Ornament from Early Herbals* by Richard G. Hatton (New York: Dover Publications, 1960)

Autumn

EVERGREEN PLANTS

In the woods of New England it would seem that in the fall, all plants die back with only a few brown leaves remaining. But look closer under the carpet of fallen leaves or snow, and a number of small, green flowering and nonflowering species appear to be thriving. Often they can be identified by brightly colored berries or conspicuous seed heads standing out against the otherwise dull brown woodland floor. There are a number of evergreen plants that, in having similar characteristics to evergreen trees, can survive the conditions of winter. Wintergreen, pipsissewa, partridgeberry, Christmas and polypody ferns, and club mosses all stay green in our New England woods. Notice their waxy leaves, closeness to the ground, and toughness of plant mass. These can be drawn as delicate line compositions or as small elements of larger drawings.

There are also evergreen species of the desert and warm climates which do not die back or turn brown in winter. Cacti, desert roses, and all manner of tropical plants, which we northerners see only in greenhouses, are there year round. Do a series of drawings to study what evergreen plants are present throughout the year, what are their stages of growth, and when they bloom. Keep a careful record of the dates and regions.

Figure 4.33
WENDY ZOMLEFER
Malacocarpus Vorwerkianus (Cactus) (black scratch board)
Courtesy of the artist

Figure 4.34
CLARE WALKER LESLIE
Field Sketch of a Canada Violet

A simple sketch like this, noting distinctive features, is enough for a drawing done in the field. With such information, a plant can later be identified by a guide book and then redrawn if so desired.

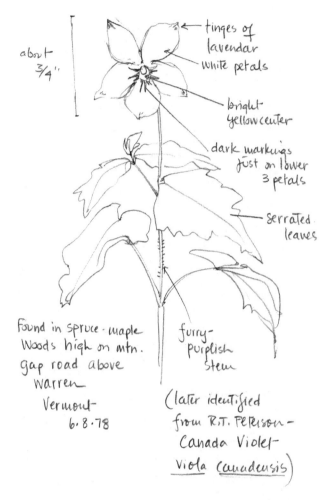

When identifying, make a drawing instead of picking plants. When you are on a trip or a hike and an unusual plant catches your eye, draw it rather than pick it. Drawing serves the immediate opportunity for on-the-spot study, whereas picking will keep others from enjoying the plant and will leave you with only a limp specimen later on. Draw just a simple diagram, enough to record distinguishable features, such as number of petals, shape of leaves, smooth or hairy stem, location, and time of year. Then later refer to a field guidebook to clarify identification and to improve on your drawing. You will be surprised at how much more you observed by drawing the plant instead of picking it.

Figure 4.35
AUBREY BEARDSLEY (English, 19th century)
Merlin and Nimve (pen and ink)
Courtesy of the Museum of Fine Arts, Boston. Hartley Collection.

Plants have been great sources for artistic design and often featured in the works of this artist.

SOURCES FOR STYLES AND IDEAS

Book illustrations, both for children and adults, offer good sources for plant drawings. Some contain very detailed illustrations, and others contain abstract designs in color and pattern. Botanical journals and horticultural magazines are sources for scientific as well as for the more descriptive styles of drawing. Historical herbals and old treatises on medicinal and culinary plants offer interesting styles in a more "old-fashioned" way. Then, of course, there are the art museums where you can find innumerable paintings, drawings, pottery, and textiles whose compositions or designs feature plant forms from the most realistic to the extremely abstract. Choosing how you are going to draw a certain plant can be as varied as deciding which plant you are going to draw.

BIBLIOGRAPHY

ALEXANDER, TAYLOR R., BURNETT, R. WILL, and ZIM, HERBERT S. *Botany.* New York: Golden Press, 1970. (PB)

BROWN, LAUREN. *Weeds in Winter.* New York: W. W. Norton and Company, 1976. (PB)

CROCKETT, JAMES UNDERWOOD. *Crockett's Victory Garden.* Boston: Little, Brown and Company, 1977. (PB) (Good photographs to draw from as well as old illustrations of plants and contemporary ones by artist George Ulrich.)

HATTON, RICHARD G. *Handbook of Plant and Floral Ornament from Early Herbals.* New York: Dover, Inc., 1960. (PB)

HOLDEN, EDITH. *The Diary of an Edwardian Lady.* New York: Holt, Rinehart, and Winston, 1977. (HB)

KING, RONALD. *Botanical Illustration.* New York: Crown Publishers, 1979. (PB)

MARTIN, ALEXANDER C. *Weeds.* New York: Golden Press, 1972. (PB)

NEWCOMB, LAWRENCE. *Newcomb's Wildflower Guide.* Boston: Little, Brown and Company, 1977. (HB)

PAGE, NANCY M. "Wild Plants in the City," reprinted from *Arnoldia,* Vol. 34, No. 4 (July/August 1974), pps. 137–252. (PB)

PETERSON, ROGER TORY, and McKENNY, MARGARET. *A Field Guide to Wildflowers of Northeastern and Northcentral America.* Boston: Houghton-Mifflin Company, 1968. (PB)

SUTTLEWORTH, FLOYD S. and ZIM, HERBERT S. *Non-Flowering Plants.* New York: Golden Press, 1967. (PB)

WARNE, FREDERICK, editor. *The Art of Beatrix Potter.* New York and London: Frederick Warne and Co. Ltd., 1967. (HB)

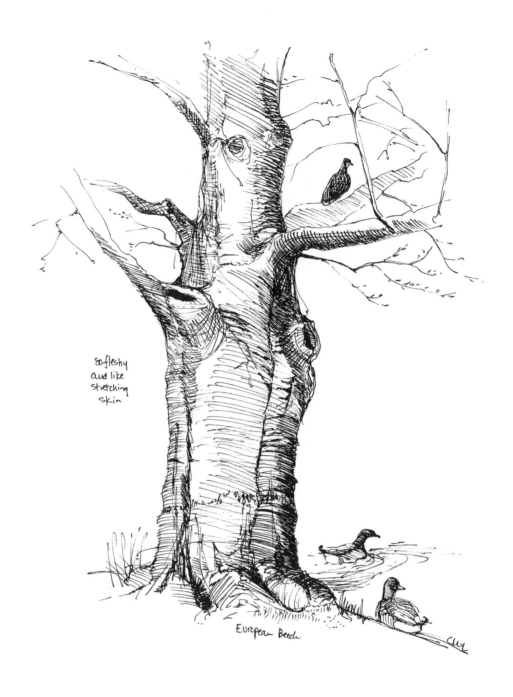

so fleshy
and like
stretching
skin

European Beech

DID YOU KNOW THAT TREES TALK? Well, they do. They talk to each other, and they'll talk to you if you listen. Trouble is, white man don't listen. They never learned to listen to other voices in nature. But, I have learned a lot from trees: sometimes about the weather, sometimes about animals, sometimes about the Great Spirit.

Tatanga Mani, a Stoney Indian, quoted in *Touch The Earth*

Without trees, the land would be barren. Yet how seldom do we pause to look at and truly study how one tree differs from another or why one grows well in one area and not in another. Perhaps if we too listened to trees, we would learn more about the land that nourishes them.

The challenge in drawing trees is that they present a rather complex form: trunk, branches, twigs, leaves, sometimes with fruits, flowers, and seed pods. How much that we see do we draw? How much detail do we include? Perhaps instead of drawing the whole tree, we might draw only a small branch, an assemblage of leaves, or simply some of its dried seed clusters. Just deciding how to draw a tree can discourage us from even trying the actual drawing. This chapter will present vari-

CHAPTER FIVE

Plants: trees and shrubs

ous approaches and methods for drawing trees, from the whole form to its individual parts. Since aspects can vary by the season, subjects for study are mentioned as they occur through the year. So, choose the current season to begin your study.

Any reference to trees in this chapter also includes shrubs. Both of these can be identified as either deciduous or evergreen. For further discussion of these terms, see the section Tree Botany.

You may want to make a natural history study of ten local trees in your neighborhood or learn how to sketch trees quickly in a landscape while you are traveling; or you may have some time in the summer to paint or draw wherever you like. By looking at trees and their forms all the time, when you start to draw them you will already have a stash of memory notes to help you remember how to visualize the initial shapes. In winter, particularly, study basic tree construction so that in the summer you will know the framework beneath those leafy masses. I like to take time while I am jogging, walking the dog, or driving the car to analyze and memorize tree forms, noting how oaks contrast with maples or poplars with birches.

Figure 5.1
VINCENT VAN GOGH (Dutch, 19th century)
Grove of Cypresses (reed pen and ink)
Collection of the Art Institute of Chicago

Trees can be learned by their physical features or by what can be called their Gestalt. *Gestalt* here means the total visual shape or "feel" which is characteristic of that particular species and not of others. The American elm has the Gestalt of a tall, spreading umbrella. The oak is all elbows and angular. The sugar maple is a large balloon of spreading limbs. Living with trees through a number of seasons helps one to learn their individual traits.

Numerous aspects of trees can also be studied: their flowers, fruits, seeds, leaf shapes, winter buds, bark textures, as well as their structure as a whole. One can also study the insects, birds, animals, and plants that live on or nearby a particular tree. When you are drawing, it is helpful to have on hand one or two basic field guides for identification and for learning some of the specific characteristics that should be noticed. One paperback often used is *Trees of North America* by C. Frank Brockman because it does cover the whole country. A recent guide is *The Tree Key* by Herbert Edlin, which has tree silhouettes in addition to color illustrations of fruit, twigs, and nuts. A more scientific paperback is one in the Peterson Field Guide Series, *A Field Guide to Trees and Shrubs* by George A. Petrides. There are a growing number of worthy field guides and natural history books out now on trees. Find those that are appropriate to your region and interest of study. Refer to the bibliography at the end of this chapter for some suggested titles.

GETTING TO KNOW TREES

Exercise 1
GETTING TO KNOW THE TREE
IN YOUR BACKYARD

Choose one tree nearby that you can observe over a period of time. Take a walk around it. Look up into its branches and figure out its branching structure. What branches cross and how? How does light affect form and shadow? Run your hands along the trunk, studying its texture, markings, and deformities. Look in holes for any evidence of insects hiding in cracks or animals living in nests or holes. Now stand back and study its full shape: the solid trunk as it curves up from the roots and ground; the first branches to fork off from the trunk; the weavings of limbs as they hold their leafy canopy of summer or their bare twigs of winter. Notice that there is a system within the branches, decreasing regularly to the outermost twig. No tree is just randomly constructed.

Examine a lower branch. What buds does it have or what characterizes the shape of the leaves? Consider how many years the tree has lived and the events that have passed beside it. At this point it is a good idea to refer to a field guide and learn some of the botanical features, such as conditions for growth, flower and fruit type, region where found, and so on.

Exercise 2
GESTURE DRAWING OF YOUR TREE

(Time: Ten minutes or less. Materials: any 11-by-14-inch or larger drawing paper or newsprint sheet.)

Do a quick gesture drawing of the tree you have been looking at, just enough to capture something of its Gestalt and overall character. See the tree as a whole form and all at once. Keep your lines moving freely over the total mass. Do not bother with realism of drawing but with realism of seeing. Begin with the trunk and major spread of branches. Then place on top primary masses of leaves. Scribble in dark areas where you see dark tones. Indicate general leaf shape and major groupings but do not bother with detail. Do not even take time to look down at your paper. Rather, as in the contour drawing, let your eyes guide your hand simultaneously around the page. Begin by focusing on how a tree grows. Draw several pages of large, sprawling tree shapes, as seen from different angles if you want. Decide which ones look most like the tree. Why? What are you noticing and what have you yet to notice more carefully?

Figure 5.2
Ten-minute gesture sketch of an oak in later winter. The
intention of the drawing was to record basic tree shape and
individual character over specific detail.

Old field oak
March - 1979

TREE BOTANY

It is important to know some botanical features
so that your observation can be more thorough.
The basic difference between a tree and a shrub
is that a tree has a single trunk and a shrub has
several. Also, shrubs tend to be smaller, even in
maturity. Whereas trees generally have a crown
of branches spreading out from a height up the
trunk, the branches of shrubs spread out from
the base or from a clustered group connected by
roots beneath the ground. Of course, there are
exceptions in which some trees look more like
shrubs and some shrubs look more like trees.
Flowering dogwood, yew, redbud, and sumac are
small trees with the growth habits of shrubs, so
they can be called by either name.

There are evergreen as well as deciduous
trees and shrubs. Basically, deciduous (or broad-
leaved) trees drop their leaves in winter. Ever-
green trees continually keep their foliage, drop-

ping leaves or needles throughout the seasons.
The prime difficulty in the cold months for all
plants is dehydration from lack of water. For
making food, large leaves demand a lot of water,
which is pumped up in surprisingly abundant
quantities through a plant's vascular system. If
you were to cut a plant or tree trunk, you would
find water seeping out of its vessels. With the
ground frozen and no access to water, deciduous
tree leaves would wither. Thus in the fall, extra
concentrated food is stored in the roots in the
form of a sugary water (sap); leaves, no longer
producing food, drop, and the deciduous tree es-
sentially is closed down for the winter. In New
England, the early spring ritual of maple sugaring
arrives when this stored sugar water starts to flow
up from the roots to the recently swelling buds,
giving new growth a hearty dose of concentrated
food. (And a hearty dose of concentrated food
for pancake and syrup lovers!)

The evergreen tree has a different system
for surviving temperature changes. First of all,
when speaking of evergreen trees, I mean two
basic types: those that have needlelike leaves and
produce cones rather than flowers (called *conifers:*
cyprus, juniper, cedar, spruce, pine, fir, and hem-
lock) and those that have broad leaves, like their
deciduous relatives, and bear flowers (called *broad-
leaved evergreens:* holly, magnolia, palm, laurel, ca-
mellia, and rhododendron.) The latter have stur-
dier leaves, especially designed either to with-
stand temperature change or to reside in warmer
climates. Notice the leaf of a holly and a white
pine. Feel how waxy and tough the leaf is in
comparison to the papery and thin maple or syca-
more leaf. This composition acts as a coat, pro-
tecting the leaf from dessication or frost. Notice
the needled leaf has actually very little surface
area bare to the elements; it grows in a cluster
and generally in a compact grouping around the
twig. Deciduous leaves, on the other hand, can
have long stems that cause the leaf to wave in
the least bit of breeze. What do you think are
the advantages and disadvantages of leaf stems?

Consider the contrasting shapes of decidu-
ous and evergreen trees. The former generally
have large spreading canopies of leaves, whereas
the latter usually have compact, dense columns
of needle-shaped leaves. The leaves of the decid-
uous trees, extending from long stems, are able
to catch more available sunlight, but cannot with-
stand the cold and freezing temperatures of win-

Figure 5.3
THEODORE ROUSSEAU (French, 19th century)
Trees and Cottage (soft pencil and textured paper)
Courtesy of the Museum of Fine Arts, Boston. Gift of Mrs. John S. Ames.

Contrast Rousseau's interpretation of a tree with van Gogh's. How do the two differ? Is either one "more accurate"? There are many ways to draw trees. What is most important is that each artist conveys the sense that he has spent some time studying the growth habits and forms of a particular tree, rather than that each branch was drawn in specific proportion.

ter. Evergreen needles, growing close to the twig, are constructed to withstand extreme temperatures and to bear up against the weight of snow and ice. Thus, while a deciduous tree essentially shuts down its food production in winter, the evergreen tree maintains its production throughout the year. In addition, a thicker sap than what flows through the deciduous tree provides the evergreens with antifreeze protection.

Study the shapes of trees and try to figure out what has determined their growth. Trees like oaks, hickories, or white pines, when growing in open areas, are large and spreading (see Figure 5.3). If growing in woods, close to other trees, they become tall and thick, having to compete for sunlight available only at the tops of their branches. If the soil is poor, a tree will not grow well, nor will it if it has become diseased. California cypresses twist and bend along the Monterey coast, battered by wind and ocean spray. Spruce trees growing on exposed mountain tops are miniature and spread low along the rock face. Paper birches of the northern woods will have a narrow, compact build and shallow roots because the soil is poor and weather conditions are harsh; but where soil and climate are more conducive to growth, these birches will spread out in shape.

In winter, trees are primarily identified by twig and bud form as well as by bark, any old fruits or seeds still remaining, and silhouette. The parts identified in Figure 5.4 are handy to know when you are drawing and identifying twigs. Initial identification of deciduous trees most commonly begins with noting whether the outermost

twigs and all buds are arranged *opposite* or *alternate* to each other along a branch:

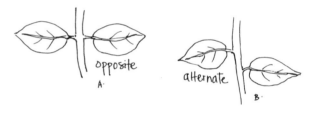

Most identification keys for trees begin with this feature because the major deciduous trees (not including shrubs or evergreens) that are oppositely branched are maples, ashes, dogwoods, catalpas, and horse chestnuts. All other trees are alternately branched. The larger branches should not be examined this way as they often have

Figure 5.4
Botanical parts of a deciduous tree twig

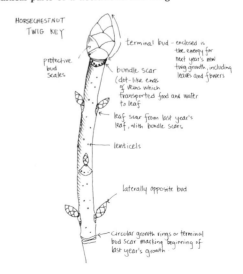

84

become irregular from disease or breakage. Because squirrels and birds have a way of biting off tasty, young buds and twiglets, several smaller branches should always be examined.

DRAWING TREES THROUGHOUT THE SEASONS

There are many ways to approach the drawing of trees, and styles can be just as varied. I have chosen to use the seasons as one system for learning, as well as for drawing, trees. Begin with the season you are presently in and go to that section. Then read through the other sections, trying their exercises when the season is appropriate. As with other aspects of drawing nature, photographs can be used during any season so that you do not necessarily have to be restricted to working with the condition outdoors.

A word on cutting tree parts (or any plant parts) to draw: It is all right to cut small samples of twigs, buds, fruits, or seed pods *if* you have permission and *if* it is not done in a careless or extravagant manner. Always use a knife or clippers so that you do not tear the branch and take only a minimally sized piece (take no more than eight inches of a twig). Since cutting is a controversial subject, always be discreet and leave little evidence that you were there. Anything that is considered endangered in your area (plant or animal that is on a registered endangered species list) should not be touched. Anything living, such as a frog or butterfly, should be drawn on site. Since we are not always able to be outdoors or have direct or prolonged contact with our subjects, it may be necessary to collect specimens. Do it intelligently and with due respect for the environment.

Winter

WINTER TREE BUDS

In winter, the drawing of trees is often limited to a view from a window, to photographs, or to a brief dash outside. However, another project to choose is learning the smaller parts of trees, which can be carried indoors and drawn. Buds, nuts, seeds, or small sections of branches offer good subjects for learning both about nature and

about drawing technique. I will often start beginning students on these small, simplified forms because line is the dominant element and the task of drawing it is much more managable than a whole tree or even another plant or animal.

Tree buds are a good project as they vary so by species in both shape and design. When winter has become dull and grey, I will go to the snowy fields in search of budding twigs. Great beauty can be found in these small containers of next year's leaves and flowers. There is the garlic-domed dogwood bud, the craggy oak bud shaped like a wolf's paw, the velvety soft green bud of the star magnolia, or my favorite, the shimmering yellow butternut hickory bud.

Buds are formed the summer before in the axils of existing leaves and will lie dormant with the next year's growth until the following spring swells and opens them. Each tree designs its own container with some protective covering for the leaf or flower within. A miracle of winter is that despite ice and snow and hard freezing of the bud, green life exists waiting within these capsules.

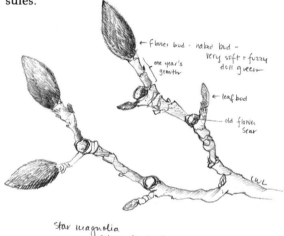

Figure 5.5
Diagrammatic study of star magnolia buds. The fuzzy heads are protecting young flowers and leaves within.

Exercise 3

WINTER TREE BUDS AND TWIGS

(Time: one hour. Materials: 8-by-11- or 11-by-14-inch drawing paper, HB or 2B pencil or a pen.)

Carefully cut four small twigs no larger than twelve inches from four differing trees (these can be shrubs and trees, both deciduous and evergreen) and bring them inside. Draw all of them on one large page or on several pages. Lay out a design of twigs that is both informative and aesthetic. Use line predominantly, adding shading only if you wish. (For advice on the shading and foreshort-

ening of twigs, see Chapter 4, "Plants: Flowers, Fruits, and Vegetables," and the sections Foreshortening and Shading versus Line Drawing. Be sure to put in the lenticels, leaf scars, growth rings, and so on. If you want to, with a magnifying glass draw one bud two or three times life-size to look at its form more closely. Be sure to label its size and the size of your twig. When you are through drawing, open the bud to see if there are leaves or flowers within. Generally, if both leaf and flower bud are large enough to be noticed, the larger of the two is the flower bud. (Sometimes on early winter twigs, the leaf bud is so minute that it is but a mere bump above last year's old leaf scar.) The styles of drawing here can be principally diagrammatic or more expressive, depending on your study.

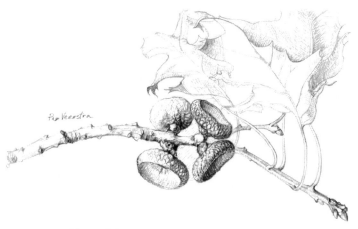

Figure 5.6
Student drawing of an oak twig with acorn caps. With a delicate, soft line, the student carefully built up form and tonal detail.

TREE FRUITS, SEEDS, PODS, AND CONES

If there is not a heavy snow cover or small animals have not yet filled their winter larders with nuts, many varieties of tree fruits, seeds, and so on can be found either on the tree or at its base. These can be interesting to draw because a great variety of forms can be found in these small shapes. Magnolia pods, spruce cones, sweet gum balls, and maple seed keys are among the many that are constructed as if only to please the eye. But remember that in nature shapes are designed for a purpose, and the purpose is survival. A tree's offspring is so constructed that it will somehow leave the tree, land, root itself, and come up as a new tree. Many thousands never make it. Elm, birch, and maple seeds have wings for being carried by the wind. Witch hazel has a hardened capsule which will burst open and shoot forth its seeds. Sycamore balls explode their fluffy seeds to float in the wind. And just the

weight of hickory and beech nuts, acorns, and walnuts sends them dropping to the ground, to roll, and settle somewhere into the soil. Thus, when drawing these forms, try to figure out the purpose behind their designs.

Exercise 4
TREE FRUITS, SEEDS, PODS, AND CONES

(Time: no limit. Materials: those that will allow you to be either scientifically diagrammatic or artistically abstract.)

Draw an assemblage of seeds, fruits, or cones that you have collected from local trees. Use line primarily or add minimal shading. Identify and label each one. Or choose one seed container that is fairly large, such as a pine cone, and draw it from several angles, becoming more and more abstract as you continue. Consider accuracy of form or abstraction of overall design.

Figure 5.7
FREDERICK WALPOLE (American, 19th century)
White Bark Pine (pencil)
Courtesy of The Smithsonian Institution.

This is a scientific illustration probably done for a particular publication on the subject. Specific botanical parts have been drawn in detail and diagrammed by letter markings.

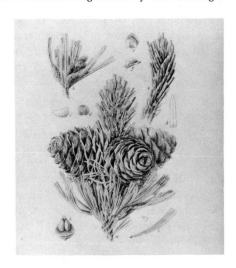

Figure 5.8
Seed pods that can be found on or near trees in winter (technical drawing pen).

WINTER TREES: SILHOUETTES

A good time to analyze tree shapes is at sunset or as they stand along the brow of a hill, silhouetted against the sky. Then you can best follow the outline configuration without the confusion of tones or foreshortening. Trace your finger over branching structures to help your eye follow their lines.

Drawing tree silhouettes must be kept somewhat schematic. Your intention is to indicate the overall Gestalt of an oak or hemlock more than to depict each branch or needle, which would lose you in confusion anyway. For examples of tree silhouettes to study, see Roger Tory Peterson's drawings in Petrides' field guide. Many artists will set up a certain pattern, simplifying tree forms to a characteristic trunk shape and modifying branching structure to a certain repetition of lines. For example, look at Figures 5.9 and 5.10A and B to see how one artist has described the silhouette of a red maple (plus other tree forms in the distance) and a white pine. The primary branching in the maple is put in and then the finer limbs are defined by repeated lines, closer to one another, which actually result in describing less the individual twigs and more the outer limits of the tree crown.

To capture this gesture takes some comparative analysis of differing species as well as some knowledge of their natural history and familiarity with why they grow the way they do. For instance, apple trees have a squat look and knobby,

Figure 5.9
DEBORAH PRINCE
Red Maple (technical drawing pen)
Courtesy of the artist

With a minimal, yet somewhat schematic use of line, the artist has achieved a clearly identifiable drawing of a red maple tree. In the open field, the silhouette can be much like that of a sugar maple.

scraggly limbs because the twigs are stout and short in order to carry the weight of the apples and are kept pruned back to prevent extensive limb growth (see Figure 5.34).

The pencil sketch of a white pine (Figure 5.10B) was done directly outdoors, and quickly because it was cold. The pen and ink drawing was the later and refined copy. Note how in the sketch the artist has sought to record the overall mass of the branches and the dimension of the tree without indicating any specific features. In the ink drawing, needles are formed by repetition of an angled hatch line not only to describe colonies of needles but also to give a strong sense of density and yet featheriness so characteristic of white pines. (For futher discussion of drawing conifers, see Drawing Coniferous Branches and Drawing Coniferous Trees.

Figure 5.10
DEBORAH PRINCE
White Pine (technical drawing pen)
Courtesy of the artist

A. Final drawing: Notice how the artist uses repetition of line to indicate mass of needles as well as simplified tracery of background silhouettes.
B. Field sketch in pencil: Done quickly outdoors to capture the suggestion of shape and posture. Light, continuous, and fast lines are used.

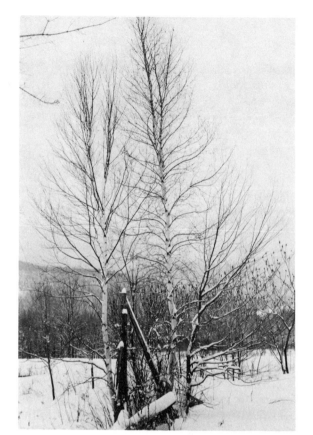

Exercise 5

WINTER TREE SILHOUETTES (DECIDUOUS TREE OR SHRUB)

(Time: One hour or more. Materials: no requirements.)

Draw three or four small silhouettes of either the trees seen from your window or those from photographs. Make them no larger than four inches and simplify to major structure only. Draw from the central trunk out to the tapering branches. A common error students make when drawing trees in any season is to draw the branches too thick, unevenly tapered, and not properly angled out from the main trunk. The look is often somewhat like that of a carrot with a lot of roots. Recognize that branches do not just jut straight out from the trunk but grow in a curve that angles up or down. Differentiate major branching structures from minor ones and from ones that can even be omitted.

If you choose to draw from some photographs of trees in silhouette (see Figure 5.11), it can help you to understand the anatomy of tree growth. Refer to Exercise 8 or practice by copying the birch silhouette in Figure 5.11.

Figure 5.11
Photograph of a white birch. A careful examination of photographs showing trees in silhouette can help a great deal in analyzing the shape and structure of branching patterns. It can be useful to trace such photographs or to copy them carefully. Try this one.

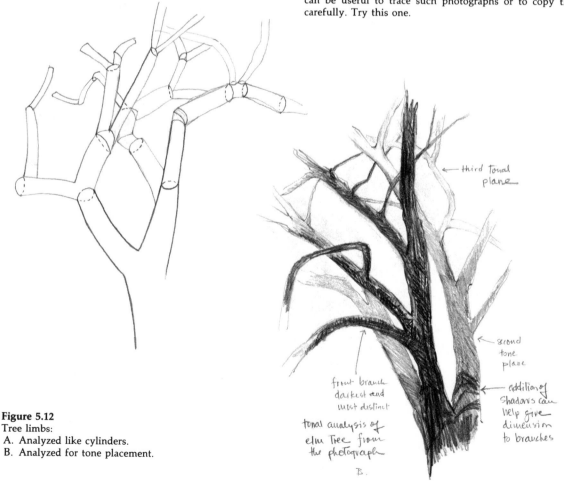

Figure 5.12
Tree limbs:
A. Analyzed like cylinders.
B. Analyzed for tone placement.

← third tonal plane

← second tone plane

← addition of shadows can help give dimension to branches

front branch darkest and most distinct

tonal analysis of elm Tree from the photograph

B.

BRANCHING AND FORESHORTENING

Branches exist, in part, to spread out leaves which in turn gather food for a tree's chlorophyll-producing process, namely, sunlight, oxygen, and water. Some branches become thick to carry broad and heavy leaves, such as those of the sycamore or hickory. Some branches are thin and carry light and delicate leaves, such as those of the grey birch and willow. Therefore, when you draw branches consider the type of leaves they bear as well as where on the branches they are positioned.

Exercise 6

BRANCHING AND FORESHORTENING

(Time: one hour. Materials: HB, 2B, or 3B pencil.)

Choose just a part of a tree to work on in this exercise. If it is difficult to make your branches look *like branches, try drawing a section of a tree by using cylinders instead. Notice how they lengthen or foreshorten as would the branches. See where light hits as they overlap one another and as one passes behind another. If some are shaded, others immediately stand out or become more distinct. Pay close attention to how branches overlap, which ones need more detail, and which ones should be darkened. As a general rule, those in front should be drawn more distinctly than those behind. To set limbs into differing spaces and planes, contrasts in shading of overlapping or adjacent branches should convey the depth on a two-dimensional piece of paper (see Figure 5.12 for assistance).*

The tree in Figure 5.13 should also be studied. Although the network of forms could easily become confused, the artist keeps shading and shape to a relatively simple system. Observe the angularity of branching so often characteristic of trees, yet something many students do not notice at first.

BARK TEXTURE

Tree bark varies greatly by species. Young trees tend to have smooth bark, whereas older trees (in order to grow in girth) have split or deeply cracked bark and even growths and deformities due to insect infestation or lightning or holes where woodpeckers have sought out insects and animals have sought out homes. The bark of the shagback hickory stretches and peels back into thick strips as it grows. The distinctive bark of the sycamore flakes into patches of light and dark. One of the ways to distinguish between balsam fir and spruce, when in stands next to each other, is to compare the bark. The balsam has a smooth bark whereas the spruce has rough. Once more, knowing some simple botanical features will help increase the accuracy of your drawings.

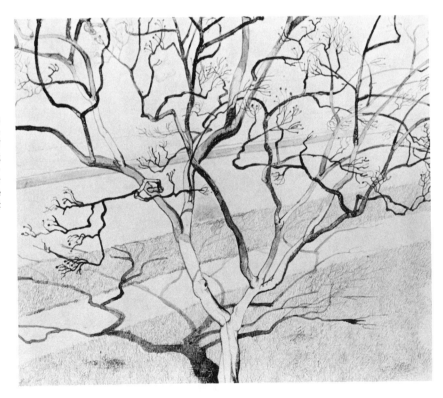

Figure 5.13
RUTH ORMEROD
The Tree Nextdoor (brush and ink)
Courtesy of the artist. Photo by Anne Ficarra

This drawing is worth a close look as the artist has successfully worked out a way to contrast the lighting and dimensions of branches so that they appear in differing planes and are not confused as they overlap. She has also captured the angularity of limbs so characteristic of small trees like this one, which may perhaps be some sort of fruit tree.

Exercise 7

BARK TEXTURE (ANY SEASON)

(Time: 15–45 minutes. Materials: very soft pencil, litho crayon, or colored crayons.)

Draw the bark of two contrasting trees. Work mostly with the side of your pencil, thinking more about texture than about line. Do not be concerned yet with volume as much as with how the bark itself folds, cracks, and shows age. Locate two contrasting trees, such as poplar with its smooth bark and elm with its deeply grooved bark. Even close your eyes and run your hands along both surfaces. Make your drawing a combination of what you feel and what you see. Although drawing is a medium much dependent upon sight, the other senses should not be forgotten. Consider how your knowledge of something might be expanded by listening, touching, smelling, and even tasting.

Figure 5.14
A photograph like this one of an elm tree can be useful to copy in order to study shadow patterns and construction of limbs. It is easier than drawing directly outdoors. In both winter and summer, take your own photographs and draw from them, as I did here.

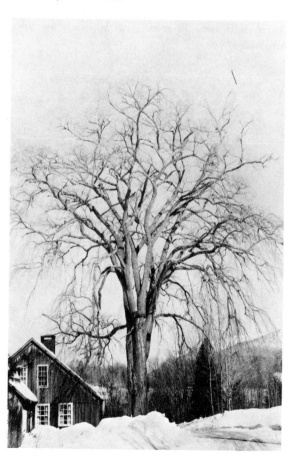

USING PHOTOGRAPHS (ANY SEASON)

Exercise 8

TRACING TREE SHAPES FROM PHOTOGRAPHS

A perfectly valid exercise in learning differences in tree shapes, both in winter and summer, is to lay tracing paper over a photograph and trace the silhouette beneath. Copying tress from photographs has its limitations because not all of the tree may be in clear image, but it can help train your hand to draw in angles and shapes you otherwise might not have realized were there. Consider copying the photographs in Figures 5.11 (white birch) or 5.14 (elm) to work on silhouettes, branching structure, and tonal shading (in Figure 5.14).

Take your own photographs of trees in both winter and summer. Photograph individual trees and those within a landscape so that you can build up a file of resources to turn to when you need such drawings. I took these two photographs to help with my own drawing of winter trees. You might consider the possibility of projecting slides onto a wall and tracing from that. Black and white 8-by-10-inch photographs can be more useful than the smaller 3-by-5.

Spring

TREE FLOWERS

There comes a day in spring when everything seems to be bursting forth. On many trees, it is the flower that emerges before the leaf, as on forsythia, redbud, dogwood, and star magnolia. Because many trees do not have such conspicuous flowers, often it is supposed that they must not have any at all. What do the flowers of oak, maple, cedar, or douglas fir look like? It may take a magnifying glass to find them, but all species of trees produce flowers of some sort (although young trees or horticulturally grown types may not).

Whether in the form of cones, catkins, or petaled flowers, trees have reproductive parts similar to other flowering plants. The male flower, or cluster of stamens, bears the microscopic pollen granules (often seen as a yellow dust) which are knocked off by wind or foraging insects. The female flower, or pistil cluster, has sticky nectar to attract insects who unknowingly deposit other tree pollen grains onto the stigma. (For a diagram of a typical flower and definition of its parts, see the previous chapter and Figure 4.16.)

Have you ever brushed past a spruce or pine tree in spring and been showered with yellow

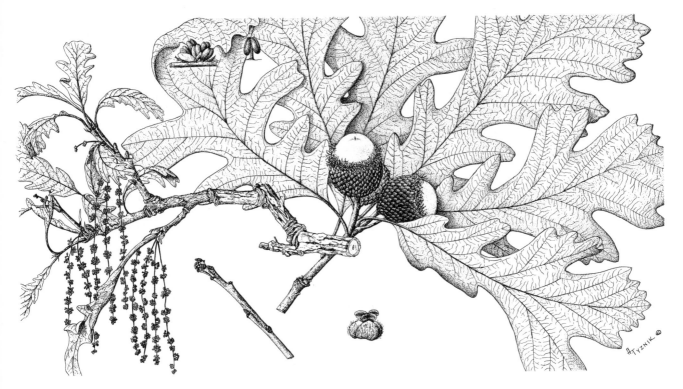

Figure 5.15
ANTHONY TYZNIK
Burr Oak
Courtesy of The Morton Arboretum, Lisle, Ill.
This was designed to diagram the parts of the burr oak, showing twig, leaf, fruit, and flower parts. Notice the rather inconspicuous chain of flowers to the left.

powder, or noticed the gutters of your street full of lime-colored Norway maple flowers after a heavy spring rain? Once the male part has scattered its pollen it dries and falls off, leaving the female part to drop its petals, if it had any, and to expand to form an acorn, maple key, apple, or pine cone.

Several relatively conspicuous and local tree flowers worth learning by drawing and diagramming are those of the maple (petalled flowers), birch (catkins), red pine (cones), willow (fuzzy tuffets), locust (pea-like flowers), or oak (long tassles of tiny flowers). See if you can locate the male and female parts.

Exercise 9
SPRING TREE FLOWERS

(Time: no limit. Materials: any finely sharpened pencil or narrow-tipped pen.)

Draw a sequence of a tree flower unfolding. Date each drawing, and be sure your sizes are proportional. Use a magnifying glass to look at parts more closely. If you have access to a microscope,

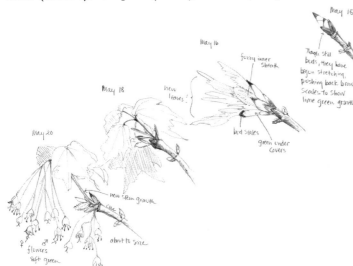

Figure 5.16
Stages of the opening of a sugar maple bud.

91

it is fascinating to see how fancy are the designs of these tiny grains or floral parts. Another project can be drawing flowers on the same branch or tree, showing various stages of opening, and considering what has determined the discrepancies. Often flowers on outer branches or on trees in full sun will bloom earlier. Another project might be to study and draw four or five different species of tree flowers and design them onto one page.

SPRING AND SUMMER LEAVES
AND BRANCHES

Before drawing the whole tree, make a study of its leaves and how they are positioned on the branches. As with the winter twigs, this is a good exercise for developing line accuracy, proportion, and composition since you are primarily dealing with flat shapes set into flat planes.

Fagus sylvatica
European Beech

Figure 5.17
ROBIN BRICKMAN
European Beech (technical drawing pen)
Courtesy of the artist

Leaves should be drawn foreshortened and as they lie naturally along the branch. Here the artist used a combination of line and stipple to indicate shading.

You might want to practice first just drawing single leaves, learning to distinguish the varieties of leaf shapes on seven or so local trees (selecting shrubs and evergreens as well). If you refer to a field guide, you will find that deciduous leaves are described by the terms diagrammed in Figure 5.18.

Exercise 10
LEAF SHAPES

(Time: no limit. Materials: any soft pencil or pen.)

Draw a whole page or several pages with just the outline of one leaf, drawn to size or to proportional size, from six different tree species. Do not draw just the flattened shape but draw the leaf foreshortened, curling, or angled (see the section on foreshortening in the previous chapter).

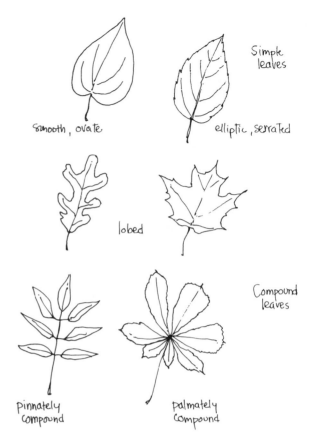

Figure 5.18
Diagram of leaf shapes.

Draw the midrib first for an idea of length and leaf angle. Think how you will arrange various leaves on the page for an interesting composition. Sketch in a light outline, seeing it first as a simple geometric shape and then refining it as your proportions improve. As I mentioned in drawing plant leaves, tree leaves can look confused if too many veins and markings are indicated. The line you use for outlining the leaf is one type of line: to define shape. The line you use for veins must vary or it will seem to define shape also. Draw with a lighter, more delicate line. Experiment with breaking up your lines, giving the effect of light penetrating form (see Figure 5.19).

Figure 5.19

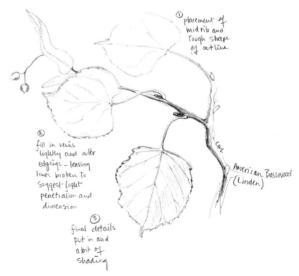

Figure 5.20
JOHN RUSKIN (English, 19th century)
Sketches of Leaves (drawing)
Courtesy of the Fogg Art Museum, Harvard University.
Gift of Mabel Sturgis.

This was probably a page from a personal sketchbook. It shows the artist exploring ways to structure leaves, probably for a finished drawing to be done later. There is an intriguing progression from the awkward forms in the upper right, down to the schematic studies in the foreground, to the more realized shapes in the far left. Then in the center is an exquisite study of leaves, highlighted in white, to accentuate their foreshortening. John Ruskin was much interested in depicting natural elements, particularly plants and landscapes.

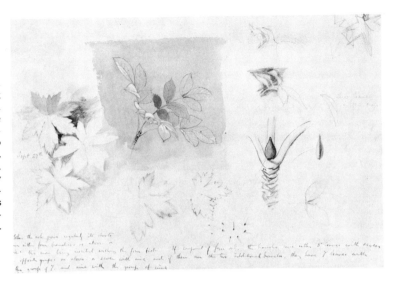

Figure 5.21
ELIZABETH MCCLELLAND
Douglas Fir (technical drawing pen)
Courtesy of the artist

Although only line is used, there is a strong sense of depth and foreshortening. How did the artist achieve them?

DRAWING CONIFEROUS BRANCHES

Evergreen conifers, with all their repeated needles, can be very monotonous as well as confusing to draw. Therefore, choose only a section of a branch (about four to six inches) and limit the detail you will put in. Learn where to repeat lines, how to overlap and foreshorten, where to use detail, and where simply to suggest. Deciding what part of the branch you are going to do is important. Choose a section that contains the key elements for identification: fruit, flowers or cones, new growth, characteristic arrangement of leaves or needles.

Figure 5.22
NANCY S. HART
White Pine (technical drawing pen)
Courtesy of The Morton Arboretum, Lisle, Ill.

As a scientific illustrator, the artist was well aware here of describing both artistic and scientific characteristics of *Pinus strobus.*

94

Exercise 11
DECIACIDUOUS AND EVERGREEN LEAVES AND BRANCHES

(Time: no limit. Materials: any medium that will allow a clear and detailed drawing.)

Do studies of different branches (no longer than 12 inches) having leaves or needles. This is a good project for indoors because small samples can be brought in, kept in water, and drawn over a period of time. You can use primarily line (Figure 5.21), line with line shading (Figure 5.23), or line with stipple shading (Figure 5.17), or experiment with shapes and tones (Figure 5.24).

Figure 5.23
LAUREL SMITH
Buttonbush (technical drawing pen)
Courtesy of the artist

Line repetition was used here to construct tonal variations.

Figure 5.24
STEVEN POLKINGHORNE
Leaves and Branches (conte crayon)
Courtesy of the artist. Photograph by Anne Ficarra

Leaves and branches can be studied directly outdoors. Here emphasis was on creating a somewhat abstract composition in form and lighting.

THE SPRING TREE

If it is spring, try to capture that essence of the individual tree, delicate and scraggly, with leaves barely emerging or with flowers festooning its branches. Draw the fledgling growth just beginning to cover the winter silhouette. Draw with a lighter hand than you would in summer. See where leaves are fully out and where they are still in bud. Until the chlorophyll process begins in full, leaves will have a soft green and limp look. Once more, use squinting to see mass and tone before detail.

Figure 5.25
WILLIAM H. WALKER
Spring Tree (soft pencil)
Courtesy of Robert M. Walker and William H. Walker II

This was probably a sketch made for a later painting. The artist was trying to depict a strong tree silhouette as well as to indicate the delicacy of new leaf forms. In early spring, heavy leaf masses are not yet present so that much light can be seen between leaves and limbs, as so described here.

Exercise 12

THE SPRING TREE

(Time: no limit. Materials: no requirement.)

Draw either from a window or directly outdoors a tree beginning to leaf. Contrast how you would draw the tree in winter or in summer with how you are drawing it now. (See the next section, The Summer Tree, for further instruction.)

Summer

Refer to the section, Spring, for additional exercises.

THE SUMMER TREE

This is the time when you can take a drawing pad outdoors, sit on a park bench, in a front yard, by a lake, and draw varieties of trees. Learn to distinguish at a glance six trees on your block, such as Norway spruce, sugar maple, weeping willow, basswood, hemlock. Learn trees individually by drawing them and reading about their life histories and physical features. I heard a sad story of a grounds' crew at a New England University cutting down a whole stand of larch one winter because they thought they were dead, having lost all their needles. No one had told them that larches (tamarack) drop their needles in winter naturally, regaining them each spring!

The key to drawing trees with all their foliage is to learn to symbolize detail, knowing what to put in and what to leave out. Use squiggles, repeated leaf shapes, shading in masses, highlighting other masses. One of the best ways to learn how to draw trees is to study very carefully the work of other artists, and of course to keep looking with a keen eye at every tree you pass. Take time to analyze the drawings included in this chapter. Finally, trial and error and your own discrimination will lead you through.

Do gestural sketches similar to those of winter trees (Exercise 2) to introduce yourself to the tree and to learn to focus on what you wish to portray. Note major dimensions, leaf masses, and branching configurations. Once familiar with the gesture begin on the longer drawing.

First, lay out in proper position on your page the outermost size of the tree skeleton. Next, lightly pencil in basic blockings of leaf clusters, looking to see how lighting will affect their shapes. Take into account dark and light mass contrasts. The upper planes will appear the light-

Figure 5.26
Student drawing in process, showing the development from the initial, light sketch, to a rough linear placement of tonal areas, to the final detail of leaves and shadows.

est if the sun is directly overhead; front and side will appear slightly darker; and underneath and interior planes will be darkest.

The student's drawing in Figure 5.26 shows the process he was using to describe a tree. The basic form was lightly sketched in, major leaf masses indicated, and then detail begun. He worked out a pattern of repeated squiggles for symbolizing leaves, which he carefully defined or only vaguely indicated. Then he simply darkened in some areas to indicate an overall shadow. Look again at Figure 5.3. With a fairly limited range of pencil strokes and tonal variation, the artist has achieved a convincingly real description of a tree. Carefully note his pencil technique to determine how this was achieved.

Foliage weight and tone will vary greatly according to the species. Poplars, birches, and locusts have a wispy delicacy, and basswoods, sycamores, horse chestnuts, beeches, and Norway maples are noted for their large spreading boughs. Conifers in a landscape with deciduous trees stand out dark and compact, the tall spruce and fir spires often rising above the other trees.

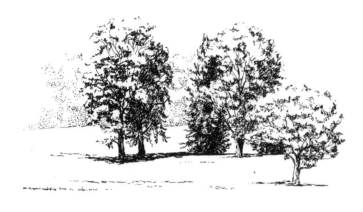

Figure 5.27
DEBORAH PRINCE
Trees on the College Campus (technical drawing pen)
Courtesy of the artist

This was done outdoors when the sun was hitting the tree at its fullest. Note how the artist describes lighting patterns among foliage by a careful placement of darkened shadings. Forms appear as if broken up by sunlight since the artist has even removed canopy outline in some spots. This is a good trick to use when wanting to depict that amount of light intensity.

Figure 5.28
Diagram of a tree schematized to show principal arrangements of trunk, branches, leaf masses, and spaces between.

Look for spaces in foliage mass where sky or branches show through. Drawing in these open, or negative, spaces as defined shapes can create a sense of dimension and airiness to an otherwise overly dense leaf mass. Overdo it and your tree will look like a patchwork. Some artists, in learning to simplify trees to understandable forms, will draw them as shown in Figure 5.28. Having worked out a rather schematized version, they can then begin to see a tree more individualistically.

Exercise 13
THE SUMMER DECIDUOUS TREE

(Time: at least 45 minutes. Materials: 8-by-11-inch or larger drawing pad and any variety of soft pencils, felt-tip pen, or colored pencils. It is all right to use a smaller drawing pad, but the drawing will be more cramped.)

Follow the previously mentioned steps in developing from the gesture to the finished detailed drawing. Keep checking the overall sense of "treeness" by squinting, standing away from your drawing, and comparing it with the tree. If you are indoors, reverse your paper in a mirror and see what the new image presents to you. Go up to the tree and examine individual leaves so that when you abstract them, you will know what you are abstracting.

DRAWING CONIFEROUS TREES

See the previous section, Drawing Coniferous Branches, for help in drawing parts of conifers. These trees present some different challenges than do deciduous trees because so much of their form is in the concentrated mass of their needles. The trick in drawing conifers is not to become distracted by our traditional concept of the triangular evergreen. Many are not so. Look carefully at the individual shapes of cedars, spruces, pines, hemlocks, and so on, seeing similarities and differences to help you in drawing. Do branches, growing out of the trunk, sweep up or down? Are needle clumps all along the branches in stout clusters or primarily at the ends in loose sprays? What is the difference between the shape and grouping of spruce and hemlock needles? Look closely.

As with the deciduous tree, see the overall shape or gesture. Sort out masses according to areas of light and dark. Do not lose sight of the trunk and branching configuration, even though they are covered by boughs. Have the branches and trunk show through in some places. Detail some areas and leave others just in tonal shadings. Determine a way to symbolize needles, as you

Figure 5.29
DEBORAH PRINCE
Birch Tree Landscape
Courtesy of the artist

Note how leaf mass is indicated without denying underlying branching structure. Spaces between masses are left to indicate the airiness and depth of foliage.

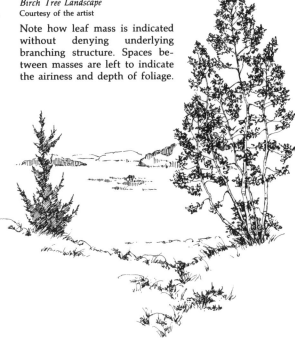

Figure 5.30
CHARLES HERBERT MOORE (American, 19th-20th centuries)
Pine Tree (pen and black ink, pencil on heavy tan paper)
Courtesy of The Art Museum, Princeton University. Gift of Elizabeth Huntington Moore

The analysis of form here is extremely detailed and sophisticated. Moore has created the feathery, yet sturdy, quality of pine tree that makes this drawing so successful. Compare his technique with that used in Figures 5.10A and 5.29.

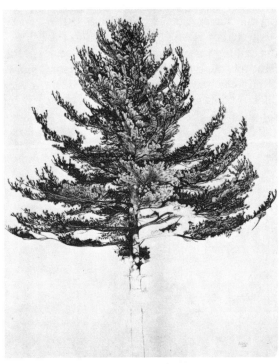

learned to symbolize leaves. You will use a repetition of short, straight lines more than you did with leaves, where curves and swirls were used in the markings.

The drawing of a white pine (Figure 5.30) is worth close scrutiny. If you can decipher the lines, see what strokes the artist used, what he chose to include, and what he chose to leave out. The pencil study of a group of evergreens (Figure 5.31) might even be helpful to copy so that you can really follow what the artist has chosen to describe and how. If you are working in pencil, try using the side so that you can obtain softer tones of graphite. Work, as the artist did, on really creating tonal as well as linear contrasts.

Exercise 14
THE CONIFER (WINTER AND SUMMER)

(Time: no limit. Materials: experiment with a variety of pencils from HB to 4B, making sure to keep them sharp.)

Start with a drawing no larger than seven inches so that you can manage a fairly detailed drawing within about thirty minutes. Refer to the section on drawing the deciduous tree for the general stages in developing a drawing. Turn back to Figure 5.10 for additional inspiration.

TREE TRUNKS, VOLUME, AND LIGHTING

In addition to texture, conveying volume and mass is important in drawing tree trunks. Consider trees as cylinders, and locate your light

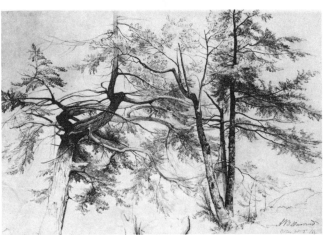

Figure 5.31
ASHER B. DURAND (American, 19th century)
Bolton, October 3, 1863 (pencil)
Courtesy of The New York Historical Society, New York City

For practice in handling pencil to describe foliage, shading, and depth, this drawing is of value to copy or to study very carefully. Asher Durand was an accomplished draftsman and knew well how to handle the pencil to achieve a marvelous variety of pencil lines and tonalities. There is a real sense of "tree-ness" without the use of much detail. How was this done?

source. The part furthest away from the light will be darkest. You can further emphasize this contrast by shading in the immediate background, thereby even blending the tree into shadows (see Figure 5.32). Then move around toward the light, adding less and less tone. The side facing the sun can be so brightly lit that it can be suggested by breaking up the outline, thus showing that light is penetrating mass. Do not overlook light reflecting from the ground. If there is snow, often your branches and trunk will be lit in very different places than if light were hitting them simply from the sky.

Figure 5.32
DEBORAH PRINCE
Tree Trunk (technical drawing pen)
Courtesy of the artist

How were volume, lighting, and textural contrasts created here? What type of lines were used and what was selected for detail or left to the imagination?

Exercise 15
TREE TRUNKS

(Time: thirty minutes. Materials: charcoal, soft pencil, or pen.)

Draw just the trunk of a tree and its lower branches. Concentrate on volume and shading instead of detailed surface markings. Locate the light source and consistently follow its path in your drawing. See trunks and limbs as a series of ellipses that vary according to your eye level with the tree. Branches should be seen as connecting into the trunk in a socketlike junction. Check to see whether roots show above the ground. Cutting the tree flat at the base disrupts the sense of the tree continuing and being connected into

the ground. If no roots show, at least indicate where the trunk and ground meet. Look at trees to see how their bases connect with the ground; they are never straight across. Either slant the base, surround it with a grassy knoll, or indicate the beginnings of roots.

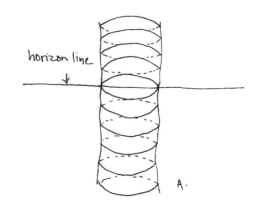

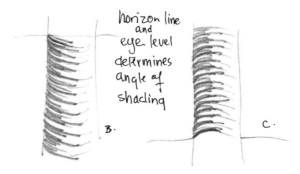

Figure 5.33
Diagrams for describing volume and shading on a tree trunk.

Autumn

Because it is difficult not to consider color when drawing fall trees, add crayons, watercolors, or colored pencils to your pen or pencil drawings. Splash patches of orange, brown, and gold over the now diminishing leaf canopies. Enjoy being abstract. You have just spent time working on technique; now spend some time on loose, free drawing. Be alert to which trees in which regions lose their leaves first. The northern hardwoods (birches, maples, aspens, and cottonwoods) will start to lose their leaves with the early frosts. Beeches and oaks carry their leaves into winter, some even remaining into spring. They are in fact related to species found in warmer climates. If you live in the south, you may have many trees that will remain evergreen throughout the seasons.

Drawing the trees of early fall is similar to

drawing summer trees, whereas drawing the last fall tree is much like drawing winter trees. Fall is a good time to set up studies that depict trees during particular weather conditions, such as rain, fog, first frost, or snow. Notice how colors and forms change on a tree as the weather changes from sun to clouds.

Exercise 16
THE FALL TREE

(Time: no limit. Materials: pencil, pen, and color.)

Do a series of drawings of one tree over a sequence of weeks, noting how its leaf canopy changes as fall progresses. Or do a series of drawings of trees during different weather conditions, watching carefully how lighting and the medium you use affects your drawing. Or do a series of abstract, gestural drawings, using a free line and applying color (watercolor and so on) in a loose, bold fashion.

TREES IN A LANDSCAPE

Knowing the gestures of trees is important when you are putting numerous species into one setting. See their general shapes and textural patterns. Experiment with ways to symbolize trees as seen from a distance and as blending into forms of land and other vegetation. Trees can help convey depth and direction in a landscape but must not be set in just as awkward lumps. Do little sketches, no larger than two inches, of generalized tree shapes, such as of spruce, maple, apple, or elm, and place these into a simplified landscape. Refer to Chapter 9, "Landscapes," for more technical suggestions on ways to set trees into landscapes and for working out composition, depth, and perspective.

Exercise 17
DRAWING TREES IN A LANDSCAPE

(Time: no limit. Materials: any medium.)

Sketch any landscape that has an interesting grouping of trees in it, whether from a photograph or from life. You might wish to frame your picture to help define the limits of your composition (see Figure 5.25). Keep your drawing simple. Try an abstract style and then work toward more realism. Seek out your own balance. Do not hesitate to add any writing along the edges of your drawing or even over the trees themselves. If you are a naturalist or are drawing a particular habitat to learn what grows there, it does help to write down specific names. Whether you are high on a mountain or in a southern woodland, this notation can help you remember months later specific features that made up that landscape and in what ecosystem those trees belonged.

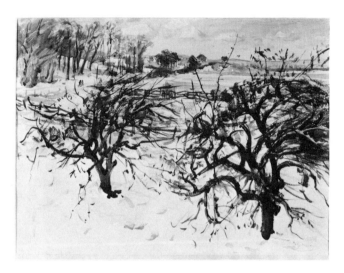

Figure 5.34
DODGE MACKNIGHT (American, 19th–20th centuries)
Snow, Cape Cod (watercolor)
Courtesy of the Museum of Fine Arts, Boston

Trees can help set the mood and composition of a landscape. Notice the depiction of scraggliness, so characteristic of apple trees.

BIBLIOGRAPHY

ALEXANDER, TAYLOR R., BURNETT, R. WILL, and ZIM, HERBERT S. *Botany*. New York: Golden Press, 1970. (PB)

BROCKMAN, C. FRANK. *Trees of North America*. New York: Golden Press, 1968. (PB)

EDLIN, HERBERT. *The Tree Key*. New York: Charles Scribner's Sons, 1978. (PB)

JACKSON, JAMES P. *The Biography of a Tree*. New York: Jonathan David Publishers, Inc., 1979.

PETRIDES, GEORGE A. *A Field Guide to Trees and Shrubs of Eastern North America*. Boston: Houghton-Mifflin Co., 1958. (HB)

PITZ, HENRY C. *How to Draw Trees*. New York: Watson-Guptill Publications, 1972. (HB)

SYMONDS, GEORGE W. D. *The Shrub Identification Book*. New York: William Morrow and Co., 1963. (PB)

———. *The Three Identification Book*. New York: William Morrow and Co., 1958. (PB) (Both books are most useful for studying and drawing trees since they identify trees and tree parts by large, clear black and white photographs.)

WILSON, ERNEST H. *Aristocrats of the Trees,* reprint of the 1930 classic. New York: Dover Publications, Inc., 1974. (PB) (Good reading.)

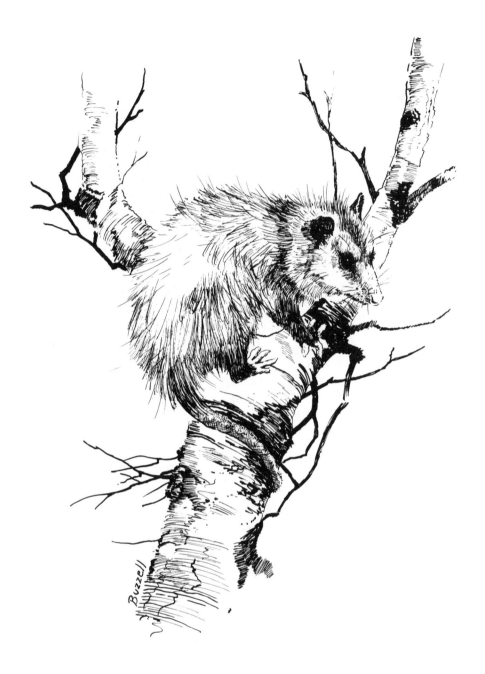

From boyhood, I have found observing and sketching animals in their natural settings a very enjoyable pastime. . . . I believe an artist's work should be a sincere statement of his feelings for his subject.

Wildlife artist John Clymer, *Animals in Art.*

Animals offer perhaps the widest and most varied range of subjects to study in the area of nature drawing. One can go to the zoo and draw mountain goats and buffalo, to a pond for frogs and turtles, to a farm for cows and horses, or to the shore for starfish and crabs, or one can stay at home and draw the household cat or dog.

The animal kingdom is immense, and obviously you cannot draw it all. Take some time to decide what animals most interest you and what methods of approach you wish to pursue. Following the intentions of this book, emphasis will be on drawing those animals that are native to North America and can be seen in their own habitats. But since it is not always or even often possible to see or draw them there, ways to study these wilder animals from photographs, museum study mounts, and so on will also be discussed.

CHAPTER SIX

Animals

Although it is a worthwhile experience to draw an elephant or tiger in the zoo, by limiting our study to those animals we can find nearer home, we allow ourselves the possibility of learning about more than just physical characteristics; we can also learn something about where they live, how they act, and how they relate to the land around them.

I find that some of my students' best drawings of animals are studies of their own pets because they already had spent a lot of time watching and just being with them. The drawing described motions, activities, and expressions

they were already familiar with. If you have never drawn an animal before, do not hesitate to begin with your own cat, dog, gerbil, or even a local farm animal. Beatrix Potter was an exceptional artist in being able to capture the essence of an animal's pose and character because she chose to draw only those animals that lived with her around her barnyard and pastures (Figure 6.2). These she incorporated into the many delightful books she wrote for children. The drawing of a salamander by an eleven-year-old boy (Figure 6.3) has an expression and realism that comes only from a certain real knowledge of his pet.

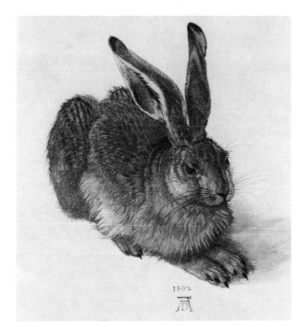

Figure 6.1
ALBRECHT DÜRER (German, 15th-16th centuries)
Hare (watercolor)
Courtesy of Graphische Sammlung Albertina, Vienna, Austria

Dürer was one of the first painters to consider animals as subjects not just for art but also for the study of natural history. Consequently, his plant and animal paintings are strikingly more realistic than those of other artists of the period.

We will begin with a brief review of some general suggestions for drawing animals, all of which can apply to drawing any creature. (Also see Chapter 1, "Beginning Drawing Exercises," and Chapter 7, "Birds," in which there are additional comments and exercises for starting any drawing.) Then since domestic animals are frequently the most available, we will start with them, going on to discuss generally each major biological grouping (or phyla as they are scientifically termed): mammals, reptiles and amphibians, fish, insects, and then all the lower forms of life. (Birds are discussed in Chapter 7.)

To clarify the system of grouping living things, let us say that the animal kingdom comprises all creatures other than plants. The animal *kingdom* is next divided into a number of *phyla* (*Mollusca, Arthropoda, Chordata,* and so on). Each phylum is divided into *classes* (mollusca, crustacea, amphibia, and so on), and each class is comprised of numerous *orders;* for example, within the class of amphibians there are orders of salamanders, toads, and frogs. Then, each order is made up of *families,* so that within the order of frogs there are families of true frogs, tree frogs, narrow-mouthed frogs, and so on. These can be further broken down into more specific genus and species such as wood frog, bullfrog, and so on. What

Figure 6.2
BEATRIX POTTER (English, 19th-20th centuries)
Rabbit's Dream (pencil)
Reproduced by kind permission of F. Warne & Co., Ltd., from *The Art of Beatrix Potter*, © copyright by F. Warne & Co., Ltd., London and New York.

To illustrate her books, Beatrix Potter used her own animals as subjects. The ability to capture gestural poses so successfully here can only come from long acquaintance with the subject.

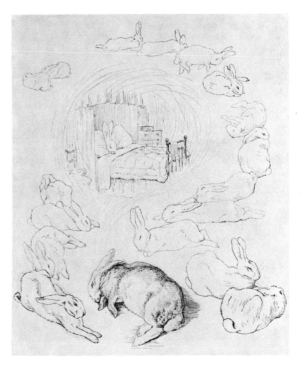

seems amazing is that of the total supposed number of animal species (about 823,000, according to E. Laurence Palmer in *Fieldbook of Natural History*), only 60,000 are in the phylum of chordates, those comprising all the animals with backbones. The remaining some 763,000 species are those lacking the central spine, such as all arthropods (including insects), molluscs, and protozoa. Thus, the number of species most commonly drawn is surprisingly small.

Figure 6.3
An eleven-year-old's drawing of his pet salamander.

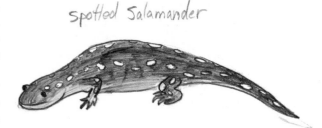

GENERAL SUGGESTIONS
FOR DRAWING ANIMALS

1. *First ask yourself,* Why do I want to draw this animal? What do I want to learn? What feature do I want to emphasize? Is it motion, shape, activity, or expression? How much time do I have? What style and medium shall I use? What do I want to *accomplish* by studying and drawing this cow, butterfly, or turtle?

2. *Always allow time to observe,* to get to know and to become accustomed to your subject and what it is doing. For example, if it is a fox, is it a young one? Might it be alone? What species is it? What is it presently doing? Why is it in that particular habitat?

Bob Kuhn is a well-known American wildlife artist who comments: "To function as an artist, you must know your subject, understand its structure, its temperament and behavior pattern. . . . Even the best reference sources do not take the place of real knowledge of animal structure, that can only be gained by putting in your time with the animals."*

3. *The first gesture sketches,* as mentioned in other chapters, are a useful way to begin drawing a subject. These are a series of quick, flowing, undetailed studies that take no more than half a minute and are not intended as finished pieces. Often there is not time to do much before an animal or animals move, or you are not yet familiar with the subject to know just how the proportions fit or where the details are placed. Use sketching as you would an initial conversation with a stranger: what's your name? where do you live? what do you like to do? and so on. Draw only general features and lines of posture, using quick strokes and not worrying over wrong lines or faulty technique. Do more looking than drawing because you must train the eye equally with the hand. Draw on top of your sketch to refine lines or do another beside it. Look at Figure 6.7, which was a five-second sketch of a mother cat and kittens, and at Figure 6.8, which is a series of sketches in preparation for an extended study of two cats. Figure 6.4 can help you see the sequential stages in developing a drawing. Next do Exercise 1, using a cat or any other subject you are familiar with.

** The Animal Art of Bob Kuhn* (Newport, Conn.: North Light Publishers, 1973), p. 10.

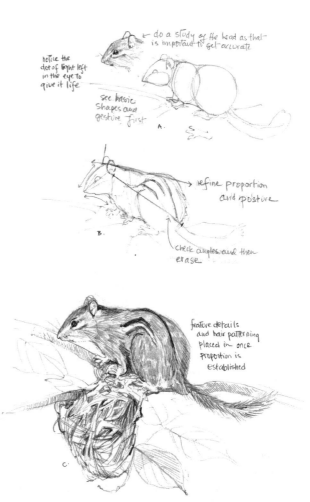

Figure 6.4
Steps in drawing any animal.

4. *Seeing basic shapes within the overall form* can greatly reduce the confusion of how individual parts fit into the whole. Some artists find that simplifying body shapes into geometric units helps them work away from the outline into the structure of the body as a volumetric mass. Many students start their drawings by following only the outline and soon become lost in surface detail or inaccurate proportions. Always begin with basic body units and build up detail only when these are firmly established. See Figures 6.4 and 6.5 for suggestions. In mammals, particularly, body parts can be seen as a system of ovals. The head is one shape, neck and shoulder another, belly another, hips another, and legs and tail also began as simplified shapes. Birds too can be seen in this manner. (You might want to refer to two examples in the next chapter: Figures 7.19 and 7.20.)

5. *The longer study* can be developed once you feel you are beyond the introductory stage. Review your sketches, looking for what about them has captured the essence of posture, shape, and

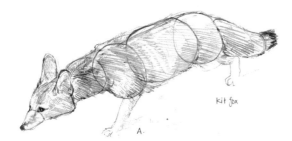

kit fox

A.

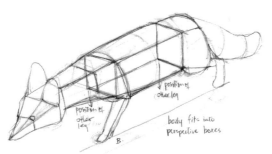

position of
other leg

position of
other leg

B.

body fits into
perspective boxes

Figure 6.5
To help understand proportion and perspective, see body
parts as geometric shapes.

character. Take a rest, again look hard at your
subject, and then decide in what manner you now
wish to draw it. Do you have an hour or only
twenty minutes? Do you want a detailed portrait
or a freer study of activity or character? (Again
refer to Figure 6.4 for the stages to follow.) Keep
holding the drawing away from you so that you
can see the whole at once and can compare it
objectively with the subject. Often if I am stuck
on a proportion or detail, I will go to a mirror
and reverse my drawing. This reverse image gives
a fresh point of view, and what has been confused
suddenly becomes clear.

6. *Prop your drawing pad or board* at an angle
so that you see subject and paper simultaneously
without too much shifting of your head. Propor-
tions can easily be wrong if you must continually
adjust your angle of vision.

7. *Be a naturalist as well as an artist.* Use draw-
ing as an opportunity to study an animal's life
history, physical traits, behavior, habitat, and its
connection with the larger chain of life. Ask
about its form and function. How do the differ-
ences among the builds of wolves, coyotes, foxes,
and dogs indicate differing styles of life? Why
is one kind of fish brightly colored and another
subtly camouflaged? What purpose do the quills
on a porcupine and a sea urchin serve? Draw
and study animals to expand your knowledge
of the natural world as well as to expand your
drawing skills.

DOMESTIC ANIMALS

Cat

Cats are good subjects to begin with as they are
available for study as well as quite amenable to
posing. There is the sleeping ball, the stretch,
the leap or pounce, the careful grooming, the sit-
ting gaze, or the slow amble about the room.
Within a brief time, a cat can go through various
sorts of poses, all of which make interesting stud-
ies. See where muscles tense and release, where
major lines of energy flow, how fur is patterned
over the body, and how major body parts would
be described.

Cats are in the family *Felidae* with lynx, bob-
cats, lions, and leopards. By practicing with a
cat, you can be ready to draw its relatives. Feline
bodies are designed for sudden leaps, short
pounces, and quick turns. Grace and fluidity are
in their nature. Since they are often night hunters,
their senses are concentrated in their ears, eyes,

Figure 6.6
CHARLES SHEELER (American, 20th century)
Feline Felicity (black conte crayon on white paper)
Courtesy of the Fogg Art Museum, Harvard University. Purchase—Louise E.
Bettens Fund

Sheeler creates an almost abstract image describing similar
lighting and modeling for both cat and background. Fur is
described here more by general pattern than by specific detail.

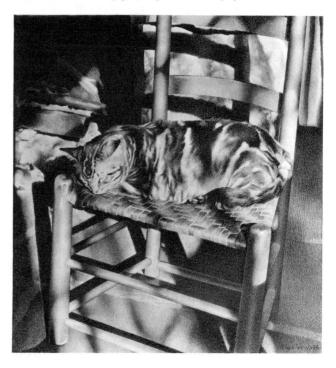

and whiskers. Notice how prominently located these parts are. The eyes are in front of the forehead for better depth and distance vision. The ears are high on the head to catch easily any sound. The face is flatter than a dog's because the nose is used less for locating scent. The paws are soundless, with retractable claws, whereas a dog easily gives away its presence just by the sound of its extended nails.

Lydia playing with kittens —

Figure 6.7
CLARE WALKER LESLIE
Gestural study of cat and kittens.

Exercise 1
QUICK GESTURE DRAWING OF A CAT

(Time: five seconds for each small sketch, with time in between for looking. Materials: any soft HB, 2B, or 3B pencil and 8-by-11-inch or larger drawing paper.)

Use quick, loose lines, barely looking at the page but primarily at the subject. Do ten little sketches of the shifting poses, taking only a brief time with each. Look for basic geometric shapes within the body's form to indicate a hip, shoulder, neck, and so forth. Do not bother with an eraser. If the cat moves before you are finished, go on to another pose and finish the first sketch if it returns to the same position. You may have several sketches or longer drawings going at once. Make little studies of specific parts, such as leg, eye, head or nose, which will help when you are drawing the whole. (See Figure 6.8.)

Exercise 2
LONGER STUDY OF A CAT

(Time: 20–30 minutes. Materials: same as above.)

Do one or two twenty-minute pose studies, concentrating on detail of body shape, fur pattern, and individual features. Keep your drawing to a comfortable size, around four to six inches. Do several gesture sketches first to get the position you like. (You can do these along the borders of your paper, erasing later if you do not want them there; or make them the line underdrawing beneath your longer study.)

Figure 6.8
CLARE WALKER LESLIE
Cat studies

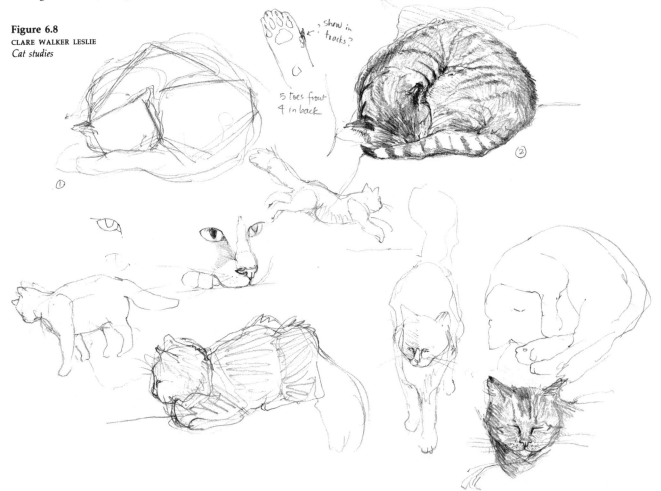

Locate the principal lighting source, major body planes, and direction of hair tracts for help in drawing fur. Fur is basically drawn with short, repeated strokes of the pencil evenly laid out in progressively darkened layers of tone. The direction of the strokes should follow the general planes of the body or the arrangement of the hair as it actually grows. Pat a cat or dog and notice how the fur lies along the body from front to back, as with all animals.

To give the sense of mass and tone, darken the fur that is furthest away from the light or falls into the hollow and creases of the body. Work color patterning first and then sort out tonal values next, because the two may conflict. Since some of the darkest colors may be where the light falls, exact patterning may have to be sacrificed for a sense of body roundness. Work with the realism you see, but also adjust it to suit the realism of your drawing. This is a common artistic dilemma, but do not be afraid to adjust your drawing if it allows for a more convincing result. (See Drawing Fur below for further details and study the examples in this chapter where fur has been treated on various animals.) Of course, some understanding of anatomy and internal structures will help in patterning fur since it is only a covering for what lies beneath.

Dog

Dogs are in the family *Canidae*, along with wolves, foxes, and coyotes. Their bodies are heavyset and designed for endurance running. Since scent and sound are components of hunting, note the ex-

tended neck, long nose, and large ears. Although domesticated dogs vary greatly in shape, their anatomy is basically the same from poodle to wolfhound. Knowing how to draw your dog can be transferred to drawing its wilder cousins. Refer to the skeletal drawing in Figure 6.19 for an understanding of a dog's structure and anatomy in comparison with those of the cat or human.

Exercise 3
QUICK GESTURE DRAWING OF A DOG

Use the directions for Exercise 1.

Exercise 4
LONGER STUDY DRAWING OF A DOG

Use the directions for Exercise 2.

The postures of a dog are often repeated and less varied than are a cat's. Therefore, concentrate on describing the several characteristic poses and expressions specific to your dog. Layer in hair texture similarly to that of a cat, only remembering that it is probably of a coarser texture. Note where it divides on either side of the spine, falling down over neck and flanks. Give your dog a sense of weight and mass. If it is lying down, make the body press into the floor and study where light and shadow play over its coat. See how the artist has drawn the essence of a lounging dog in his small sketch (Figure 6.9) by a clear understanding of posture and anatomical arrangement. Note also how the angle of pencil line for shading helps indicate the direction of the body's planes and foreshortened angles. How shading is positioned can greatly help or detract from describing body mass.

Figure 6.9
JOHN SINGER SARGENT (American, 19th century)
Two Studies of a Greyhound Lying Down (pencil)
Courtesy of the Museum of Fine Arts, Boston. H. L. Pierce Fund

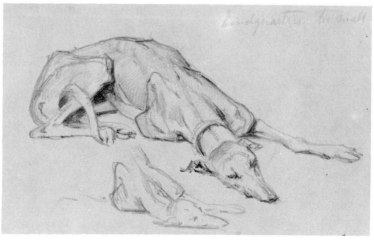

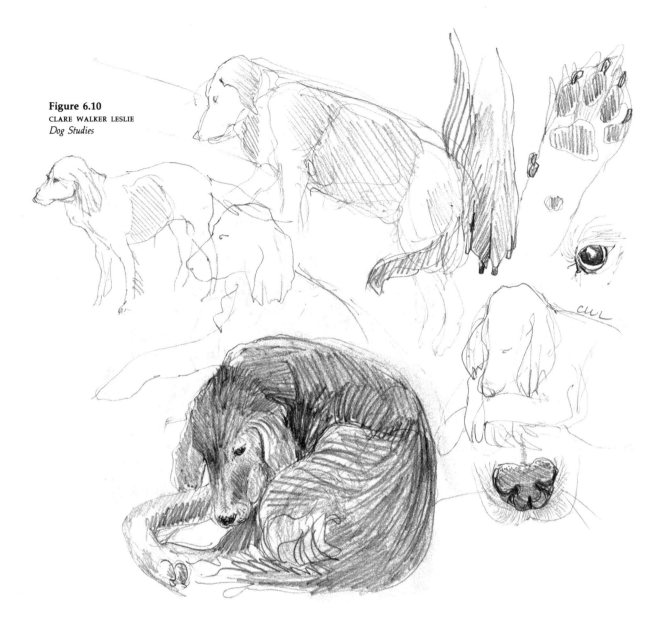

Figure 6.10
CLARE WALKER LESLIE
Dog Studies

Animals in the Pet Store

A pet store is a marvelous resource for a variety of tame animals. Guinea pigs, gerbils, hamsters, mice, and rabbits all are worth spending some time with because they resemble their wild cousins who are more difficult to find, no less to see long enough to draw. Puppies, kittens, and other young animals may also be found there, and of course the fish tanks and aquariums have tropical fish of many types. Sometimes a terrarium may be found that has snakes, turtles, or salamanders.

Be sure to get the store's permission before you sit down beside a cage or tank to draw. (Since the cages' location may be awkward for drawing purposes, I recommend taking a folding stool so that you can sit comfortably while at work.)

Small animals can be frustrating to draw as they are continually in motion, asleep in a ball, or hidden from view. Therefore, expect at least a page of indecipherable scribbles before you begin to grasp the form of the small creature. Use sketching to familiarize yourself with the subject and its activities. Save detailed drawing for when it is at rest or when you have enough sketches to do a composite drawing from memory. Use these quick studies as references when drawing the wild animal from a photograph or in another situation. I used sketches of pet store hamsters and gerbils, combined with sketches of a deer mouse recently killed by one of our cats, for a finished study of a wild deer mouse whose particular pose was unattainable from photographs. In the same rodent order, mice, hamsters and gerbils display somewhat similar poses and behavior characteristics. Thus, such combination studies can be useful.

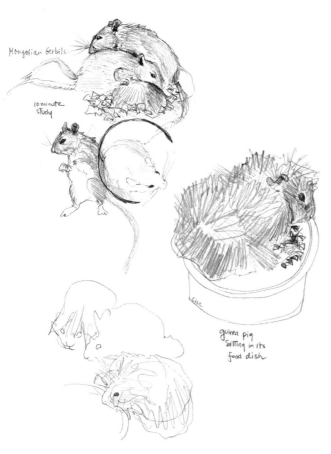

Figure 6.11
CLARE WALKER LESLIE
Studies of gerbils and guinea pigs at a pet store. This work demanded much quick sketching and adding from memory once the animal moved.

Farm Animals

A local farm or farm zoo can be a good place to draw. If weather permits, take your drawing equipment along and spend some time sketching the animals you see there. If you are not used to drawing animals outdoors, farm animals are good subjects to begin with. They are large and present a fairly simple build to draw. Their forms reduce easily to basic geometric shapes, and they tend not to move around a great deal nor suddenly vanish from view. Feeding, resting, standing, and roaming slowly about are the basic activities to draw for sheep, goats, pigs, cows, or horses. Horses, perhaps, provide the most varied possibilities for drawing and their shape and beauty have long fascinated artists, but do not forget the other farm animals as they are also well worth the time spent watching and drawing.

There are many artists whose works are worth studying if you are particularly interested in drawing horses. To begin, *The Anatomy of the Horse* by George Stubbs is a classic reference. Of course, a careful study of horses can help when you are drawing other four-legged animals, particularly those of similar body build; these include all the larger hooved animals, such as the deer, elk, and moose, as well as the more closely

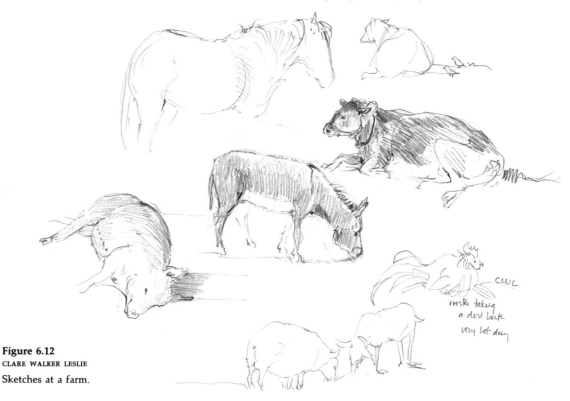

Figure 6.12
CLARE WALKER LESLIE
Sketches at a farm.

Figure 6.13
CLARE WALKER LESLIE
Studies of two Belgian workhorses.

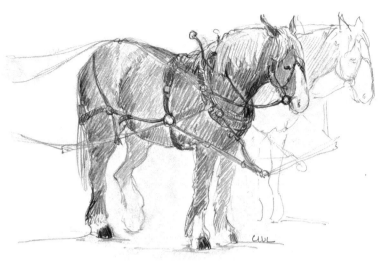

Figure 6.14
GORDON MORRISON
Studies of Goats (HB pencil)
Courtesy of the artist

Pay close attention to the way shading is rendered and forms are simplified. Often artists will actually draw in the area to be shaded, as was done here, to emphasize its shape and contour.

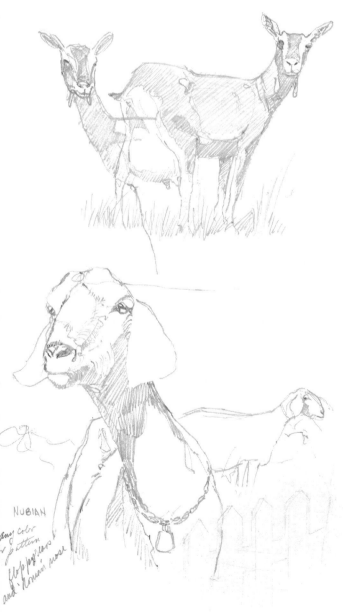

related mule, donkey, and zebra. It is good practice to draw several animals of the same order or family to learn their common characteristics. Two superb artists who drew horses were Edgar Degas and Henri de Toulouse-Lautrec (Figures 6.15 and 6.16). Study their contrasting rendering of shading and definition of form. It is even worthwhile to copy these drawings for a closer look at how each artist handled his subject.

When you first get to the farm, concentrate on the sketching method. Do not immediately set up a detailed drawing until a subject settles down for a while or until you have had full opportunity to see what other animals are around. If cows are being milked, a lamb was just born, or piglets are running behind their sow, sketch these activities before beginning a lengthy study of a grazing bull. This kind of quick sketch allows you the opportunity to watch the behavior of animals and to learn something about their character while recording it in a drawing. Save your lengthier drawing for when you want to do a composed study of one particular animal.

The general suggestions for sketching any active animal apply here as well. Keep your sketch simple, drawing only major shapes and using minimal shading. Draw gesture and character before detail. Study how the artist used a simple method of shading on the goats in Figure 6.14. The drawing of the two Belgian work horses in Figure 6.13 was drawn during short moments over a half-hour period, as the horses were working and only stopped briefly in that particular position before moving on. The sketches in Figure 6.12 were drawn during those intervals of waiting for the horses. If you find yourself beginning to

Figure 6.15
EDGAR DEGAS (French, 19th-20th centuries)
Horse with Saddle and Bridle (drawing)
Courtesy of the Fogg Art Museum, Harvard University.
Grenville L. Winthrop

This is a superb drawing to study shading, line, and depiction of such details as facial expression, muscles, and skin tone.

Figure 6.16
HENRI DE TOULOUSE-LAUTREC (French, 19th century)
The Jockey (lithograph)
Courtesy of the Museum of Fine Arts, Boston. Horatio Greenough Curtis Fund

Compare this work with Degas's study for the use of line and the expression of body posture.

Exercise 5
SKETCHING FARM ANIMALS

(Time: 45 minutes minimum. Materials: any size drawing pad that can be easily carried and held while you are standing, eraser, several pencils, sharpener, day pack, clips for the paper, hat, dark glasses, and a stool if you wish.)

First, do a series of six or seven quick sketches of the same or different animals (but of the same species) in various poses and activities. When you become more comfortable drawing outdoors and perhaps with standing in an awkward position, do a longer drawing. Do not work for more than twenty minutes on one subject so that you have the opportunity to draw several animals before leaving. Draw groupings of animals and smaller studies of heads or leg positions.

The Zoo or Wildlife Sanctuary

The advantage to drawing in such relatively contained areas is that you can draw varieties of animals from many different regions of the country and compare similarities and differences among species. Since animals are generally penned in small areas, you will not see them behaving as they would in the wild. Thus, use these places for your more analytical study of both drawing technique and animal structure. As Glen Loates, the Canadian wildlife artist points out: "For me, as for most wildlife painters, zoos are a major source of information. To understand an animal's relationship to its natural environment, it must be seen and sketched as much as possible in the field, to capture the anatomy and movement. But

draw an animal only to have it move, start another drawing of that or another animal. When your first subject returns to its pose, continue that drawing. You may have two or three drawings going at once. But this way you will not become so frustrated and can learn to capture various poses of animals all at once.

for details of eye color, expression and texture, it is essential to view the subject leisurely at very close range and this can only be done from live animals in zoological parks or compounds."*

Exercise 6
DRAWING ZOO OR WILDLIFE
SANCTUARY ANIMALS—OUTDOORS

(Time, materials, and instructions are the same as for Exercise 5.)

You might want to spend the time drawing only the larger game animals or just the smaller woodland mammals or only those that might be seen nearby your home. In other words, have a focus for study so that you do not leave with just a series of pretty pictures and no new knowledge of the animals themselves.

ANATOMY

Before we continue, it is important to mention the value of knowing something about anatomy. In drawing domesticated animals, we focused much of our interest on gesture and behavioral sketching—which provided an introduction to drawing all manner of animals. But there comes a time when sketching external features without knowing some internal structure and anatomy is not enough.

I find that students often have difficulty drawing animals accurately because they do not understand how an animal "works" beneath all that fur and flesh. It is hard to know where to place hips, joints, eyes, ears, legs, and so on if their construction is not known. For most of us, it is enough to have made some general study of muscle and bone structure, but some reading in physiology and animal anatomy would certainly be of advantage.

Locate a skeleton of any animal from a museum or biology lab or from photographs. It does not matter what the animal is since structures are comparable for each other, be it mammal, reptile, or fish. Understand that parts move according to a defined arrangement. In all vertebrates, the spine is the primary support from which hangs the rib cage and various other appendages. In any moving form, it is the hips and shoulder blades that bear the weight and force

* Paul Duval, *The Art of Glen Loates* (Scarborough, Ontario: Cerebrus Publishing Co., Ltd., 1977), p. 73.

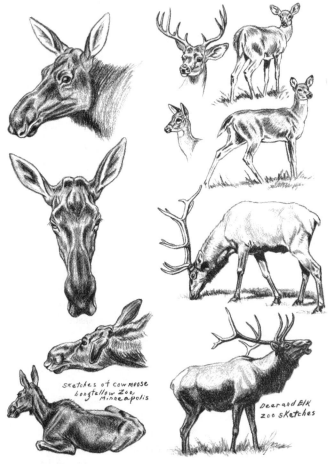

Figure 6.17
WALTER J. WILWERDING (American, 20th century)
Sketches of Cow Moose, Deer, and Elk (pencil)
Reproduced from Walter J. Wilwerding, *Animal Drawing and Painting* (New York: Dover Publications, 1956).

Wilwerding's book on animal drawing is one of the classics.

Figure 6.18
GLEN LOATES (Canadian, 20th century)
Timber Wolves
Reproduced by permission of Cerebrus Press, Inc., Ontario, Canada, from *Mammals in Profile*, a Nature Book Series.

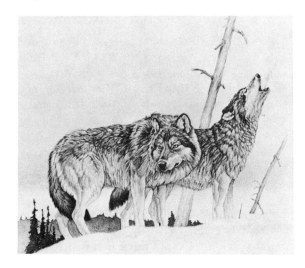

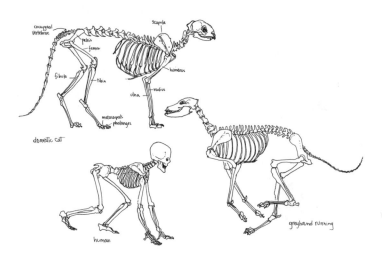

Figure 6.19

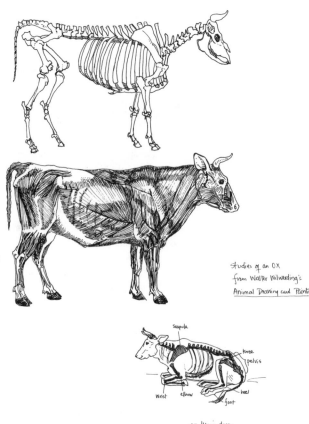

Figure 6.20
Studies of the anatomy of an ox.

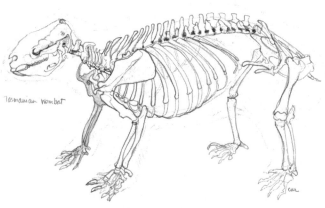

Figure 6.21
Skeleton study of a Tasmanian wombat from a museum of natural history.

of movement. Be sure to draw these parts as large and flexible. Put yourself on all fours and try to walk. See what muscles are used and what limitations for four-footed walking our two-footed bodies have. Look particularly at an animal's legs and note the different placements of knees and elbows. In animals, these parts are high up against the belly, and it is the wrists and ankles that extend to form the lower legs. You might want to study or even copy the small diagrams in Figures 6.19 and 6.20, noting similarities and differences in body construction. All the books listed under Animal Drawing in the bibliography to this chapter, with the exception of Muybridge's, have analyses of animals' anatomies.

Exercise 7
STUDYING ANATOMY

(Time: one hour or more. Materials: 2H or HB pencil, then ink over if you wish; any good drawing paper.)

Copy one of the skeletons in Figures 6.19 or 6.20 or in another animal drawing book or biology textbook. If you have access to a museum or laboratory skeleton, draw from that.

WILD ANIMALS

Apply the information found here to those animals that live specifically in your area or that interest you most. Do not think that just because

an animal is wild, you will catch only a brief and all too frustrating glimpse of it hopping out of sight. Even though few artists rely solely on their field sketches, they find these brief encounters essential to understanding the characters of animals in their native habitats. As Bob Kuhn remarks, "When pursuing the elusive but essential ingredient called animal character, it is imperative that one see his subject in its wild state. . . . The difference between a wild and zoo lion

112

Figure 6.22
D. D. TYLER
Harbor Seal Cow Nursing Pup, Typical Seal Ledge in Background (conte crayon)
From *A Field Guide to the Whales and Seals of the Gulf of Maine*, 2nd. ed., by Steven Katona, David Richardson, and Robin Hazard. College of the Atlantic, Bar Harbor, Maine. Courtesy of the authors.

is astonishing."* You may never have the chance to draw an antelope or wolverine or grizzly bear in the wild. But probably you can find nearby squirrels, chipmunks, turtles, frogs, raccoons, rabbits, and even deer or fox for some brief intervals before they disappear. Combine these field sketching opportunities with those of wildlife parks, zoos, and museums; and of course, good photographs are always available when nothing else is.

As stated repeatedly, learn something about each animal you are observing so that your drawing reveals more than just physical characteristics. How much more informative is the artist's illustration of a harbor seal (Figure 6.22) because she depicts both cow and pup in a particular pose and within a characteristic habitat. Even the drawing of an opossum (Figure 6.23) tells us that the animal climbs trees and can balance by wrapping its tail and fleshy feet around the trunk. The visual image can so often be used instead of the written word.

The Smaller Mammals

Woodchucks, beavers, porcupines, gophers, squirrels, mice, and lemmings make up one of the larger orders of mammals called *Rodentia* (the gnawers). Rabbits, pikas, and hares are in the

order of *Lagomorpha* because of differences in dental and skull structure. Moles and shrews, in the order *Insectivora*, and bats, in the order *Chiroptera*, are the only small mammals to feed principally on meat (mostly insects). The other small mammals are primarily vegetarian, subsisting on plants, nuts, and seeds, and so have the characteristic paired upper and lower teeth for chewing, gnawing, and nipping. On the other hand, moles and other insectivores have back-grinding teeth comparable to those of the larger meat-eating mammals.

Since these small creatures are prime subjects for predation by many larger animals, alertness, tension, and speed are built into their characters. Distinctive features include oblong heads with extended noses, whiskers, and ears, all for keen sensing. The upper jaw extends over the lower jaw for the chewing by large incisors. The eyes are generally set far apart on either side of

Figure 6.23
RUSS BUZZELL
Opossum (pen and ink)
Reproduced by permission of the Massachusetts Audubon Society

* *Animal Art*, p. 14.

the head and are large and beady, ready to pick up the least movement. The bodies are compact and low to the ground with short legs meant for hopping, darting, or waddling, depending on the species. The tails can be used for balance (squirrels and gophers), for alarm signals (rabbits and chipmunks), or for steering (beavers and muskrats).

The drawings of a red squirrel (Figure 8.2) are a good way to approach field sketching by using minimal shading. Look closely at the method of shading and see if it is one you might employ. The plate of five rodents (Figure 6.24) shows a way to present comparative species all on one page. Note physical differences and see if you can tell how function has determined the form of each one. The drawing of a cottontail

rabbit (Figure 6.25) can be studied for its method of patterning rodent fur. This is also an excellent example of how an artist has caught that moment of life in an animal: the wary tension and alertness expressed in poised ears, glinting eyes, and compressed body nestled low into some grasses.

Exercise 8
DRAWING SMALL MAMMALS

(Time and materials: no requirements.)

If you are working from life, do quick sketches. If you are using photographs or study mounts, do longer drawings. Concentrate on fur patterns, expression, and characteristics particular to the species. When possible, put the animal into an activity with other animals or within a bit of its environment. For ways to build up a drawing, see Figure 6.4. Gather as much information about the animal as you can from guidebooks and other sources.

Figure 6.24
CHARLES E. ROTH
Plate of New England Rodents (black ink and watercolor wash)
From *An Introduction to Massachusetts Mammals* by Charles E. Roth, published by the Massachusetts Audubon Society. Courtesy of the artist.

One way to study and draw animals is to learn a small group of related species such as exhibited here. Note the way the artist describes fur texture and characteristic expression and posture of each animal. The eyes are alert from a white glint of light pigment added to each. The technique used was that of dry-brush watercolor, using black ink.

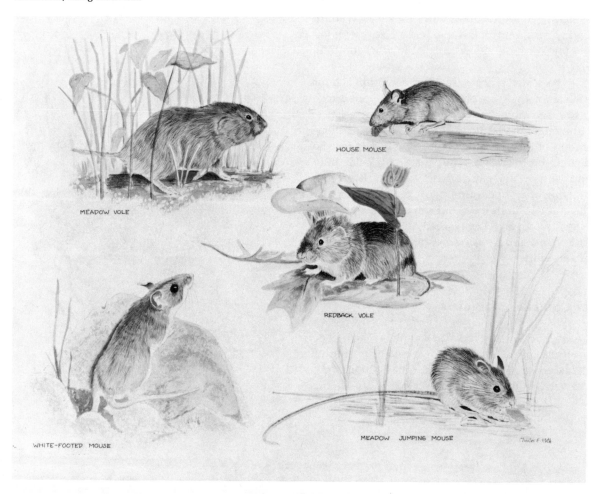

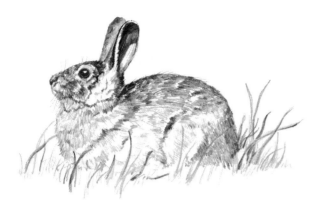

Figure 6.25
RUSS BUZZELL
Eastern Cottontail Rabbit (pencil)
Courtesy of the Massachusetts Audubon Society

Note particularly how the artist uses repeated lines to build up fur texture. The animal has also been set into a characteristic posture of crouched wariness.

The Larger Mammals

There are three major scientific groupings of large North American mammals: *Carnivora* (meat eaters), *Artiodactyla* (herbivores having split toes or hooves), and *Cetacea* (sea mammals). The carnivores of North America vary in size from the least weasel, sea otter, and bobcat to the mountain lion, wolf, and grizzly bear. The largest animals tend to be the herbivores (grass eaters), which include the caribou, buffalo, deer, moose, and pronghorn sheep. Whales, dolphins, and porpoises comprise the cetaceans, all of which live in marine environments.

Most of these animals you will probably draw from photographs, zoos, aquariums, dioramas in natural history or science museums, or study mounts. Pay close attention to muscle and bone structure, as well as to posture and fur patterns. These animals tend to be massive, with distinctive body parts, in contrast to the more compact builds of the smaller mammals. Features used in defense or attack may be sharp teeth, powerful feet, or pointed antlers. Knowing the reasons for the build of each animal before drawing it will help deepen your understanding and improve your drawing. If you are having difficulty with proportions, reduce the major masses to simple shapes and break up the outline into workable parts.

Pay close attention to how activity, behavior, and environment determine the form of an animal. For example, deer have long, thin legs to carry them swiftly through woodland brush and through dense grass meadows. Their hooves are split largely to aid in balance and to grip un-

Figure 6.26
Studies of a deer mouse.

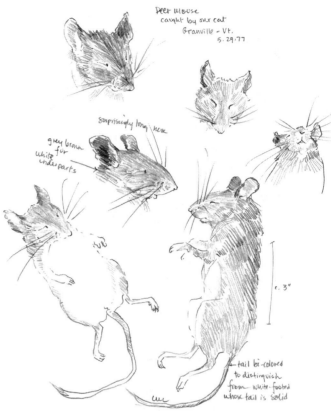

even turf. Pronged antlers and sharp hooves are their principal defense, aside from swift movement. Their necks must be long enough to reach the ground for feeding on plants or high up for feeding on winter apples. Their ears and eyes are large for catching the slightest sound or sight of ever-present enemies. A flick of the white tail patch catches the predator's eye, but then drops as the animal blends its muted form into the shadows of the forest. Draw each animal with at least this sort of minimal knowledge, adding what you can about size, physical descriptions, habitat, and feeding preferences. It can only help increase both the accuracy of your drawing and your understanding of the animal.

Exercise 9
DRAWING LARGER MAMMALS

(Time and materials: no requirements.)

If you do not have access to a zoo to draw the live animal or to a museum to draw the study mount, draw from a clear and accurate photograph. Refer to the section Drawing from Photographs later in this chapter. Using photographs can help familiarize you with an animal's various poses and behavior characteristics, as well as the environment in which it lives. Draw the whole animal

Figure 6.27
CHARLES LIVINGSTON BULL (American, 19th-20th centuries)
Polar Bear and Seal (drawing, watercolor and ink)
Courtesy of the Glenbow Museum, Calgary

Although forms are described with little detail, there is great understanding of expression and pose as well as design and composition. Bull was one of the noted American wildlife artists who produced numerous book and magazine illustrations bringing to the attention of the public many wild animals not previously so naturalistically described.

as well as individual features; this was the purpose of the study of the white-tailed deer in Figure 6.40, done from a study mount at a natural history museum.

Reptiles and Amphibians

It is believed that for two hundred million years, reptiles and amphibians were the kings of the land. When the Rocky Mountains arose, mammals arrived and the great dinosaurs disappeared. The closest living relative today is the crocodile. Amphibians and reptiles have changed and adapted to the different conditions of the modern age, and now a total of about 8,500 species can be found throughout the world.

Though termed "cold-blooded," reptiles prefer warmth in their environment, and amphibians prefer coolness. Think where you find snakes, frogs, and turtles. The field of herpetology deals with these two very different classes together. Amphibians (salamanders, frogs, and toads) generally have an aquatic, larval stage; their breathing apparatus then changes from gills

to lungs and skin. As adults, they leave the water to live on land. Their skin remains smooth and thin to better receive oxygen directly from the environment. Reptiles (snakes, lizards, alligators, and turtles), who do not have the same aquatic stage, have scales or plates that protect their bodies from excessive shifts in moisture or heat loss.

Get to know the reptiles and amphibians in your area. Even if you do not live near a wild place, these animals can be found in pet stores, at aquariums, and in various photographs from field guides and nature books. When drawing them concentrate on body color, patterns, and texture, as shape will be rather simple. (But do not be deceived by a simple form; you may find the subtleties of shape changes can make these animals quite difficult to draw convincingly.) Make a turtle's shell nubbly, a snake's back scaly, or a frog's skin wet and slippery. Look carefully at the animal's expression; often the success of a drawing depends on how well the eyes, mouth, and facial profile have been described. Try to indicate posture and activity as distinctly as possible so that something can be learned about the animal from the drawing.

Exercise 10

DRAWING REPTILES AND AMPHIBIANS

(Time and materials: no limit, but be experimental.)

If you are drawing for a biology lab, make your shapes simple and in careful proportion. Do not bother with shading, keeping principally to line and details of feature. If you are drawing in

Figure 6.28
GUNNAR BRUSEWITZ (Swedish, 20th century)
Sketchbook Page of Toads (pencil and watercolor wash)
From *Skissbok* by Gunnar Brusewitz, published by Wahlström and Widstrand.
Courtesy of the artist and the publisher.

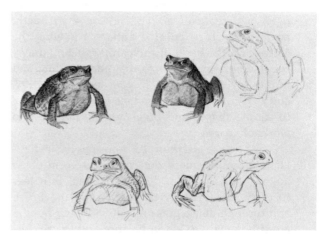

Figure 6.29
CLARE WALKER LESLIE
Eastern Box Turtle

Combined study using guide book, photograph, and a box turtle shell.

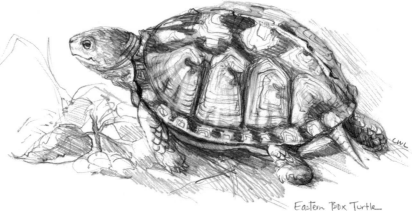

Eastern Box Turtle

the field, make quick sketches of various postures and parts of the body which can be combined into one longer drawing later on. Draw for scientific rather than artistic study. Write down observations such as approximate size, activity, details of features, and location. Refer to the toad sketches in Figure 6.28. Try adding color to your drawings, such as colored pencil or a light watercolor wash. Many reptiles and amphibians have beautiful colors and designs. (For methods of using color, see Chapter 3, "Methods and Techniques."

Fish

Thinking about fish cannot be separated from thinking about water, currents and eddies, coral reefs, fishermen, and so on. Why not go to a local fish market and ask for a whole fish to draw? Take it apart and draw the skeleton as well. Or go to an aquarium or pet store or to a friend's fish tank. For beautiful paintings of fish, look at any sportsman's magazine or conservation journal. It is the sportsmen and the conservationists who have supported not only the protection and breeding of many freshwater and ocean species but also the work of many wildlife artists.

In drawing fish, consider their flowing movements, how their fins and tails work both for locomotion and for giving behavioral signals, the glitter of scales, and their exquisite color markings. Note differences among fish of various locales, such as ocean, tropics, and freshwater ponds. Almost all fish have the basic parts diagrammed in Figure 6.30. Since fish forms are relatively simple and the technique for drawing not too complex, try experimenting with media. Try using soft charcoal or pastels on very large charcoal paper. Be loose and think of movement, grace, and color. Or try a large brush full of wet,

sloppy black ink or tempera on large newsprint paper. If you are beside a fish tank or aquarium or have a variety of color photographs, draw fast line gestures of groupings for an excellent study in repeated design and patterning. Notice how rarely the fish run into each other. (Schools of fish and flocks of birds must have similar social dynamics.) Watch closely to see how body shapes change as the fish turn in and out and float past you.

Figure 6.30
Diagram of fish anatomy.

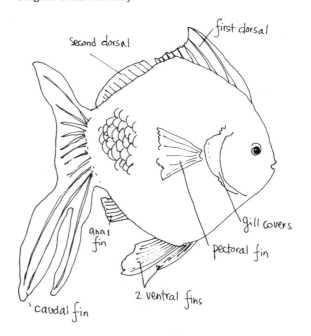

second dorsal

first dorsal

gill covers

pectoral fin

2 ventral fins

anal fin

caudal fin

Exercise 11
DRAWING FISH

Design your own assignment and choose your own medium.

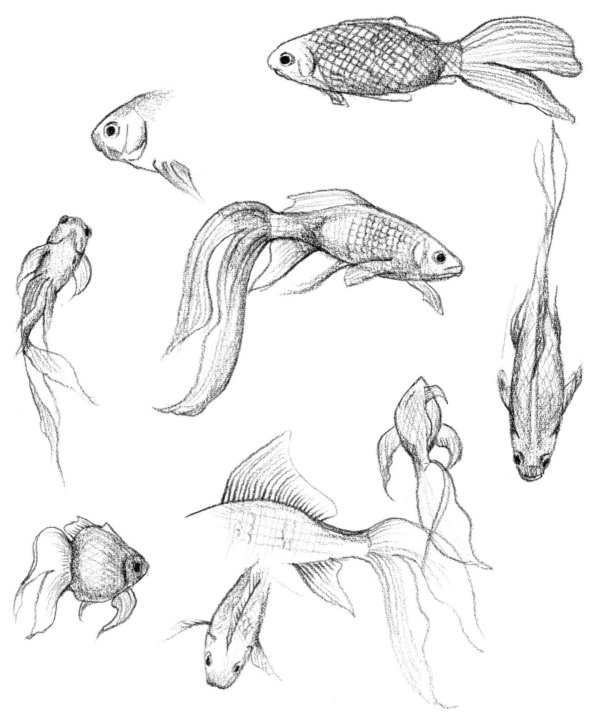

Figure 6.31
Student drawings of a tropical fish as seen in a fish tank (black colored pencil).

Insects

For a long time, I refused to draw or even look closely at an insect. Not only were they seemingly uninteresting to watch but their forms were impossible to understand, being in constant motion. One day a friend encouraged me to have another look, and a fascinating world suddenly opened wide. Insects are extremely varied as well as extremely abundant the world over. Much can be learned about an environment and its components by the insects dwelling there. Plants are dependent on insects for pollination, and many animals feed on them. Although some are harmful to the human world, many, such as the ladybird beetle and the praying mantis are most helpful.

Because their designs and colors can be quite striking, insects are really beautiful to draw. Some butterflies and beetles are so dazzling in appearance that one wonders why. Do not worry about accuracy when you are drawing insects in the field. The challenge is in describing motion, activity, and key identifiable features. Details can be drawn from a field guide or a pinned specimen. Once you know the key anatomical differences among fly, beetle, butterfly, grasshopper, and dragonfly, you will be able to draw each much faster. When I began, I did not know that the three pairs of legs all extend from just the thorax so that my insects always looked odd. (See the diagram of basic insect parts in Figure 6.32.)

To begin, I would suggest looking closely at a particularly fragrant flower, such as an apple blossom, milkweed floret, or daisy head. Watch what visits it and how the insect crawls over and into its center, collecting nectar and pollen. Draw the bee, ant, butterfly, or whatever, *as you see it* and as best you can. Have on hand a magnifying glass to look more closely if you wish. Look mostly at the insect and only a little at the page, sketching a bit of wing, body part, or gestured motion. Write down where it was found, what it was doing, and its general color pattern. Identify the species later. Another place to look at insects is in any field or garden on a spring or summer's day or around a porch light on a hot summer's evening. A visit to a pond can provide varieties of subjects, too, such as those hovering above the water (dragonflies), those gliding on top of the water (water striders), or those diving into the water (water boatmen). If you look care-

Figure 6.32
DONALD W. STOKES
Diagram of insect parts.

fully, you can find insects just about anywhere, including on a windowpane in winter.

The British artist David Measures published an illustrated journal of his studies of butterflies nearby his home. He wrote: "For me, through watching butterflies, a new world was revealed, supplying, as well as interest, surprise, amusement, and admiration. . . . I began to wonder why butterflies close up, why they chase each other, where they go at night, how they communicate, and what happens in the rain. . . . Think of the wealth of life performing in front of your gaze in each and every spot."*

Insects belong to the phylum *Arthropoda,* all of which have jointed legs and external skeletons, such as spiders, centipedes, and crustaceans. But insects (in the order *Insecta*) differ in that they have three pairs of legs (whereas the others in the phylum have four or more), usually one or two pairs of wings, and a three-parted body. Grasshoppers, crickets, and true bugs go through stages of development, shedding their "skin" as they grow. A small grasshopper is, in fact, a

* *Bright Wings of Summer* (Englewood Cliffs, N.J.: Prentice-Hall, Inc., 1976), p. 29 and 31.

young adult. Butterflies, moths, bees, flies, and ants go through four life stages: egg, larva (grub, maggot, caterpillar), pupa (cocoon), and adult.

Exercise 12
DRAWING INSECTS

(Time: enough to locate an interesting subject, watch, and draw for at least fifteen minutes, and then to write down what you saw and what your subject was doing. Materials: any pencil or ball-point or felt-tip pen. Add watercolor or colored pencil later for color notes.)

The challenge can be as much in the finding as in the drawing, and then it becomes quite fascinating simply to watch what an insect may be doing. Invariably, they are doing something, whether it be feeding, resting, mating, attacking another insect, laying eggs, or making a cocoon. You might want to use a net to catch a few specimens, putting them in a jar to draw closely and then to let go (which is the procedure used by the student who drew the crane flies in Figure 8.13).

Figure 6.33
CLARE WALKER LESLIE
Field sketches of insects at a summer porch light.

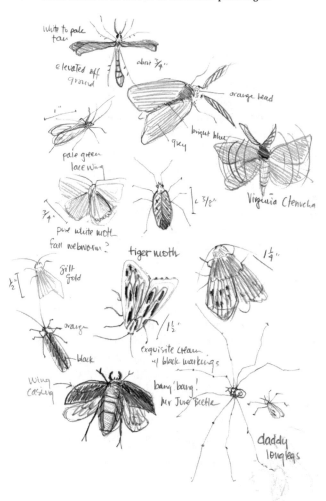

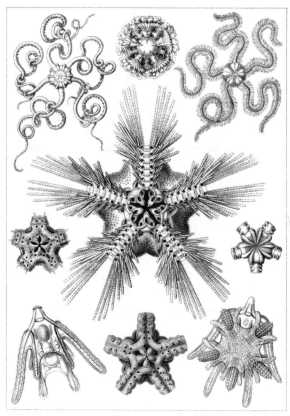

Figure 6.34
ERNST HAECKEL (German biologist, 19th-20th centuries)
Various Types of Starfishes (lithograph)
Reproduced from Ernst Haeckel, *Art Forms in Nature* (New York: Dover Publications, 1974).

Haeckel was fascinated by the beauty and geometry of natural forms, particularly microscopic ones from the deep sea.

The Lower Forms of Life

For lack of a better name, the least completely evolved animals are generally termed the "lower forms of life"; the chordates, and specifically the mammals and birds, are considered to be the "higher forms of life." The former include all the animals without internal skeletons: one-celled protozoa, sponges, jellyfish, worms, shellfish, crabs, spiders, and insects (which have just been discussed separately). Most are drawn principally by the biology student or the scientific illustrator. However, many have exquisite forms, colors, and geometric shapes, despite their small size and the dark realms many inhabit. All perform functions similar to those of the higher animals, but in simpler ways and with less complex internal systems.

Where can these creatures be found? Some can be found along the beach or rocky coast, under a rotting log, in the soil, or in an aquarium,

120

freshwater pond, or salt marsh. Investigate guide-books to shells and marine and pond life for identifying many of these species.

Exercise 13

DRAWING THE LOWER FORMS OF LIFE

(Time and materials: be experimental.)

The next time you visit a beach, pond, damp woodland, or hot desert, take along a drawing pad and sketch whatever of these creatures you find. In Chapter 8, "Keeping a Field Sketchbook," is a page of drawings (Figure 8.10) I made on a rocky coastal beach in Maine. Look at it for a way to arrange various studies on one page and as a way of doing record-making sketches while outdoors.

Figure 6.35
GORDON MORRISON
Green Crab, Seabrook, New Hampshire Channel (HB pencil)
Courtesy of the artist

Sketches can be done on the spot and descriptive notes added if a creature cannot be removed from the area.

ASPECTS OF DRAWING ANIMALS

Animals in Motion

Drawing animals in motion poses a real challenge because the artist must become somewhat of a magician: How do you symbolize in a static form that which is moving? (All drawing, in fact, is a form of symbolism.) Artists have experimented with many methods. One artist draws birds in flight with blurred wings, claiming that is what is seen and not the individual wing outline. You can draw the defined form of a leg, tail, or whatever part that is in motion and put small lines of action around it, to show the gesture of movement (as is often done in cartoon drawing). You can draw the animal in a position of action with its legs stretched out, as in Figure 6.37. Or you can draw the animal in some exaggerated posture of motion to emphasize tensed muscles, foreshortened legs, thrusting neck, and heaving body, as did Toulouse-Lautrec (Figure 6.16). Often I will imply action by breaking up the strict outline of legs and other moving parts and, as in a sketch, drawing in several lines to suggest a moving outline.

Elements such as a tail streaming behind, ears swung back, neck outstretched or widely spread legs are all tricks that can be used. If you are having difficulty understanding the general path of action, draw one or several gestural lines first to indicate the direction of movement and

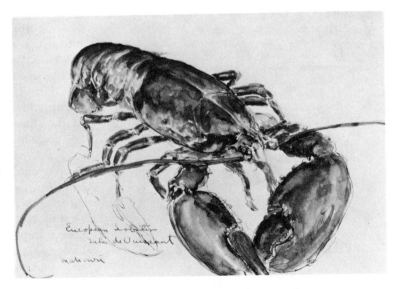

Figure 6.36
MAHONRI YOUNG (American, 19th-20th centuries)
European Lobster (watercolor)
Courtesy of the Fogg Art Museum, Harvard University. Gift—Mrs. Morris Stokes

Try loose, free sketches of animals that suggest gesture and character over detail.

VARIOUS POSITIONS OF JUMPING HORSE

Figure 6.37
WALTER WILWERDING
Various Positions of a Jumping Horse
Reproduced from Walter Wilwerding, *Animal Drawing and Painting* (New York: Dover Publications, 1956).

Lines describing the direction of motion are added and are useful to include if one is having difficulty seeing the particular angle of movement.

build the body around it. To show these motions in Figure 6.37, I have drawn lines along the curve of the backbone. Of course, knowing anatomy will help you to understand how a leg bends, where the muscles are, and how the body stretches—thus contributing to a convincing study. A useful book to draw from is Eadweard Muybridge's *Animals in Motion,* which is full of small, sequential photographs of various animals in positions of walking, pacing, trotting, or running.

Study your own body in motion; feel where the hip shifts and the leg bends. You might even construct a small sculpture in modeling clay to obtain the three-dimensional feel of muscles, body mass, and posture in various stages of movement.

Character and Expression

All animals have particular traits characteristic to the species and to the individual. To us, mammals appear to show more expressive behavior than do other animals. There is the snarl of anger in the lynx, the bellow of warning in the buck deer, the alert stare of the chipmunk, the kindly gaze of the cow, and so forth. Each expression can be further emphasized by the particular pose into which an animal is put. For example, in Figure 6.38, the artist has chosen to depict a fox in the midst of yawning. The animal is lying down in a curled position of sleep, and its mouth is opened wider than in a howl. The central focus in the drawing is specifically around the head and mouth. It makes us yawn to look at it.

Eyes can greatly help suggest an animal's expression. By placing a small white dot of light into them, you can give that added sense of life. Be sure to position the white spot correctly according to the angle of the head and the light source implied by the shading, or it will only look odd. Set the eye just above the cheekbone ridge and not too close to the forehead. Carefully

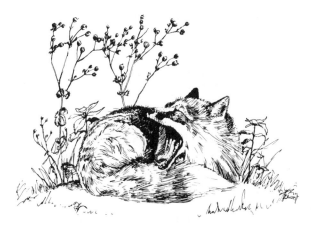

Figure 6.38
RUSS BUZZELL
Red Fox
Courtesy of the Massachusetts Audubon Society

note where the eye is placed in each species to get the right feel and also note the way the eye's basically rounded shape will change from different perspectives. (See Figure 6.39 for ways of drawing various animals' eyes.)

Figure 6.39
Eye positions and shapes among several animal types. Take particular notice of the way a white glint can be placed in an eye to add a bit of liveliness. Placed in the correct position, according to the angle of the head, it can convey a sense of the animal's expression.

Surface Tones and Textures: Fur, Scales, Coloration, and Shading

Block in your animal's body shape first and then begin building up, from light to dark tones, the surface textures and patterns. Decide whether you want to detail the whole body surface by indicating each hair or scale or merely give the general effect of overall texture and pattern. Once again, to know muscle structure, direction of hair growth, or the actual construction of fish or reptile scales will make your drawing easier and more convincing. Whenever possible, draw an animal that you have had opportunity to see up close or even hold in your hand to carefully scrutinize its surface layout.

Study the drawing of the white-tailed deer in Figure 6.40. Using a series of repeated, even pencil strokes, I built up layers of fur, working back and forth between darkest and lightest tones to keep the whole range in balance. The motion of the hand for drawing fur or any type of linear shading, for that matter, is a steady arm with just the wrist flicking evenly back and forth, returning the pencil stroke to the same position

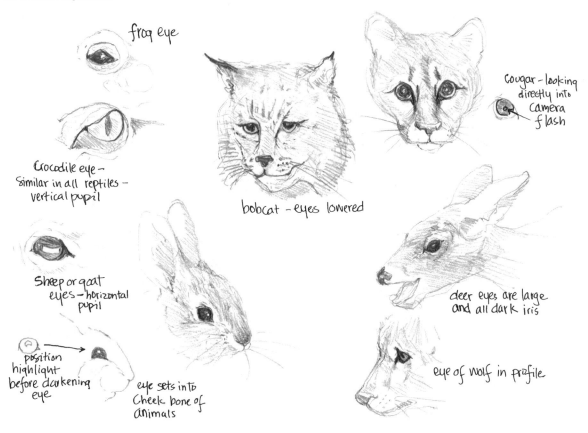

frog eye

Crocodile eye — Similar in all reptiles — vertical pupil

bobcat — eyes lowered

Cougar—looking directly into camera flash

Sheep or goat eyes — horizontal pupil

position highlight before darkening eye

eye sets into cheek bone of animals

deer eyes are large and all dark iris

eye of wolf in profile

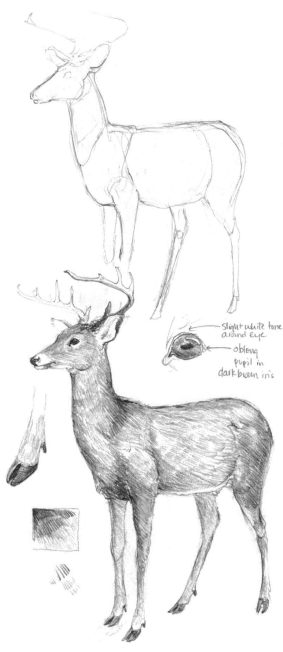

each time. Try it on a scrap of paper to see how it works. Refer to the small boxed diagram in Figure 6.40, which shows the type of strokes that can be used.

George Founds has drawn fur and fur coloration in rather a schematic way (Figure 6.41). Edgar Degas has taken care to work in tones, erasing and smoothing them out to build up beautifully the sheen of horsehide (Figure 6.15). Line, in building up tones, fur patterns, and texture, is the handmaiden of form and no longer the definer of outline. Therefore, keep line here simple and repeated and vary *not* by direction but by weight and intensity of tone.

With snake and fish scales, tortoise shells, and frogs' skin, much of the work has to do with giving the suggestion of shine, smoothness, or roughness. Using your eraser or finger, rub to lighten tones for highlights or to soften for a sheen. Vary the weight of your line for lighter or darker tones, whether with pen or with pencil.

Try to keep separate in your mind color pattern, surface texture, light, and shadow. Some artists place modelling and shading in first, like

Figure 6.41
GEORGE FOUNDS (American, 20th century)
Bobcat
Reprinted with permission from *Defenders* Magazine, Copyright 1978 by Defenders of Wildlife, Washington, D.C. Courtesy of the artist and the publisher.

George Founds uses a somewhat stylized, though effective shading technique here.

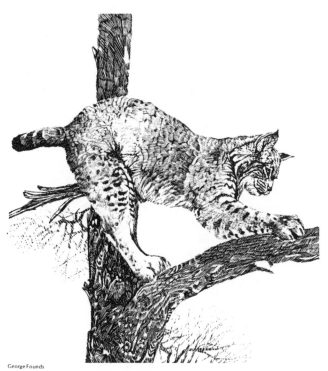

George Founds

Figure 6.40
CLARE WALKER LESLIE

Studies of a white-tailed deer and its hair pattern.

a tonal wash. Others prefer to put in patterning and texture first. Whatever you do, be sure to keep both in balance. Although it sounds like an arbitrary rule, artists must often see clarity of expression over reality of subject. In other words, if a turtle's back is highly patterned but *also* in a strong light that disguises the pattern, you may have to change the lighting to bring out patterning. Only experience can tell you how best to do it. Obviously, George Founds did not see the bobcat's fur as he described it, but instead gave it the *effect* he wished to convey (Figure 6.41).

Drawing Animals within an Environment, in Activity, or with Other Animals

Always be aware of drawing an animal as more than a descriptive portrait; also make it alive with a distinctive character and posture. Choose to copy photographs that show particular activities and interactions so that you can learn something about the animal other than its physical build. Whenever possible, expand your study to include natural history so that you can say, "*That* is what this animal does" or "*That* is where it lives."

Glen Loates comments, "As many as forty-five rough pencil sketches have been done of a single animal, in an attempt to capture all of its movements and anatomy. For the details of feather and fur, I always use skins and pelts. . . . The layman should be able to look at a good animal painting and feel surprised and excited, be convinced of its anatomical structure, and be able to gain familiarity with its habitat, as well as a love for the subject itself."*

Drawing from Photographs

Wildlife artists continually resort to using photographs, combining them with their field studies. Artists call these photo files their "morgues." The larger and more complete the files, the more accurate can be their drawings. Photographs provide information about behavior, posture variations, and types of habitat the animal frequents that cannot be gotten from a live animal in a zoo or from a study mount.

* *The Art of Glen Loates,* p. 188.

However, as mentioned in other chapters, beware of the pitfalls of using photographs. Lighting can be deceptive. The animal may be in a pose that is difficult to see because of foreshortening, blurring from motion, or simply poor photography. A camera can only record what it receives. You must record what you *know* to be there, whether you see it clearly or not. Students who are not familiar with the live animal or with its structure may put in things that are not there because a photograph confused the image. (Shadows are particularly deceiving.)

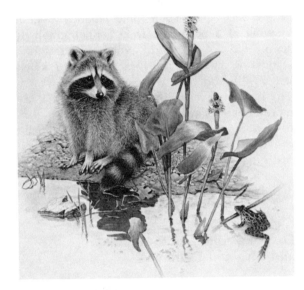

Figure 6.42
GLEN LOATES (Canadian, 20th century)
Young Raccoon (watercolor)
Reproduced by permission of Cerebrus Press, Inc., Ontario, Canada, from *Mammals in Profile,* a Nature Book Series.

Loates has chosen not to merely draw the portrait of a raccoon but to describe a small story that helps offer some additional information about the animal. The subject is a young raccoon meeting, perhaps for the first time, its potential dinner. The expression Loates describes seems to mix surprise, curiosity, and basic hunter's instinct.

The coyote in Figure 6.43 was drawn by a student who is a good draftsman but does not know the build of coyotes. She thought she had carefully marked off her proportions and had done a fine job describing hair texture, though not quite according to its direction of growth. But the body seems to be made of rubber and fluff, not of bone, muscle, and hair. The problem was that the legs in the photograph were blurred by motion and thus appeared oddly bent. The muzzle, being turned away and partially in shadow, looked thinner than it was. If she had

worked from bone, muscle, and basic body shape *out* to fur and external proportions, her drawing would have been a great deal more accurate. Know your subject well enough so that you can take from a photograph what is accurate and rearrange what is not. As Bob Kuhn says, "The more you draw from life, the more independent you are from outside reference sources. . . . Dependence on good readable source material limits what you can attempt. If you want to move animals around in your painting, then you ought to be able to construct them without resort to specific photographs."*

I once spent some time laboring over a drawing of a porcupine from a photograph. It simply did not look right. Not until I saw one wandering across our lawn and was able to sketch it from life did I see where I had gone wrong: The head was much more blunt and the body more square. The slight observations that can only occur from seeing an animal in the wild can help make a drawing from a photograph really become alive. When possible, work from three or four photographs at a time so that the deceptions in one can be understood in another.

Drawing from Study Mounts and Museum Dioramas

A natural history or science museum, nature center, or biology department may have stuffed or mounted skins of various animals for display or study. Some of the larger science museums in urban areas such as Washington, New York, or Boston do have halls of dioramas with groupings of animals in specific environments, for example, grizzlies of the Yukon, polar bears of the arctic, or various animals typical to a southeastern woodland.

The advantage of dioramas is that the animals will not move away, are close enough for drawing details, and have been positioned into active poses. Habitats are laid out within a small and "readable" space and are often ones, such as the arctic or desert, that many of us have not had opportunity to see. Use these displays to draw animal groupings, animals in activities, and animals within relatively uncomplicated settings.

Individual study mounts also provide expe-

* *Animal Art*, p. 14.

Figure 6.43
Student drawing, from a photograph, of a coyote. Although technique is well conceived here, the student fails to describe an accurate study because she did not understand anatomy or fur patterning and depended too much on what she read directly from the photograph.

rience in drawing wild animals closely without the frustration of their moving away. Draw them at differing angles and do studies of specific parts, as in Figure 6.44. Be aware, though, that some of these mounts may be quite old and so the luster of the fur has long gone. Since they are stuffed and wired, they may not have been put into truly accurate postures. Also, there is not the same life in a glass eye as in a real one.

Exercise 14
DRAWING AT A NATURAL HISTORY MUSEUM, SCIENCE MUSEUM, OR AT AN AQUARIUM

(Time: two hours. Materials: portable and simple, such as an 8-by-11-inch drawing pad, HB and 2B pencils, felt-tip pen, colored pencils, eraser, sharpener, folding stool.)

You may be drawing in semidarkness, surrounded by squealing children, and awkwardly balancing your pad to catch whatever light there is in these dark halls. Do not attempt a finished or detailed drawing unless you have good lighting, can sit comfortably, and can have the animal close enough to study properly. Rather, do a series of gesture drawings to learn the animals in a particular diorama or fish tank. Use this chance to learn about the animals more than to produce skilled drawings. Use drawing as a means of recording the specifics of your visit to a particular museum. For further methods of laying out a sketchbook page, see Chapter 8, "Keeping a Field Sketchbook."

Drawing from Television

This is a challenge, but also excellent practice in drawing fast. There are many special programs on television now about nature and wildlife that

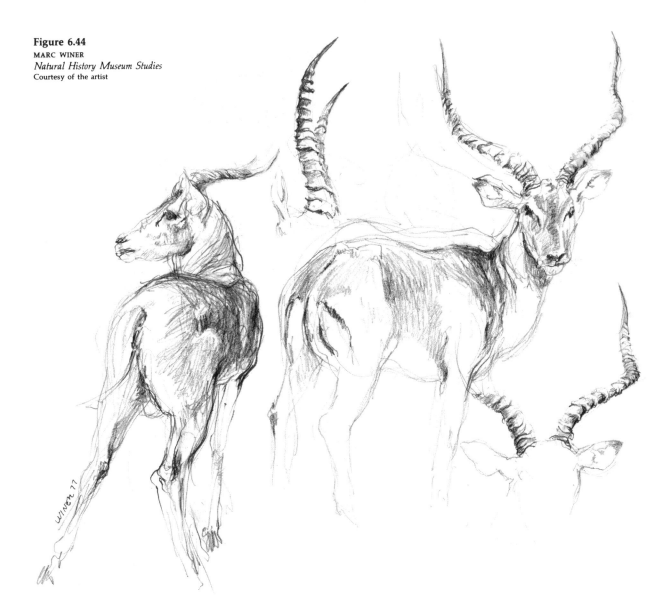

Figure 6.44
MARC WINER
Natural History Museum Studies
Courtesy of the artist

Figure 6.45
CLARE WALKER LESLIE

Sketchbook page from a visit to an aquarium. This drawing offers a focus for study and taking records of animals seen at places such as an aquarium. I found I learned and remembered more details from this visit than from others when I had not brought a sketchbook.

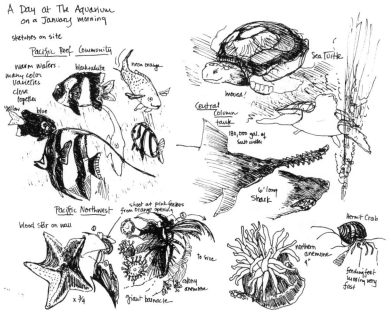

give a glimpse into a world that might not otherwise be seen, including such unusual activities as the challenging duel of two bull elks, the underwater swimming of a beaver, or the raising of wolf pups.

Have your drawing pad ready and do some brief studies of such activities. Programs like those produced by Jacques Cousteau and National Geographic are good ones to watch. At first, you will only get down very brief and partial images of a head, curve of a back, general movement of a body. Memorize basic postures and general features; then during the commercials, refine your sketches as you remember the images. You will be surprised at how much can be recalled. All these skills of quick and accurate seeing and drawing from memory are used in field sketching.

Studying the Works of Wildlife Artists

You may find that you will have to learn to draw natural subjects on your own, which is the rule and not the exception among wildlife artists. The outdoor world was their classroom. Of course, a firm grounding in the techniques of drawing at some point becomes important, and that can be gained from any art school, center, or college.

Next in importance to the animals and plants themselves are the works of other wildlife artists. The plates included in these and other chapters can well stand alone as instructors in nature drawing, and were so chosen. Use them again and again for technical and stylistic reference as well as for inspiration in getting yourself drawing.

Until recently, most of the more scientific studies of plants and animals appeared as illustrations in biological texts or as decorative subjects for sporting prints. Drawing or painting natural subjects in any very naturalistic fashion did not interest the art world. Certainly artists throughout the world, since the cave painters, have depicted all aspects of nature with great interest, but more as objects of beauty, symbolism, and decoration. The animal or plant as an object for scientific study did not concern artists until quite recently.* However, Leonardo da Vinci and Al-

brecht Durer were early exceptions to this standard.

Gradually, wildlife artists are becoming more respected as "legitimate" artists and not mere illustrators, and every now and then an art museum will feature a show on animal art or scientific illustration. But examples of good wildlife art can be found in many other places. Look at sportsmen's, natural history, and environmental magazines. Look in second-hand bookstores for out-of-print books on nature, where some of the finer artists have been recognized for their superb illustrations. Several from whom I have learned are Charles Livingston Bull, Francis Lee Jaques, Beatrix Potter, Bob Kuhn, Ernest Thompson Seton, and William Hamilton Gibson. (Look at the bibliographies in all the chapters in this book for works of these artists.)

Figure 6.46
GEOFFREY TONY (16th century)
Page from The Book of Hours
Courtesy of the Museum of Fine Arts, Boston

Throughout history, animals and plants have interested artists in many cultures as subjects for decoration, symbolism, and design, as well as for scientific study.

* For an introduction to the historical development of animal art, see S. Peter Dance, *The Art of Natural History* (New York: The Overlook Press, 1978).

Art museums will occasionally have drawings or paintings by artists who *also* delighted in drawing natural subjects (such as Winslow Homer, Toulouse-Lautrec, John Singer Sargent, and Andrew Wyeth). Because many of these works are drawings or prints and are not hung on the gallery walls, ask if you can visit the photo reproduction files.

Field guides and books on natural history often have illustrations by the better known artists of nature. Occasionally, monographs appear of the works of some wildlife painter; a few are listed in this chapter's bibliography. Posters and greeting and gift cards also are sources for drawing styles, and some of the better illustrations of plants and animals today are found in children's books. Since their turnover is very high, new books with good illustrations seem to appear daily. One of the purposes of this book is to help you set up your own program for studying nature through drawing. Realize that the search to find good reference material is all part of the study.

BIBLIOGRAPHY

Animal Drawing

ELLENBERGER, W., BAUM, H., DITTRICH, H. *An Atlas of Animal Anatomy for Artists.* New York: Dover Publications, Inc. (PB)

KNIGHT, CHARLES R. *Animal Drawing: Anatomy and Action for Artists.* New York: Dover Publications, Inc., 1947. (PB)

MUYBRIDGE, EADWEARD. *Animals in Motion.* New York: Dover Publications, Inc., 1957. (HB)

SETON, ERNEST THOMPSON. *Art Anatomy of Animals.* Philadelphia: Running Press, 1977. (PB)

STUBBS, GEORGE. *The Anatomy of the Horse.* New York: Dover Publications, Inc., 1976. (PB)

WILWERDING, WALTER J. *Animal Drawing and Painting.* New York: Dover Publications, Inc., 1956. (PB)

Books with Illustrations by Artists of Animals

BERRY, WILLIAM D., and BERRY, ELIZABETH. *Mammals of the San Francisco Bay Area.* Berkeley: University of California Press, 1959. (PB)

DANCE, PETER S. *The Art of Natural History: Animal Illustrators and Their Work.* New York: The Overlook Press, 1978. (HB)

CIRKER, BLANCHE, ed. *1800 Woodcuts by Thomas Bewick and His School.* New York: Dover Publications, Inc., 1962. (PB)

DUVAL, PAUL. *The Art of Glen Loates.* Ontario: Cerebrus Publishing Company Ltd./Prentice-Hall of Canada, Ltd., 1977. (HB)

GRAHAM, KENNETH. *The Wind in the Willows.* (Illustrations by Ernest H. Shepard.) New York: Charles Scribner's Sons, 1954. (HB)

HAECKEL, ERNST. *Art Forms in Nature.* New York: Dover Publications, Inc., 1974. (PB)

JAQUES, FLORENCE PAGE, and JAQUES, FRANCIS LEE. *Artist of the Wilderness World.* New York: Doubleday & Company, 1973. (HB)

KUHN, BOB. *The Animal Art of Bob Kuhn.* Newport, Conn.: North Light Publishers (a division of Fletcher Art Services, Inc.), 1973. (HB)

MATTIESEEN, PETER. *Wildlife in America.* (Pen and ink illustrations by Bob Hines.) New York: Viking Press, 1959. (PB)

MEASURES, DAVID G. *Bright Wings of Summer.* Englewood Cliffs, N.J.: Prentice-Hall, Inc., 1976. (HB)

SAMSON, JOHN G., editor. *The Worlds of Ernest Thompson Seton.* New York: Alfred A. Knopf, 1976. (HB)

WARNE, FREDERICK, editor. *The Art of Beatrix Potter.* London and New York: Frederick Warne & Co., Ltd., 1967. (HB)

Field Guidebooks

BURNETT, R. WILL, and FISHER, HARVEY. *Zoology.* New York: Golden Press, 1951. (PB)

BURT, WILLIAM H., and GROSSENHEIDER, RICHARD P. *A Field Guide to the Mammals.* The Peterson Field Guide Series. Boston: Houghton-Mifflin Company, 1952. (HB)

MITCHELL, ROBERT, and ZIM, HERBERT. *Butterflies and Moths.* New York: Golden Press, 1964. (PB)

MURIE, OLAUS J. *A Field Guide to Animal Tracks.* The Peterson Field Guide Series. Boston: Houghton-Mifflin Company, 1952 (HB)

PALMER, E. LAWRENCE. *Fieldbook of Natural History.* New York: McGraw-Hill Book Company, Inc., 1974. (HB) (An excellent reference book with superb line drawings by numerous artists whose works are worth studying.)

ZIM, HERBERT. *Insects.* New York: Golden Press, 1951. (PB)

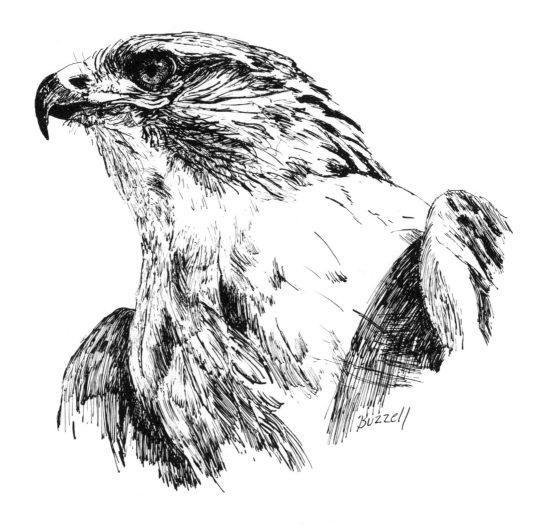

From a day in my twelfth year when I discovered the splendor of a common crow, I have been engrossed by the variety in form, colour, pattern, moods, and expressions of birds. I am grateful that there are more than can be comprehended truly in one lifetime. . . .

Bird artist Terence Shortt,
Animals in Art

Throughout the seasons, birds can be observed in just about any location. We hear their singing, admire their flying, and find them living relatively close to us in both city and country. Put a bird feeder out in winter and there soon will be juncos, chickadees, blue jays, or cardinals to watch and sketch. Sit on a city park bench and pigeons, house sparrows, and starlings will be there looking for food. Or along any seacoast, gulls, terns, ducks, and cormorants will be flying past. Quite easily, many birds and their activities can be watched without going any great distance or to any science museum or zoo. Many of us spend hours in happy preoccupation "bird watching" out along rainy seacoasts and in hot summer meadows. Increased interest has resulted for

CHAPTER SEVEN

Birds

many people who want to learn how to record what they are observing in order to better remember behavior, activity, and species of bird seen in the field.

However, birds can be a challenge to draw. They demand a good deal of watching because their poses and activities can be so variable and change so quickly as they hop and fly about. Also, unlike many other animals, their shapes are often small and indistinguishable, being primarily oval and compact. Part of the fascination is that in drawing birds, we begin to know something about not only their physical characteris-

tics, but also the environments in which they and we live.

There are many aspects of bird study from which to choose. First, there are the physical differences between species, such as between crow and robin or sparrow and duck. Then there are such areas as habitat, behavior, migration, and the daily activities of feeding, courting, fighting, singing, nesting, raising of young, and so on. There is anatomy, such as how a wing beats or why a woodpecker does not shatter its skull in pounding so heavily on a tree. There are many mysteries about birds that have occupied orni-

These sketches show a robin in two poses: gathering material for a nest and settling into it. In field sketching, it is useful to draw a bird in such a way as to show something of its activity and behavior.

thologists for years in study and research. Becoming familiar with the life histories of at least a few birds will add interest as well as information to your study.

A man who has spent much of a lifetime watching and drawing birds is the ornithologist William H. Drury. His two sketches of a robin in Figure 7.2 are quick studies of a bird observed in the act of building a nest. Not only has Drury depicted a bird with animation, he has told something about the bird's behavior that allows us to say, "Ah, that is what a robin does." A differ-

132

ent, though equally valid approach to drawing birds is revealed in figure 7.3. Roger Tory Peterson is one of the foremost bird artists today and has also greatly contributed to fostering public interest in birds and bird watching over the last number of years. He uses hours of observation, field studies, skins, and photographs to paint beautifully detailed portraits such as this. Whatever your purpose, you should follow a method of learning that includes both sketching in the field and drawing from books, photographs, and skins.

WATCHING BIRDS

Exercise 1
BECOMING ACQUAINTED WITH BIRDS

If you are not already familiar with birds, start to notice what is singing in your backyard, hopping on your lawn, or sitting on a nearby telephone wire. Is it black, grey, or yellow? Is it less than four inches or more? Does it have a yellow, blunt bill or a black, pointed one? Learning physical features, at a glance, is essential for both artist and naturalist in learning to identify birds. Eventually, when you have a sketch pad with you, jotting down these features without even knowing the bird will help you find it in a guidebook.

The next thing to observe is what the bird is doing. Something is always happening, even if the bird is just resting.

The season, weather, and location will greatly determine a bird's behavior, so carefully note down such data. Is it singing from the top of a tree? Does it have food in its bill, and who might it be feeding? Is it chasing another bird? Birds can also be identified by behavior and activity patterns. For example, a tern will carry little fish for long distances down a beach toward a potential mate, continually dipping its bill in the water seemingly to keep the fish wet and fresh for the waiting female. Sometimes there is failure, as when a larger gull charges and robs the smaller bird of its catch. If we watch and record such activities, we can learn about courting behavior, food-finding abilities, and relationships between and within species. Watch birds to learn not merely their physical traits but also something about their lives.

Exercise 2
BASIC EQUIPMENT
FOR WATCHING BIRDS

Borrow or buy one guidebook suitable for your area. Spend some time becoming familiar with its arrangement, seeing what species live where and at what times of year. Note major family groupings, such as ducks, hawks, gulls, herons, warblers, and owls, and

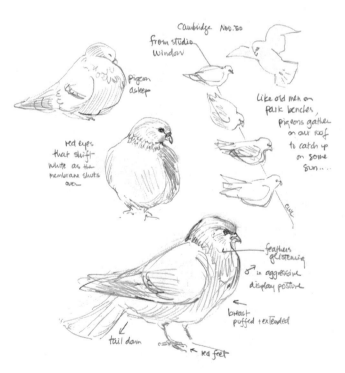

Figure 7.4
CLARE WALKER LESLIE
Studies of pigeons on a roof.

Figure 7.5
TERENCE SHORTT (Canadian, 20th century)
Field Sketches for a Painting of a Varied Thrush
Copyright 1978 by the National Wildlife Federation. Reprinted from the October-November 1978 issue of *National Wildlife* Magazine

General Regions to find Birds

CITY
downy woodpecker
starling
pigeon
house sparrow
herring gull
blue jay

WOODLAND
barred owl
red-eyed vireo
hermit thrush
downy woodpecker
American redstart
ruffed grouse

FAR WEST
Prairie falcon
California quail
Sandhill crane
pygmy owl
Scrub jay
Canyon wren

MEADOW
Song sparrow
blue bird
common crow
broad-winged hawk
American goldfinch
barn swallow

SUBURB
Cardinal
robin
grackle
house wren
junco
ruby-throated hummingbird

MOUNTAIN
raven
white-throated sparrow
ruby-crowned kinglet
red-tailed hawk
great horned owl
pine siskin

SOUTH EAST
turkey vulture
yellow-billed cuckoo
wild turkey
Louisiana heron
killdeer
pileated woodpecker

FRESH WATER POND or MARSH
Wood duck
Canada goose
tree swallow
red-winged black bird
spotted sandpiper
great blue heron
American coot

SALT WATER COAST
common loon
black-backed gull
common eider
sanderling
surf scoter
double-crested cormorant

Figure 7.6

learn in detail about five local ones. See Figure 7.6 for a list of some common birds found in various areas of the country. Apply these habitats to where you live, noting which birds are similar and which are different. You might want to make a similar list for yourself to see how it changes according to the season. Start to draw and to learn just a few birds at first, and begin with locally common birds so that you will be able to watch them outdoors.

Although there are now many good field guides available, I use and recommend Birds of North America by Chandler S. Robbins and Arthur Singer or A Field Guide to The Birds by Roger Tory Peterson. When I was first learning to draw birds, I copied (in pencil) the little watercolor illustrations by Singer to begin to feel the general rhythm and shape of birds in my hand. This practice can be very helpful. Make studies no larger than three or four inches and copy only from clear photographs or accurate drawings.

Birds can be watched and drawn with or without using binoculars, or even a telescope. Take along a sketchbook or just a note pad that will fit easily into a pack and not be cumbersome. Jot down with whatever quick lines you can such features as size and general shape, color, actions, and location. A student showed me a sketch she had done of a bird that was black, had red somewhere on it, and was hanging on a cattail. I knew it to be a red-winged blackbird just by the gesture she had managed to capture, by its cattail habitat, and by her use of color, even if the red was not placed correctly on the wings. She exclaimed that by drawing, she had learned her first bird.

Figure 7.7
Student contour drawings copying the illustrations by Austin Singer in *A Field Guide to the Birds*. He titled these "no-peek" bird shapes and found this a very helpful, if also humorous, way to begin learning bird form. Try it and see how it helps you.

Beginning to Draw: Sketching Birds Outdoors

Although it is perhaps easier to start drawing birds from photographs, from study mounts, or even at a zoo, beginning right away to sketch them alive and in the wild allows the opportunity to learn their natural habits and postures. (And it provides a good excuse to be outdoors!)

Exercise 3

SKETCHING BIRDS OUTDOORS

(Time: at least thirty minutes. Materials: any size drawing pad and an HB or 2B pencil or felt-tip or ball-point pen.)

Using a pen is good practice because you are forced to make simple lines, add little shading, and not use an eraser. Pencil allows for more variety and sensitivity of line, but because you can erase, it can slow down your observation and can become smudged and pale. Learn the advantages of both. Places to draw are a city park, bird feeder, duck pond, backyard, seacoast, open meadow. Is there a particular location nearby where you might find birds to draw?

HOW TO BEGIN SKETCHING

Always first take time to just watch the bird or birds through binoculars or telescope or with the naked eye. Sort out two or three continually repeated poses to draw, such as a swallow's glide, a sparrow's head raised in song, a chickadee fluttering up to a feeder. Set into your mind's eye the basic gestural pose and decide how you would draw it from memory. Then, sketching freely and lightly, put down what you observed. Do not try to make art masterpieces but begin with the basic and oval body shape, setting head out from the larger end and tail from the narrower end. Sketch in only a general placement and shape of wings and tail. (See Figures 7.9, 7.19, and 7.20 for basic lines.) The purpose now is principally to accustom yourself to looking and noting what general features should be recorded. Observing carefully is as important as drawing carefully. Even if you abandon sketching to just watch, realize that this can be very useful for imprinting into the memory certain poses and physical features. Some of my best sketches of birds resulted from first watching a bird and then drawing it from memory later. Do not be concerned with detail. Simply record the major shape and body parts.

You may sketch only part of the head before the bird moves, in which case draw its new posi-

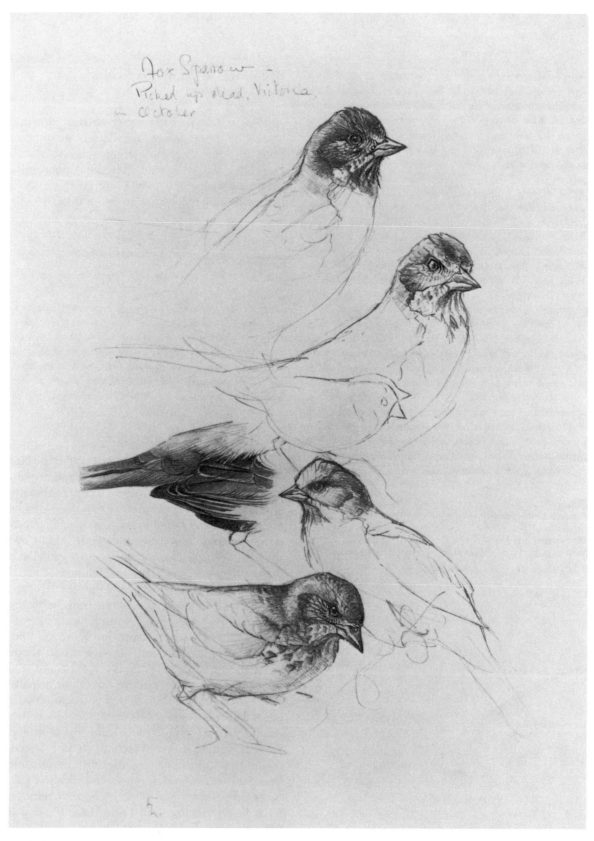

Figure 7.8

J. FENWICK LANSDOWNE (Canadian, 20th century)
Preliminary Sketches for a Painting of a Fox Sparrow
Reprinted from *Birds of the West Coast* by J. Fenwick Lansdowne, with permission of Houghton Mifflin Company, Boston.

tion. You may fill the first pages with only parts of birds or simplified silhouettes. Draw a bit of head, tail shape, belly angle, leg posture. Then when the bird stays still for a while, put the parts together. Keep your sketches small so that you cannot consider detail. See how the Canadian artist J. Fenwick Lansdowne sketched the fox sparrow, working detail into only parts of the body and keeping lines minimal for the other parts (Figure 7.8). It is common for an artist to do many such sketches to work out the desired postures and features before settling on the final drawing or painting. Any books illustrated by this artist can be extremely useful to study.

The Scottish artist John Busby has spent hours outdoors doing small sketches of the birds around his native Edinburgh. He then takes the accumulated studies and works them into larger oil or watercolor paintings. Because of his constant field study, Busby's paintings are recognized for their ability to express the life and behavior of a bird—which so often is difficult without this degree of careful observation. As the artist says, "any budding naturalist will see far more by drawing continually [outdoors] than by going to museums or referring to drawings in field guides. It is also a good idea to show from various artists' [works] that there are many ways of drawing— far too many 'How to do it books' try to impose a formula." (Personal communication, 1979.) The drawings in Figure 7.9 are just a few of the many field studies Busby keeps in his reference files.

Figure 7.9
JOHN P. BUSBY (Scottish, 20th century)
Field Sketches of an Algerian Marsh Owl, Blackbird, and Several Sanderlings (pen and charcoal pencil)
Courtesy of the artist

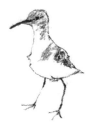

John Busby, who teaches painting at the Royal Academy of Art in Edinburgh, is also an artist well known for his paintings of birds. His interest is in conveying a sense of spirit and activity over accuracy of detail.

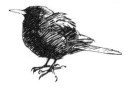

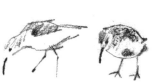

a bird is designed. All the best artists began as you are beginning now, and many still hesitate to show their field sketches, realizing how unsophisticated they are. It takes patience and a very different skill to draw a bird alive and continually moving, as opposed to one from a photograph or study mount.

BIOLOGY OF BIRDS

There are about 1,780 species of birds living in North America, with about 645 species breeding north of Mexico. At their peak number at the end of summer, the whole population in North American is roughly 20 billion, and the world population is about 100 billion. Of course in winter, with only the hardy residents present in the northern climes, populations are at their lowest. Any amateur bird watcher in most areas of this country can probably see about 300 species a year without too much hunting.

There are 20 orders (major groupings) of birds in North America (including Central America). Orders are categorized by closely related families, being grouped according to sexual, physical, and behavioral characteristics. Turn to a guidebook and notice how these groups are organized. Generally, the least completely evolved

Exercise 4

CONTINUATION OF EXERCISE 3

(Time: at least thirty minutes. Materials: any size drawing paper and an HB or 2B pencil or felt-tip or ball-point pen.)

After a break or on another day, return to the same place and the same birds. It is advisable to draw only two or three differing shapes until the feeling of "bird-ness" is in your hand. Have two or three little sketches going at once so that when birds move back and forth, you can continue working on the previous pose. The sketches in Figure 7.10 were made over a period of fifteen minutes while I watched blue jays and evening grosbeaks at our winter feeders. Some sketches were "stop and start," some were abandoned, and some were drawn after the bird flew off.

At first do not spend more than one minute on any sketch. If the bird seems relatively still, such as when it is sleeping or resting, try a longer study; however, still keep it small so that you can complete a fair semblance before the bird shifts. Do not be discouraged by your scribbles but look back over your pages and see that indeed you are looking more knowledgably at how

Figure 7.10
CLARE WALKER LESLIE

Sketches of birds at a winter feeder.

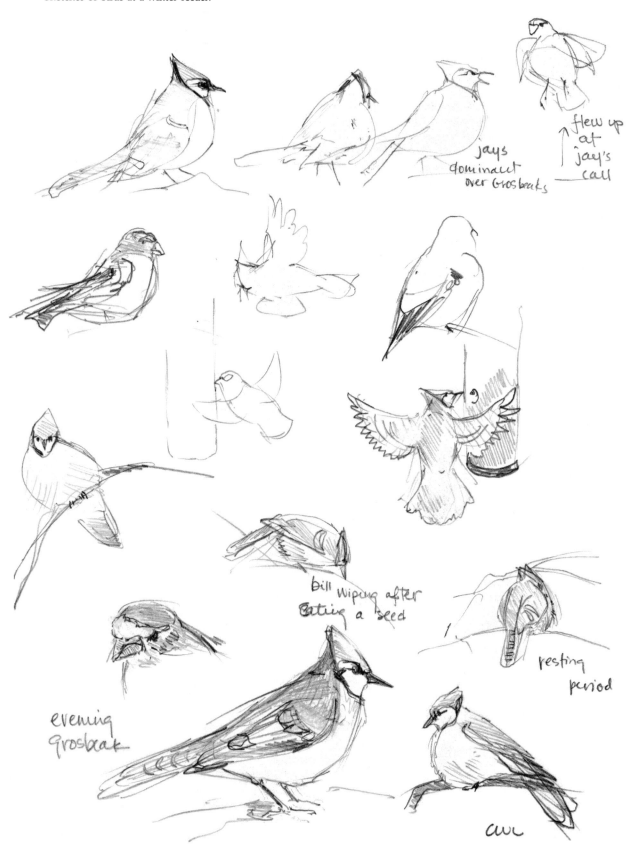

jays
dominant
over Grosbeaks

flew up
at
jay's
call

bill wiping after
eating a seed

resting
period

evening
Grosbeak

cwe

138

Figure 7.11
Photograph of Eric A. R. Ennion, a renowned British bird artist who stresses continual field study and drawing in his teaching. Here he is instructing a student who is drawing a falcon in a wildlife zoo. Dr. Ennion has had the student draw pages of parts of the bird, gathering two-inch studies of particular body gestures. At the day's end, the student had achieved a much better understanding of how a falcon is structured.

(or oldest) species will be first (loons, grebes, and the tubenoses, such as fulmars and petrels) and the most completely evolved (or more recent) last (sparrows, longspurs, and snow buntings). This organization will help you not only to locate an individual more readily but also to understand certain traits common to birds of a given family. Because of their amazing adaptive capabilities and flight mobility birds can be found in all varieties of environments and on all continents. For further reading, see any college ornithological text, such as Joel Carl Welty's *The Life of Birds*, or even the introduction to your field guide.

Skeleton

The bone structure of birds resembles other animals, with exceptions. The bones of birds are hollow, to minimize weight in flight, and some are fused together for added strength and durability. The largest bone, the sternum, or breast plate, helps contain the heaviest muscles for flight. Notice the extended, rotund breast of most birds and realize that this is where the majority of their flesh is located.

Taking time to draw a bird's skeleton will improve your accuracy when you add feathers and flesh. Many students have difficulty drawing birds in flight, for example, because they do not know where the wings fit into the shoulder. Or

they may have trouble drawing standing birds because they cannot understand where the legs tuck up underneath the body feathers.

Exercise 5
DRAWING A BIRD'S SKELETON

(Time: thirty minutes or more. Materials: no requirements other than making sure you have a sharp pencil and a handy eraser.)

Either copy the diagram shown here (Figure 7.12) or find a bird skeleton you can study. Rather than labor over detail, diagram the principal placement of bones. This is not an exercise in technique but in anatomy. Notice length of neck, heaviness of breast bone, and placement of legs which help balance the weight of the front and the lightness of the tail region. A bird's legs must also be flexible for pushing off in flight and then retracting easily under the body when not in use. The neck has more vertebrae than most other animals because it extends out further from the body and swivels about at more angles. Since birds have only peripheral vision, they must continually twist their heads in order to see around them. Try turning your head the way a bird does. Can you do it? Continue the examination of a bird's skeleton as you draw it, asking questions about structure and then attempting answers from what you already know about how birds function.

Figure 7.12

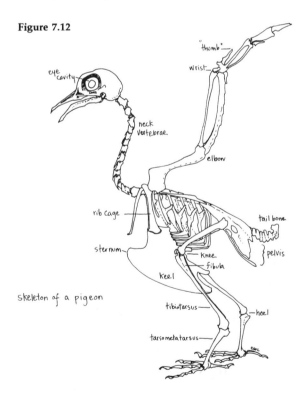

skeleton of a pigeon

External Parts

Notice how different is the external from the internal appearance of a bird. Where have gone

the long neck and legs? How does the wing fold in beside the rib cage? Much of a bird's thin frame is covered by layers of feathers. A careful study of external parts can be most useful for drawing a bird at a distance or in motion. You know how the bill is shaped or what feathers make up the wing. Charles F. Tunnicliffe, a renowned British bird artist, drew many pages of detailed studies (Figure 7.13), which was his way of learning and recording the anatomical parts he then used as valuable reference material for the many paintings of British birds he did throughout his life.

Exercise 6

DRAWING THE BIRD
TO LEARN ANATOMY

(Time: no limit. Materials: any soft pencil, 8-by-11-inch
or larger drawing paper.)

Locate a four-inch or larger photograph of a bird in profile, an illustration in a field guide (such as from Birds of North America *by Chandler Robbins) large enough to distinguish each physical feature, or a stuffed study mount from a biology department or science museum. Do not attempt a living bird for this exercise,*

Figure 7.13
CHARLES F. TUNNICLIFFE (British, 20th century)
Plate of a Whimbrel (pencil and watercolor)
From the catalog of the exhibition entitled *Bird Drawings* by C. F. Tunnicliffe at the Royal Academy of Arts, London, 1974. Courtesy of Victor Gollancz, Ltd., London on behalf of the artist

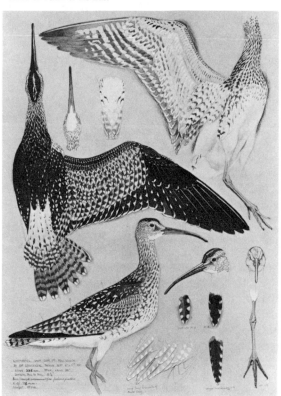

Figure 7.14
Parts of a bird.

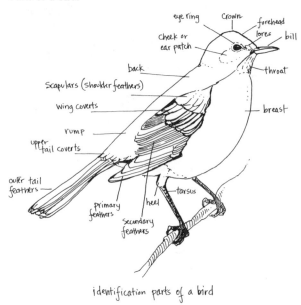

identification parts of a bird

and once again, do not yet concern yourself with drawing technique. This is an exercise for learning the placement of the external parts of a bird. Draw a bird and label it similarly to that in Figure 7.14.

WINGS AND FEATHERS

Birds are principally adapted for flight. Where they land is where they can be safe from prey, find shelter, feed, and nest. Many birds must migrate tremendous distances both spring and fall because no one habitat is suitable all year. Therefore, how a bird's wing is shaped is one indication of how a bird lives. For example, pelagic (ocean-living) birds have long, thin wings for sustaining long flights over open ocean. Grouse have short, round wings for quick but strong bursts of flight through dense brush. Turkeys and domestic fowl have barely any wings at all since it is their legs that are their principal means of defense and travel.

Wings are similar to our arms except that the "hand" is fused into one long finger and functions in flight as the rotating propeller of the wing tip. It is structured to push against air currents as it beats in a rotating, and *not* up-and-down, motion. Study the variety of wing positions of the Canada geese in Figure 7.15. See how much the wing swings around, pushing this heavy bird through the air. The outermost finger-like feathers, called primaries, act to break the wind and direct the bird's smaller turns.

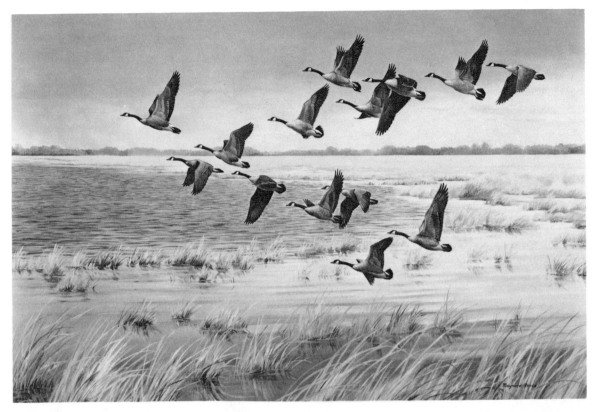

Figure 7.15
MAYNARD REECE (American, 20th century)
Winging South—Canada Geese
Courtesy of the artist and Mill Pond Press, Inc., Venice, Fla.

Observe how all bodies are in flock formation and at a uniform angle, with only the wings beating out varied patterns. Tracing these silhouettes can help you to learn the shapes of wings in flight.

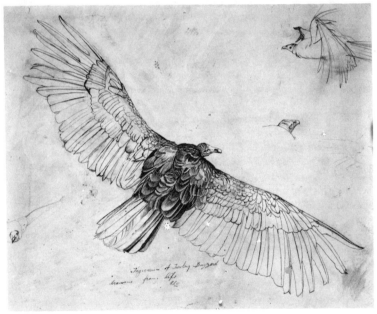

Figure 7.16
ANDREW WYETH (American, 20th century)
Drawing of a Buzzard (soft pencil)
Courtesy of the Museum of Fine Arts, Boston

Wings are made up of layers of feathers, which not only carry the bird in flight but also add insulation to a body that must survive extremes of cold, heat, and dampness. Andrew Wyeth's drawing of the turkey buzzard (Figure 7.16) should be examined closely. The large outer flight feathers are called *primaries;* the slightly smaller flight feathers next to the primaries but closer to the body are called *secondaries.* Roughly,

this outer row of feathers is divided in half between the two types, both of which act as the large articulating "fingers" in the beat of the wing. The feather layer above them is made up of the *tertials,* and the *wing coverts* are the smallest layers over the upper wing bone. *Scapular* feathers cover the shoulder and fold over the closed wing, helping to press it smoothly into the body's contour. All these feather types can be clearly seen

in Wyeth's drawing. The wing, in cross-section, looks like the following:

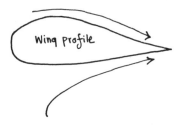

It is a shape that has long been copied by aeronautical engineers because it offers maximum lift of the wing.

Exercise 7

DRAWING BIRD WINGS AND FEATHERS

(Time: no requirement. Materials: no requirement.)

Copy the drawing by Wyeth (Figure 7.16), closely observing how he defines each feather and its central shaft, and then label (if you wish) the different feather types. Or copy the studies by Tunnicliffe (Figure 7.13), noting the difference between the buzzard and the whimbrel. The buzzard needs large, wide wings for aerial gliding, whereas the whimbrel, a distant migrator, needs long and narrow wings that can agilely maneuver and can sustain endless miles of flapping. If you have access to a mounted bird skin with outstretched wings or even to a pigeon being used for lab work, seize the opportunity for a close study drawing of just the wings.

Feathers must be insulators from heat and cold, water resistant, flexible yet strong, and be light weight. If you pull the individual "hairs" of a feather apart, you will see that they are lined with tiny barbs that lock the hairs together, forming a solid surface. Birds spend hours "preening" their feathers to realign these hairs, to clean them, and to add a waterproofing oil, found at the base of their tails. The feathers of wing and tail are designed as instruments of flight, to be stiff and large. The smaller, downy feathers of body and head are designed as insulators, to be soft and compress into numerous layers.

BEAKS (OR BILLS)

Knowing the use of a bill will help you to draw the right bill on the right bird. Waterfowl, for example, have long, flat bills for sifting through surface vegetation or for grasping firmly at fish and crustaceans beneath the water. A heron's bill is long and pointed for quickly spearing an unsuspecting fish. A warbler's is thin and small for catching insects, and a finch or cardinal has one adapted for crushing hard seeds. In part because of this adaptive feature, finches and cardinals can survive our northern winters when insects no longer abound.

Exercise 8

DRAWING BIRD BEAKS

(Time: no requirement. Materials: any HB or 2B pencil and any drawing paper.)

From a field guide, copy just the head profiles of six or seven birds with contrasting beaks. Label underneath the bird, its habitat (land, water, marsh, and so on), and what its food might be, judging by the shape of the bill. These can be simple, small diagrams.

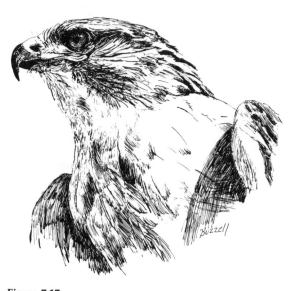

Figure 7.17
RUSS BUZZELL
Hawk
Courtesy of the Massachusetts Audubon Society

Study the shape and placement of the eye, with its heavy lid and the sharply curved bill. Note also the way the artist has described the feathers.

FEET

Like beaks, feet are designed to best service the bird in its environment. Most birds have scaly, hairless feet well insulated against heat and cold. Some birds, such as grouse, owls, and some hawks will have "pantaloons" of feathers covering much of their legs. In most species, toes (whether webbed or not) are placed three in front and one in back, to maintain balance, and have long toenails that both grasp and cling. (Woodpeckers and parrots are two types of birds with two toes in front and two behind.) Birds that must perch in trees for periods of time have a tendon that locks their feet automatically to the branch as they land, so that when they sleep or if the limb moves, they will not easily fall off. Ducks, geese, and loons have thick legs with webbed feet, which are set far back on the body

to serve as sturdy paddles. Hawks and owls have thick taloned claws for grasping at prey while still in flight. Herons and shorebirds have long, thin legs with splayed toes for careful balancing while they wade through shallow waters. When you draw the legs, be sure to include the joints so it looks as if the bird can bend them.

TECHNIQUES FOR DRAWING A BIRD

Each artist has a certain style and method of depicting birds that suits his or her purpose and interest. Some lean toward naturalism, some toward artistry. Some prefer the freer field sketch or painting, some the detailed portrait. The Amer-

Figure 7.18
ROBERT GILLMOR (British, 20th century)
Wren Singing (pen and ink)
Printed as a Christmas card for the British Trust for Ornithology. Courtesy of the artist and the British Trust for Ornithology.

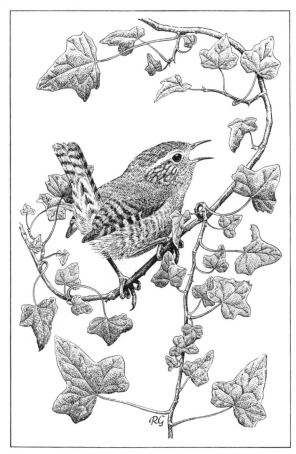

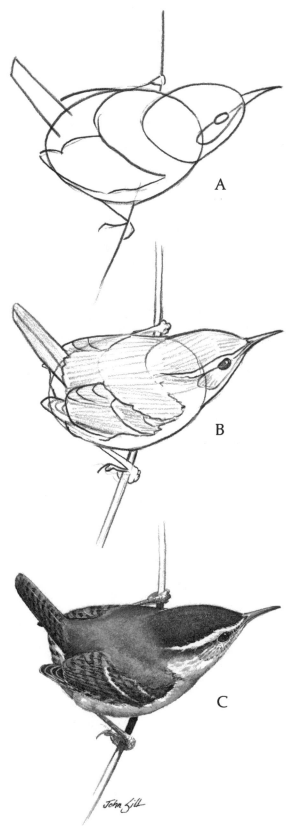

Figure 7.19
JOHN SILL (American, 20th century)
Carolina Wren (two working sketches and the final watercolor done in black and white pigments)
Courtesy of the artist

ican bird artist John Sill specifically drew for this book the stages he uses when laying out a painting (Figure 7.19), from simplified geometric shapes to final placement of detail. (Of course, what cannot be seen are the hours of field observation that went into making this such an exceedingly lively bird.) Whether you follow his method or not, it is valuable to see how one artist proceeds. In speaking of his work, Sill comments that his desire is to "remain the observer; to attempt as much as possible to depict the bird in all its wildness, without interference of the human." (Personal communication, 1979.)

As with drawing anything, start lightly. Even do a page or two of warm-up, gestural sketches until you are seeing the bird fully and feeling its shape in your hand. Sketches are particularly important when you are drawing a live bird, because the eye always needs time to begin deciphering what features to record. Notice the types of loose, gestural drawings and partial detail

studies in Figure 7.20. The student had been able to spend some time over several weeks drawing the owl, in addition to having time to observe its behavior and habits in a wildlife sanctuary. The ability to capture character and pose as well as she did is due to the time she allowed for careful watching and continual drawing.

Exercise 9
DRAWING THE BIRD IN DETAIL

(Time: no limit. Materials: soft pencil, good drawing paper, pencil sharpener.)

Read through the sections following this exercise, and look at Figures 7.19, 7.20, and 7.21. Then, whether drawing from a photograph, study mount, or the live bird, proceed to do a drawing that takes no more than one hour to complete. Do two or three smaller light sketches first, either under your drawing or along the side of the page, for a sense of subject and desired pose. It is advisable to make a drawing no larger than six inches from a subject that clearly shows all details.

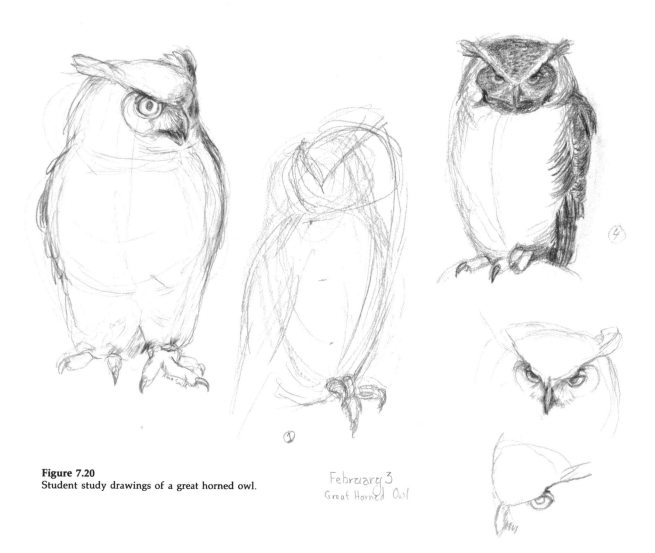

Figure 7.20
Student study drawings of a great horned owl.

February 3
Great Horned Owl

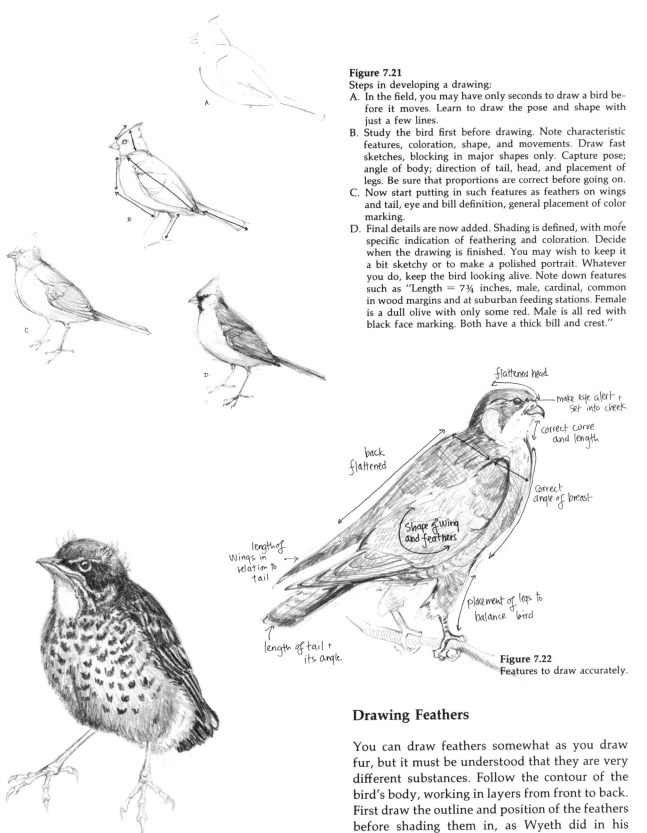

Figure 7.21

Steps in developing a drawing:

A. In the field, you may have only seconds to draw a bird before it moves. Learn to draw the pose and shape with just a few lines.
B. Study the bird first before drawing. Note characteristic features, coloration, shape, and movements. Draw fast sketches, blocking in major shapes only. Capture pose; angle of body; direction of tail, head, and placement of legs. Be sure that proportions are correct before going on.
C. Now start putting in such features as feathers on wings and tail, eye and bill definition, general placement of color marking.
D. Final details are now added. Shading is defined, with more specific indication of feathering and coloration. Decide when the drawing is finished. You may wish to keep it a bit sketchy or to make a polished portrait. Whatever you do, keep the bird looking alive. Note down features such as "Length = 7¾ inches, male, cardinal, common in wood margins and at suburban feeding stations. Female is a dull olive with only some red. Male is all red with black face marking. Both have a thick bill and crest."

flattened head

make eye alert +
set into cheek

correct curve
and length

back
flattened

correct
angle of breast

Shape of wing
and feathers

length of
wings in
relation to
tail

placement of legs to
balance bird

length of tail +
its angle

Figure 7.22
Features to draw accurately.

Drawing Feathers

You can draw feathers somewhat as you draw fur, but it must be understood that they are very different substances. Follow the contour of the bird's body, working in layers from front to back. First draw the outline and position of the feathers before shading them in, as Wyeth did in his drawing of a buzzard (Figure 7.16). Make the wing and tail feathers large and distinct and the body feathers smaller and softer looking. Use short repeated lines, as in Figures 7.17, 7.18, and

Figure 7.23
RALPH SCOTT (wildlife sanctuary director)
American Robin Fledgling (soft pencil)
Courtesy of the artist

Sketched from life.

7.23. Whether you believe in detailing each feather or indicating the overall impression, be certain you know the anatomy.

Drawing the Eye

Setting the alert glint in a bird's eye helps bring it to life, perhaps more than does posture. The glint is the small dot that comes from light reflecting off the curved lens. Without that white spot, an eye looks flat and dull. With it, you can help set the tilt of the head as well as the character of the bird. Look at the eyes in Figures 7.17, 7.18, and 7.23, noticing how the white highlight enlivens the bird's expression. Knowing where to put the spot in (on top, near the back, or in the center of the eye) is determined by the angle of the head and the direction of light hitting the eye. Draw in the shape of the highlight and then darken the eye all around it, leaving it blank. Or a glint to the eye can be added later with a dab of something like white typing correction fluid or white paint.

Of course, the size of the bird's eyes varies by species. Note the heavily lidded eye of the hawk in Figure 7.17. (Perhaps the lid acts as a visor against the glare of the sun.) Owls' eyes are large and suited for night vision; their frontal

placement allows for the depth perception other birds lack. When you are drawing the eyes, be sure to set them just above the cheekbone and just beyond the end of the beak opening, as in Figure 7.24. Many students set the eyes too far up or down on the head.

PLACES AND RESOURCES FOR DRAWING BIRDS

Sketching Birds in the Field

I have mentioned previously ways to sketch birds outdoors. Quick line studies of overall posture and gesture are about all that you can get down on paper. Keep them small, several to a page, and try to note location, activity observed, date, and species. Try to capture the energy and alertness of the bird as if it were about to fly off, turn its head, or bob its tail. This sense of a bird's being cannot be so well studied from photographs, from skins, or even from a bird in captivity. However, since most often in the field the bird will be no closer than twenty yards, detail will be next to impossible. Field sketching can be compared to writing poetry. You need to use as few lines as possible to describe the most expressive gestures. Go toward simplicity, not complexity.

Keep drawing equipment to a minimum so that if a bird flashes into view, you can grab for what you have and not fumble about unnecessarily for just the right pencil, which then must be sharpened. For this reason, I will often use a felt-tip pen or mechanical pencil whose point is always sharp and will not break. Have along a day pack to carry such things as binoculars, an 8-by-11-inch or smaller sketchbook, several drawing tools, a sharpener, an eraser, and a field guide if you wish.

The studies of barn swallows (Figures 7.25 and 7.26) are a good example of field sketches, which were refined later indoors. Observe how the artist has concentrated on depicting different behavioral postures in each study, seeking to understand the bird in activity. As the swallow moved, Morrison redrew its pose, noting the changed tilt of the head or the varied shift of a wing beat. The birds are drawn small and with minimal detail and tonal modeling.

important distance proportions

Watch carefully how bill or beak curves back into cheek

eye sets into upper curve of the cheek

all birds have some form of cheek, sometimes partially delineated by an eye streak. Proper placement of cheek will help to set proper placement of the eye.

cheek patch continues curve from bill, back through eye, to form face marking of house sparrow

adding a highlight to the eye gives it life. Note carefully where light hits, to correspond with angle of the head

house sparrow

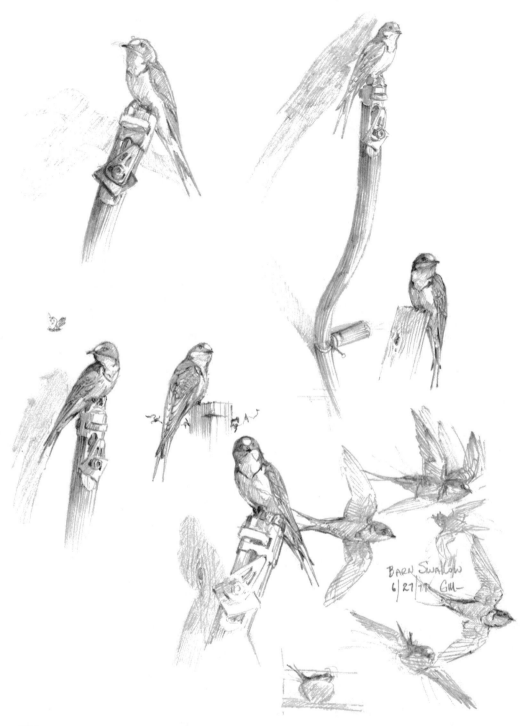

Figure 7.25
GORDON MORRISON (American, 20th century)
Barn Swallow (HB pencil)
Courtesy of the artist

In looking for a suitable subject, the artist watched for an interesting pose of a
barn swallow, finally choosing the one in the upper right. He then lined a frame
around it to see how it would set. It soon became the painting.

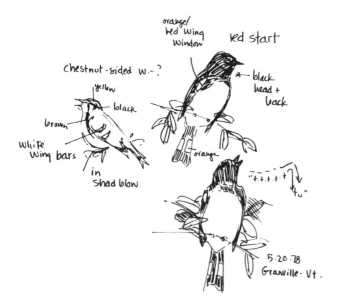

Figure 7.26
CLARE WALKER LESLIE

Looking up at warblers in the shadows of leaves.

Figure 7.27
CHARLES F. TUNNICLIFFE (British, 20th century)
Sketchbook Page of a Curlew and Red-Breasted Goose at the Zoo
Courtesy of Victor Gollancz, Ltd., London on behalf of the artist

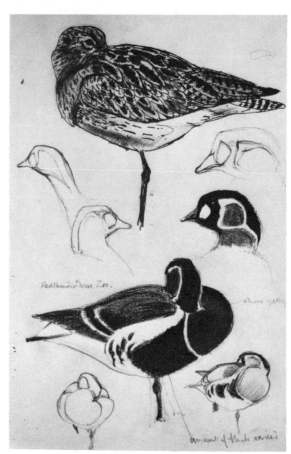

Drawing from Photographs

As in other aspects of drawing nature, photographs of birds can be of great advantage or disadvantage. Always choose a photograph, whether black and white or in color, that clearly shows all features of the bird and does not deceptively foreshorten or cast confusing shadows. Photographs are used to provide studies of live birds in active poses that cannot be carefully observed when the bird is hopping about. But these poses can be deceptive. A wing appears bent in flight when actually light is hitting it, or the bird has briefly moved into an uncommon position. Always try to work from several photographs of the same bird for a more complete image. Collect pictures from magazines or newspapers and set up your own file of drawing resources.

Drawing Birds at the Zoo, Farm, Wildlife Sanctuary, or Duck Pond

Birds that are raised in captivity will not display the same movements of flight, food foraging, courtship, or predator wariness that make up the wild bird's repertory. Yet captivity is an invaluable opportunity to study wild birds at close range that one might never see otherwise. The two study pages (Figure 7.27) of the falcon and the red-breasted goose and curlew were probably made from captured birds (the latter page says "zoo" after the name of each bird.) Note the sequences of drawings, the parts drawn, and the simple shapes used to describe each bird. Tunnicliffe was a master at this type of close study exercise. Balance your sketches between brief and lengthier poses, when the bird is active or is sleeping.

Carry minimal and portable equipment similar to that suggested for sketching birds in the field. Bring a firm backing for your paper, if you are using loose sheets, and have several clips to keep your papers from flapping in the wind.

Drawing Birds from Museum Dioramas, Mounted Specimens, or Study Skins

Take advantage of all opportunities to draw birds. You may even find someone who raises ducks

or chickens, has a parakeet, or keeps a "hospital" for wounded wild birds. Pet stores sometimes have birds other than parakeets. Take a sketch pad to a science museum to draw the birds in the dioramas or display cases. By the way, this is also an excellent place to find skeletons to draw. Just remember, do not become frustrated if these field sketches are rough and not as proficient as you would wish. All of this takes time, practice, and a lot of looking.

Biology departments or nature centers may have birds that have been stuffed and mounted into lifelike poses. Although these can be quite old, dusty, and a bit misshapen, they provide opportunity for a close look at details. Since taxidermists were not always familiar with bird postures, some specimens may not be in truly appropriate poses. Recognize as well that the live bird would have all its feathers aligned and, of course, would not have glass eyes. Choose first the birds you already know, using this chance principally to study an individual close up from various angles. Do *not* try to pass off this study as a drawing of the live bird. Any discerning eye can quickly tell the difference.

ASPECTS OF BIRDS TO STUDY

Drawing to Understand Behavior

One of the intriguing things about watching birds is that we can follow their activities and behavior more readily than we can other animals that tend to be more secretive in their ways or to be more active at night. In the spring, establishment and defense of territory, singing, courtship, mating, nesting, and rearing of young can all be fairly easily observed with the more common birds.

In the summer, nesting and rearing of second or delayed broods take place. Pairs are bonded, and you can watch their activities together and with their young. Songs become quieter now that the flurry of courtship is over, and the birds are mostly maintaining territories for rearing young, foraging for food, and enjoying the summer days. Some relatively common birds to watch are the house and song sparrows, starlings, robins, swallows, crows, mockingbirds, and blue jays.

In the fall, birds become restless. Breeding and rearing of young is over. Pairs disband, flocks reassemble, and the long migration south for many birds begins. The birds that stay or have migrated from further north to settle in for the winter have adaptations to survive the cold.

In the winter, activity centers around food and shelter. Birds must be continually feeding to keep up their body heat. Some may gather in small flocks to share the shelter and food. This is true of both water and woodland birds. If you have groups of birds at a feeder, such as chickadees, juncos, or blue jays, watch and then draw their behavior. Who is dominant? What postures are taken? Who stays on the ground to catch fallen seed? If you live near an open freshwater

Figure 7.28
JOHN GUILLE MILLAIS
Goldeneye (gouache on paper)
Courtesy of the Glenbow Museum, Calgary

In early spring, certain waterfowl begin their courtship activities. Displays of dramatic behavior such as these can be seen along the salt-water coasts or inland bays where these birds winter. Millais has described four distinct behavior poses: submitting female in upper right, competing males in upper left, flirting male displaying neck and splashing foot, flirting male displaying full breast and body toward the waiting female.

Figure 7.29
NED SMITH (American, 20th century)
Life Along an Old Fencerow (Song Sparrow)
Copyright 1974 by the National Wildlife Federation. Reprinted from the June-July 1974 issue of *National Wildlife* Magazine.

The artist describes not only what a song sparrow looks like but also something of its habitat and behavior. We can learn that sparrows live in open fields where goldenrod grows. They apparently catch grasshoppers, judging by the cocked head and watching gaze at the stilled insect beside it.

pond or saltwater bay, watch and draw the intermingling groups of black duck, goldeneye, and eiders.

In each season—whether you are by the ocean watching gulls, in the mountains watching hawks, or by a tree watching a nuthatch—draw to describe a particular activity of that bird or birds. Include a bit of the background to help set the bird or birds into a specific location. Look at Figure 7.29: Not only does the artist describe what a song sparrow looks like, he relates something of where it lives and what it eats. This is also the case in Figure 7.31, where a specific behavioral activity is occurring between gulls and cormorants.

Draw birds in groups, for example, a parent with young; a small group of mixed species feeding on a beach or in a park; or a small flock of similar species in a tree, on a phone wire, or feeding in an open field. Learn why certain species can feed together without fighting and others cannot.

Birds in Flight

To draw birds in flight it is necessary to spend time looking at a skeleton and at a wing stretched out on a study specimen. Know the structure and parts that make up a wing and you will understand better how it works. Also, spend time just watching birds fly. A good place to go is to a harbor where there are fishing boats and thus lots of foraging gulls, to any open field where small woodland birds and hawks pass by, to a city park where there are pigeons, house sparrows, or starlings fluttering about, or to a nearby pond where there are ducks and small marsh birds. Photographs can be helpful, but remember, they have caught one instant out of many and your need is to show a more generalized posture.

Do not attempt any detail of individual feathers but see the simplified geometric shape of each wing. Is it fully stretched out for landing? Is it curved out for an up beat or bent over for a down beat? You might even copy the wing positions of the geese in Figure 7.15 to see how shapes can vary in the rotation of the wing. Look at the gulls in Figure 7.31. How simple are the body and wing shapes, and yet action has been convincingly described. The success of drawing a bird in flight has a lot to do with knowing what geometric shape the wings make as they

Figure 7.30
ROBERT GILLMOR (British, 20th century)
Little Ringed Plover Family (watercolor)
Reprinted from the calendar "British Wildlife." Courtesy of the artist and Penna Press, Ltd.

Figure 7.31
CHARLES F. TUNNICLIFFE (British, 20th century)
Sketchbook page of gulls and cormorants
Courtesy of Victor Gollancz, Ltd., London on behalf of the artist

Tunnicliffe records at the bottom of the page: "Cormorant fishing. Kept coming to the surface with fish. Gulls hovering about and attempting to take the fish everytime the cormorants broke surface. Cormorants jabbed at the gulls in annoyance. June 1st."

Figure 7.32A-B
J. FENWICK LANSDOWNE (Canadian, 20th century)
Short-Eared Owl (sketch and finished painting)
Reprinted from *Birds of the West Coast* by J. Fenwick Lansdowne, with permission of Houghton Mifflin Company, Boston

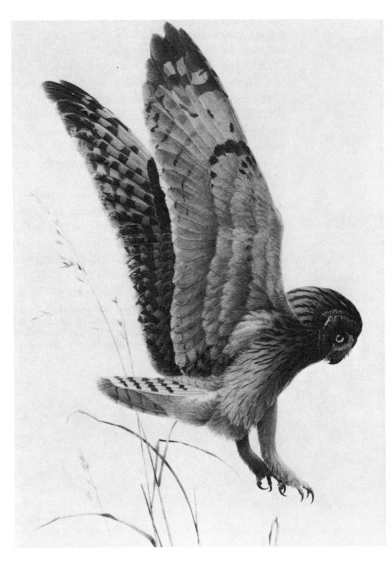

angle out from the body and what suggests movement and lift. Understanding the curve of the body, head, and tail is also important.

Take time to study the preliminary sketches in Figure 7.32. With few lines the artist has convincingly described the essence of strength and aggressive action. Note the loose, open lines he used, not taking time to erase but simply reworking a line that was not appropriate.

Consider also drawing birds in flocks. There is a phenomenon which is intriguing to watch when birds gather in flight groups. How do they all move and turn together in such synchronization? Who knows to lead and who to follow?

What determines the flying distance between individuals? There somehow arises an overall harmony of flight pattern and purpose. Birds to watch in flocks are migrating waterfowl in a low line formation over open water, geese flying high in a wedge formation, or cowbirds and blackbirds in thick flocks hovering over open pastures.

Types of Birds

WATERFOWL

Waterfowl is another name for fresh- and saltwater ducks and geese, although there are many birds that inhabit watery environments. These all belong to the order *Anseriformes,* having in common webbed feet, aquatic habits, long necks, flat bills, narrow, pointed wings, and a diet of small water plants and animals. Go to a pond, lake, marsh, or seacoast and you will find wild ducks in both summer and winter. In the fall, the freshwater ducks will leave inland ponds and lakes when they ice over to fly far south to open water or to join their saltwater relatives along the winter seacoasts. Ducks and geese have stocky builds and generally more flesh than other birds, which may help buoy them up in water, insulate them against cold temperatures, and power their long-distance travel.

See the goldeneye's plump breast, paddle-shaped bill, and heavy body in Figure 7.28. When you are drawing a duck in water, really set it into and beneath the surface. Draw reflections or ripples and have the breast fully jutting out

Figure 7.33
Diagram of a duck in water

Notice oval head and cheek, head set into the breast, breast curved out into the water. Make the bird really sit *in* the water. Adding ripples and reflections helps. Check carefully angles, curves, and correct proportions of each body part. Again, make the bird look alert.

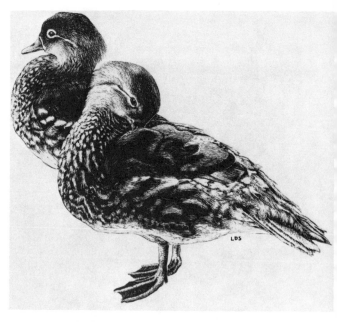

Figure 7.34
LEE SALBER
Two Female Wood Ducks (scratchboard)
Courtesy of the artist, editor of *Ducks Unlimited* Magazine

beyond the head (see Figure 7.33 for some diagrammatic suggestions).

The artist of Figure 7.34 is editor of *Ducks Unlimited,* a magazine published by Ducks Unlimited, Inc., a national organization dedicated to the conservation and propagation of North American waterfowl. As hunter and artist, Lee Salber has spent much time watching ducks, which shows in the sensitive way he has captured the expression and pose of the two birds. Salber says of his painting: "People unfamiliar with hunting would probably fail to make any connection between it and art, for they tend to see the sport only in terms of harvesting animals. . . . A hunter must have an intimate understanding of the game he pursues. The thousands of hours I have spent in the field over the years are not only valuable in developing hunting prowess, but contribute, through observation, to accurate wildlife sketches. . . . Hunting also provides the opportunity for a sportsman/illustrator to handle an animal where unfaded colors and bone structure can be observed first hand." (Personal communication, 1979.) Since hunting is an issue of considerable debate, try to separate the politics and ethics of the sport from the many contributions to wildlife art made by artists who were also hunters.

BIRDS OF PREY

Birds in the order *Falconiformes* (vultures, hawks, and falcons) and *Strigiformes* (owls) have characteristics in common: large, heavyset builds;

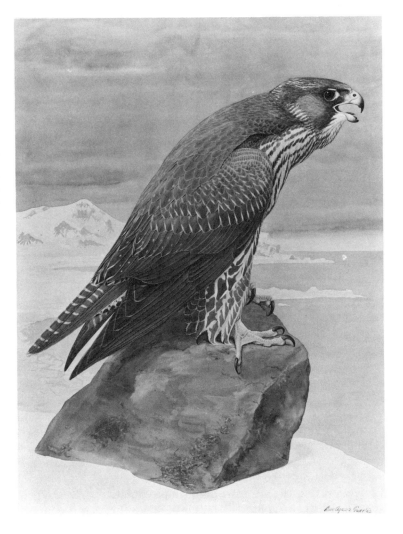

Figure 7.35
LOUIS AGASSIZ FUERTES (American, 19th-20th centuries)
Gyrfalcon (watercolor on paper)
Courtesy of Glenbow Museum, Calgary

Fuertes was influential in loosening the Audubon tradition of painting, introducing a freer brush technique and a more naturalistic way of depicting birds. Much of this style resulted from his long hours of field work, doing small watercolors of birds on the spot.

compact, flat heads; large eyes; hooked bills; and large, taloned feet for grasping at their prey of small animals. In drawing the falcon group, study the following examples: Figures 7.1, 7.17, 7.22, and 7.35. Pay close attention to the beak, shape of the head, position of the eye, and pattern of the feathers. Decide whether you want a detailed portrait or a looser sketch.

For drawing owls, see Figures 7.20 and 7.32. Owls' feathers have a particular feature unique to their family. In addition to being subtly camouflaged to blend into woodland foliage, they are particularly designed to make no sound as the bird flies. Each feather is coated with an extra layer of downy hairs which prevents the whistling or flapping noise so often associated with other birds. Even the feet are covered with feathers.

Often, an excellent way to learn how to draw birds is to study other artists' techniques and even to copy them for new methods. Copying is valid if it is not done extensively (or ever passed as one's own work). It was a common practice among the early masters in order to learn from their elders. For example, many of the works of the young Degas are exact copies of Rembrandt's and Michelangelo's drawings. You might find it helpful to copy the drawings in this and other chapters. You might also want to note an artist's name and locate more of his work in other sources. Do not hesitate to balance your own drawing of a subject with a study of how others have drawn the same.

PERCHING BIRDS

All those birds that perch (alight and cling onto tree perches) are grouped in one order, *Passeriformes;* this is the largest order, comprising twenty-five different families. All are medium to small land birds whose feet are adapted to cling firmly onto branches; they are noted songsters, eat mostly insects and seeds, and can live

Figure 7.36
RUSS BUZZELL
Eastern Red-Winged Black Bird (pen and ink)
Courtesy of the Massachusetts Audubon Society

in just about any habitat. Swallows, crows, thrushes, wrens, and sparrows are in this group.

Because their bodies are small and lack a distinctive outline, they may at first seem harder to depict than the larger birds. You might want to begin by using either the method the artist used for Figure 7.19 or my method in Figure 7.21. Whichever you choose, start with simple shapes and progressively build up detail. Begin with the body in the shape of an egg; then add tail, head, wings, and legs in simple geometric shapes, depending upon the angle at which you see them. Since the tail helps to balance the bird, it should be placed carefully to give that effect. Notice in Figure 7.36 that the tail is down to help brace the bird as it thrusts its body and head forward.

STUDYING THE WORKS OF OTHER ARTISTS

The field of bird art has changed a great deal since the days of John James Audubon. In the eighteenth and nineteenth centuries, artists had no binoculars, photographs, or museum specimens to work from, and means for preserving were extremely crude. All subjects that were drawn had first been shot, so artists had but a limp specimen in front of them, with only the memory of it alive in the field. They would do their best to wire the bird into a reasonably life-

like pose, but these postures were understandably stiff and unnatural.

Although there were many other talented and well-known bird artists during his time, Audubon is best remembered because he brought to the field a novel way of depicting birds. All were drawn life-size (even the swans and vultures) and were published life-size in his *magnum opus, Birds of North America* (see Figure 7.37). Birds were placed in more characteristic postures and in settings that described something of the species' environment. For the first time, people could view bird paintings not as mere portraits but as visual records of avian natural history and behavior.

However, bird painting had some years to go before it became more naturalistic. In this country, it was Louis Agassiz Fuertes (Figure 7.35) over fifty years later who helped encourage artists to draw the bird as seen in the field, often including a whole landscape as background. Binoculars had been invented, techniques for collecting and preserving specimens had become more sophisticated, and natural history museums had been established. Thus, artists such as Fuertes were given greater public support for their paintings and field research.

Since the time of Fuertes, there have been very talented painters throughout the world. In this country, look for works by such artists as George M. Sutton, Don Eckelberry, Roger Tory Peterson, Maynard Reese, Francis Lee Jaques, Arthur Singer, and Guy Tudor, to name just a few. Take note also of the artists in this chapter who have come from Europe and Canada and who are among today's leading bird artists. Unfortunately, it takes some hunting to find their published works. Drawings of birds can be found as illustrations to books on natural history, and of course, specifically those on birds. There are a few monographs published on the works of several of these artists (see the bibliography to this chapter). Unfortunately, few art museums yet carry their works unless they happen to have a special exhibition on bird art. Science museums and nature centers are more likely to exhibit these artists. There are several nature magazines which will often carry such illustrations, for example, *National Wildlife, Audubon, Defenders of Wildlife, Nature Canada,* and *The Conservationist* (see Bibliography).

You will find that the best course for learning to draw birds is one you design yourself.

Figure 7.37
JOHN JAMES AUDUBON (American, 18th-19th centuries)
Blue Jay—1825 (watercolor on paper)
Courtesy of The New York Historical Society, New York City

When this watercolor was reproduced as an engraving in *Birds of America,* Audubon remarked in the caption: "Who could imagine that a form so graceful, arrayed by nature in a garb so resplendent, should harbour so much mischief;—that selfishness, duplicity, and malice should form the accompaniments of so much physical perfection."

Figure 7.38
ISSAI (Japanese)
A Bantam Cock (brush and ink)
Courtesy of the Museum of Fine Arts, Boston

Whatever your purpose, try to center your study on four topics: learning the bird in its native habitat; learning something of its anatomy, behavior, and physiology; learning something of its life history; and learning the techniques for drawing it. Above all, learn to enjoy just watching birds, taking time to be with them in the fields and woodlands during any season.

In conclusion, consider for yourself whether or not you would agree with the comment made by John Busby about his own work: "I try to convey a sense of encounter and the drawings are as much about the experience of watching as they are about birds themselves. I much prefer

the reality of a living bird to its idealized image in most bird books." (Personal communication, 1979.)

BIBLIOGRAPHY

DARLING, LOIS, and DARLING, LOUIS. *Bird.* Boston: Houghton-Mifflin Company, 1962. (HB) (A delightful text, readable and informative for the novice. Illustrated by the authors.)

HOCHBAUM, H. ALBERT. *Travels and Traditions of Waterfowl.* Minneapolis: University of Minnesota Press, 1956. (PB) (Fascinating and well written.)

JAQUES, FLORENCE P., and FRANCIS LEE JAQUES. *Artist of the Wilderness World.* New York: Doubleday and Company, 1973. (HB) (Paintings by the artist.)

LANDSDOWNE, JOHN FENWICK. *Birds of the West Coast.* Boston: Houghton-Mifflin Company, 1976. (HB) (Paintings by the artist.)

MARCHAM, FREDERICK G., editor. *Louis Agassiz Fuertes and the Singular Beauty of Birds.* New York: Harper and Row Publishers, 1971. (HB)

MATTHIESSEN, PETER, PALMER, RALPH S., and CLEM, ROBERT V. (illustrator). *The Shorebirds of North America.* New York: Viking Press, 1967. (HB) (Superb paintings and drawings of shorebirds.)

NORELLI, MARTINA R. *American Wildlife Painting.* New York: Watson-Guptill Publications, 1975. (HB) (Concentrates on the works of several early American naturalist/artists, ending with Louis A. Fuertes.)

PETERSON, ROGER TORY. *A Field Guide To The Birds.* Boston: Houghton-Mifflin Company, 1947. (PB)

————— *A Field Guide To Western Birds.* Boston: Houghton-Mifflin Company, 1961. (PB)

ROBBINS, CHANDLER S., and SINGER, ARTHUR. *Birds of North America.* New York: Golden Press, 1966. (PB)

WELTY, JOEL CARL. *The Life of Birds.* Philadelphia: W. B. Saunders Company, 1962. (HB) (Good college ornithology text.)

Journals and Catalogues

Art for Collectors, a catalog of wildlife paintings for sale at Mill Pond Press, Inc., 204 S. Nassau St., Venice, Fla. 33595.

Audubon, published by the National Audubon Society, 950 Third Ave., N.Y., 10022.

The Conservationist, published by the New York State Department of Environmental Conservation, 50 Wolf Rd., Albany, N.Y., 12233.

Defenders, published by The Defenders of Wildlife, 1244 19th St., Washington, D.C. 20036.

Ducks Unlimited, published by Ducks Unlimited, Inc., P.O. Box 66300, Chicago, Ill., 60666.

National Wildlife, published by National Wildlife Federation, 225 E. Michigan, Milwaukee, Wisc., 53202.

Nature Canada, published by the Canadian Nature Federation, 75 Albert St., Ottawa, Canada K1P6G1.

The Laboratory of Ornithology at Cornell University offers a correspondence course as a college-level introduction to ornithology. It has been recommended as very worthwhile. For information, write to Laboratory of Ornithology, Cornell University, 159 Sapsucker Woods Rd., Ithaca, N.Y. 14853.

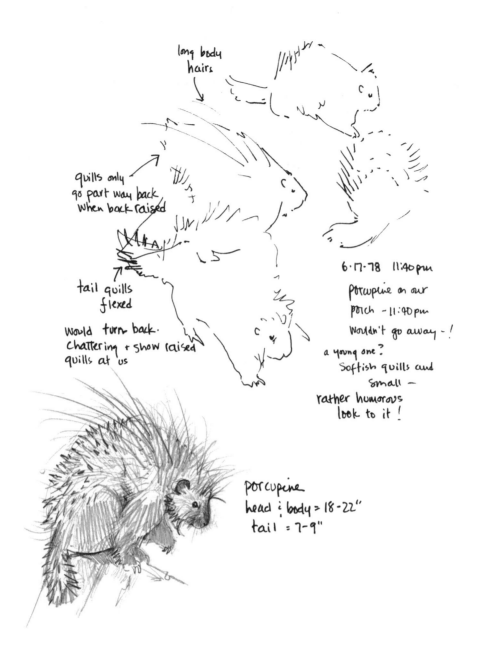

long body
hairs

quills only
go part way back
when back raised

tail quills
flexed

Would turn back.
chattering + show raised
quills at us

6·17·78 11:40pm

porcupine on our
porch – 11:40pm
Wouldn't go away –!

a young one?
Softish quills and
small –
rather humorous
look to it!

porcupine
head + body = 18-22"
tail = 7-9"

Y OU MUST WALK sometimes perfectly free, not prying nor inquisitive, not bent on seeing things. Throw away a whole day for a single expansion, a single inspiration of air. . . . You must walk so gently as to hear the finest sounds, the faculties being in repose. . . . Nature will bear the closest inspection. She invites us to lay our eye level with her smallest leaf, and take an insect view of its plain.

Henry David Thoreau

Keeping a sketchbook of in-the-field notes and quick drawings can be as valuable for studying nature as your drawing pad. The basic difference is in purpose and approach. Field drawings are *sketches* and should not be viewed as finished *drawings.* Sketching, or quick drawing, is used here more as a tool for recording what you notice as interesting. The subject itself holds more significance than the way in which it was recorded.

When used for observing an event in nature, a drawing becomes the tool, or *process,* for learning about natural history. It is *not* the *product* for displaying how well you can draw. Recognizing the difference between drawing and sketching, as defined here, is extremely important when ap-

CHAPTER EIGHT

Keeping a field sketchbook

proaching this type of study. You can keep a field sketchbook without knowing much about drawing technique. You can use it to help learn about the progressions, cycles, and inhabitants of the natural world, aspects that become less evident when the subject becomes an isolated study for learning drawing technique.

Keep a field sketchbook as a running journal of what you have observed, whether it be daily or weekly, whether it be outside your back door or on a hike, whether your interest lies mainly in insects or plants or in landscapes or wildlife. I keep each of my journals for one year, observing

principally the natural events in the two environments in which I live: A city in Massachusetts and a rural landscape in Vermont. Limiting observation to just a few habitats helps to focus and add depth to your study; and turning back in summer to see what was happening in winter can be a fascinating way to recognize how seasons and their activities progress.

Field sketching offers a method of observing nature that can be more immediate and direct than is the more technical study of the drawing pad. Some of my best field sketches were made while I was so involved in looking that the draw-

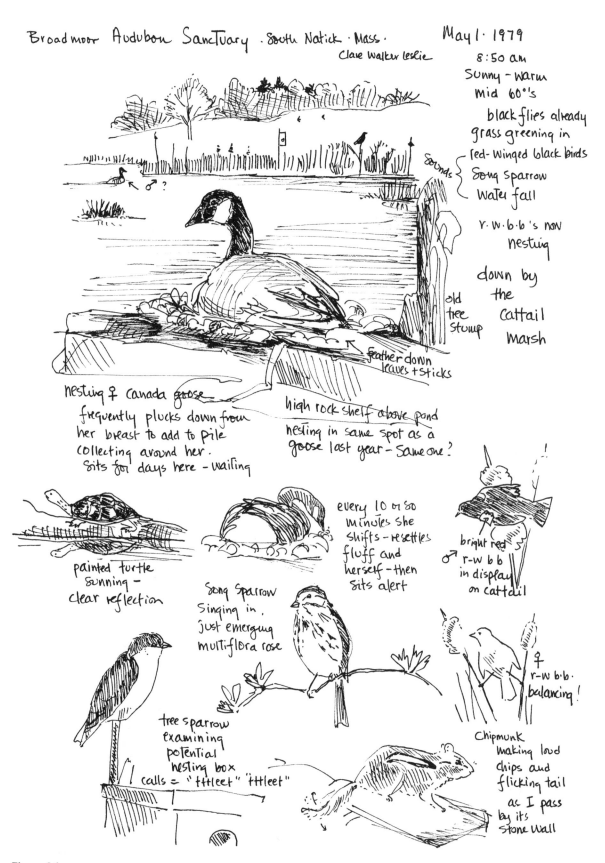

Broadmoor Audubon Sanctuary · South Natick · Mass.

May 1 · 1979

Clare Walker Leslie

8:50 am
Sunny - warm
Mid 60°'s
black flies already
grass greening in
red-winged blackbirds
Song Sparrow
Water fall
} Sounds

r.w.b.b.'s now
nesting

down by
the
Cattail
Marsh

old
tree
stump

Feather down
leaves + sticks

nesting ♀ Canada goose
frequently plucks down from
her breast to add to pile
collecting around her.
Sits for days here - waiting

high rock shelf above pond
nesting in same spot as a
goose last year - same one?

painted turtle
sunning -
clear reflection

Song Sparrow
singing in,
just emerging
multiflora rose

every 10 or so
minutes she
shifts - resettles
fluff and
herself - then
sits alert

bright red
♂ r-w b b
in display
on cattail

♀
r-w b.b.
balancing!

tree sparrow
examining
potential
nesting box
calls = "tttleet" "tttleet"

Chipmunk
making loud
chips and
flicking tail
as I pass
by its
stone wall

Figure 8.1

160

ing took care of itself, capturing a freshness of observation so often lost when one is drawing more consciously. A student, an experienced naturalist who was new to drawing, commented upon returning from an outdoors exercise: "This has finally forced me to sit still long enough to start really looking. Just ordinary things became fascinating, and I noticed things, when I had to draw them, that I had never taken time to examine closely."

The British artist and naturalist David Measures has published his journal of sketches and observations of butterflies in *Bright Wings of Summer:*

Working only out of doors and only from life, my drawings are intended to note activity of the insect rather than make a picture of it. It is neither relevant to make a finished drawing nor is there any need; there are many excellent painted facsimiles. The pleasure is in being outside and taking part in its life and daily experience. A page of notes covering perhaps two hours in time has a strong feel of place and time, even though it consists only of jottings, and a few sketches. . . . They [the drawings] are my ways of recording my response, a form of visual shorthand, and although I hope they convey something of the pleasure and de-

light I have found, I am sure other people find their own ways of recording just as satisfying.*

Keeping a field journal is not novel among scientists or artists. The early naturalist/explorers of this country all kept journals and drawings of their expeditions to collect plants and animals. Before the advent of proper preserving methods, museums to house specimens, or the camera and other recording technologies, the journal was a crucial tool for documenting collected information. For further reading on these early American naturalists, see Joseph Kastner's *Species of Eternity,* or Wayne Hanley's *Natural History in America from Mark Catesby to Rachel Carson.* (Refer to this chapter's bibliography.)

One nineteenth-century artist and naturalist, Ernest Thompson Seton, spent a great deal of time in the upper Midwest and in Canada observing the animals of the mountains and open plains. He based his paintings and the many stories he wrote for children on direct information he had gathered and recorded in his field journals.

* David Measures, *Bright Wings of Summer* (Englewood Cliffs, N.J.: Prentice-Hall, Inc., 1976), p. 15.

Figure 8.2
ERNEST THOMPSON SETON (Canadian/ American, 19th-20th centuries)
Sketchbook page
From *The Worlds of Ernest Thompson Seton,* John G. Samson, ed. Copyright 1976 under the International Union for the Protection of Literary & Artistic Works. Reprinted by permission of Alfred A. Knopf, Inc.

Sketches were made of a red squirrel and a marten from life in Yellowstone National Park. Notice the way the artist used repeated lines instead of areas of tone as a means of shading.

Figure 8.3
WILLIAM HAMILTON GIBSON (American, 19th–20th centuries)
Page from *Sharp Eyes: A Rambler's Calendar of Fifty-Two Weeks Among Insects, Birds, and Flowers* by W. H. Gibson (Harper and Brothers, 1891)

Gibson was a naturalist and artist who wrote several fascinating books about his explorations and discoveries among the everyday occurrences outdoors. Often these earlier books on nature can be good resources for studying ways to keep naturalist journals.

Although somewhat criticized for anthropomorphism, he always claimed that he could prove what he had seen by evidence in his journals. A page from one of his many studies is included in Figure 8.2.

SETTING UP A FIELD SKETCHBOOK

Learning the techniques for drawing natural subjects is very important, but too much theoretical study indoors can divert you from learning how things live and interact in their own habitats. If you are a naturalist learning to draw, do not abandon your study of technique for only field sketching. If you are an artist, you may find that looser drawing is a valuable contrast to your more careful work indoors.

I ask students to have both a field journal and a drawing pad. The journal they use for learning about nature; the drawing pad for learning about drawing. Balance your study by using both. If you find an object such as a seed pod

and wish to make a detailed study of it, do not use the field sketchbook since the paper quality is poor; also any good drawing may suffer the strain of continual transport outdoors. Use instead the drawing pad or another sheet of finer quality paper; then the finished drawing can be safely stored. On the other hand, if you see something such as a raccoon wandering through your back yard, go get your sketch pad. Quickly sketch its gestures of movement, other actions, major color markings, and approximate size. The animal will not wait for you to take the time for a careful drawing. Later, use these sketches in conjunction with photographs and guidebooks for a more thorough study. I rely continually on my field sketches to convey the primary features and behavioral gestures that a photograph cannot provide. Look through the various field sketches in this chapter to familiarize yourself with this type of observational drawing.

Drawing Equipment

1. An 8-by-11-inch *hardbound* drawing notebook. These are also available in smaller or larger sizes in most art or stationery stores. The size suggested fits well into a day pack yet is large enough for medium-sized sketches. Look for the notebooks with the regular, smooth-surfaced, white, bond paper of standard weight. Students have found that some papers blur the ink or do not take a pencil line well because the paper grain is too rough. Since this is a low-grade drawing paper, much erasing or sensitive line and tonal work will not be possible. The major advantage of these notebooks is that they are hardbound, can survive a year's use, have enough pages to last through four seasons, and are not expensive.

Figure 8.4

2. Day pack or carrying bag for keeping equipment together and out of the way.

3. Small waterproof carrying case for pencils (HB, 2B, and an inexpensive mechanical pencil, which is always sharp yet lacks the same quality of lead), eraser of any kind, pencil sharpener or small knife.

4. Six-inch ruler for recording the size of things.

5. Small plastic bags or jars for carrying samples home, *if* collecting is permissible.

6. Small knife for cutting (to avoid tearing) plant material. Always use discretion when collecting anything, and always try to sketch on site rather than to collect.

7. Not essential but nice to have:

• coloring tools: colored felt-tipped pens, crayons, colored pencils (select four or five appropriate colors only), small watercolor set with one or two brushes and a little water bottle for rinsing

• magnifying glass

• binoculars

• field guidebooks; be selective, perhaps taking only a bird and/or wildflower book and saving any other identification for later

What to Draw

Before you go outside or decide which window to watch from, think a moment about *what* you might find to observe. Ask yourself, "What is happening outdoors this time of year? Is it a plant, animal, tree, cloud pattern, or landscape shape

WHILE RED FOXES CAN DIG THEIR OWN DENS IF NECESSARY, THEY PREFER MERELY ENLARGING EXISTING BURROWS, USUALLY THOSE OF WOODCHUCKS.

Figure 8.5
NED SMITH (American, 20th century)
Life in a Fox Den
Copyright 1976 by the National Wildlife Federation. Reprinted from the June-July 1976 issue of *National Wildlife* Magazine.

A field sketchbook page can also be assembled with drawing reworked from earlier sketches done outdoors. Most likely the artist did that here for purposes of clarity in publication.

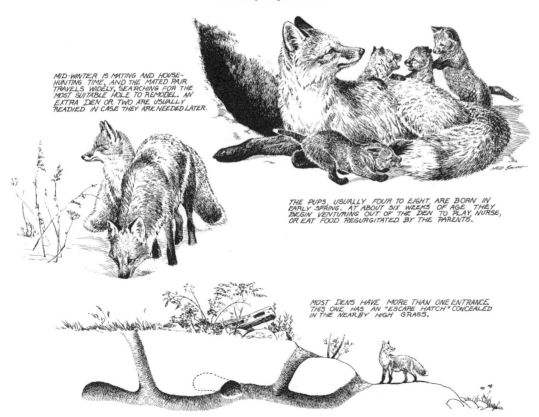

MID-WINTER IS MATING AND HOUSE-HUNTING TIME, AND THE MATED PAIR TRAVELS WIDELY, SEARCHING FOR THE MOST SUITABLE HOLE TO REMODEL. AN EXTRA DEN OR TWO ARE USUALLY READIED IN CASE THEY ARE NEEDED LATER.

THE PUPS, USUALLY FOUR TO EIGHT, ARE BORN IN EARLY SPRING. AT ABOUT SIX WEEKS OF AGE THEY BEGIN VENTURING OUT OF THE DEN TO PLAY, NURSE, OR EAT FOOD REGURGITATED BY THE PARENTS.

MOST DENS HAVE MORE THAN ONE ENTRANCE. THIS ONE HAS AN "ESCAPE HATCH" CONCEALED IN THE NEARBY HIGH GRASS.

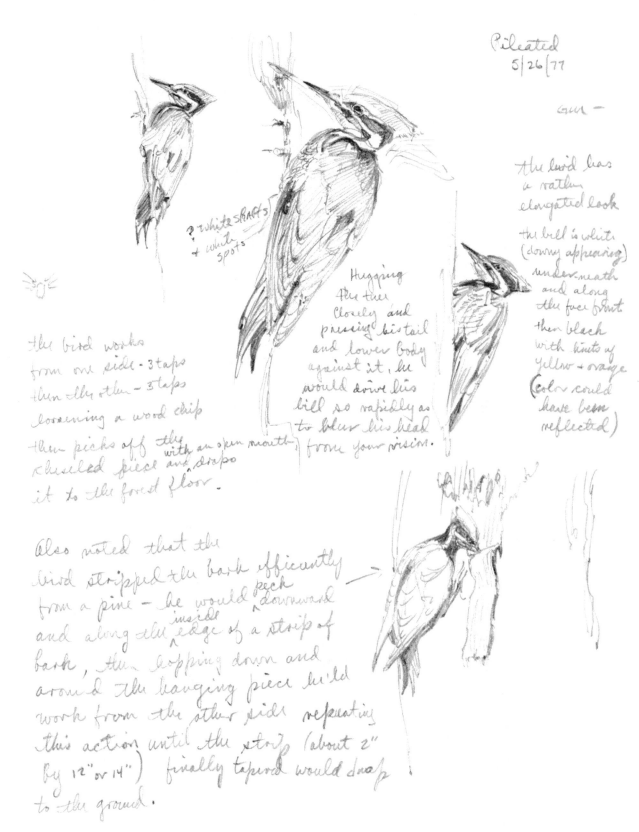

Pileated
5/26/77

Gm —

the bird has
a rather
elongated look

the bill is white
(downy appearing)
underneath
and along
the face front
then black
with hints of
yellow + orange
(color could
have been
reflected)

? white shafts
+ white spots

Hugging
the tree
closely and
pressing his tail
and lower body
against it, he
would drive his
bill so rapidly as
to blur his head
from your vision.

the bird works
from one side - 3 taps
then the other - 3 taps
loosening a wood chip
then picks off the chiseled piece
with an open mouth and drops
it to the forest floor.

Also noted that the
bird stripped the bark efficiently
from a pine — he would peck
downward
and along the inside edge of a strip of
bark, then lopping down and
around the hanging piece he'd
work from the other side repeating
this action until the strip (about 2"
by 12" or 14") finally tapered would snap
to the ground.

Figure 8.6
GORDON MORRISON
Pileated Woodpecker, May 26, 1977
Courtesy of the artist

One subject can be recorded, describing different poses with full recording of
the activity observed.

164

that is interesting to study now? What natural history do I want to learn that is particular to this season?" Did you ever record the stages of tree buds unfolding and wonder about plant growth? Did you ever sketch to learn animal tracks printed across fresh snow? Or did you ever follow the movements of a common house fly across your window and wonder how it clung to the glass? Begin with events as small as these. Do not seek out, and become discouraged in not finding, the big events of nature. They seldom happen. However, there is much to be learned in watching the everyday occurrences.

I stopped one day to look at a grasshopper. Suddenly it began to move its back legs rhythmically up and down across its wing casings. The rasping sound I had been hearing from the tall summer grasses, and had often wondered about, was coming from this small creature. I now did not have to read in a book about how short horned grasshoppers made their noise: I had *seen* it. I went for my journal, and made a brief illustration before the insect jumped away. This is the sort of event to look for, and by recording it, you will have the opportunity to analyze and to remember a natural process. Though small, these events are exciting for the doors they open to learning more about nature. Your learning can be enlarged not only by watching, but also by questioning, studying, and observing what is happening.

Figure 8.7

KEEP SUBJECTS SIMPLE

Keep subjects simple: one plant at a time, one animal, or one tree. Five or six one-to-four-inch drawings can be gathered on a page to document one day's observation. Leave room enough for writing, and make the page visually attractive. Do not tear out pages you do not like, but realize that a sloppy journal will soon not be pleasing either. Use simple lines and avoid elaborate shading. Spend no more than ten minutes on a subject (or until it moves). Speed is an important factor in sketching outdoors. You can always refine or redo drawings later.

WHERE TO BEGIN AND HOW TO START LOOKING

Students who are just starting to keep field journals are overwhelmed by all there is to see;

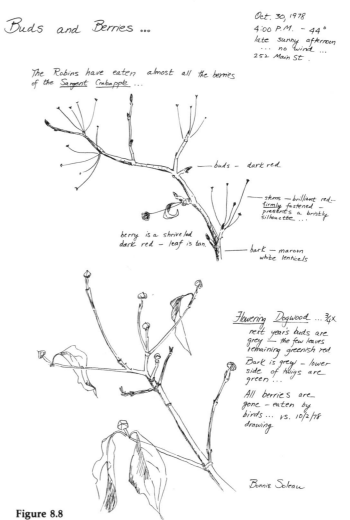

Figure 8.8
Student sketchbook page.

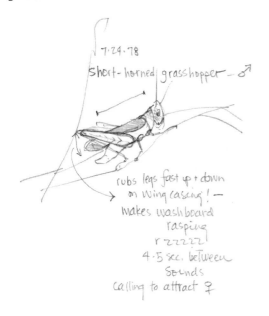

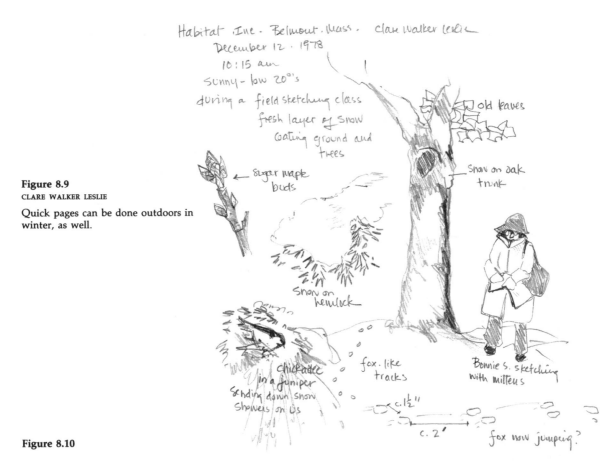

Figure 8.9

CLARE WALKER LESLIE

Quick pages can be done outdoors in winter, as well.

Habitat Inc. Belmont. Mass. Clare Walker Leslie
December 12. 1978
10:15 am
sunny - low 20°'s
during a field sketching class
fresh layer of snow
coating ground and
trees

old leaves

sugar maple buds

Snow on oak trunk

Snow on hemlock

Chickadee in a juniper sending down snow showers on us

fox. like tracks

Bonnie S. sketching with mittens

c. 1½"

c. 2'

fox now jumping?

Figure 8.10

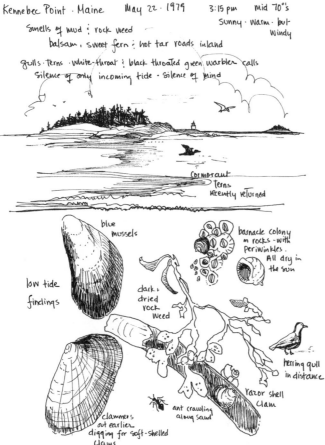

Kennebec Point · Maine May 22 · 1979 3:15 pm Mid 70°'s
Smells of mud & rock weed sunny · warm · but
balsam, sweet fern & hot tar roads inland Windy
gulls · terns · white-throat & black throated green warbler calls
silence of only incoming tide · silence of mind

Cormorant
Terns
recently returned

blue mussels

barnacle colony on rocks - with periwinkles. All dry in the sun

low tide findings

dark & dried rock weed

herring gull in distance

razor shell clam

ant crawling along sand

clammers out earlier digging for soft-shelled clams

nothing stands out. To help them begin I will often set a structure: Find four things that live here and help describe this habitat; four things that characterize this season; or a meadow flower, insect, small branch, or animal evidence. Draw them and learn something new about them.

To begin with writing can help those who find it a more comfortable medium than drawing. Note at the top of your page date, time, place, weather, sounds, and perhaps your mood or attitude toward the place. (See Figure 8.9 or 8.10.) Do not rush into drawing just anything. If you are outdoors, first walk around to become generally familiar with the area. When you are ready or something has caught your attention, sit down, clear your mind of other thoughts, focus your vision, and begin to look. Have an overall purpose, such as: What is here this season that would not be here another and why? What are some plants unique to this habitat and what determines their ability to grow here? What insects might be on leaves and flowers and why are they here? What characteristic plant, tree, insect, or bird might be here to draw and where is it located? The student who drew the page in Figure 8.8 chose a very specific subject and took time to observe in detail.

166

I was walking along a beach in Maine when I drew the page in my journal depicted in Figure 8.10. Nothing in it is exceptional, but by drawing I was able to study for a few minutes the elements inhabiting that realm. How rarely do we take this time just to *be* in a place. Though brief, this moment of watching, examining, and recording adds significance to our own lives.

USE SKETCHING TO LEARN ABOUT NATURE

Do not judge your sketches as works of art or as examples of your drawing capability. Polish these sketches later if you wish, but be sure that the freshness of the initial observation is not lost—as so often it can be. If you are bothered because a leaf does not look foreshortened or a fox looks massive, *then* is the time to use the drawing pad to work on technique. (Turn to other chapters in this book for exercises to help with the specific difficulties you may be having.)

Keeping a Field Sketchbook Outdoors

The following is an exercise that can be applied anywhere indoors or out, with young children as well as with adults. Children seem to love particularly to keep journals describing different things from week to week or place to place. I have had five-year-olds use simple journals as early readers. They take great pleasure in drawing individual things and labeling them to learn a new word. For four weeks in a class with ten-year-olds, we measured *each* week the size of a daffodil as it grew from first shoot to open flower.

One elderly student took excursions outside her city apartment to look for things to draw that were particular to the season. Upon return, she would sketch a day's observations in a small journal kept just for these accounts. Her drawings, though simple, depict well the seasonal changes and were a source of continual delight and learning.

Exercise 1

A FIELD SKETCHBOOK PAGE

(Time: 30 minutes or more. Materials: any pencil, ball-point pen, or felt-tip pen; several sheets of 8-by-11-inch white bond or drawing paper clipped onto a firm backing, or a hardbound notebook.)

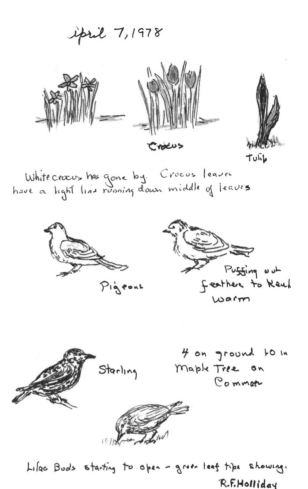

Figure 8.11
Student notebook entry drawn on returning from a walk outside a city apartment.

Find a place you wish to observe for a while. If you haven't already, read the section entitled Using a Field Sketchbook. Look at the examples of field journal pages in this chapter for ways to lay out a page and the subjects that might be observed. Consider your subject, draw it with minimal lines, and be diagrammatic. Save artistic experimentation for later. Record, both verbally and visually, and do more looking than drawing.

Gunnar Brusewitz, the Swedish artist, naturalist, and writer considers himself to be a "nature reporter." He explains that "my books contain what could be called 'nature-reportage' and therefore I choose the fastest technique—pen drawing with watercolors. . . . For me, it is indifferent if the drawings seem to be 'finished' or just 'sketches' (one never knows when a drawing is finished). They are often made very rapidly in the field and for me it is most important if my drawing corresponds with my impressions." (Personal communication, 1979.)

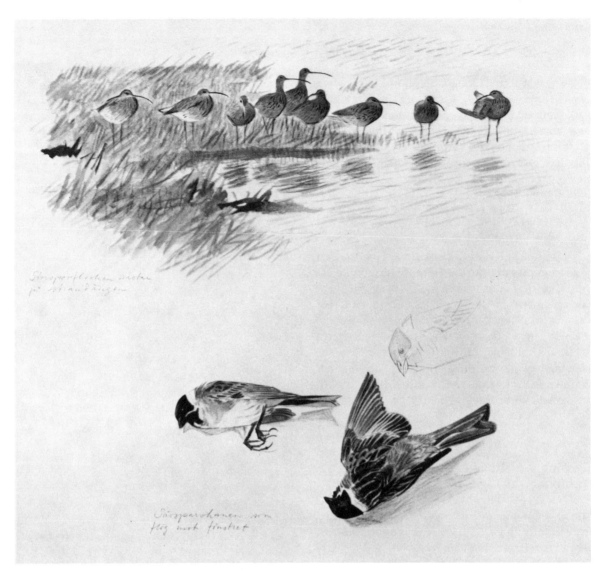

Figure 8.12
GUNNAR BRUSEWITZ (Swedish, 20th century)
Journal page (pencil and watercolor)
From *Sjö* by Gunnar Brusewitz. Courtesy of the artist and the publisher Wahlström and Widstrand, Stockholm

The sketches were made outdoors in pencil, and watercolor and detailed lines were added later.

Exercise for Indoors

A field notebook does not have to be used only in the field. Sometimes weather, time, or state of mind prevents you from taking a notebook with you when you are outdoors, but you still wish to draw the things you noticed there. Here are two options: Look very closely and draw later from memory, or collect and bring back a few specimens to draw with more time. Since collecting is often not advisable, be extremely careful what you take. Things that are dead, such as a seed pod, shell, butterfly wing, or dried weed, are all right to collect. Take only a small sample

of any plant, and only with permission. Leave any animal and draw it later from memory. With careful observation, you will be surprised at how much you will remember and be able to record.

Drawing from specimens indoors means you can work more comfortably, be more accurate with identification, and have guidebooks nearby for reference. Decide whether you wish to include these drawings in the journal or in the drawing pad. If the former, be sure to include date, place collected, size, and more observational data than would be necessary for a drawing pad.

There are subjects indoors, as well, that can be sketched rather than drawn. Look for things

showing sequences of activity that demand quick documentation and reveal something about a natural process. Our cat gave birth to five kittens early one morning while we watched. My husband exclaimed, "Go get your sketchbook!" I did and sleepily scrawled down the whole event in a series of sketches that now provide visual description of an experience not often recorded. I will never forget how excited and involved I was by that drawing. A student found a crane fly on his window, put it in a small bottle, and drew the sequences in Figure 8.13. It is not that there is a lack of subjects to draw; rather it's a matter of *seeing* them as interesting enough to study.

Exercise 2
A SKETCHBOOK PAGE INDOORS

(Time: no limit. Materials: no requirements.)

Follow the same directions for Exercise 1 if you are looking out a window. If you are documenting a sequence indoors, such as the budding and flowering of a plant, the birth of field mice in

Figure 8.13
Student drawings of a crane fly in a small jar.

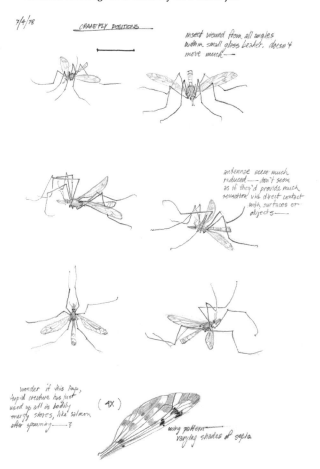

the closet, or the activities of a house fly, fill the whole page with that one subject, being sure to include time, place, and date.

TECHNIQUES FOR KEEPING A FIELD SKETCHBOOK

1. Include written features: date, time, location, weather, sounds, and any other specifics of the habitat worth noting. As the journal progresses and seasons change, dates and locations become significant for seeing how things slowly change throughout a day, week, month, or year.

2. Learn the advantages of using a pencil or a pen. I generally use a felt-tip pen more in the field because it makes clear and distinct lines, lets images be correct the first time, and prevents fussing with line quality or shading variation (which can occur with a pencil). And unlike a good drawing pen, if it is lost it is no disaster. One student used a pencil for drawing and a pen for writing. Use the simplest of coloring tools, or if you do not have any, just draw an arrow and write beside the object what colors you see.

3. Integrate drawings with writings, creating a visually pleasing and more personal record. Do not pack so much information or so many drawings on a page that presentation becomes confused. For an example of an attractive page, see Figure 8.14.

4. Be as accurate as possible with both drawing and seeing, continually checking your subject for scientific and visual correctness. Even a quick sketch without detail should be accurate, or a key feature in identification may be missed. If there is a choice between watching or drawing, watch and then draw from memory when the creature has vanished. Always try to draw in order to learn and to become more observant. I call it "lazy seeing" when a student draws something but fails to notice anything of interest or something new to learn. Always ask yourself, as a naturalist, what more you can learn to push your study forward.

5. Do not take time to search through a guidebook unless you can quickly locate the subject. Instead, write down key features and gestures that will aid in identification afterwards. Figures 8.15 and 8.16 are examples of a field drawing being worked over later with identification and detail from guides and photographs.

Figure 8.14
WAYNE TRIMM
Winter Sketchbook Notes
Reprinted from *The Conservationist*, December–January 1972–73, published by the New York State Department
of Environmental Conservation. Courtesy of the artist, art director and senior editor of *The Conservationist*

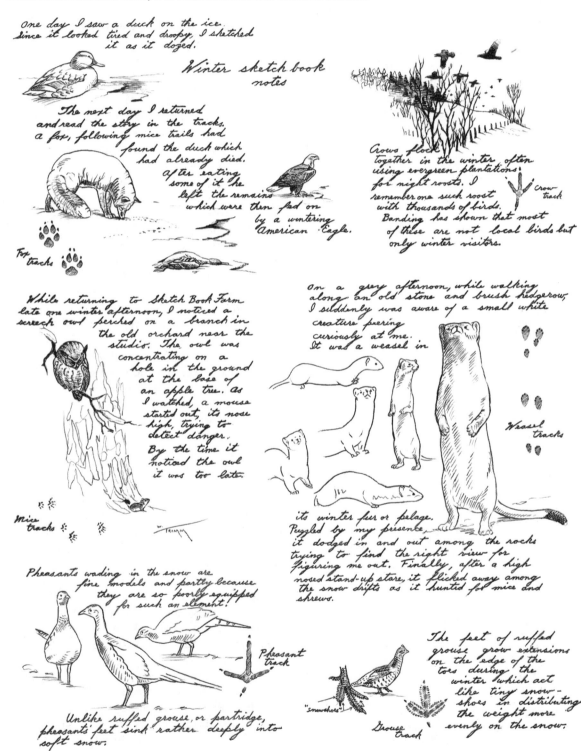

Winter sketch book notes

One day I saw a duck on the ice. Since it looked tired and droopy, I sketched it as it dozed.

The next day I returned and read the story in the tracks. A fox, following mice trails had found the duck which had already died. After eating some of it he left the remains which were then fed on by a wintering American Eagle.

Fox tracks

Crows flock together in the winter, often using evergreen plantations for night roosts. I remember one such roost with thousands of birds. Banding has shown that most of these are not local birds but only winter visitors.

Crow track

While returning to Sketch Book Farm late one winter afternoon, I noticed a screech owl perched on a branch in the old orchard near the studio. The owl was concentrating on a hole in the ground at the base of an apple tree. As I watched, a mouse started out, its nose high, trying to detect danger. By the time it noticed the owl it was too late.

Mice tracks

TRIMM

On a grey afternoon, while walking along an old stone and brush hedgerow, I suddenly was aware of a small white creature peering curiously at me. It was a weasel in its winter fur or pelage. Puzzled by my presence, it dodged in and out among the rocks trying to find the right view for figuring me out. Finally, after a high nosed stand-up stare, it flicked away among the snow drifts as it hunted for mice and shrews.

Weasel tracks

Pheasants wading in the snow are fine models and partly because they are so poorly equipped for such an element! Unlike ruffed grouse, or partridge, pheasants' feet sink rather deeply into soft snow.

Pheasant track

The feet of ruffed grouse grow extensions on the edge of the toes during the winter which act like tiny snow-shoes in distributing the weight more evenly on the snow.

"snowshoes"

Grouse track

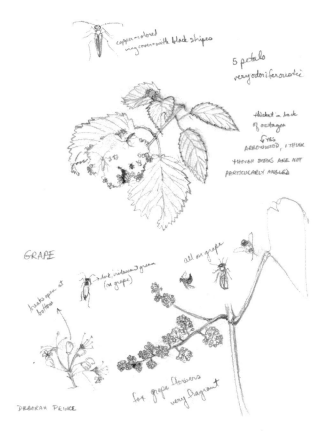

Figure 8.15
DEBORAH PRINCE

Field sketches of grape and arrowwood viburnum.

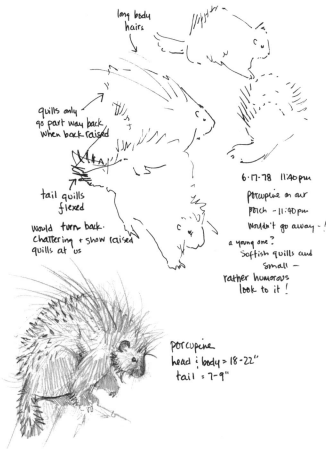

Figure 8.16
CLARE WALKER LESLIE

Field sketches of a porcupine in our barn, and a study drawing made from a photograph and guidebook later.

SOME TOPICS FOR FIELD SKETCHBOOK PAGES

1. Draw sequences of growth: tree buds coming into leaf; birds courting, building nests, and raising young; flowers coming into bloom; the seasonal cycle of life around a pond. Learn what stages of growth living things go through.

2. Choose a specific place. Go there each week and document the changes in the environment over a period of weeks, a season, or a year. Become familiar with plant and animal cycles from birth to full growth to death. Notice just the contrast in the height of plants between April and July.

3. Draw all the insects feeding or resting on one plant. How do they interact? What are they feeding on? How do they fly in and depart? If you look closely, you will be surprised by how much activity is going on.

4. Draw all that you see within a 3-by-3-foot plot in your front yard: weeds, leaves, flowers, seed pods, insects. Learn to look within small areas and to see how things survive living next to each other.

5. Look out a window. Draw three or four living objects or events signifying that particular place and time of year, for example, the sun setting at 4:30 P.M., some leaves newly opened, a bird flying by, some daffodils in bloom. Write down the proper data and return to the same window a week or so later, observing what is different. Something is always there to draw and to observe, despite how dull the day may seem. The sketches in Figure 3.3 for the finished drawing in Figure 8.17 were a combination of several done while observing squirrels at a city window and outdoors in a nearby park.

6. Consider the world of night. Take a walk and for twenty minutes or so just listen, smell, touch, and try to decipher forms as your eyes grow accustomed to the dark. Return and list in your journal what you experienced: wind sounds, animal rustlings (what?), silhouettes of trees, va-

Figure 8.17
CLARE WALKER LESLIE
Eastern Grey Squirrel (fountain pen)
Drawn for the *Massachusetts Audubon Society Newsletter,* March 1979

Drawings were reworked from looser field sketches in pencil.

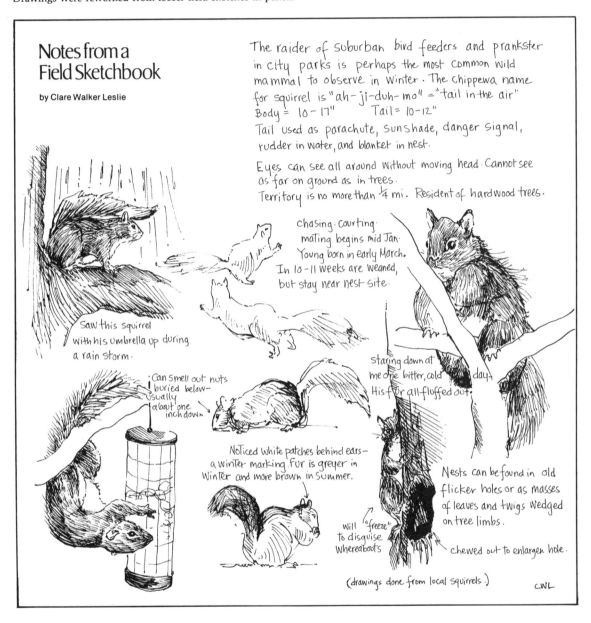

rieties of textures. Then do a small sketch of dark shadows and lighting contrasts that make up the landscape just seen. We do not experience the world of night enough. This is a time when many animals become active and the land takes on a new dimension.

7. Visit a science museum, aquarium, zoo, botanical garden, or center where there is a variety of living things to be sketched. Arrange five

or six subjects (as in a field sketchbook) onto one page and add whatever written documentation you wish. Figure 8.18 records the elements noted in a timberline meadow diorama at a natural history museum.

8. Use the chart in Figure 8.19 for further ideas. Set up a sketchbook journal as a way to seek answers to the many daily mysteries and events occurring in the natural world. Use it as

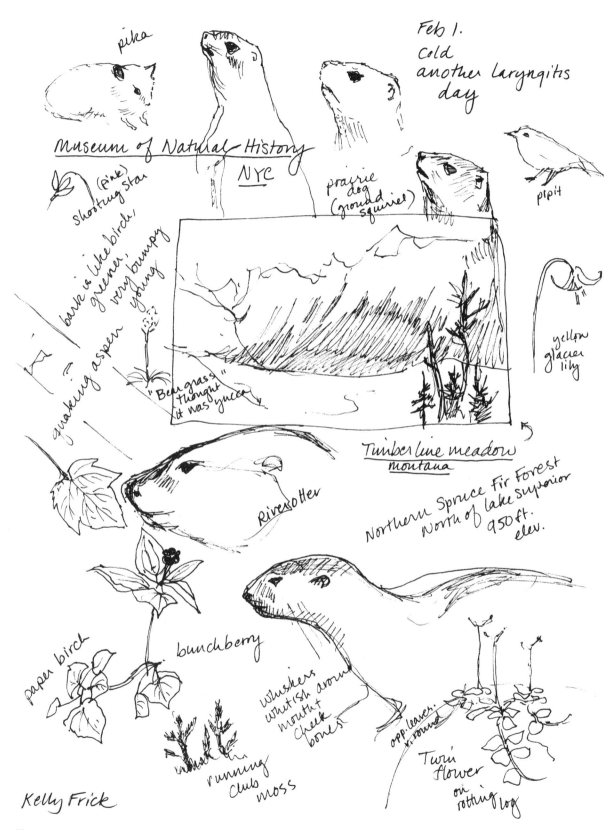

pika

Feb 1.
cold
another laryngitis
day

Museum of Natural History
NYC

(pink)
shooting star

bark is like birch, greener, very bumpy
quaking aspen young

prairie
dog
(ground squirrel)

pipit

"Bear grass"
thought
it was yucca

yellow
glacier
lily

Timberline meadow
montana

River otter

Northern Spruce Fir Forest
North of lake Superior
950 ft.
elev.

paper birch

bunchberry

Whiskers
whitish around
mouth
cheek
bones

opp. leaves. round

Twin
flower
on
rotting log

running
club moss

Kelly Frick

Figure 8.18
Student sketchbook page done at the American Museum of Natural History,
New York City, of a timberline meadow in Montana.

* Suggested ideas to study in a field sketchbook – add your own *

	CITY	SUBURBS	MEADOW	WOODLAND
WINTER	bird + animal activities tree silhouettes tree buds weeds in back lots and pavement edges weather, temperature patterns	tree seeds + nuts – who eats what? Animal tracks in snow birds at a feeding station or in the Park temperature + weather chart Phases of moon – length of days twigs + buds	Winter weeds animal activity + tracks landscape studies animal evidences – holes + food caches night walk – stars + sounds tree silhouettes	lichens + fungi + evergreen animal tracks in snow Plants resident birds + their activities identify evergreen trees animal homes – holes + nests Snow depths
SPRING	emerging leaves – sequences tree flowers first flowers blooming Birds nesting + Calling squirrel behavior documenting weather changes	dates of first seen returning birds flower blooming sequence first trees to bloom + leaf out nesting birds + animals Sounds + Smells at night – frogs + birds	pond life – insects + plants bird courtship flower blooming sequence first insects + their activities animal night activity – frogs, woodchuck, skunk color contrasts with winter	first wildflowers first trees to leaf out nesting animals returning birds Sounds + Smells blooming sequences
SUMMER	flowering wild plants in back lots local bird + animal activity temperature + weather contrasts Urban gardens + flowers insect signs + Sounds night sounds	moths of night lights butterflies + activities local animals + activities garden vegetable growing sequence tree + shrub varieties	grass varieties – timothy + orchard nesting birds – where landscape varieties temperature + weather patterns Animal activities sounds – night + day	insects – what doing tree types birds + their nests animal activities – day + night life under a log or stone Sounds – day + night
FALL	first signs of frost – What dies Progression of trees to drop leaves What birds leave Contrast animal activity with Spring: birds, insects	animal winter preparation last flowers to bloom life under a log or stone Why do leaves change color? Sequence of trees to drop leaves Sounds of day contrasting with night Weather records	insect activity last flowers to bloom birds that migrate weather changes – cloud studies Animal preparations for winter	Winter animal preparations berries, nuts, seeds, fruits mushrooms turning tree leaf sequences smells sounds What dies, what sleeps

Figure 8.19

a general program of study in natural history and as a diary that follows rhythms and patterns beyond the reach of human control.

BIBLIOGRAPHY

ADAMS, RICHARD. *Nature Through the Seasons.* New York: Simon and Schuster, 1975. (PB)

BESTON, HENRY. *The Outermost House: A Year of Life on the Great Beach of Cape Cod.* New York: The Viking Press, 1956. (PB)

BRADY, IRENE. *Wild Mouse.* New York: Charles Scribner's Sons, 1974. (HB) (A delightful, illustrated account in a journal form of the sequential delivery of young mice.)

BRUSEWITZ, GUNNAR. *Sjö.* Stockholm: Wahlström and Widstrand, 1975. (HB) (Available only through the publisher but well worth the effort.)

————. *Skissbok.* Stockholm: Wahlström and Widstrand, 1970. (HB) (Also only available through the publisher.)

DILLARD, ANNIE. *Pilgrim at Tinker Creek.* New York: Harper and Row, 1974. (PB)

GIBSON, WILLIAM HAMILTON. *Sharp Eyes: A Rambler's Calendar.* New York: Harper and Row, 1891. (Some of the best naturalist journals, superbly illustrated, appeared in the late nineteenth and early twentieth century. Gibson's is among the best. He wrote a number of books which can be located through dealers in old books.) (HB)

HANLEY, WAYNE. *Natural History in America from Mark Catesby to Rachel Carson.* New York: Quadrangle Press, 1977. (HB)

HOLDEN, EDITH. *1906: The Country Diary of an Edwardian Lady.* New York: Holt, Rinehart and Winston, 1977. (PB)

KASTNER, JOSEPH. *Species of Eternity.* New York: Alfred A. Knopf, 1977. (PB)

MEASURES, DAVID. *Bright Wings of Summer: Watching Butterflies.* Englewood Cliffs, N.J.: Prentice-Hall, Inc., 1976. (HB)

WALLACE, DAVID RAINS. *The Dark Range: A Naturalist's Night Notebook.* San Francisco: Sierra Club Books, 1978. (PB)

THE UNEXPLAINABLE THING IN NATURE that makes me feel the world is big far beyond my understanding—to understand may be by trying to put it into form. To find the feeling of infinity on the horizon line or just over the next hill.

Georgia O'Keeffe, *Georgia O'Keeffe*

I am sitting here about to discuss landscape drawing when just beyond my window there is the most exquisite view. How *bold* to attempt writing about how to draw such a scene! How even *bolder* to attempt drawing it. Everything is deep in a blanket of white, and it is still snowing heavily. Trees are draped in soft coverings. Shapes are blurred. Blue jays and chickadees at our feeders are the only color in this muted scene of white and grey.

As an artist, my immediate urge is to draw what I see; to record it, to make it somehow more connected to my own world. I am involved in its beauty and serenity. But how to transcribe mood, image, activity, color, and texture onto a flat piece of paper, using only the limited marks of pencil or pen? That is the whole challenge of drawing landscapes, and of *all* drawing, for

CHAPTER NINE

Landscapes

that matter. Many people would much rather take a photograph than risk an unsatisfactory sketch. However, in drawing, you have time to study, to analyze, and to really see. You can interpret, select, and rearrange in order to convey a mood or emphasize a certain part of a subject, which a camera cannot do. Pausing to draw what I see outdoors allows me the time to appreciate and to study a moment of quiet contact with a world I might have otherwise not noticed. The drawing itself was much less significant than was the moment for study it provided. The drawing was actually thrown into the fire, but the image will long stay with me. It is important for you to realize that a drawing's best product is often *not* the work itself, but the time it provided for quiet contemplation.

LEARNING TO LOOK AT LANDSCAPES

There are many ways to draw landscapes and many great landscape artists. We can learn a great deal by simply feeling free enough to experiment,

Figure 9.1
GUNNAR BRUSEWITZ (Swedish, 20th century)
Illustration (pencil and watercolor)
From *Skissbok* by Gunnar Brusewitz. Courtesy of the artist
and the publisher Wahlström and Widstrand, Stockholm

to make mistakes, to try different techniques, and to study the works of others. Take plenty of time to look at different landscapes, analyzing form, composition, and particular features. Keep in mind what makes a landscape interesting enough to draw, and then emphasize that element (or elements). Was it the rolling sweep of hills, the variation between land form and water, or a meadow and woods that provides the setting through which a fox is running? Since you cannot possibly draw *all* you see, learn to sort out the most important aspects.

Always have a sketchbook with you, or even simply the back of an envelope, to jot down an interesting scene that could be expanded into a more detailed drawing later. One student took a small sketch pad with her on a trek by dogsled across parts of Greenland. With mittens on, she drew quick, colored pencil sketches of barren landscapes and huddled sled dogs. Though very simple, they captured the essence of what she was seeing. (By the way, the woman was over sixty.)

There are a number of theories and exercises that may help you to feel more confident about drawing landscapes. Try them and then adjust them to your own style and interests. The exercises are designed to be used directly, whether outdoors, looking out a window, or drawing from a photograph. Although it is preferable to work

directly from nature, you may not always have the opportunity.

Landscapes can be the most difficult subject in drawing nature. It is perhaps the most intellectually demanding because you have to draw many elements, not merely a few, which may differ greatly from each other in size and character. You must select, represent, leave out, rearrange, and in effect, be a magician tricking the viewer's eye into *believing* that what you drew was what was there, and that your flat page really *does* have three dimensions. There is no one way to do this. Often you need to apply theories and techniques that come more from the art school than from the biology lab. In fact, you can become more the artist than the naturalist in your attempt to make the landscape you draw on paper "look right." To me, landscape drawing can be more poetry than prose. It is symbol, brevity, pattern, and design. American landscape artist John Carlson, in his very useful book *Landscape Painting*, writes: "We must have design in a picture at the expense of truth. The artist must look to nature for his inspiration, but must rearrange elemental truths into an orderly sequence or progression of interests."* We cannot just copy nature; we must learn to symbolize it. And that is what art is: a symbolization of nature.

* John F. Carlson, *Carlson's Guide to Landscape Painting* (New York: Dover Publications, 1958), p. 98.

178

Figure 9.2
GOSHUN (Japanese, 18th-19th centuries)
Farmhouse by a Stream (ink brush on silk)
Courtesy of the Museum of Fine Arts, Boston

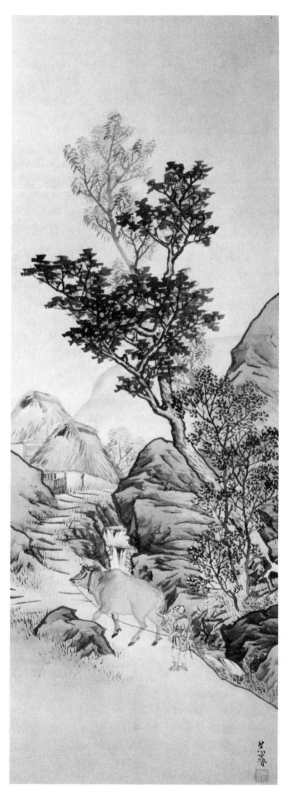

Because there are so many different approaches to drawing (and painting) landscapes, I have filled this chapter with numerous examples from a variety of artists whose works I feel would be helpful to you to study and even to copy. Look at each one carefully and analyze critically the artist's style and intent. I have selected mostly American landscape artists because I feel they have depicted scenes you are more likely to see yourself. Since there has been a resurgence of interest in American landscape painters recently (particularly those of the nineteenth and early twentieth centuries), you can find their works in most art museums or reproduced in many current books on art. It is interesting to note that many of the nineteenth-century landscape painters did much to awaken the interest of both Americans and Europeans to the glorious panoramas of this country, particularly in the West, New England, and the Deep South. Previously, subjects for painting had been primarily confined to the more intimate scenery of Europe. Along with this interest arose the burgeoning environmental concern to permanently preserve some of the large wilderness areas, such as Yellowstone, Yosemite, and the Grand Canyon. For contrast

Figure 9.3
HOMER DODGE MARTIN (American, 19th century)
Sheep Hill, New Jersey (pencil)
Courtesy of the Museum of Fine Arts, Boston

This is a good drawing to study carefully the tonal variation from foreground to background and the pencil technique used in defining tree foliage and foreground vegetation.

of style, you might want to look at some of the landscapes of the Far East by the Chinese and Japanese brush painters.

Exercise 1
LOOKING AT LANDSCAPES

The first questions always are, "Where do I begin? What do I put in? What do I leave out?" Spend some time just looking at landscapes around you: from your window, in your backyard, while you are driving, and even in books or magazines. What *are the major shapes you see in trees, hills, water, rocks? Vertical and horizontal shapes? What does the foreground, the middle ground, and background contain? Where does sky drop behind land? What attracts you enough about this scene to want to draw it?*

Squinting your eyes will help you to see major forms and blur out the less important shapes and details. Another aid in composing a landscape is to hold your hands up in a frame, like a camera lens, moving them around to select the frame you like best. You can also use a camera lens or make a frame by cutting a large enough hole (such as 4 by 5½ inches) out of a piece of 8-by-10-inch cardboard. What I have my students use because they can carry it easily with their drawing equipment is an empty 35mm slide frame.

Learning how to frame your composition and where to put its borders is a key trick for a successful drawing (as well as a successful photograph). Be sure that trees are not cropped and shapes left dangling or undefined at the edges. Start thinking now about what makes a good landscape composition. See Figure 9.6 for an interesting way to lay out a composition within a frame structure suited to a page of writing and Figure 9.7 for an example of one scene framed three different ways.

Exercise 2
THE GESTURE DRAWING

(Time: 1- to 5-minute sketches. Materials: soft drawing pencil such as an HB, 2B, or 3B, charcoal pencil, or felt-tip pen.)

Draw three frames on three separate 8-by-11-inch pages approximately 6 by 7 inches, 8 by 6 inches (vertical), and 4 by 7

Figure 9.4
Student drawing made along a highway north of Seattle. A very free, quick gesture drawing.

Figure 9.5
CLARE WALKER LESLIE

A field sketch drawn more to capture the mood of the moment than to depict its realism.

home for a shovel with which to dig it up, his wife unfortunately induced him to change his shoes, when the fern seed fell out and was lost and with it went all knowledge of the treasure. In Swabia it was believed that fern seed brought by the devil near midnight would enable one man to do the work of thirty. It must be confessed t h a t fern seed received in such a manner would go a long way toward convincing o n e of its powers.

The lady fern is found in nearly all parts of North America and is equally com-

THE HAUNTS OF THE LADY FERN.

Figure 9.6
WILLIAM W. STILSON
Illustration of Lady Fern (pen and ink)
From *Our Ferns in Their Haunts* by William N. Clute (Frederick A. Stokes, Publishers, 1901)

This composition is tightly constructed, leading the eye from open, foreground forms to the focal, detailed ferns in the center ground and then back to a generalized vista behind. A useful (and rather exquisite) example of how to work with an unspecifically defined landscape subject.

Figure 9.7A-C
Three examples of framed gesture sketches working out major landscape forms and shadings. A gesture drawing is done very quickly with the whole composition seen at once. Notice how in each sketch, foreground, middle ground, and background vary.

inches. By drawing a margin within your paper you are providing the limits of a photograph or framed picture. The eye knows the boundaries and can thus focus toward the composition's center. Many artists use these frames, so do not think of them as merely a beginner's crutch. Framing drawings, in fact, has been a popular technique for numerous illustrations in magazines and books for a long while. The illustration in Figure 9.6 is just one way to frame a subject.

Now set the landscape into one of the frames you have drawn moving your pencil fast over the entire space so that lines connect and you are seeing the whole picture at once. Do not think. Just react to what you see. Be bold; be scribbly; make dark shadings where you see dark patches. See spaces between forms, and simplify shapes. Notice how forms relate to one another and how some shapes dominate and others diminish into the distance. Do the same scene three times, slightly changing its position within your frame. Try a large foreground and small background.

B

A

C

Try a small foreground and large background. See how the vertical versus the horizontal shape changes your composition. Do each of these fairly quickly so that you remain loose and can compare them while you are still fresh. As I mention in other chapters, the gesture drawing is not merely a beginner's exercise but an important technique to use when warming up or when you are feeling tight. Use this exercise throughout your drawing of nature.

If you are drawing outdoors, prop your pad at such an angle that you can see the landscape and your pad with the same glance. Try holding your pad at arm's length, which allows looser lines and a greater distance to view both pad and landscape at once. While you are drawing outdoors, the sunlight may glare on your paper and hurt your eyes. Propping your pad will help but you might want to have handy a pair of dark glasses or a hat.

ELEMENTS IN A LANDSCAPE

Masses and Planes

When we look at landscapes we are seeing various *masses*, which are set into various *planes*, which recede into the distance. Planes may be separated into *foreground, middle ground, background,* and *sky.* The challenge is that you may not immediately recognize any such divisions in your landscape. But these planes in your drawing will convey a sense of depth and help give cohesiveness and legibility to the overall composition. Try to imagine that you have no depth perception. See these large masses as flat shapes running across your page. (Do not see detail or depth yet.) Now imagine that you are making a tapestry landscape from pieces of fabric or paper. You must cut out shapes which make up your foreground, middle ground, background, and sky. These shapes, by their size, relation to one another, and placement on your fabric will give the *illusion* of distance (see Figure 9.8).

Because I came to drawing landscapes from a background of doing silkscreen prints (which of necessity simplifies land forms to their primary shapes), I am increasingly convinced of the importance of students having some experience with design and composition in order to achieve a successful drawing. Many landscape artists will

Figure 9.8
A tapestry landscape from fabric or paper helps to distinguish major masses.

tell you that a composition should still hold together even after being reduced to an abstract design of flat shapes. Although you may never return to the following exercises, be aware of their value in learning about design and composition.

Exercise 3
MASSES AND PLANES

(Time: 30 minutes. Materials: any drawing tool and any paper.)

Diagram a landscape, photograph, another artist's drawing (as depicted in Figure 9.9), or an imaginary scene in terms of flat masses and planes. Do not use any shading; just outline the shapes. Experiment by varying the sizes of your planes. What does this do to the sense of distance?

It may help to hold your pencil at arm's length and perpendicular to the ground so that you can line, along the pencil, the relative heights of each plane (see Figure 9.10). Mark off between the tip of your pencil and your thumb the proportions of your planes and the larger masses within. This is a good trick for sizing up any shape or angle, whether on trees, animals, buildings, or mountains. As with any subject, once you have calculated your basic shapes and composition, you can start to develop a solid drawing.

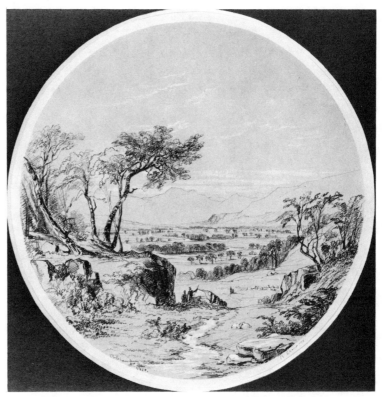

Figure 9.9A-B
BENJAMIN CHAMPNEY (American, 19th century)
Mountain Landscape, 1850 (graphite pencil drawing on prepared gesso tinted ground)
Courtesy of the Fogg Art Museum, Harvard University. John Witt Randall Bequest

A. A clear delineation of planes in a composition well designed to fit the circle shape. Study Champney's pencil technique as a way to describe vegetation and land forms.
B. Diagram of Champney's major planes and masses.

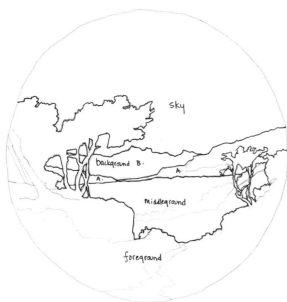

moisture particles in the atmosphere, air becomes less transparent the further away an object is from the eye. Thus, by giving distant forms a softer, lighter *tone* and fewer details, a sense of *aerial perspective* (three-dimensional depth) can be suggested. (*Value* is actually the term defining the whole range of specific tones, from light to dark, but the two words are used interchangeably.)

Figure 9.10
By siting your pencil perpendicular with various distant forms, and sizing between your thumb and pencil tip, you can ascertain proportional differences and thus make the relationships of forms more accurate.

Aerial Perspective: Value and Tone

All your planes now are made up of flat shapes with no color or depth. Look at your landscape again and see that the tones of each mass vary in intensity as they recede into the distance. This effect has to do with *light* as it hits these masses, making them darker or lighter depending on their relation to the sun and to your eye. Because of

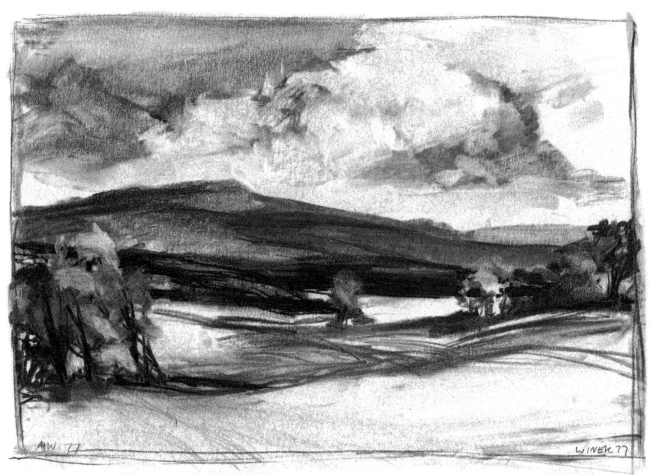

Figure 9.11
MARC WINER
Landscape (vine charcoal)
Courtesy of the artist

In Figure 9.11, the artist has indicated a variety of values which give an expansive sense of distance as well as strong value contrasts. Notice particularly how, by juxtaposing a very strong dark with the white of the paper (in the upper right of the middle ground), he "tricks" the eye into believing that the distance between the two planes is actually very large.

Value and tone are independent of color pigmentation, but they can affect color by making it darker or lighter. A tree may be dark green in shadow and light green in sun. Still, the whole foliage is green. Since we are not working in color with most drawing tools, we must, like the black and white film, *represent color in terms of value.* We can only use a black tone to indicate dark green leaves and a light grey tone to indicate pale green leaves. If two trees have the same color and light intensity but one is further away than the other, give the further one a lighter tone. If the further tree is a darker color, make it darker, but also draw it less distinctly and, of course, smaller.

Contrasting the value of your planes and individual forms is the key to achieving a sense of depth.

If you have everything in your landscape equally detailed and of equal value, it will look like everything is within the same plane. Study Figures 9.2 and 9.12 to see how the contrasted darks and lights of individual trees and land forms give a sense of distance and space. Both artists achieved this effect by selectively varying the intensity and weight of their pencils. Knowledge of the full tonal range of your medium (whether pen, pencil, charcoal, or brush) can also greatly help you create a more tonally varied picture.

Learn the chart in Figure 9.13, which will also help you to draw animals, plants, and other natural subjects. Good black and white photographs can be useful for sorting out these value ranges. In fact, you might find it easier to start drawing from photographs since the camera usually has made a clear selection already (see Figure 9.14A, for example).

Figure 9.12
JASPER CROPSEY (American, 19th century)
Conway, New Hampshire, Birch Trees (pencil, heightened with white)
Courtesy of the Museum of Fine Arts, Boston. Gift of Maxim Karolik

Woodland settings are extremely complex subjects to depict. Working primarily with tonal values to define differences between forms, Cropsey subtly achieves a real sense of depth, foliage mass, trickling water, and filtering light. Analyze how he achieves lighting contrasts and spatial depth.

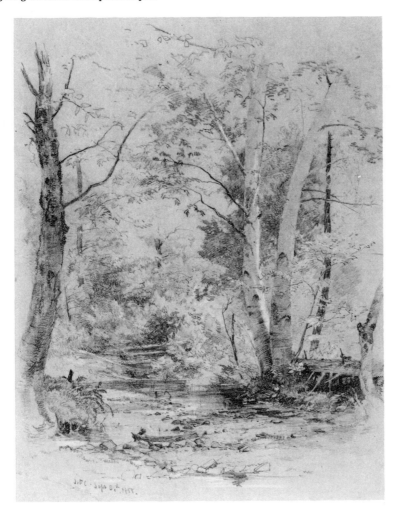

Figure 9.13
Diagram of contrasts to consider for a sense of aerial and distance perspective.

	COLOR		TONE	DETAIL	LIGHT	
background	light	dark	pale	less	shadow	light
foreground	dark	light	dark	more	light	shadow

Figure 9.14A-C
A. Grey, winter days can be helpful in studying tonal values. Use black-and-white photographs to sort out the various values and even draw from them.
B. Pencil study differentiating five primary values in the photograph.
C. A more abstract pencil and ink wash of the same landscape.

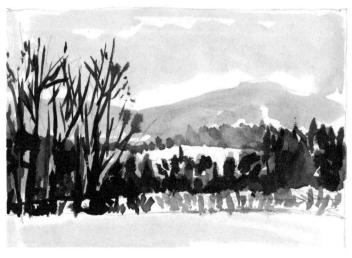

Exercise 4
VALUE AND TONE STUDY

(Time: 30 minutes to one hour. Materials: soft pencil, charcoal pencil, or black ink and brush; any good drawing paper.)

On one page do two or three small, framed landscape studies from life, photographs, or your imagination. Give each plane a different tonal value. Notice how varying tones help give a sense of depth, or defeat it, and how white areas introduce space, depth, and relief for the eye. Learn that white spaces can be as important a compositional element as subject areas.

Exercise 5
VALUE AND TONE LONGER DRAWING

(Time: 30 minutes to one hour. Materials: any medium.)

Do a landscape drawing, creating primarily areas of tone and value and as few outlined shapes as possible. Draw a frame one inch in from your paper edge, or work without a frame. Stay away from details and linear definitions. Use the side of your pencil, as described in Figure 9.15B. Draw from a photograph or from life. "Scribble" your pencil back and forth loosely, as in the gesture drawing, only this time for areas of tone instead of just line. Use your finger or a cloth to smudge some areas and soften others. An eraser used lightly over your image can also soften tones.

The artist used a gum eraser and his fingers to smudge and pick out tonal areas in Figure 9.11. With charcoal he has created a predominantly tonal, nonlinear drawing. Since tone indicates the *shading* of a form rather than its outline, when line is used (in Figures 9.2 and 9.12) it should be of a repeated and uniform nature so that the overall effect is of shading rather than outline. Since many of us learn to draw by using line predominantly, it is good practice to experiment with just tone to create forms. Drawing a landscape with a brush and black ink wash also can be a helpful experience.

Light

Always try to locate a light source so that values can be relatively true to life. Light can come from the sky, be reflected from another surface, come from behind, or be evenly illuminated (as on a cloudy day). You may have to change the lighting if on the flat paper it does not give the same sense of light and space as you observe. Notice how Figure 9.12 gives a definite and beautifully atmospheric feeling of light filtering through leaves, bouncing onto trunk and around masses,

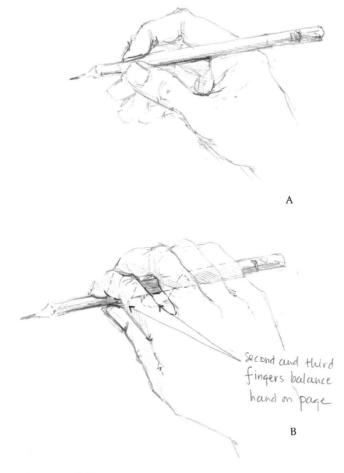

A

B

Second and third fingers balance hand on page

Figure 9.15A-B
A. Shows the conventional way to hold the pencil, which is appropriate for detail and most drawing work.
B. Shows a looser way (rather like the way a violinist holds a bow), which allows for a freer and more flexible movement of the hand and faster tonal shading. Balance the lead and your hand on the page with just your second and third fingers touching the page. Try both and see which you prefer.

and reflecting onto water. One way to emphasize light hitting a form is to strongly contrast the adjacent form by making it much darker. In how many places has the artist created light by juxtaposing it next to dark? Another way is to leave areas of paper blank, which allows for spatial relief as well as the presence of light.

Light is very tricky to capture because it has no form, but only shading, tone, and atmosphere. Light is separate from color and from form, although it influences both. It takes experience, study, and experimentation to get a feeling for light. The French Impressionists were so fascinated by depicting light and atmosphere that they gave up describing the solid form in an attempt to show how the visual perception of images is actually broken up by atmospheric conditions of light, color, moisture, and so on.

Exercise 6
LIGHT

(Time: 15 minutes to one hour. Materials: any soft drawing pencil, charcoal, or grease crayon; try crayons or colored pencils if you wish to include color; any good paper.)

Choose a small scene or portion of a scene, such as a clump of trees, pile of rocks, stone wall, bank of grasses with low plants, or patch of water with some rocks beside. Choose something that has strong contrasts and a light source you can directly locate. Squint for a few minutes so that details and linear features merge into just masses of lights and darks. Make tonal marks on your paper where you see the darkest areas. Again, try using the side of your pencil to create areas of tone; then leave blank your lightest patches. Move around and just draw in only two more shades of light: middle dark and middle light. You may have to draw quickly if you are working outdoors since light changes rapidly and shadows move. Become sensitive to how the presence and absence of light can affect a scene and the forms within it.

Smaller Masses and Planes

Exercise 7
SMALLER MASSES AND DETAILS

(Time: one hour. Materials: HB or 2B pencil or pen and ink, good drawing paper.)

Once you have established your major planes, tones, and masses, you can start to divide larger shapes into smaller ones and bring out detail. Do an extended drawing, working in as much detail as seems appropriate. Start to watch your drawings carefully and help yourself by knowing when to stop. (See Figures 9.21 if you are a bit confused about which steps follow which.)

Be careful not to include too much. Can you explain *why* you put in all those extra lines and all that fuzzy detail in the leaves and flowers? Is it necessary in supporting the theme of the whole picture? One of the masters of simplicity

is the artist Andrew Wyeth: "I don't agree with the theory that simplicity means lack of complexity. Just because you have a simple subject of a hill doesn't mean that it isn't complex as hell. . . . Don't show every muscle in the body you are painting, emphasize just the salient points, just enough."*

Linear Perspective and Foreshortening

Generally, when things are further away, they are smaller. Notice a row of trees angling away from you in a straight line. The trees get progressively smaller until they hit the horizon or disappear from view. You probably learned something about perspective, vanishing points, and disappearing railroad tracks in an elementary school art class. In nature, however, perspective is not so neatly worked out; paths curve, trees vary in shape, and horizons are hidden by foliage or mountains. Therefore, you must learn to feel perspective and not rely on mechanical lines and rules of geometry. In fact, some landscape artists do not bother to teach it, preferring the student to study by direct observation.

Some awareness of linear perspective is useful, however, when drawing landscapes with proper depth and proportion, particularly those having repeated or linear forms such as roadbeds, bridges, plowed furrows, or rivers. By carefully placing objects in a progressively diminishing size, we can establish a sense of three dimension-

* Thomas Hoving, *Two Worlds of Andrew Wyeth: A Conversation with Andrew Wyeth* (Boston: Houghton-Mifflin Company, 1978).

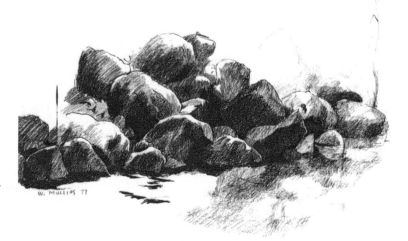

Figure 9.16
WAIF MULLINS
Creek Boulders (soft pencil)
Courtesy of the artist. Collection of Brenda Milbourn.
Photograph by Anne Ficarra

ality as well as help guide the eye throughout the composition. Notice how the artist of Figure 9.9A has used a diminishing path to lead the eye through and into the scene beyond. The path reappears, much smaller, and two figures are walking on it (similar to but much smaller than the two foreground figures). What cannot be seen in this drawing, nor in most landscapes, is that there is a point at the horizon where that path will vanish and its two sides will merge and join. That point of merging (known as the *vanishing point*) is set by a line that goes from the *viewer's* eye straight to the horizon. *As the viewer's position changes, so will the vanishing point.* The height of the horizon on which the vanishing point appears depends on the *eye level* of the viewer. If the viewer is above the horizon, the lines of convergence will look like those in Figure 9.17B; if the viewer is below the horizon, the lines of convergence will be like those in Figure 9.17A.

This phenomenon can be quite confusing

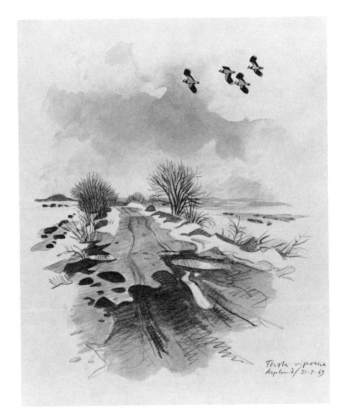

Figure 9.18
GUNNAR BRUSEWITZ (Swedish, 20th century)
Illustration (pencil and watercolor)
From *Skissbok* by Gunnar Brusewitz. Courtesy of the artist and the publisher Wahlström and Widstrand, Stockholm.

An example of linear perspective. How does the artist achieve such a marvelous sense of space and depth?

Figure 9.17A-B
Examples of linear perspective.

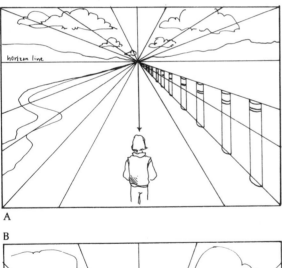

A

B

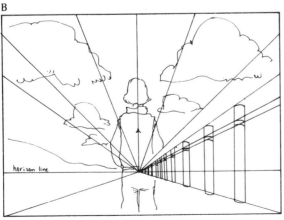

when read about and not seen. Look at the diagrams and apply Figure 9.17A to Figure 9.18. Notice how the tracks in the roadbed converge and ultimately disappear at the far horizon. *You* are the viewer and this is *your* vision. But linear perspective is not so obviously revealed in Figure 9.19. The perspective is "felt" by the artist and aided by strong diagonals of field borders and by diminishing forms and lighting toward the distance.

Exercise 8
LINEAR PERSPECTIVE

(Time: 45 minutes to one hour. Materials: drawing pad and soft pencil.)

In a drawing stress linear perspective in the spacing of trees, a roadbed, animals, fences, or whatever. Consider whether your horizon will be high or low. If it is low, consider also that the sky and clouds follow a similar foreshortened perspective.

Remember that since the actual mechanics of linear perspective are not seen (no lines are drawn between those trees), the best way to learn

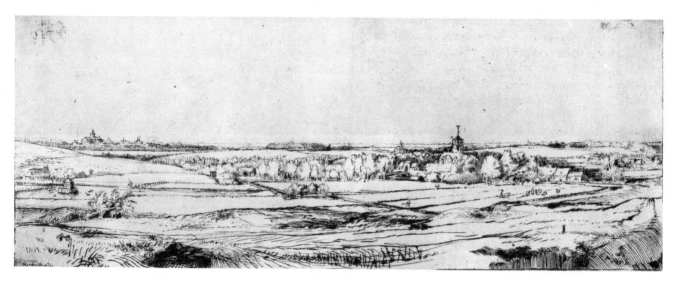

Figure 9.19
REMBRANDT VAN RIJN (Dutch, 17th century)
The Goldweigher's Field (etching)
Courtesy of the Museum of Fine Arts, Boston

it is to look repeatedly at landscapes and develop over time a sense of foreshortening and depth and how to convey them in a composition. If you are eager to learn more about such things as one-point perspective, two-point perspective, and the rendering of objects in space (for example, houses, city streets, machinery, and so on) refer to any good book on mechanical drawing.*

Composition

Landscape drawing is a study in composition. We select objects and general masses from the scenery before us and form them into a design on our page, leaving out this and emphasizing that. Often we will look less at the subject and more at our paper in order to form a unified design as well as a landscape recording. Georgia O'Keeffe comments: "It is surprising to me how many people separate the objective from the abstract. Objective painting is not good painting unless it is good in the abstract sense. A hill or tree cannot make a good painting just because it is a hill or tree. It is lines and colors put together so that they say something. For me, that is the very basis of painting."†

This book is about nature as well as about art, and the naturalist in us wants to draw what we see exactly. So how does the one balance the other? There is no answer. You must ask whether your own interest in studying nature comes more from the artist or from the naturalist in you; whether you have a long time or only a brief moment to draw; whether you wish a loose style or a detailed one. But regardless of style and intent, a good understanding of composition is invaluable.

Some landscape artists recommend dividing the paper as in Figure 9.20. Try it and then in the future use it only if it proves useful. Do not have distracting detail around the edges or in the foreground without having a strong or repeated detail in other areas of the composition. The eye must not be cornered but must be helped to travel through your picture. That is, there must be a flow of forms that connect and relate to each

Figure 9.20

* For example, see Nathan Goldstein, *The Art of Responsive Drawing* (Englewood Cliffs, N.J.: Prentice-Hall, Inc., 1973).
† *Georgia O'Keeffe* (New York: The Viking Press, 1976).

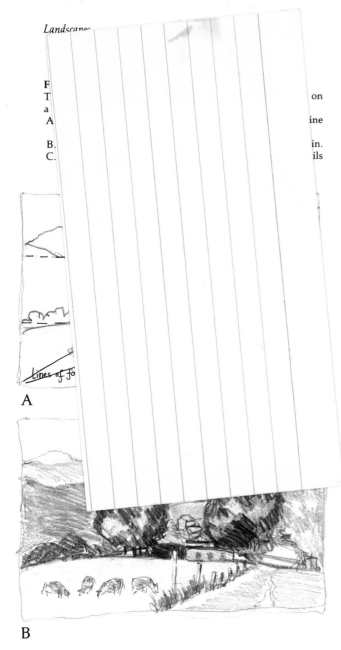

A

B

C

other so that the eye is naturally led from one form to another through all planes. A common problem with beginners is in spotting the particulars but not being able to connect them into an integrated whole. Remember, *individual forms must serve to support the purpose of the whole.* Squinting can help to sort out the essentials.

Exercise 9
COMPOSITION STUDY

(Time: 45 minutes to one hour. Materials: drawing paper and soft pencils.)

Draw a grid similar to Figure 9.20 on your page (at least 3 by 5 inches). Set a landscape composition into it. First establish foreground, middle-ground, and background positions. I find my first line often is the horizon, which immediately helps determine the shapes of the planes above and below. Decide before you begin whether it is better to have a vertical or a horizontal composition featuring foreground, middle ground, or background. I have had students do Exercise 2 and draw three or four little framed gesture drawings first to see which they liked best. This step can eliminate the possibility of getting partly through a drawing only to realize your composition is not what you want.

Figure 9.22
Student drawing (felt-tip pen)

This study was done outdoors looking directly at the subject. A predetermined frame was first sketched in in pencil because the artist felt it helped define the size limits of her composition. Although the center of her composition is empty, she leads the eye away from the edges and through the scene by placing objects and drawn lines on the diagonal. The tree at right is a bit too strong, but she somewhat recovers this mistake by having several delineated trees to the left. She also saves a potentially boring, horizontal composition with a diagonally placed arrangement of trees and pond.

SOME CONSIDERATIONS IN DRAWING LANDSCAPES

If you are struggling at this point, just remember that the ability to draw landscapes does not come overnight. Also, do not think that you must always conform to a certain series of rules or to a certain style. Sometimes I draw very detailed landscapes; sometimes quite abstract ones. It depends on my mood and the time I have. To repeat the underlying philosophy of this book: Using drawing as an opportunity for being with nature is more important than the accomplishment of the drawing.

While I was writing this chapter, I was reading Thomas Hoving's *Two Worlds of Andrew Wyeth*. It is full of many interesting thoughts by a man who has spent a lifetime drawing, painting, seeing, and working always to come closer to things natural and simple. He is a firm supporter of theory and technique, but, he says, they should be used with caution: "Why not have both? Why not have abstraction and the real, too? . . . Bring in the new with the traditional and you can't beat it. I believe, however, that I don't want to let one take over the other. If somehow I can . . . combine my absolutely mad freedom and excitement with truth, then I will have done something."* Later on he comments: "Art, to me, is seeing. I think you have got to use your eyes as well as your emotion, and one without the other just doesn't work. That's my art."†

When to Stop and What to Leave Out

I like to stop my drawing before it is fully finished. (When is a drawing finished anyway?) It

* *Andrew Wyeth,* p. 53.
† *Ibid.,* p. 185.

Figure 9.23
CHARLES BURCHFIELD (American, 19th-20th centuries)
Dandelion Seed Balls and Trees (watercolor on paper)
Courtesy of the Metropolitan Museum of Art, Arthur Happock Hearn Fund, 1940

is very easy to overkill a drawing and to keep adding just one more line. "When in doubt, leave out," an artist friend once told me. Keep your landscapes simple but not simplistic. Leave space and some mystery to your picture so that the observer can enjoy some involvement in imagining what is there. Some blank areas are a rest for the observing eye and allows one to concentrate on detail in other areas. You can always add something to a drawing later, but it is more difficult to take out what is already there.

Stand up and look at your drawing from a distance. Landscapes, particularly, need to be held upright and from some feet away. Tape the drawing to a wall and walk by it for a week. Put it in the mirror to reverse the image. This is a helpful trick with any drawing because it gives you a fresh view on your subject. Try turning the landscape upside down to see if the composition is strong enough to hold it together.

Drawing the Same Subject

Familiarity helps a great deal in drawing something. Use different media; draw in different sizes; see it in different seasons, times of day, and weather conditions. Try a fast sketch, a tone study, a detailed drawing, a large and bold abstract with color. Above all, feel free to experiment, and with experience, you will learn how to create a pleasing landscape.

Drawing from Photographs

I have discussed this in other chapters but it is important to mention again. Photographs can be worthwhile sources for drawing landscapes, particularly if you cannot be outdoors. If you choose black and white, make sure it clearly distinguishes linear and aerial perspectives. Choose those photographs without a lot of detail and with distinct tonal contrasts. Because the values are clearly evident in it, you might try drawing Figure 9.14A. If you are using color photographs, convert the tonal values to black and white and balance your artistic and scientific urges for abstraction or realism.

SKETCHING LANDSCAPES OUTDOORS

Studying the landscape outdoors by doing brief rather than prolonged sketches can be fun and does not entail a lot of technique. You are there to record, to put down quickly but with feeling a response to a particular setting, be it a woodland path, an open plain, a stormy sea, or your backyard. Many artists kept landscape sketchbooks. The sketches were often mere jottings and meant only for personal use as notes for later drawings or paintings.

Figure 9.24
WILLIAM H. WALKER (American, 19th-20th centuries)
Courtesy of Robert M. Walker and William H. Walker II

This is a small pencil sketch my grandfather did in a 5-by-7½-inch notebook he carried around with him, jotting down potential studies for future paintings when a subject interested him. It is a very personal note-taking study. Color notes are written around the edges. He often used a frame in which he placed his compositions.

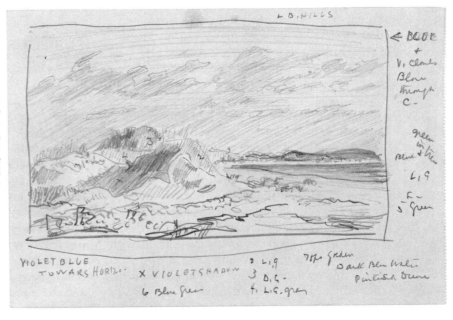

Something made me look up. There they were those geese of northern marshes.
October 3. 1978
8:10 am
McLean's fields.

Figure 9.25
It is useful to have a drawing pad along in a day pack so that an inspiration can be recorded on the spot without having to try to recapture it later. The purpose here was to capture in a somewhat poetic, abstract fashion a moment that quickly vanished.

When you are sketching outdoors, carry the simplest of tools that will fit into a day pack or coat pocket. Make your sketching simply a note-taking study of nature, and make your longer drawing a study of technique as well as of nature. Learn to see the differences between sketching and drawing to help you decide which you prefer to do and when. (See Chapter 8, "Keeping a Field Sketchbook," for further discussion.)

Winter. Study land and tree forms simplified; learn tonal values in the subdued colors of winter; explore different media by doing little subject studies of snow and trees, frozen lakes, barren fields; draw from photographs; learn to draw with mittens on.

Spring. Keep a daily or weekly journal of changes in the landscape around you; watch the vistas change as leaves appear; experiment with a few colors of green, yellow, and brown in a small abstract landscape of spring; use crayons, colored pencils, or magic markers.

Summer. There is a lot to draw in summer so be selective and simple. Concentrate on landscapes that depict an event: sunset, moonrise, feeding animals, summer storm, and so on. Take your sketchbook with you on vacation and draw little landscapes instead of taking photographs.

Fall. Fall is color and texture and you simply must experiment with colors other than black and white. Be abstract, be impressionistic; then be realistic. Notice and draw specific changes in the landscape: what trees turn color first and how a place changes after frost or first snow.

VIEW FROM N/W WINDOW - CAMBRIDGE

Figure 9.26
Drawing by an elderly student from her apartment window. The success of this drawing is in the care and delight she took in doing it.

SUBJECT STUDIES

Water

Drawing water can be more difficult than one might think, but through drawing, one will realize how varied are its forms. Water lies on a plane which generally is set perpendicularly back from the picture's plane; it has a surface texture, whether it be calm, rippled, or tumultuous, which is defined by light reflection; and it has a form, which like snow is often described by objects passing over it. Do you want to draw a placid river, a stormy sea, a rushing waterfall, or a quiet pond? Each demands a different kind of seeing and drawing.

Figure 9.27
WILLIAM TROST RICHARDS (American, 19th century)
The Shores of Conanicut Island, 1882 (India ink on white paper)
Courtesy of the Fogg Art Museum, Harvard University

Using a number of rapid gestural lines, Richards has built
up a range of tonal values to suggest ocean waters as well
as rock forms. Notice how areas of white left for wave crests
stand out strongly when darker, underwave tones are placed
beside. By curving lines in the direction of the wave flow,
Richards helps direct the eye to see movement and form.
Yet the overall pattern of his lines goes from lower left to
upper right, which is the direction of the major water flow.

Drawing from photographs can help be-
cause reflections and tonalities can be made more
obvious for you. Keep a water sketchbook. Study
water very carefully for a long enough time to
absorb into your mind's eye the primary patterns,
reflections, and textures and how you might re-
cord these by line and tone. Study how adjacent
land forms meet the water and also help set it
into a definite environment. Use reflected shad-
ows, as in Figure 9.29, to further suggest the pla-
nar surface and texture. Wave and shadow pat-
terns at an angle and in clustered areas can greatly
add to the feeling of depth and "watery-ness."

Study Figures 9.27, 9.28, and 9.29 to see
how each artist worked to gain a sense of water.
Each was experimenting, as you will be, to see
what would be the most convincing expression.

Figure 9.28
GORDON MORRISON
Zealand Falls (pencil)
Courtesy of the artist

The artist has used a series of line types here to suggest cascad-
ing, swerving, and frothing water. He has taken advantage
of negative space to define the white foam of water, describing
its shape by little squiggles and curls. Follow the variety
of line strokes, which result in a very dynamic image, despite
the lack of tonal variation. See how he shows the shifts in
planes between flat foreground, vertical middle ground, and
flat background.

Figure 9.29
DEBORAH PRINCE
Crum Creek, 1969 (pen and ink)
Courtesy of the artist

This is a successful drawing for several reasons. By shading and silhouetting tree forms, the artist suggests a grey day or dusk. There is a real sense of depth as forms move the eye through a well-placed composition and into the background. Creek banks are set well into the water and then reflect out in the ripples. The reflections of trees and banks, drawn flat across, help to flatten the surface as well as give it planar depth. Foreground reflections under rocks are strongest, followed by diminishingly subdued reflections in the middle and backgrounds. Though a relatively simple drawing, it is well designed and constructed.

Copy the use of line if it will help you to get into your own hand the feeling of drawing water. Try different line types: broken lines, repeated lines, lines flat across or on the diagonal, squiggles and curls, and tonal variations. Watch to see what marks help best to define the type of water condition and its position within a certain pictorial plane.

Clouds

A sky can have more character if it includes cloud patterns. When you study the clouds, what varying shapes do you see? Notice how clouds change according to wind velocity, weather conditions, and the passing of light over or through them. They also can vary from morning to evening. Drawing clouds is like drawing snow. It is learning to draw *around* the form, placing in shadows and outline, and leaving blank the actual form so that the white of the paper is what defines it. Look carefully to see where light hits the clouds and where shadows appear. Clouds can pass by each other, casting shadows or causing interesting backlighting.

Clouds in a sky can help define the weather and the time of day. Sunsets and storms create dramatic patterns and exotic skies. The puffy clusters during fair weather or the large thunderheads *(cumulus)* before summer rains are good to practice on for creating mass and shading. High, thin strips made entirely of ice crystals are called

Figure 9.30
THOMAS DEVIS ANTHONY (English, 18th-19th centuries)
Llandaf Cathedral (ink and watercolor wash)
Courtesy of the Museum of Fine Arts, Boston

Observe how the artist applied a range of tones to create a very dramatic scene.

Study of clouds on a sunny-warm June day — Wispy and soft-

Figure 9.31
Cloud Study

cirrus. Low, uniform sheets forming rain, fog, or just haze are called *stratus.* *Nimbus* clouds hang low and in grey sheets carrying rain or fog.

Sometimes clouds may be darker than the sky; sometimes lighter. Experiment in varying the shading of both. Clouds can give a sense of distance or closeness of adjacent land masses by sitting down behind them, hovering just above, or riding high overhead. In Figure 9.31 clouds were used to give a dramatic effect of light and dark behind the cathedral, causing the sharp tone contrasts on the trees and building. See how a light wash of grey sky next to white accentuates the cloud's whiteness. Then the cloud becomes tinged with grey so that it will sit down behind the trees at its base. If you are having difficulty with value studies, you might consider copying this drawing, using a fine pen with a black ink wash.

Keep a cloud sketchbook. Document how clouds vary from day to day and weather change to weather change. Use a kneaded eraser or your finger to smudge areas, pull out tonal values, and contrast lighting effects (as in Figure 9.11). Try different media, particularly the softer tools, such as charcoal, grease crayon, or a very soft pencil.

Rock Forms

Drawing rocks becomes a study in volume and lighting. Squint your eyes until you can distinguish only the major forms and value ranges, from darkest to lightest. Try to differentiate at least four tonal gradients and roughly the shapes they describe over a surface. Study Figure 9.16 to see how powerfully the artist has built up a

Figure 9.32
DODGE MACKNIGHT (American)
In the Hollow of the Hill (watercolor)
Courtesy of the Museum of Fine Arts, Boston

MacKnight takes full advantage of the white paper to convey a real sense of snow. A sharp contrast between foreground and middle ground is made by juxtaposing the white curve of snow abruptly next to the very dark evergreens.

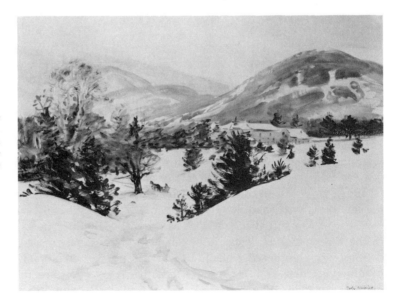

197

convincing feeling of rock mass by using more tone than line in a full range from dark to light.

Figure 9.27 offers another useful study of rocks. Examine where the artist has placed his darkest values to define not only lighting but also angularity of rock forms. I would suggest you begin your study of rocks by using a very soft pencil rather than pen so that you can erase, smudge, and move values around. Use the side of your pencil and emphasize shading over line. Be very careful to keep track of the direction of your light source. If you are drawing outdoors, light continually shifts, and you may find that what began in shadow is now in sun. Develop right away a major lighting scheme on your drawing and *stick* to it or you will become confused. Having used pencil, now try pen, as its tonal contrasts are so strong and can give a very different effect. But remember, because pen cannot so easily be erased, start lighter than you want; you can always get darker, but never the reverse.

Figure 9.33
Snow is primarily depicted here by the white of the paper. Dark forms and tones are drawn around to define its shape.

Snow

Drawing snow is learning to eliminate and to utilize the white of the paper. Often the presence of snow, as with clouds, is best defined by the darker forms and shadows that lie beneath or beside it. A few soft shadows, such as the tracks in the foreground of Figure 9.34, can help give definition to an otherwise blank ground. The art of drawing snow is in learning what to leave blank.

Trees and Other Natural Forms Within a Landscape

Vegetation in a landscape composition must be generalized. You cannot draw every leaf on the tree or every plant in the field or you will have a jumble. Rather, work for an overall sense of plant forms and values. Then put in only the most significant detail which will help carry the eye through your composition. The more natural history you know the more accurate your shapes can be. Look carefully at the examples included in this chapter to see how the artists set various natural forms into their compositions and how they help direct the eye.

Learn what natural elements make up a particular habitat, such as a desert, plains, deciduous woods, or pond, so that you will not put the wrong vegetation into the wrong landscape. When you are sketching outdoors, you might label some of the different plants you draw to help you recall later the specific elements making up that particular habitat. Refer to relevant chapters for more detailed ways to draw trees, plants, and animals within landscapes.

Small Vignettes

If you do not want to tackle the whole vista, just draw a small section, such as a group of trees with selected plants below, a mossy bank, a section of ground and rocks three feet square. Form your hand into a frame, use a camera lens, or use a cardboard frame with a four-sided hole. This frame will help you select a worthy subject that may be otherwise difficult to decipher. Draw a frame on your page or leave enough paper to border your drawing and help design an interesting composition. These vignettes may be brief sketches, somewhat abstract or highly detailed.

Color

Enjoy using color. It is present in nature everywhere, even though most of our drawing tools limit us to tones of black and white. So get out crayons, colored pencils, magic markers, and watercolors. Be a realist and add color precisely as you see it, or be an abstract expressionist and enjoy purple skies, orange canyons, and blue

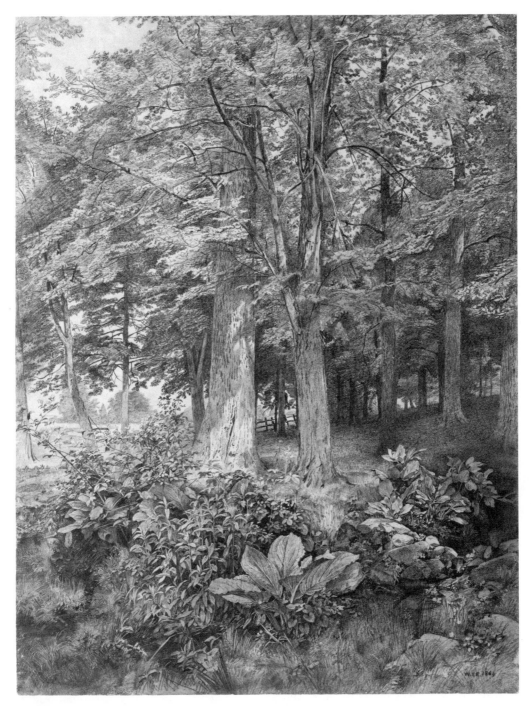

Figure 9.34
WILLIAM TROST RICHARDS (American, 19th century)
A Corner of the Woods (pencil)
Courtesy of the Museum of Fine Arts, Boston

This is an interesting drawing of a very complicated subject. The artist controls what he wants you to notice by emphasizing first a distinct foreground, then winding your eye back to highlighted tree trunks and branches, and then taking it further back to the darkly silhouetted distant trees. Despite the complexity of the subject, never is the scene confused. Throughout there is a tightly woven compositional structure. Reduce the composition to simplified shapes and you will see that Richards began with a balanced design.

Figure 9.35
TOM GRIFFITH
Sierra Stream (pen and ink)
Courtesy of the artist

mountains. Color sets mood. Become involved with subtleties of tonal changes across a meadow or over the spread of a tree canopy. Look at the works of such landscape painters as Winslow Ho-

mer, Georgia O'Keeffe, Claude Monet, or Vincent van Gogh to study how they used color.

"The greatest of Art is not in the display of knowledge or in material accuracy, but in the distinctness with which it conveys the impressions of a personal vital force, that acts spontaneously, without fear or hesitation."*

BIBLIOGRAPHY

CARLSON, JOHN F. *Carlson's Guide to Landscape Painting.* New York: Dover Publications, Inc., 1959. (HB) (A well written and informative paperback. Highly recommended.)

GOLDSTEIN, NATHAN. *The Art of Responsive Drawing.* Englewood Cliffs, N.J.: Prentice-Hall, Inc., 1973. (HB)

GUSSOW, ALAN. *A Sense of Place: The Artist and the American Land.* San Francisco: Friends of the Earth, 1971. (HB)

HOVING, THOMAS. *Two Worlds of Andrew Wyeth: A Conversation with Andrew Wyeth.* Boston: Houghton-Mifflin Company, 1978. (PB) (Paintings and drawings by Wyeth are included.)

McSHINE, KYNASTON, editor. *The Natural Paradise: Painting in America 1800–1950.* New York: The Museum of Modern Art, 1976. (PB)

O'KEEFFE, GEORGIA. *Georgia O'Keeffe.* New York: The Viking Press, 1976. (HB)

POORE, HENRY RANKIN. *Composition in Art.* New York: Dover Publications, Inc., 1967. (PB) (Intelligent and thorough treatment of composition with works by great masters as examples.)

SIMMONS, SEYMOUR, and WINER, MARC. *Drawing: The Creative Process.* Englewood Cliffs, N.J.: Prentice-Hall, Inc., 1977. (PB)

* George Inness, nineteenth-century American landscape painter in *The Natural Paradise: Painting in America 1800–1950,* Kynaston McShine, ed. (New York: The Museum of Modern Art, 1976).

Index